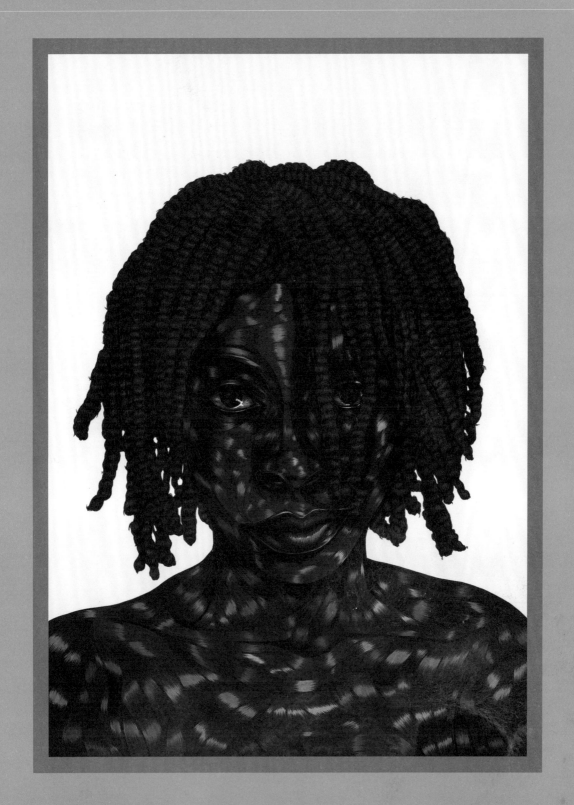

AFRO-ATLANTIC

HISTORIES

MASP MUSEU DE ARTE
DE SÃO PAULO
ASSIS CHATEAUBRIAND

DelMonico Books • D.A.P.
New York

Edited by
Adriano Pedrosa
Tomás Toledo

Texts by
Adriano Pedrosa
Ayrson Heráclito
Deborah Willis
Hélio Menezes
Kanitra Fletcher
Lilia Moritz Schwarcz
Tomás Toledo
Vivian A. Crockett

AFRO-ATLANTIC

HISTORIES

CONTENTS

ARTISTS IN THE

BOOK

Afro-Atlantic Histories at Museu de Arte de São Paulo Assis Chateaubriand

The United States of America presentation of *Afro-Atlantic Histories*, organized by the Museum of Fine Arts, Houston and the Museu de Arte de São Paulo (MASP) in partnership with the National Gallery of Art, Washington, D.C., brings together an extensive selection of artworks and documents linked to the "ebbs and flows" (to use an expression coined by the French Brazilian photographer, ethnographer, and *babalawo* Pierre Verger) among Africa, the Americas, the Caribbean, and Europe throughout five centuries. Brazil is a crucial territory for those histories, as it received about 40 percent of all Africans who were forcibly taken from their native continent over more than 300 years to be enslaved on this side of the Atlantic. The United States of America also plays a key role in such histories, so it makes sense that an exhibition originally organized and presented in Brazil now moves further north in a much revised manner.

Afro-Atlantic Histories was originally presented in a much larger scale at the MASP and at the Instituto Tomie Ohtake in São Paulo in 2018. After gathering international attention and recognition, we were approached by our colleagues in Houston to put together a more concise version of the show for US audiences. We were fortunate that the National Gallery of Art later joined the project with enthusiasm. In this sense, we must thank specially Mari Carmen Ramirez, the curator from Houston who first saw the show in São Paulo, as well as the director there, Gary Tinterow, who are both esteemed colleagues and collaborators of ours in São Paulo. An acknowledgement is due also to Deborah Roldan, director of exhibitions in Houston, who has led the organization of the project in the United States of America. We very much appreciate this opportunity to work together in what is a major project. Thanks also to our colleagues in Washington, D.C., particularly the Director of the Gallery, Kaywin Feldman, who early on saw the potential of the project. We are also grateful to the Instituto Tomie Ohtake, our partners in São Paulo who co-hosted with us the exhibition in 2018, in particular to Ricardo Ohtake, President, and Vitória Arruda, Director.

Afro-Atlantic Histories is curated by a Brazilian team, led by Adriano Pedrosa, Artistic Director, MASP, and Lilia Moritz Schwarcz, Adjunct Curator of Histories, MASP. The genealogy of the project harks back to *Mestizo Histories*, an exhibition presented at the Instituto Tomie Ohtake in São Paulo, in 2014, co-curated by Pedrosa and Schwarcz. At MASP, the project started off as *Histories of Slavery*, and was thus presented in a first seminar in 2016.[1] After that, Pedrosa and Schwarcz reflected on some of the discussions that were brought about in that first seminar and, in a second seminar in 2017, the project assumed its definite title, *Afro-Atlantic Histories*. They defined the framework of all of the

exhibition's sections, except for Routes and Trances: Africas, Jamaica, Bahia, which was later proposed by Ayrson Heráclito. Pedrosa and Schwarcz were then joined by Tomás Toledo, chief curator, MASP, and two guest curators: Heráclito and Hélio Menezes, all of which made crucial contributions to the development of the exhibition. For the United States presentation, Kanitra Fletcher, who was Assistant Curator in Houston and is presently Associate Curator in Washington, D.C., was the curator responsible for the dialogue with the Brazilian curatorial team. From the MASP team, Amanda Carneiro, Assistant Curator, also played an important role in this dialogue. We are very much grateful to all of the curators involved in the first and second presentations of *Afro-Atlantic Histories*, in Brazil and in the US.

This publication, edited by Pedrosa and Toledo, is put together through a special partnership with DelMonico Books • D.A.P., and we must thank them as well as our colleagues Karen Marta and Todd Bradway at Karen Marta Editorial Consulting for all the extraordinary work they have put into it. Special thanks also to Paula Tinoco at Estúdio Campo, São Paulo, who designed this volume, and the authors who contributed to the publication: the curators Vivian Crockett, Fletcher, Heráclito, Menezes, Pedrosa, Schwarcz, Toledo, and to Deborah Willis, whose text was presented in our 2016 seminar and originally published in our *Antologia*.

At MASP, *Afro-Atlantic Histories* should be understood in the framework of an ongoing series of yearly projects around different histories: *Histories of Childhood* in 2016, *Histories of Sexuality* in 2017, *Women's Histories, Feminist Histories* in 2019, *Histories of Dance* in 2020, *Brazilian Histories* in 2021-22, *Indigenous Histories* in 2023, *Queer Histories* in 2024, *Histories of Ecology* in 2025, and *Histories of Madness and Delirium* in 2026. The original word in Portuguese, *Histórias*, quite different from the English *Histories*, encompasses both history and story, fiction and non-fiction, and in a polyphonic and plural manner, it possesses a quite speculative, impermanent, fragmented, non-totalizing quality. Looking back and ahead at MASP's program, it becomes clear that, as an institution devoted to art, we are more interested in social histories that can be translated or accessed through visual cultures and that are relevant to our times and to people's everyday lives, rather than art history alone.

We are grateful to all the artists and lenders who generously loaned works to both iterations of *Afro-Atlantic Histories*. The yearlong program of *Histories* exhibitions at the MASP constitute an exceptional opportunity for the museum to acquire works, and since 2018, many have been brought into the collection in the Afro-Atlantic framework, in turn advancing our mission to become an increasingly "diverse, inclusive and plural" museum.[2] It is worth mentioning the artists here, as many of them have their works reproduced in this publication: Abdias Nascimento; AD Junior, Edu Carvalho and Spartakus Santiago; Bruno Baptistelli; Chico Tabibuia; Dalton Paula; Emanoel Araújo; Flávio Cerqueira; Jaime Lauriano; José Alves

de Olinda; Maria Auxiliadora da Silva; Mario Cravo Júnior; Maxwell Alexandre; Melvin Edwards; Rosana Paulino; Rosina Becker do Valle; Rubem Valentim; Senèque Obin, and Sonia Gomes.

Lastly, we would like to thank all of MASP's teams, board members, patrons, as well as our strategic partners, who provide important funding to all our activities all year long: Itaú and Vivo.

Heitor Martins
President, Museu de
Arte de São Paulo
Assis Chateaubriand

Adriano Pedrosa
Artistic Director, Museu
de Arte de São Paulo
Assis Chateaubriand

1. The seminars unfolded into a reader in book format of its own, Histórias afro--atlânticas: antologia (São Paulo: MASP, 2018, 624p), which also included additional essays on the subject. The presentations of both seminars can be viewed on MASP's Youtube channel https://www.youtube.com/channel/UCl_tZ6fP9TdaAT-guYYRC1XA.

2. Our mission is printed on the last page of all our publications, including this one.

1. Views from the Portraits section at MASP, with works by: José Correia de Lima (fig. 201), Unidentified Artist (fig.200), Théodore Géricault (figs. 208-211), Flávio Cerqueira (figs. 258, 259), José Gil de Castro (fig. 197), Victor Meirelles (fig. 214), Dalton Paula (figs. 194, 195).

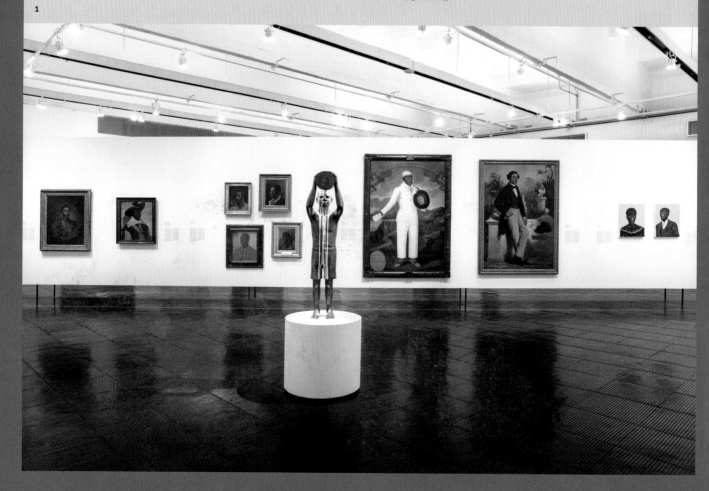

Afro-Atlantic Histories at Instituto Tomie Ohtake

Afro-Atlantic Histories was first hosted in São Paulo in 2018, the 130th anniversary of the abolition of slavery in Brazil, which was the last Western country to abolish the system and also the nation that benefited most from the trafficking of Africans. Today, we have the second-largest Black population in the world, behind only Nigeria.

The complex network created by modern-age mercantilism, which combined slave labor with human trafficking, was based on a vast sequence of so-called "discoveries"—that is, European occupation and domination in territories of the Americas, the Caribbean, and Africa. Such processes resulted in wounds that remain open to this day. This is the basis of *Afro-Atlantic Histories*, a project that examines the field of art and creation throughout the centuries.

Due to its scope and relevance, the exhibition is a collaboration between Instituto Tomie Ohtake and the Museu de Arte de São Paulo Assis Chateaubriand (MASP), whose 2018 program focused on discussions around "Afro-Atlantic histories" and their multiple meanings. The event is also highly relevant for Instituto Tomie Ohtake as a follow-up to the 2014 exhibition *Histórias mestiças* [*Mestizo Histories*], curated by Adriano Pedrosa and Lilia Moritz Schwarcz,

both of whom led the work on *Afro-Atlantic Histories*. Both shows have several overlaps and explore similar issues, but here the scope is much broader, including the Americas, the Caribbean, and Africa.

Instituto Tomie Ohtake hosted two major sections of *Afro-Atlantic Histories* in 2018: Emancipations, which explored the many struggles for freedom and abolition that took place across the Afro-Atlantic route, triggered by the introduction of commercial slavery, and Resistances and Activisms, which examined how, from the postslavery period through the present day, Afro-descendants have never stopped fighting for their liberties.

Instituto Tomie Ohtake would like to thank MASP for this pivotal partnership and the amazing partnership work that has allowed us to bring this exhibition to fruition and now to its second iteration, in the United States of America. We are grateful also to the two institutions that are partnering with MASP and ourselves for the US tour: the Museum of Fine Arts, Houston and the National Gallery of Art, Washington, D.C. We must also thank the artists, museums, galleries, and private collectors who have loaned their artworks, as well as the sponsors SESI and the federal and state administrations, whose fiscal incentive laws made *Afro-Atlantic Histories* possible in São Paulo in 2018.

Ricardo Ohtake
President, Instituto Tomie Ohtake

Afro-Atlantic Histories at the
Museum of Fine Arts, Houston,
and the National Gallery of Art,
Washington, D.C.

When the Museu de Arte de São Paulo Assis Chateaubriand (MASP) first staged the monumental exhibition *Afro-Atlantic Histories* in 2018, the show drew international praise. Adriano Pedrosa and his team of curators brought to light the extraordinary artistic legacy of the African diaspora in the West. The brutality of the transatlantic slave trade—which enabled the ruthless enslavement by Europeans and Americans of Africans who were captured and transported to the Caribbean and the Americas for nearly four centuries—is well known and continues to shock. In this exhibition, Mr. Pedrosa and his team foregrounded the myriad histories of people of African descent.

The exhibition at MASP rightly centered attention on Brazil, which alone received some 40 percent of the enslaved individuals taken from Africa, and which now boasts the second-largest population of Africans after Nigeria, but the show's rich selection expanded to include all of the Americas. *Afro-Atlantic Histories* revealed the staggering power of the art made by Africans and their descendants in the Americas, as well as the response by European artists to the stimulating presence of multifarious African cultures in their midst. Needless to say, we were thrilled when Mr. Pedrosa consented to mount the exhibition again at the Museum of Fine Arts, Houston, and the National Gallery of Art, Washington, D.C.

Kanitra Fletcher, then associate curator of modern and contemporary art at the Museum of Fine Arts, Houston, worked closely with her colleagues in Brazil to adapt the exhibition for the United States, and penned an insightful essay for this volume. She has since been appointed associate curator of African American and Afro-Diasporic art at the National Gallery of Art, and we are delighted that she is able to see this project through to completion. Our sincerest thanks go to Heitor Martins, president, and Adriano Pedrosa, artistic director, of MASP, as well as to the respective teams in Brazil, Houston, and Washington, D.C., who worked passionately to make this exhibition a reality.

This new iteration of *Afro-Atlantic Histories* is based on a core selection of works of art from the original exhibition, accompanied by others that further illuminate the North American legacy of the Black diaspora. It is organized into six sections: Maps and Margins; Enslavements and Emancipations; Everyday Lives; Rites and Rhythms; Portraits; and Resistances and Activisms. We are grateful to the lenders who generously lent works to the exhibition. We extend our deepest thanks to the Ford Foundation and its president, Darren Walker, for their immediate and substantial support. Their enthusiasm buoyed the project through the trials of the COVID-19 pandemic. Finally, we wish to express our admiration for and gratitude to the many artists, past and present, whose work continues to move and instruct us so profoundly.

Gary Tinterow
Director
The Margaret Alkek
Williams Chair
The Museum of Fine
Arts, Houston

Kaywin Feldman
Director
The National Gallery
of Art

Afro-Atlantic Histories, *Histórias afro-atlânticas*

This book is a hybrid of sorts—it cannot be properly called an exhibition catalogue, as it does not perfectly reflect the checklist of either *Histórias afro-atlânticas*, presented simultaneously at Museu de Arte de São Paulo Assis Chateaubriand (MASP) and at Instituto Tomie Ohtake in São Paulo in 2018, or *Afro-Atlantic Histories*, presented at the Museum of Fine Arts, Houston and the National Gallery of Art, Washington, D.C., in 2021–22.

This publication is a more concise development or unfolding of the original 2018 volume published by MASP and the Instituto—which did in fact reproduce all the works in the Brazilian exhibition and included a full checklist, in 460 pages and over 500 images.[1] The Brazilian catalogue was accompanied by an anthology of writings, which gathered forty-six texts, some of which were drawn from presentations made in two seminars organized by MASP in 2016 and 2017 in preparation for the exhibition, as well as a questionnaire with responses by ten Brazilian artists, critics, curators, and scholars.[2]

Given that the United States presentation of the exhibition is more focused than the first one, and in fact excludes two of the eight sections presented in São Paulo (Routes and Trances: Africas, Jamaica, Bahia, and Afro-Atlantic Modernisms),[3] we felt it

was crucial to maintain the presence of all artists and curators in this book that were presented in Brazil. This was specially justified because the present English edition will likely have much wider circulation than the previous one. In addition, as we finalize this publication, two venues in the U.S. are scheduled to receive the exhibition—in Houston (2021) and Washington, D.C. (2022)—though others are also under discussion. The exhibition checklist will thus likely change over the course of the U.S. tour of *Afro-Atlantic Histories*, as it so often does in cases such as this.

The Brazilian catalogue included only the essay by Adriano Pedrosa ("History, Histórias") and the section texts written by the curators. The latter presented the conceptual framework of each section and interpretations of many (though not all) of the works. For this volume, all such texts remain the same, though have been edited and revised for the English reader. Some works discussed in the texts and reproduced here will not be featured in the U.S. exhibition tour, and a small number of works have been added— some of which had been in preliminary checklists of *Histórias afro-atlânticas*, others suggested by our colleagues in Houston and Washington, D.C.

Because of the absence of an English-language anthology of writings to accompany this volume, we commissioned a number of additional texts for this edition by curators and scholars involved in the project in different ways: Lilia Moritz Schwarcz, Adjunct Curator of Histories at MASP and a leading figure in the development of all of our *Histórias* exhibitions;

Kanitra Fletcher, Associate Curator at the National Gallery of Art and key interlocutor of the *Afro-Atlantic Histories* presentation in the United States; Vivian Crockett, Assistant Curator at the Dallas Museum of Art and, as an African-Brazilian woman living and working in the United States, perhaps one of the most apt individuals to understand the complexities and subtleties of the Brazilian and U.S. Afro-diasporic connections; and Deborah Willis, a leading U.S. scholar in the field, whose text is drawn from a presentation she gave at MASP in our first seminar in 2016 and included in our Portuguese anthology. We are grateful to all of them for their insightful contributions, to the Brazilian curatorial team whose texts are republished here, and to Karen Marta and Todd Bradway, from Karen Marta Editorial Consulting, close partners in all of our publications at MASP.

Adriano Pedrosa
Artistic Director, Museu
de Arte de São Paulo
Assis Chateaubriand

Tomás Toledo
Chief Curator, Museu
de Arte de São Paulo
Assis Chateaubriand

1 Adriano Pedrosa and Tomás Toledo, eds., *Histórias afro-atlânticas: Catálogo*, bilingual edition in Portuguese and English (São Paulo: MASP, 2018).

2 Adriano Pedrosa, Amanda Carneiro, André Mesquita with Arthur Santoro, Hélio Menezes, Lilia Moritz Schwarcz, Tomás Toledo, eds., *Histórias afro-atlânticas: antologia*, Portuguese edition (São Paulo: MASP, 2018).

3 It is for this reason that the two sections are included at the end of this book.

Following Pages:

Maxwell Alexandre

b. Rio de Janeiro, 1990; lives in Rio de Janeiro

2. *We Were the Ashes and Now We Are the Fire*, from the series *Brown Is Paper*, 2018
Latex, grease, hen, bitumen, dye, acrylic, vinyl, graphite, ballpoint pen, charcoal, and oil stick on brown paper
360 x 475 cm
Museu de Arte de São Paulo Assis Chateaubriand – MASP
Gift of Alfredo Setubal, Heitor Martins and Telmo Porto in the context of the *Afro-Atlantic Histories* exhibition, 2018
MASP.10813

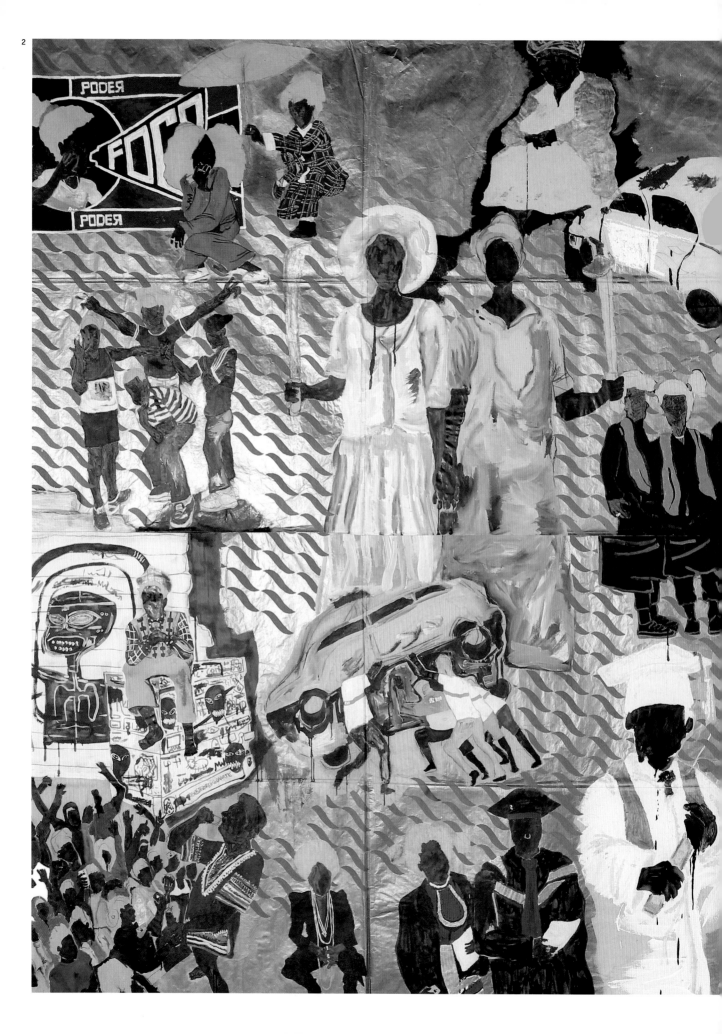

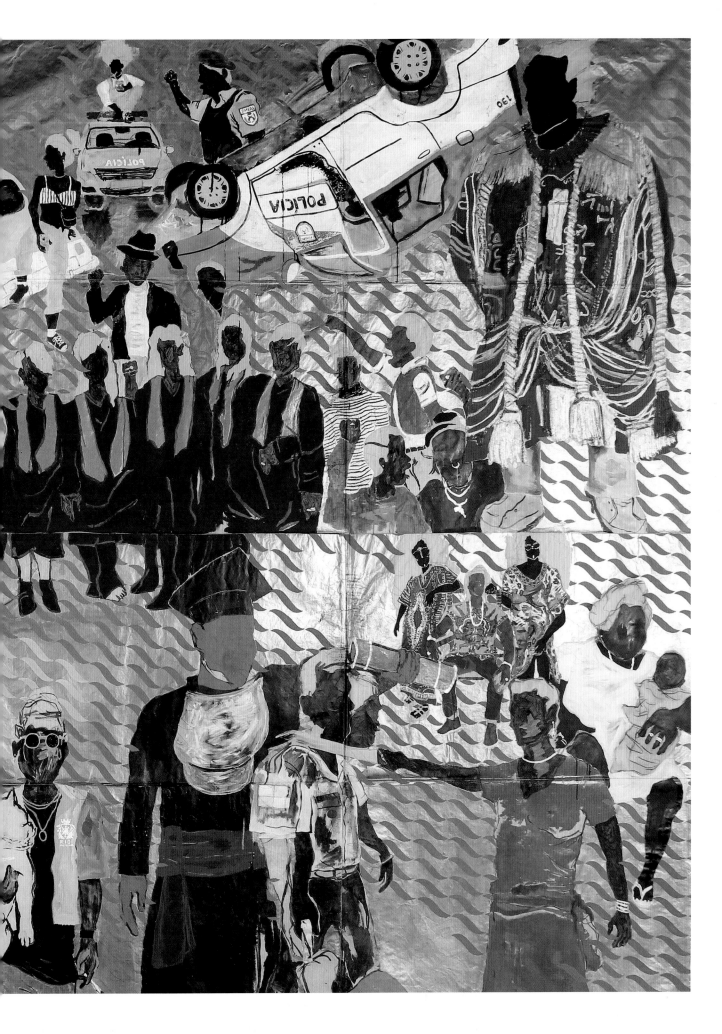

HISTORY,

HISTÓRIAS

Adriano Pedrosa

1

The discipline of art history, with its deep European roots, frameworks, and models, is the most powerful and enduring apparatus of imperialism and colonization.[1] A brilliant fabrication centuries in the making, it has astonishing implications. If the foundation of art history rests upon the excellence of a number of painters and sculptors,[2] it was also necessary to construct stories of causality and connection between them, configuring the grand narrative of art history imbued with chronicles of progress, development, and refinement. Artists, artworks, and oeuvres become elements that choreograph the evolution of movements, schools, styles, periods, and eras. Thus were accounted for what were considered the highest achievements of European and later Euro-American material cultures. Such a select group of authors and their creations form what is known as the canon, which is thought to embody what are the most sophisticated manifestations of Western civilization. If the authors are identified as geniuses and masters, their products assume an almost otherworldly, reverential property. As art historian Steve Edwards has put it: "The canon is a structural condition for art history."[3]

1. An earlier version of this text was published in Adriano Pedrosa and Tomás Toledo, eds., *Afro-Atlantic Histories* (São Paulo: MASP, 2018), vol. 1, pp. 32–33.

2. One can trace it back to Giorgio Vasari's classic *Le vite de' più eccellenti pittori, scultori e architettori*, published 1550–68.

3. Steve Edwards, ed., *Art and Its Histories* (New Haven: Yale University Press, 1999), 13.

The canonical masters and geniuses were invariably white, male, educated, and European.[4] In this ethnocentric scheme, a perverse hierarchy of objects and authors is drawn along a regimented axis. On one side of the axis, we find the European or Euro-American cultivated fine-art object—such objects and their styles were often associated with the tastes of the elite and the ruling classes, though always properly researched and legitimized by critics and art historians. On the other side of the axis, the artifacts of the rest of the world, particularly those produced by authors in the former colonies without emulating European styles and forms or without European training—the exotic, primitive, tribal, folkloric object. The fine art European object becomes the highest standard, the endpoint of the axis along which all others must be judged, categorized, classified, and positioned. In this totalizing scheme, all human-made objects must find their appropriate place, and Europe becomes what art historian Donald Preziosi has called the "brain of the earth's body: the most thoroughgoing and effective imperialistic gesture imaginable."[5] What is configured is a potent and intricate articulation between culture and art history on the one hand, and colonization and imperialism on the other, that allows cultural, and more precisely art-his-

torical, imperialism to subsist despite the end of direct colonialism. In this context, hierarchies of race, gender, and class are imposed, and so-called native, Indigenous, inferior, subordinate, subaltern, and nonwhite peoples are to be conquered, catechized, educated, "dominated, variously exterminated, variously dislodged."[6]

The apparatus of art history consists of an arsenal of books and texts, biographies and monographs, essays and papers, all copiously illustrated, published, translated, circulated, and taught at universities and schools in the West and translated and exported to its former colonies. Yet art history would necessitate a much more tangible, concrete instrument to impose its forceful task: the museum. A repository of fine-art objects, the art museum has developed an elaborate system to both propagate and feed the art-historical canon, which is grounded on its collections yet multiplied and disseminated through exhibitions as well as publications, catalogues, captions, didactic labels, guided tours, talks, lectures, seminars, and more recently audio guides, websites, videos, and social media. These in turn are constructed by armies of curators, researchers, museologists, conservators, interns, fellows, and more.

4. Author and activist Robin Morgan coined the term *herstory* in 1970, underlining the necessity of constructing histories from a feminist perspective, and criticizing the patriarchal character of *history*. In art history, or art *herstory*, the inaugural text is the widely anthologized "Why Have There Been No Great Women Artists?" by Linda Nochlin, first published in *ArtNews* (January 1971).

5. Donald Preziosi, ed., *The Art of Art History: A Critical Anthology* (Oxford: Oxford University Press, 1998), 519.

6. Edward Said, *Culture and Imperialism* (New York: Vintage Books, 1993), 10.

7. Yet these third world canonical figures are often trained within the European tradition and their works establish a dialogue or unfolding of it, at times bringing native, folk, or indigenous elements to it.

8. Catherine King, ed., *Views of Difference: Different Views of Art* (New Haven: Yale University Press, 1999); Dilip Parameshwar Ga-onkar, ed., *Alternative Modernities* (Durham, N.C.: Duke University Press, 1999); Shmuel N. Eisenstadt, *Multiple Modernities* (London: Transaction, 2002); Kobena Mercer, ed., *Cosmopolitan Modernism* (Cambridge, Mass.: MIT Press, 2005); Kitty Zijlmans

In the past few decades, contemporary art productions from outside Euro-America have been increasingly brought into displays by many museums and biennials, and the so-called model of the global contemporary art exhibition has been a norm since the 1990s. More recently, museums in Euro-America have attempted to incorporate "other modernisms" into their exhibition programs and collections—the third world canon, or the canon of the Global South, composed as it is by the leading modernist and 20th-century figures of local metropolitan art histories in Latin America, Asia, and Africa.[7] All this reassessment is in turn grounded on a great deal of art-historical, curatorial, and critical research under the headings of art and globalization, global art histories, world art studies, plural modernities, multiple modernities, alternative modernities, cosmopolitan modernisms, *mondialisation*, and others.[8] Yet a challenge remains: to find other tools, models, and concepts to assess other narratives beyond Eurocentric criticism and history.[9] In this sense, Argentine critic and semiotician Walter Mignolo has in fact argued that it is not a matter of seeking "alternative modernities, but alternatives to modernity."[10] If we do not, we risk falling into what critical theorist Homi K. Bhabha describes as "exhibiting art from the colonized or postcolonial world, displaying the work of the marginalized or the minority, disinterring forgotten, forlorn 'pasts'—such curatorial projects end up supporting the centrality of the Western museum."[11] The matter is not so much of doing away completely with the traditional art-historical toolbox, which would probably entail the end of the museum altogether, but of finding other instruments in order to render it more diverse, inclusive, plural—to cannibalize it, developing a mestizo, anthropophagic toolbox of sorts.

2

What other histories can art help to account for or to approach beyond the history of art? What other characters, themes, and narratives besides the styles, movements, schools, and periods of art history itself? How can we assess and construct histories that are more plural, inclusive, multiple, diverse? What lies beyond the history of the Renaissance and the Baroque, Impressionism and Expressionism, abstraction and figuration,

and Wilfried van Damme, eds., *World Art Studies: Exploring Concepts and Approaches* (Amsterdam: Valiz, 2008); Terry Smith, Okwui Enwezor, and Nancy Condee, eds., *Antinomies of Art and Culture: Modernity, Postmodernity, and Contemporaneity*

(Durham, N.C.: Duke University Press, 2008); Catherine Grenier and Sophie Orlando, eds., *Art et mondialisation: Anthologie de textes de 1950* à *nos jours* (Paris: Centre Pompidou, 2013).

9. James Elkins writes on the Western-ness of methodologies, institutions, and terms in "Why Art History Is Global," in Jonathan Harris, ed., *Globalization and Contemporary Art* (Oxford: Wiley-Blackwell, 2011), 375–86.

10. Walter Mignolo, *The Darker Side of Western Modernity: Global Futures, Decolonial Options* (Durham, N.C.: Duke University Press, 2011), 28.

11. Homi K. Bhabha, "Postmodernism/ Postcolonialism," in Robert S. Nelson and Richard Shiff, eds., *Critical Terms for Art History* (Chicago: University of Chicago Press, 2003), 449.

Constructivism and geometry, Pop, Minimal, and Conceptual art? A number of histories could be considered: histories of sexuality, of madness, of childhood, of feminism, of colonization and imperialism, of indigeneity, of the Afro-Atlantic. The themes are vast and by necessity encompass many territories, periods, media, and objects, not devoid in fact of Eurocentric inflections. Yet we must admit that such expansive and ambitious projects are doomed to incompleteness, fragmentation, partiality.

Histórias in Portuguese (much like the French *histoires* and the Spanish *historias*, yet unlike the English *histories*) can identify fictional and nonfictional narratives, written or oral ones, personal or collective, micro or macro. As a framework to coalesce narratives that have been left aside, at the margins, and forgotten, *histórias* are open, plural, diverse, and inclusive. They may encompass myriad narratives: the personal, the political, the artistic, the cultural, the mythic, the oral, the visual, the underground, the minor, the marginal, as well as possess a quality that is preliminary, processual, incomplete, partial, fragmented, even contradictory. *Histórias* are thus distinctly polyphonic, speculative, open, impermanent; their many layers are inescapably in friction. There is a cannibalizing quality to the term—they can devour everything,

and indeed their own contrary (even traditional art history and its canon may constitute one of the many layers of *histórias*).

As a museum located in the Global South housing what is considered to be the most important collection of European art in the Southern Hemisphere, the Museu de Arte de São Paulo Assis Chateaubriand (MASP) is in a privileged position to question the primacy of the canon. It is perhaps the only museum outside Euro-America that actually holds many examples of the European canon and thus can attempt to challenge it, or *decolonize* it—a term that can have quite different connotations in various contexts, and perhaps should in fact be understood as context-specific, ever shifting. We are in the territory of investigation and speculation here, learning, unlearning, and experimenting throughout the process. There is certainly no recipe for decolonizing the museum, as much as there are many understandings around it.[12] What seems to be a prevalent understanding among those engaged in decolonizing practices at the museum is that one can always decolonize further afield.

This is the broader context of the program at MASP around several *histórias*, a number of which have been approached: childhood in 2016, sexu-

12. A research project titled "Art and Decolonization" is being developed by MASP and Afterall at the University of the Arts, London, with two conferences already organized in 2018 and 2019, others in the planning stage, and an anthology to be published in 2022.

ality in 2017, the Afro-Atlantic in 2018, women and feminism in 2019, dance in 2020. Future *histórias* are planned: Brazilian in 2021–22, Indigenous in 2023, queer in 2024, ecology in 2025, madness and delirium in 2026. As we are able to conceptualize the program with more time and resources, it has become increasingly complex, with many participants bringing their voices, the museum itself turning into a platform more than an institution with a single monolithic, authoritative voice. The *histórias* and its themes are developed throughout the year, with monographic exhibitions as well as a major group show, itself challenging established chronologies, hierarchies, and distinctions between periods, styles, schools, media. If the group exhibition necessarily brings in the work of different authors, it should also encompass several curators. Each section of the group exhibition may express the different voices of the artists and the curators, providing a distinct accent to each one of them. The program includes several international conferences organized a few years in advance, as well as publications, workshops, film and video programs, courses, talks, and outreach programs. The audio program is particularly revealing, as it invites many individuals to speak about the works in MASP's collection—from critics to curators, academics, historians, and children—constituting an ever ex-

panding archive of many voices. The exhibition catalogues of our different *histórias* are accompanied by an anthology of texts presented in seminars as well as other writings. With its polyphonic and multivalent character, this is how the different *histórias* at MASP are constituted—much more as a point of departure than of arrival. As *histórias*, they necessarily turn to the past, but with a steadfast commitment to the present and the future: to provoke discussions, debates, and doubts, and to be reconsidered, revised, rewritten themselves.

SLAVE MARKETS:

WHEN RESIGNATION IS A FORM OF RESISTANCE

Lilia Moritz Schwarcz

In order for Afro-Atlantic slavery to exist and persevere, it was necessary to naturalize the system, which presupposes the ownership of one person by another, and which depends upon the use of violence by ruling minorities who have power over captive bodies. Even further, forcible labor cannot be maintained without parallel attempts to invisibilize trauma and suffering as well as the structure that upholds them.

To administer this regime but simultaneously underplay its violence and inequality, colonial elites throughout the Americas not only created "best-practice" manuals of torture and abuse, advising on the most efficient methods of "domesticating" workers, but they also disseminated images of slave markets as orderly and peaceful sites. Generally created by European or European-descendant artists, these images of the slave trade were consumed by white elites, who were not troubled by the actual use of force in these markets and who had no concern for the suffering of Africans. To the contrary, their intention was to reify this form of extreme dominance, which presupposes the buying and selling of people either recently arrived on slave ships or born in captivity in the Americas.

The constancy of this visual pattern[1] is attested in picturesque books published throughout the Atlantic. Unlike travelers' accounts, some of which offer horrific descriptions of slave markets and insurrections, painters who portrayed them went to great lengths to normalize their operations and whitewash their inherent brutality. These scenes calmly depict

commercial transactions in which humans were exhibited, inspected, evaluated, and touched, much like cattle. Ironically, many of these works later became weapons in the abolitionist arsenal.[2]

In 1816, French painter Jean-Baptiste Debret arrived in Rio de Janeiro with the Missão Artística Francesa (French Artistic Mission), whose remit was to establish a school of art. Debret would become a kind of "ethnographer" for the group, visually recording their pleasant life in the Portuguese colony. He had trained in France and spent time in Italy, from 1784 to 1785, in the company of his cousin, the Neoclassical painter Jacques-Louis David. Returning to Paris in 1785, he joined the School of Fine Arts and won his first prize. For the subsequent fifteen years, he directed David's atelier,[3] a demonstration of his connection to not only his famous cousin but also the Neoclassicism he embodied. His style moved away from his other famous cousin, François Boucher, a painter of scenes of gallantry for the court and one of the last representatives of the Rococo.

Debret exhibited at the Salon, submitting large canvases of subjects from antiquity as well as scenes of court life under Napoleon, all of dubious aesthetic value (although he won second prize at the 1798 Salon). He was thoroughly committed to the principles of French Neoclassicism, and its characteristic themes and compositional devices pervade his work: idealized figures, the symmetry of forms, and the cult of virtue associated with Republican antiquity.

Nonetheless, within the competitive world of the French arts, Debret was a lesser-known painter, supporting himself with work in David's studio. A variety of circumstances propelled his move to Brazil. His only son died. The fall of Napoleon resulted in David's exile to Belgium. Debret's finances were ruined with the closing of his cousin's studio and the loss of his post as the lead painter to the now-deposed king of Westphalia, Jérôme Bonaparte, Napoleon's younger brother. Debret declined an invitation to be court painter in Saint Petersburg under Alexander I, instead signing on to the expedition headed for Brazil with Jacques (Joachim) Lebreton, secretary of the Académie des Beaux-Arts. Electing to work for the prince of Portugal Dom João VI, one of Napoleon's greatest adversaries, might seem shortsighted, but Debret saw an opportunity to escape the war and political intrigues that had lately engulfed the European continent and start afresh.

Whether he arrived in Rio de Janeiro—then the capital of the United Kingdom of Brazil, Portugal,

1 Here I refer to the concept developed by Michael Baxandall in *Patterns of Intention: On the Historical Explanation of Pictures* (New Haven: Yale University Press, 1992).

2 On the concept of contested assets, see Robert S. Nelson and Margaret Olin, eds., *Monuments and Memory, Made and Unmade* (Chicago: University of Chicago Press, 2003).

3 Rodrigo Naves, *A forma difícil: Ensaios sobre arte brasileira* (São Paulo: Editora Ática, 1996), 47.

and the Algarves—intending to document Brazil's viceroyalty (later empire) and produce a book about this region of the New World, we do not know. In any case, the literary theme was an established vogue: picturesque books from remote and exotic places constituted a promising global market. What is certain is that, soon after settling in Brazil, Debret approached the Portuguese court and began painting in watercolor. He portrayed the royal protagonists and their main events, documented the local flora and fauna, and dedicated himself to recording everyday life in Rio de Janeiro, particularly the enslaved, who were everywhere. With a mixture of criticism, admiration, and curiosity, he painted the well-formed figures of the *quitandeiras* (greengrocers), who dominated the streets with their trade, as well as the activities of porters, lumbermen, healers, and *quilombolas* (runaway slaves). Two of his watercolors were censored by the Brazilian Historical and Geographic Institute: one depicts a plantation foreman whipping a slave with the situation repeated in the background (fig. oo), the other is a scene of Valongo, the largest slave market in the Americas (fig. oo). Uncoincidentally, these works generated an immediate reaction from local elites. While other depictions reinforced a notion of peaceful life in the Portuguese tropics, these two watercolors—later transformed into lithographs—left the system's open wounds, if not conspicuous, at least apparent.

In the Valongo scene, the newly arrived Africans are clearly in wretched condition, malnourished and emaciated. One lies prone on a bench, obviously ill. A group of children huddle on the floor. An aristocratic gentleman sporting fashionable dress and a wide-brimmed hat negotiates the sale of a Black child with a grotesquely characterized slave trader whose obese body sprawls across an armchair. Debret employs a light palette, oscillating between shades of beige, brown, and blue. Nothing escapes his notice, from the wooden ceiling to the floor of burnt cement. The artist most certainly intended this image as an indictment of the slave trade. He was, after all, a product of the French Enlightenment and had experienced the struggle for "liberty, equality, fraternity," values in short supply in this tropical land of forced labor and naturalized hierarchical language.

Of course, colonial elites did not object to the existence of the market itself. Nor did the warehouse itself garner a reaction, despite its visibly poor structuring and wooden benches with no backrests. Disapproval of the image was limited to a concern for obstructing evidence that slave trafficking extended even to children,

separating them from their families. The censorship of the image speaks volumes about the official commitment to suppressing the reality behind the "traffic in souls" and its markets. In their alternative reality, slaves are exclusively imagined as passive victims.

A few decades later, in another part of the Americas, Thomas Satterwhite Noble told a different story. Born in 1835 in Lexington, Kentucky, Noble was raised on a cotton farm and experienced first-hand the harsh system of slavery that dominated the South, which led him to take up the abolitionist cause through his art after the U.S. Civil War. Showing an early interest in the arts, he studied under the portraitist Samuel Woodson Price in Louisville in 1852, then at Transylvania University in Lexington with Oliver Frazer and George P. A. Healy. In 1853, he moved to New York, then continued his training in Paris with Thomas Couture, a painter of historical canvases whose students included Édouard Manet and John La Farge.[4] Returning to the States, Noble's artistic career was interrupted by the outbreak of the Civil War, in which he served on the Confederate side from 1861 to 1865. After the war, he moved to St. Louis and earned national recognition with one of his first canvases, The

American Slave Mart (1865), which guaranteed him a scholarship in New York. There, he established himself as a painter of historical scenes depicting the evils of slavery. These works include John Brown's Blessing (1867), in which the militant crusader blesses a Black child held in the arms of its enslaved mother; The Modern Medea (1867), which relates a scandalous event of 1856 in which a Black woman named Margaret Garner killed her children to spare them the indignity of enslavement; and The Price of Blood (1868), which features a white man selling his own mixed-race son.

Noble tapped his own experience of the slaveholding South to produce works that helped spread the abolitionist cause to countries where slavery was still practiced, including Puerto Rico, Cuba, and Brazil. The American Slave Mart no longer exists, but contemporary accounts provide a description of its content, which differs in crucial ways from Noble's second (unfinished) rendition of the subject, reproduced here, titled The Last Sale of Slaves in St. Louis (fig. 33).[5]

From what we know, the picture is based on an event that occurred on New Year's Day in 1861. According to Galusha Anderson's Story of a Border City during the Civil War (1908), on that day some 2,000 activists invaded a slave auction in St. Louis and halted

4 James D. Birch-field et al., Thomas Satterwhite Noble, 1835–1907 (Lexington: University of Kentucky Press, 1988), 39.

5 See Tuliza Kamirah Fleming, "Thomas Satterwhite Noble (1835–1907): Reconstructed Rebel," PhD diss., University of Maryland, College Park, 2007, 71–94.

the proceedings. After two hours, the auctioneer gave up on selling his "ebony charges" and returned them to the local prison. This was to be the last slave auction in St. Louis.

Noble approached the narrative differently. After ten months of research, he set out to illustrate a theme he claimed had never before been addressed in painting. In the original version, the center of the canvas was occupied by a "beautiful octoroon girl"[6] standing on an auction block; in the second version, the woman holds an infant in her arms. Noble romanticized the figure with conventional gestures and an ethical stance highlighting an inversion of values: this "new race" is more sensitive than whites, with their degraded customs. As the auctioneer is about to bring down the gavel, indicating acceptance of a bid, a man at the right raises his arm to make a higher offer. Surrounding the platform is a crowd of onlookers dotted with vignettes of enslaved Black people awaiting their destinies.

In the earlier painting, directly in front of the platform, the artist had placed a stylishly dressed man and woman, who in the second canvas have been replaced by a portrait of Noble, his wife, and son. The play of shadow and light in the painting directs the viewer's attention to a white dog, resting unaware of the event, and the boy. Thus the artist situates himself as an eyewitness to history and introduces his child to the horrors of slavery as young people like himself are being sold. The auction is held in front of the courthouse, the citadel of justice, which is only sketchily rendered in the second painting. At the left, ignoring the proceedings, are three white men absorbed in debate. The figures were described in newspaper reports as symbolic representatives of three political factions—proslavery, conservative (undecided), and abolitionist. The young abolitionist at right lectures the proslaver in the cape on "racial equality," while the fence-sitter in the top hat looks on. Still, they turn their backs to the embarrassing scene, as if theory were more important than reality.

Both Debret and Noble used art as an interventionist tool, a vehicle for denouncing the naturalization of the slave trade. The French painter was more "discreet," probably because his patron was the prince of Portugal, but it is notable that, in both works, the enslaved figures betray no hint of agency or desire to revolt; they are passive victims resigned to their fate. This appears to be the limit of 19th-century abolitionist art, which foregrounded white protagonists even when addressing racial injustice.

6 Within the racial system that once existed in the United States, prejudice was marked by origin. It was the "one drop of blood" which determined that a person with African ancestors, from different generations, was Black. An "octoroon" had one-eighth Black ancestry, including a Black great-grandfather or great-grandmother.

Such a stance is challenged by Nona Faustine. A photographer and visual artist, Faustine was born in 1977 in Brooklyn, where she currently resides. A graduate of the School of Visual Arts and the International Center of Photography/Bard College MFA Program, she places her own body at the center of her explorations into the regime of slavery, particularly the persistence of slavery-era prejudices and the system's lasting impacts on contemporary values.

Faustine's first exhibition, *White Shoes*, consists of ten composite images that form a serial narrative. Each photo was taken at a different location in Manhattan or Brooklyn—including the Botanical Gardens, the Tweed Courthouse, the New York State Supreme Court, and Lefferts House (fig. 34)—and each site shares the fact of having played a pivotal role in the history of U.S. slavery. Through Faustine's critical lens, New York's reputation for cosmopolitanism and tolerance begins to crumble. Reaching back in history, she reminds us that for 200 years the city was the capital of the slave trade in the United States. Enslaved people were routinely trafficked through its port until 1827, when the institution was abolished in New York state. In each photograph, Faustine wears nothing but white high-heeled shoes. Her body is an inescapable element of the landscape, and her nakedness alludes to the ways in which enslaved women were exposed at auctions and in scientific photos as specimens to be examined. The white shoes suggest the image of the sensualized Black woman, their color denoting colonization and bleaching.

Faustine thus embodies a physical record of the countless anonymous women relegated to the slave master's dungeon, exploited in the fields and in domestic environments. The artist dialogues with the history of her ancestors, who arrived on the route toward Ellis Island—later taken by migrants seeking better lives—but who could not choose their own destinations. She references the violence of historical photographs of unnamed Black wet-nurses; of ethnographic photos and daguerreotypes of Black bodies forced to pose before the cameras of professionals in the mid-19th century. Moreover, she stakes out a space for Black women's bodies in art history—not as nude models, or exotic, marginalized objects, but as protagonists. She criticizes the mainstream privileging of white, youthful beauty, while Black female bodies remain largely absent from Western culture.

In *From Her Body Sprang Their Greatest Wealth* (fig. 35), Faustine poses at an intersection on Wall Street where a lucrative slave market had operated

throughout the colonial period. A yellow taxi—an iconic symbol of the city—glides by in the background. She stands rigidly atop a wooden crate, recalling Noble's auction scene. Her wrists are bound with chains below her breasts. Her body is utterly alone and vulnerable, exposed at the very heart of the international financial system, and we feel her discomfort. "You have to take a risk," she explains, "putting your own body in the line of fire, otherwise the scars are easily forgotten." The nudity of a Black woman, who "lets herself be seen" and still challenges the camera, is in itself an act of rebellion and insubordination (not to mention the fact that under city law, the artist could have been arrested for indecent exposure).

The scene deliberately evokes a slave market. In this case, however, Faustine's act is in no way passive or accommodating. Looking defiantly into the camera, she interrogates the past and reveals continuities in the present. New York's position as a nexus of the transatlantic slave trade echoes today, and Faustine's own history traverses many forms of memory and silencing—the uses of photography, the trafficking of Africans to the United States, Black women separated from their families and raped by their masters, the whitening imposed on Black bodies, the dearth of African American artists in the canon of

art history. With her self-portraits, Faustine probes the city's history as a Dutch colony, and in *From Her Body* we are reminded that the protective wall for which the street was named was built by enslaved peoples.

Racism is a social construct arising from the dismantling of the slave system in the Americas and crystallized in a deterministic evolutionary pseudo-science. It persists today in perverse forms of knowledge and practice based on seemingly common-sensical theories that rationalize the subjugation of Black bodies and their erasure from the past and the present. As Saidiya Hartman has observed, narrating is a way of reviving the dead.[7] In her work, Faustine gives life to ancestors who were unable to leave records of themselves, their desires, or their forms of resistance. Ultimately, there are two courses of action in relation to silenced memories: the first is simply to transcribe what the colonial archives contain; the second is to question the very production of past knowledge, to begin again and rewrite history.

Nude and alone on an urban street, wearing her white shoes, the artist transforms her body into an act of protest and a site of memory.

7 Saidiya Hartman, "Venus in Two Acts," *Small Axe* 12, no. 2 (2008); Saidiya Hartman, *Scenes of Subjection: Terror, Slavery, and Self-Making in Nineteenth-Century America* (Oxford: Oxford University Press, 1997).

VISUALIZING SLAVERY:

IMAGE AND TEXT

Deborah Willis

In the first half of the 19th century—in Africa, Europe, the Caribbean, and the Americas—photography was used for a variety of purposes: scientific and ethnographic studies, portraiture, art, pornography, documentation. It allowed families of all classes to preserve their likenesses for posterity. Portraits of African Americans were produced regularly in studios throughout the country; those of well-known people were displayed in living rooms everywhere. The photograph is an instrument of memory and reflects on the value of self, family, and memory in documenting everyday life. As a photographer, educator, and curator, I believe that photography helps to tell stories about family life, and I have often asked students and artists about what the photograph means to them as an object to expand upon personal memories.

Black people's enslavement, emancipation, and freedom were represented, documented, debated, and asserted in a wide range of photographs from the 1850s to 1900. These images are historically situated representations created usually by the photographers and subjects and offer a powerful visual narrative with enduring meanings and legacies. This essay considers the photographs of enslaved men and women in Brazil and the United States in the 19th century. Brazil was the last place in the Americas to abolish slavery—it didn't happen until 1888—and that meant that the final years of the system were photographed.

In my view, the notion of representing and embodying humanity during slavery is rarely seen. However, there are some portraits of the Black labored body on cotton, sugar, rice, and

coffee plantations that offer a much more complex reading of slavery for a 21st-century viewer. The photographers and the subjects in the photographs used skillful ways to foreground identity in pose and dress by focusing on objects such as musical instruments, plants, baskets, jewelry, and food. What makes the concept of this essay interesting and fresh to a broader audience is the use of text and photographs in history telling, as well as a focus on the resilience found and imagined in the words and images. Central to my work in the photographic archive is an ongoing critique that engages in the history of images of the African diaspora to contemporary artists who uncover these images to make art. The photograph confronts the complexity of the photographic image in looking at race and desire as the Black body is rendered resilient, sexualized, and compliant. The historical gaze has profoundly determined how the Black body is regarded in contemporary society. The interplay between the historical and the contemporary, between self-presentation and imposed representation, are fundamental aspects of artmaking practices today. Key to my camera and written work is an ongoing critique that focuses on how the display of the Black body affects how *we* see and interpret the world. I consider the notion of beauty: how it is perceived, what it meant in the 19th century, and how best to describe it today given the plethora of images in print. Researching, teaching, writing, and making art about the African diaspora are important to my work.

The images I read here represent a vibrant history. The photographs are rare, informative documents of various aspects of the Black population—slave trade and free—in South America and the Caribbean during the 19th and early part of the 20th centuries.

Focused specifically on the evolution of photography in South America, this essay also reimagines the visual documentation of the cultural and economic roles of African people in developing this part of the New World. Black labor was crucial to the New World's industrial and commercial growth. Photographic evidence of the presence of Blacks in the countries of Brazil and Chile, among others, and the islands of Haiti, Jamaica, and Curaçao dates from the mid-1800s. The first Africans, however, were imported primarily as slave labor in the 16th century by Spanish, Portuguese, French, British, and Dutch colonists.

Some of the photographs illustrate Black men and women at work in the sugarcane fields and coffee plantations. Others are portraits of Black merchants—men, women, and children—balancing their wares on their heads. During the early period of photography, adjustable posing chairs and headrests were designed to keep sitters stationary while being photographed. In these images, we can see that the formula for standard portraiture in South America was the same whether the subjects were from middle-class backgrounds or were newly freed Africans.

Marc Ferrez is well known for his photographs of the newly freed enslaved people in Bahia wearing vibrant cloth and metal jewelry. The majority of the

images are printed on albumen paper (both mounted and unmounted), cartes-de-visite (calling cards), cabinet cards, and stereographs. The 20th-century images are printed on gelatin silver paper. A large portion of the early 19th-century images were made by photographers native to or based in South America (Ferrez in Brazil and Eugenio Courret in Peru, for example). The later 19th-century images were made by photographers sent to the regions by American and European galleries, such as Publishers Photographic Service (later known as Underwood & Underwood).

A small number of photographs reach beyond the documentary level and approach the fine line of art photography. In some cases, these images can be considered high-quality candid snapshots. Ferrez, for instance, consistently posed his subjects in a less rigid manner, never with the simple frontality of the strict documentarian. Itinerant and travel photographers captured through their lens men, women, and children on the streets of Cuba, Barbados, and Curaçao holding seemingly intimate conversations and carrying their wares to the market. In the early 1860s, when cartes-de-visite became popular, pictures of Indians and Africans in their personal dress were sold as tourist souvenirs.

Further investigation into the 19th-century photography of Africans in the New World is greatly needed. Miraculously, the photographic evidence of the retention of African culture has survived through the years, despite neglect and exposure to the salt air, insects, and high humidity typical of tropical environments. However, what I've found is that photographs enabled me to visualize Black people and their work through dress, gaze, and body adornment.

Brazilian coffee plantations illustrate the vast quantity of labor required to cultivate the crop. Images of a diverse group of enslaved men and women who worked closely together in the fields help to imagine a sense of the work process as they they raked coffee beans. By the mid-19th century, we see larger numbers of photographs, and Black people's freedom had become the most inflammatory social and political issue in the United States. Urban Black life was a world apart from the rural and plantation experience. Enslaved people were often hired out, and some used their pay to buy their freedom. They performed a variety of services. Some worked as itinerant merchants or as childminders. Black women and men worked in the markets. The most picturesque of the African market women were known as *baianas*—all of them fascinated writers and photographers because of their dress of full lacey skirts and colorful shawls and head wraps. The photographers also framed Africans who were forced to adapt to unfamiliar social settings but still managed to retain much of their African culture through dress, hairstyles, religion, food, and ways of transport in a transformative manner.

In the 1850s, the intensifying national conflict over slavery and Black freedom played out through competing campaigns of photographic imagery. Slavery's defenders employed visual

imagery, especially photography, to illustrate and advance their arguments portraying Blacks as less than human with limited intellectual ability, stunted morality, and overall incapacity for freedom. Unfortunately, proponents of slavery and its ideology of Black inferiority used photography to reinforce existing paradigms of racial difference and legitimate the ownership of Black people as property. Photographs of enslaved people defy easy categorization because they are the record of the brutal racism and domination at the core of the colonialist regime and at the same time they present images of enslaved women, children, and men in various locations. They are both compelling and haunting documentation of individuals otherwise lost to the written, historical record.

During slavery, photographs of enslaved and free Black men and women both changed and supported idealized racist scientific theories about Black inferiority. In America and Brazil, Louis Agassiz, the Harvard University natural scientist and zoologist, found photography the ideal medium for his studies, which were centered on the idea of white superiority over Black. In the mid-1850s, while attending a conference in Columbia, South Carolina, Agassiz observed the enslaved men and women living on B. F. Taylor's Edgehill Plantation and the properties of Wade Hampton II. He asked a colleague, Dr. Robert W. Gibbes, to hire someone to photograph these enslaved people on his plantation.

Gibbes hired Joseph T. Zealy, a popular South Carolina daguerrean, to make

portrait studies of African-born and African-descendant Black men and women and possibly children. The group included Ebo, Foulah, Gullah, Guinea, Coromantee, Mandingo, and Congo, documented in carefully handwritten labels accompanying the portraits that identified the subject's occupation, country of origin, and plantation owner. Such classifications were essential for Agassiz's research. Posed nude or partially dressed, the Black body became both muse and object of curiosity to Zealy and Agassiz. Jack, Renty, Alfred, Fassena, Drana, Delia, and Jem, among others, were taken into Zealy's studio. In 1975, these daguerreotypes were found in an attic on Harvard University's campus and since then have been published and discussed widely. They confront the complexity of photography and ethnology; by taking profile and frontal portraits, Zealy and Agassiz marked the images as representative of all Black bodies. Viewed as human property, the Black body is represented as labor. All of the subjects were photographed and examined with all these factors in mind. The white male gaze of both photographer and ethnographer dominate through the placement of each subject, whether sitting in a chair or standing on a patterned carpet. The visual narrative informs us that both subjects and images are objects to be handled. Such perspectives encourage a discourse that views the Black body as inferior and at the same time sexualized, based on the full-frontal nude poses revealing the penises of the men and the breasts of the women.

Other historical images found in various archives, such as Ferrez's *Slaves on*

a coffee plantation, Paraíba Valley, Brazil (ca. 1882), *Slaves harvesting coffee, Rio de Janeiro* (ca. 1882), and *Coffee harvest transported on an ox cart, Paraíba Valley, Brazil* (ca. 1885), document not only the plantations and their output, but the clothing, dress, and fabrics worn by the laborers on the land. Ferrez reimagined the work and the idealized view of plantation life. These images appear more like traditional portraiture in which the individual presents herself to the camera and at the same time viewers see enslaved people who had pictures made for their own possession and possibly for work creating a new visual narrative about their life. Cartes-de-visite in public and private archives of women wearing bandannas and voluminous skirts appear to exchange gazes with a viewing public that reflects a possibly resigned look about posing as many mask the inner self. The transatlantic slave trade transferred not just people but also African culture, foodways, knowledge, and skills to the Americas, including women's ability to cultivate rice and other crops using hoes and baskets. Historians of slavery have demonstrated that Black men and women maintained a distinctive culture infused with African social customs, linguistic patterns, and spiritual beliefs, and it is found in their dress and foodways. Photographs of women adorning their clothing with silver, beads, needlework, and shells helped to shape how a contemporary reader viewed these women and their self-fashioning as crucial to their lives in bondage. Gesture and clothing offer a subtext to reading these photographs from the multigenerational group, possibly family, to the individual portrait. I hope to have shown that the study of history through photography is becoming more and more critical to correcting the images of the past.

OCCUPY

SELF-
PORTRAITURE

Kanitra Fletcher

Art historian Kobena Mercer has argued that "self-portraiture in its received sense is a structurally impossible genre for the black artist to occupy."[1] Nonetheless, the exhibition *Afro-Atlantic Histories* shows multiple examples of how Black artists of different genders, generations, and nationalities have not only occupied but also helped redefine the genre. Employing various strategies, such as masquerade, autobiography, inclusion of others, and the symbolic use of the body, as well as its absence, their work demonstrates that artists are not removed from or unaffected by the myths and narratives surrounding slavery, gender roles, African religions, Black families, and more. Indeed, their self-portraits evoke the impact of these histories on their own lives and experiences.

In so doing, these artworks challenge the conventional understanding of self-portraiture as a representation of "the unified self."[2] Instead, they counterintuitively reflect the blind spots of self-perception. Rather than conveying an autonomous subject, self-portraiture is defined by its limitations: the inability to entirely

1 Kobena Mercer, "Busy in the Ruins of Wretched Phantasia," in *Mirage: Enigmas of Race, Difference and Desire*, ed. Ragnar Farr (London: ICA Editions, 1995), 28. Mercer bases his argument on the idea that Black people "are denied entry into the alterity which Lacan sees as grounding the necessary fiction of the unified self." The following essay offers a redefinition or alternate understanding of the self-portrait that is not predicated on a fiction of a unified self, that in fact depends upon an incomplete othering of the self, which a Black artist can and arguably best occupies.

2 Ibid.

see or show oneself, literally and figuratively, is a critical facet. Despite or due to these blind spots, a self-portrait is not so much a fallacy as it is a reworking and re-creation of the artist. An unknowable dimension of the self always exists, and this circumstance becomes an advantage in the process of self-portraiture. To compensate effectively for the elusive and unseen dimensions of oneself, artists creatively fill these voids, these spaces that are free from judgment or discrimination.

Moreover, the self becomes an object of investigation for the artist to portray. Several writers have described the procedures of objectification and othering in self-portraiture. Shearer West has written, "underlying all self-portraiture is the mystery of how an individual sees himself or herself as other. A self-portrait involves an artist objectifying their own body and creating a 'double' of themselves."[3] For Gen Doy, "the self confronts the self as an other while in process of fabrication."[4] And Kirk Varnedoe asserted that the self "is fabricated as another object" and a "division between observer and observed must first occur within the artist."[5] In its portraiture, the self has been split or doubled, taking on a life of its own to exist as a work of art.

If self-portraiture is shaped by invisibility and a deficiency that objectifies and "others" the self, could not Black artists' self-imagery enter this realm? Using Mercer's own words, would not these artists "in a culture where blackness serves as the sign of absence, negativity and lack," where it is "objectified under the imperial gaze" and "perceived by others as the Other," figure as self-portraitists par excellence?[6]

Notwithstanding the negativity of this view of the Black experience, the self-portraiture that it elicits transcends such circumstances. The artists configure new roles and ways of understanding their own lives and histories, and by extension those of others. Moreover, these realities and imaginings of selfhood further broaden the significance of the genre and its major thematic categories, as described in the following passages. In various examples featured throughout *Afro-Atlantic Histories*, Black artists demonstrate that they indeed have occupied self-portraiture.

Masquerade

Masquerade, role playing, alter egos, disguise—these strategies are based on the concealment and transformation of the artist. In breaking away from their normal appearance, artists challenge the conventions—racial, gendered, and otherwise—of their

3 Shearer West, *Portraiture* (Oxford: Oxford University Press, 2004), 165.

4 Gen Doy, *Picturing the Self: Changing Views of the Subject in Visual Culture* (London: I. B. Tauris, 2005), 36.

5 J. Kirk T. Varnedoe, *Modern Portraits: The Self & Others* (New York: Wildenstein, 1976), xxi, xxiii.

6 Mercer, "Busy in the Ruins of Wretched Phantasia," 27–28.

usual identities, as well as larger cultural and political repressions.

Liberated American Woman of the '70s (1997; fig. 217), a self-portrait by Cameroonian artist Samuel Fosso, exemplifies the use of masquerade in photography. Here, he expresses his desire to escape the social ills and conformities imposed on him and others. In earlier works, from the 1970s, Fosso depicted himself in tight shirts, bell-bottoms, and platform shoes, apparel banned by the Cameroonian dictatorship. He recognized how dress and adornment can function as tools of protest. By simply donning a pair of trousers, he was taking a risk and displaying his contempt for a political regime and the restrictive, traditional values it espoused.

Fosso continued to explore the transformational and subversive possibilities of fashion in *Liberated Woman*. The image is from his *Tati* series, named after the Parisian department store, which had invited him to set up a studio there and use their clothing and cosmetics. In the photograph, Fosso wears a vibrant pantsuit of patchwork fabric, beaded necklaces, a straw cowboy hat, and burgundy stilettos. Against a backdrop of painted vegetation, he kneels on a red and white gingham cloth, his left knee raised to showcase the impressive height of his heels.

Fosso looks squarely at the viewer. His eyes and lips are lined with makeup, his expression exudes confidence. He describes his portrayal as "a dream that narrates slavery, segregation, and the desire to be free, to get revenge, to be independent from whites, from men, to be economically independent, to make a career for herself."[7] His deliberate pose and assured expression project a sense of not only her willingness to pursue her freedoms, but also her conviction that they will be attained.

As Fosso represents a figure from the women's liberation movement of the 1970s, he also portrays his defiance of gendered dress codes of the 1990s, perhaps recognizing how he has gained freedoms and benefitted from the past struggles of women. *Liberated Woman* suggests that, because of past social movements, such as the liberation of American women, Fosso can now represent himself as an African man in untraditional ways, repeatedly altering his image throughout his body of work. *Liberated Woman* is a compelling example of the ways in which Fosso's self-portraiture affirms the complexities of Black African manhood and creates space for the artist's continual reinvention and representation of the self—which Fosso has pursued over the past five decades.

7 Quoted in Emmanuel Iduma, "The Self-Portraits of Samuel Fosso," *Guernica*, November 17, 2014, at https://www.guernicamag.com/the-self-portraits-of-samuel-fosso/.

Autobiography

Although Richard Brilliant has claimed, "self-portraiture always makes a concentrated autobiographical statement," masquerade and autobiography nonetheless are divergent modes.[8] Autobiographical imagery emphasizes the confessional nature of a self-portrait. Viewers become intimately acquainted with the artist, as diaristic self-portraiture typically refers to a personal tragedy or difficulty, and its expression often appears to be a form of therapy.

Shearer West has pointed out, "the conventions of portraiture convert this apparent life moment into an art form," and artists are free to omit, edit, and exaggerate details as they choose.[9] However, rather than subterfuge, autobiographical self-portraits are better considered as visual memoirs. Similar to the way memory functions, the memoir merges fiction with fact. Autobiographical self-portraiture captures the ways that artists remember and perceive the past. It explores artists' interpretations of their experiences beyond the minutiae to reveal lives rather than conceal identities. In so doing, they distill from those events what was important and why it matters, the knowledge they gained and now strive to pass onto others.

The Afro-Peruvian poet, composer, choreographer, and activist Victoria Santa Cruz understood that the personal is political. *They Shouted Black at Me* (1978; figs. 310–312) recounts an experience from her own childhood to help advance the Afro-Peruvian social justice movement of the 1970s. This nearly four-minute video captures her compelling performance of a poem describing her evolution from hating her Black features to proudly proclaiming "Sí! Soy Negra!" (Yes! I am Black!). It begins soberly, the camera focused on the artist's grave expression. Accompanied by a steady drumbeat, she describes people yelling "Black!" at her seven-year-old self and how she subsequently "stepped back" and distanced herself from her Blackness by straightening her hair and powdering her face. Santa Cruz then found herself at a mental and emotional precipice, about to fall.

As she narrates, nearly every line is punctuated by the chant of "Negra!" by five male and female performers standing alongside Santa Cruz. The repeated refrain provides a rhythmic pulse to the poem that builds tension and then provides cathartic release when the artist, rather than capitulating to despair, declares "So what?" and exclaims, "Yes, I'm Black!" She then describes how she eventually resisted the judgment of others, embraced the beauty of her Blackness, and

8 Richard Brilliant, *Portraiture* (Cambridge, Mass.: Harvard University Press, 1991), 158.

9 West, *Portraiture*, 178.

realized that she has "total control. . . . Finally!" By the end of the poem, Santa Cruz's voice has become stronger, more defiant, the drum beating at an accelerated pace, the hips and elbows of the group thrusting in dance, in a thrilling, empowering conclusion.

While Santa Cruz based *They Shouted Black at Me* on her own experience as a child being rejected by her friends for her race, it nonetheless speaks of a shared experience. Her struggle resembles those of Black women across the Afro-Atlantic, beyond Peru and South America, to accept and eventually appreciate, even celebrate, physical aspects of Blackness in the face of historical denigration. Learning from her past, Santa Cruz said, "I came to discover what it means to stand on your feet without looking for someone to blame, suffering but discovering things. I began to discover life," and she wanted to impart her wisdom and empower all those who would listen. She continued, linguistically and politically shifting focus from herself to "we," her Black viewers: "It's terribly important to know that there is no revolution without evolution. And at this point, I know who I am. I know who we are, and we have to do something to be free."[10] Thus, *Me gritaron negra* is a powerful renunciation of colorism and racism that recounts Santa Cruz's personal history to inspire future viewers.

Affinity/Affiliation

Another approach to self-portraiture focuses more explicitly on artists' relationship to others by picturing them with friends, family, and even strangers. The groupings indicate the significance of certain people in the artists' lives and, by extension, their identification with certain political projects and alliances, as well as social and cultural histories. Moreover, these self-portraits convey the artists' empathy for others. If the self evolves and expands through relationships with people, empathy is the bridge between those individuals, and self-portraits with others convey this process.[11]

Self-imagery with others also impresses upon viewers the collective nature of art and the self, affirming that artists do not work alone. Despite the myth of the artist as an autonomous creative genius, Ernst Rebel explains that the communal aspect of artmaking is age-old. Within the medieval guild system of the early modern era, "community and collective consciousness were part of the artist's profession. . . . It was both a shackle and a chance, a condition and limitation of creativity in one."[12] While group self-portraits challenge the traditional notion of the individual self, they nonetheless illustrate that love, family, friendship, group solidarity, and community ethos are critical aspects

10 Marcus D. Jones, Mónica Carrillo, and Ana Martinez, "An Interview with Victoria Santa Cruz," *Callaloo* 34, no. 2 (Spring 2011), 305.

11 Vivien Margaret Gaston, *The Naked Face: Self-Portraits* (Melbourne: National Gallery of Victoria, 2010), 77–78.

12 Ernst Rebel and Norbert Wolf, *Self-Portraits* (Cologne: Taschen, 2008), 15.

45

of the ways in which one develops a sense of individuality and finds a place in and path through the world.

Similar to Victoria Santa Cruz, the Afro-Brazilian artist Paulo Nazareth comments on the denigration and reclamation of Blackness in *CA— Black Neger* (2012–13; fig. 306). The photograph is part of an ongoing project titled *African Notebooks*, for which Nazareth has embarked on walks through the Americas and the African continent. Encounters with others along the way have provided opportunities for Nazareth to investigate the transhistorical nature of Black experiences.

In *Black Neger*, Nazareth documents his meeting with an anonymous Black American man on the street. They each hold a large sheet of paper with handwritten text: the American man's sign says "NEGRO," Nazareth's "PRETO." In the past, these terms have been used as demeaning labels and state-ordained classifications for Black people in the United States and Brazil, respectively. By holding the signage in front of their own bodies, the men label themselves with these words to subvert their meanings and deprive them of their power. In so doing, they recall larger cultural and historical movements of Black people to reclaim and reinterpret

such terminology.[13] In light of these similar processes of reclamation by Black communities across the Americas, Nazareth's image of himself alongside an anonymous man from another country asserts a deep, shared connection that is intraracial and cross-cultural, historical and enduring.

The monumental seven-piece photographic composition *Replenishing* (2003; Pérez Art Museum Miami) by Afro-Cuban artist Maria Magdalena Campos-Pons evokes a closer bond, one between a mother and daughter, as well as the artist's ties to the histories of her ancestors. Standing against nondescript gray backgrounds, Campos-Pons and her mother, in floor-length dresses, squarely face the viewer. Although the women are joined by intertwined strands of colorful beads, the division of the image into a grid creates a sense of literal and figurative distance between them.

Replenishing represents Campos-Pons's physical separation from her mother, who resides in Cuba, while the artist has lived in the United States since 1991. It also alludes to past disruptions and forced separations of families that have displaced Black people to and throughout the Afro-Atlantic. Yet, in the gripping of the beads, the women sustain their connection to one another. *Replenishing* reflects the strength

13 In recent years in Brazil, the word *preto* has been appropriated and resignified by young Black activists, who use it as a term to express pride, political empowerment, and ethnic solidarity.

14 Sally Berger, "Maria Magdalena Campos-Pons, 1990– 2001," in *Authentic/ Ex-Centric: Conceptualism in Contemporary African Art*, ed. Salah M. Hassan and Olu Oguibe (The Hague: Prince Claus Fund Library, 2001), 122.

of their emotional bond and the spirit of their connection to the cultural heritage of past generations. As Sally Berger observes,

> it encompasses a larger story. It reveals a history of survival—of a culture, a religion, and a people—from the oceanic voyage from Africa during the slave trade in the 18th century, to its aftermath in Cuba on the sugar plantations, to the present day in the United States. It is a felt history—not one of the rhetorical facts and figures told through non-spoken, fragmented narratives.[14]

Body

The investigation of one's own body and its social and psychological meanings emerged as a strategy for self-representation in the early 1900s. Before then, full-length portraits were rare, and nude ones were "virtually nonexistent."[15] Historians often credit philosophical developments as chief factors in this new emphasis on corporeality. Freudian psychoanalysis, with its theory of physical energy as a motivating factor behind human behavior, was a key impetus, as well as Friedrich Nietzsche's *The Birth of Tragedy* (1872), considered "one of the seminal texts for the modern body cult."[16] Nietzsche

celebrated Dionysian dancing, which called the entire symbolism of the body into play. Likewise, artists have drawn on the expressionistic capacities of their bodies to convey their own emotional and psychological states, often addressing past traumas that now inform how their bodies fit and function in particular spaces in the world.[17]

The body is an especially effective medium through which to communicate larger societal concerns and historical subjects related to race, gender, class, and sexuality. Frances Borzello has observed that artists deploy their bodies "as a way to present much broader issues and ideas," with the result that "it is no longer clear when a self-portrait is a self-portrait. . . . The presentation of abstract issues through the artist's own body has complicated the whole idea" of the genre.[18] In using her own body, the artist humanizes abstract concepts, demonstrating their personal repercussions and real-world stakes.

For her *White Shoes* series, the Black American artist Nona Faustine conducted research on New York City's links to slavery, locating several sites across the five boroughs where human bodies, not unlike her own, were trafficked, sold, put to work, and laid to rest. Faustine stages her photographs at these locations to insist on the remembering of a largely

15 James Hall, *The Self-Portrait: A Cultural History* (New York: Thames & Hudson, 2014), 253.

16 Ibid.

17 Ibid., 254.

18 Frances Borzello, *Seeing Ourselves: Women's Self-Portraits* (New York: Abrams, 1998), 170–71, 199.

forgotten or unknown history of the city, and the North in general, that upends notions of slavery as a strictly Southern phenomenon. In fact, Black Africans were traded far from the plantations, in places such as Wall Street, the setting of her arresting image *From Her Body Sprang Their Greatest Wealth* (2013; fig. 35). There, Faustine presents herself as one of those Black women from long before, whose bodies were forms of currency, commodities traded like stocks on an earlier Wall Street, between Water and Pearl Streets, the block that "operated from 1711 to 1762 as the city's first slave market, where in one day 50 Native and African men, women, and children could be bought and sold."[19]

From Her Body shows the artist identifying with and as the enslaved woman of the past indicated in the title. Faustine is completely nude, save for a pair of white high-heeled shoes and metal cuffs that bind her wrists. Standing on a plain wooden box in the middle of the intersection, she solemnly faces the viewer as a taxi approaches and rounds the corner in the background. This reenactment of a scene of an enslaved woman presented at an auction recalls the fact that "one of the earliest forms of wealth accumulation in the Americas depended on the ownership of black bodies."[20] Black women were a source of capital for their owners. They labored and they produced laborers to benefit enslavers and their families, creating wealth that was then passed down to future generations living today. Faustine viscerally remembers this past and recalls related abstract concepts, such as wealth, finance, and capital, through her bodily presence.

Moreover, the timelessness of nudity, in contrast to the way clothing trends mark time, allows Faustine's body to signify both past and present. Her manacled body posed on the box situates us in the eighteenth century, whereas its presentation against the cityscape and in white heels reminds viewers of the present-day. Faustine thus embodies a historical moment as she articulates its lingering effects and influence on the here and now. These dueling notions of time are complemented by those of her bodily exhibition. Faustine's nudity connotes the vulnerability and brutal degradation of the past, but it also projects defiance and resilience, as suggested by her erect posture and gleaming white shoes that assert her womanhood and refusal to succumb to the debasing forces of white supremacy and patriarchalism. Unashamed and "dressed" in her heels, Faustine portrays the struggle but also suggests the survival, even the thriving, of Black men and women who were able to live, procreate, and create culture and community—of which she is living proof.

19 "African-American Artist Poses Nude at New York's Historic Slavery Sites," *Artnet News*, July 6, 2015, at https://news.artnet.com/about/artnet-news-39.

20 "Nona Faustine: White Shoes," *UKEssays*, November 2018, at https://www.ukessays.com/essays/photography/nona-faustine-white-shoes.php?vref=1.

Absence/Negation

Other self-portraits do not present bodies at all. They instead rely on means such as text and objects to represent the artist, thereby affirming the self as something that exists beyond the limits of the body. Rather than depicting one's figure or features, this type of self-portraiture looks outward and reminds the viewer that the world around the artist—her context—shapes her understanding of who she is, rendering a body insufficient for representation of the self.

Furthermore, if the self eludes definition, it remains a subject to be continually interrogated rather than enclosed within a figure that others label or categorize for convenience. A Black self-portraitist must contend with the ways in which her presence is racially circumscribed in popular-cultural discourses and her likely desire to break free from this bind. Abstracting or removing the body altogether thus serves as a fitting response. As Leigh Raiford theorizes,

> if Blackness is itself an imago, a fantasy woven out of the anecdotes and stories, fears and desires of a dominant society, then perhaps the best way to represent that Blackness is not through a turn toward verisimilitude. Rather, one might . . .

represent Blackness not as a true likeness but as an always already invention, Blackness not as a finite answer but as an endless series of questions.[21]

Accordingly, to create *Runaways* (1993; figs. 61-64), the African American artist Glenn Ligon asked several friends a question: How would they describe him to the police if he went missing? He made a set of ten lithographs, each printed with a different response, each providing a different account of the physicality and personality of the same subject. One reads:

> RAN AWAY, a man named Glenn, five feet eight inches high, medium-brown skin, black-framed semi-cat-eyed glasses, close-cropped hair. Grey shirt, watch on left hand. Black shorts, black socks and black shoes. Distinguished-looking.

Others describe Ligon as "quiet," "very warm and sincere," and looking "like he might have something on his mind—he'll find you." Ligon then formatted the sheets to look like 19th-century advertisements published to locate runaway enslaved people, using a similar typeface and illustrated with the then-ubiquitous icons of Black figures running with knapsacks and kneeling with hands chained and clasped, looking upward in desperation.

21 Leigh Raiford, "Burning All Illusion: Abstraction, Black Life, and the Unmaking of White Supremacy," *Art Journal* 79, no. 4 (Winter 2020), 82.

While the work daringly equates historical descriptions of enslaved people written by their owners with contemporary forms of "capturing" a Black subject, Ligon's friends' differing accounts nonetheless call into question the notion of a fixed, unchanging self. One print describes Ligon as "pretty dark-skinned," another says he has a "medium complexion (not 'light skinned,' not 'dark skinned,' slightly orange)," and yet another states that he has a "quite light skin tone (faded bronze)." As these judgments on the degree of melanin in Ligon's skin suggest a moving target, they also point to an irreconcilability in representing him, his appearance as well as his character. Without an image of Ligon to which the viewer can refer, *Runaways* creates further confusion.

Yet this uncertainty rids Ligon of the responsibility to approximate himself to others' descriptions or, conversely, to disprove their reports. The work, despite its theoretical attempts to locate or capture the artist, ironically frees him. Ligon's absence in *Runaways* evokes an escape from a supposed captivity, from the "performative fiction of the portrait," and ultimately from the definition of others' words.[22]

The Black artists included in *Afro-Atlantic Histories* demonstrate that, whether through likenesses or their absence, self-portraiture relies on and reveals blind spots. One can never perceive or portray oneself fully and must objectify the self to render it as an artwork. In the perception of oneself as something necessarily "other," however, the artist gains distance and, by extension, freedom to imagine who she is or could be. These blind spots further offer Black artists the opportunity to fully occupy and open up the genre. They have elaborated on classic categories of self-portraiture in unique, culturally specific ways, whether through their attire, childhood traumas, nude figures, or no figure at all. Moreover, the inclusion of self-portraits throughout the exhibition, in multiple sections, personalizes its broad themes. On intimate levels, these works illustrate how the "Enslavements and Emancipations," "Rites and Rhythms," and "Resistances and Activisms" of the African diaspora are not abstract concepts or phrases: they summarize real-world histories and experiences in which Black artists are heavily and personally invested, in which they see themselves.

22 Ibid., 90.

A PLACE TO CALL HOME:

REFLECTIONS ON TRANS-NATIONAL TRANS-LATIONS

Vivian A. Crockett

Hank Willis Thomas's *A Place to Call Home* (2009; fig. 11), an eight-foot cartographic rendering of an imaginary Africa-America in which South America is replaced with the African continent, can be read in a variety of ways. On the one hand, the work fulfills the artist's self-confessed longing for a sense of connection to Africa, achieved by bridging the literal distance between both geographical sites. In doing so, it might be alternately read as further effacing the presence of African diasporic populations within the Caribbean and Latin America, the very communities already subject to political exclusion, systemic inequities, and cultural erasure. A third reading might affirm the overlooked importance of South America within Afro-Atlantic discourses, as explored in Frank Bowling's *Map* paintings. In *Night Journey* (1969–70; fig. 6), the Middle Passage is invoked by the swaths of yellow paint that bridge the oceanic divide between the two continents. Bowling has elsewhere explored the visual similarities between the shapes of their land masses.[1]

In *(Other) Foundations* (2017–19), Aline Motta asks: "If belonging is

1 Frank Bowling is a particularly important case study in the context of African diasporic exchange. Born in Guyana, he has resided between London and New York for most of his life.

a fiction, can I point a mirror to Nigeria and see Brazil? Is the inverse possible?" The film is the culmination of a trilogy—beginning with *Bridges over the Abyss* (fig. 294)—in which the artist searches for traces of her ancestral lineages, mends severed kinship ties, and examines the contradictions and personal implications of her Portuguese and West African heritage.[2] Motta and the characters in her film oscillate the mirrors in their hands from their respective locations in Lagos, Cachoeira in Bahia, and Rio de Janeiro. As the mirrors sway, they reflect bodies of water and flashes of light. They become portals, or signal lamps.

Much like the works described thus far, this essay is a personally motivated attempt to find myself reflected, in my double-postcolonial hybrid status as a Black cultural worker born in Brazil and residing in the United States, caught between Black curatorial life at the anti-Black interstices of two art systems. If Jacques Derrida laments the estrangement of monolingualism, I might alternately profess, "I have two languages; neither is mine."[3] In her own citation of Derrida, Kaira Cabañas cautions against what she terms "monolingualism of the global,"

the assimilationist logic that informs seemingly benign attempts to integrate other cultures—to make them "legible and knowable"—through the preexisting dominant rubric.[4] One of her main concerns is the decontextualized manner in which Arthur Bispo do Rosário's creations (figs. 277, 360) have circulated within the global art fair circuit.[5]

Anchored by the artists and works presented in *Afro-Atlantic Histories*, this essay weaves a noncomprehensive narrative of cultural exchange between Brazil and the United States through three main touchpoints, set roughly forty years apart.[6] In doing so, I seek to reveal the discursive frameworks through which some of the works gathered within the scaffolding of *Afro-Atlantic Histories* have previously circulated and, by extension, how these precedents might implicitly temper the contextualization of these works in the U.S. iteration of the exhibition.

2 Aline Motta's inclusion in *Afro-Atlantic Histories* can be traced to her long-running exchange with Hélio Menezes, one of the curators of the original exhibition. She also exhibited in MASP's 2019 *Feminist Histories* project.

3 Jacques Derrida, *The Monolingualism of the Other, or, The Prosthesis of Origin*, trans.

Patrick Mensah (Stanford: Stanford University Press, 1998), 1. Here, I also indirectly summon the queering of postcolonial hybridity, as developed by José Esteban Muñoz in *Disidentifications: Queers of Color and the Performance of Politics* (Minneapolis: University of Minnesota Press, 1999).

4 Kaira M. Cabañas, *Learning from Madness: Brazilian Modernism and Global Contemporary Art* (Chicago: University of Chicago Press, 2018), 145.

5 Cabañas details Bispo's explicit resistance to being exhibited in an art institutional context, a request that was ignored shortly after

his death when Frederico Morais curated *Registros de minha passagem pela Terra* at Parque Lage in 1989. She makes an important distinction here: "My goal is not to disavow Bispo's creative production as art. Instead, I hope to make a case for the difference between identifying Bispo as a contemporary artist and the contempora-

neity of Bispo's art." See ibid., 111–40 (quote, p. 133).

6 While *Afro-Atlantic Histories* expands the discourse on representations of Blackness beyond these two localities and provides glimpses into examples from throughout Latin America and the Caribbean, works from the U.S. and Brazil make up the bulk of the exhibi-

The Permanence of Structures[7]

In "History, *Histórias*," Adriano Pedrosa characterizes the discipline of art history as "a powerful and enduring apparatus of imperialism and colonization," whose evolutionary narrative has been constructed and legitimized over centuries.[8] Artistic hierarchies are further perpetuated by the museological, academic, and market systems, what Pedrosa succinctly terms "art-historical imperialism." Like the forces from which it springs, art-historical imperialism has an enduring presence in our contemporary realities and can be further compounded at various cross-cultural touchpoints.

The extant visual records of Black life under slavery are embedded in the very artistic hierarchies we are now attempting to upend, acutely conjoining visual pleasure and the gruesome violence of colonial and imperialist subjugation. Albert Eckhout and Jean-Baptiste Debret's visual output (figs. 00, 00), for example, was the direct result of their integration within imperial governing bodies, wherein visual documentation was tantamount to the literal possession of land and people.[9] If contemporary discourses in the United States privilege the ethos of refusal, *Afro-Atlantic Histories* takes the opposite approach: providing so much visual evidence of these legacies of violence that their impact cannot be refuted. Art-historical *mea culpa*, if you will.

The fetishistic conundrum implicit in this overwhelming amalgamation is never wholly resolved. Rather, the various *Histories* projects organized at MASP throughout the years adopt the Brazilian term *histórias* translated simultaneously as *histories* and *stories*. *Histórias* aims to account for both the fictions of hegemonic systems and the praxis of historical repair, of critical fabulation, that reaches for the unspeakable and the unknowable.[10] The hope is that an official, authoritative history can be replaced with a "polyphonic" modality, wherein such tensions, incongruities, and counternarratives will coexist.

Denise Ferreira da Silva, in dialogue with Phanuel Antwi and C. Riley Snorton, reminds us that we must resist false narratives of progress that seem to imply that colonial/racial violence can be—or eventually will

tion. One might note that the show—and in turn, this essay—presents a limited engagement with the African continent itself, something that I hope future exhibitions will more thoroughly address.

7 Each subsection of this text is named after a work in the exhibition: Rosana Paulino, *The Permanence of Structures*

(fig. 13); Sidney Amaral, *Neck Leash—Who Shall Speak on Our Behalf?* (fig. 48); Paulo Nazareth, *The Tree of Forgetting* (fig. 87–89); Nona Faustine, *From Her Body Sprang Their Greatest Wealth* (fig. 35); and Maxwell Alexandre, *We Were the Ashes and Now We Are the Fire* (fig. 2).

8 Adriano Pedrosa, "History, *Histórias*," in this volume, 00. Please see Pedrosa's text for the sources and theoretical precedents from which his analysis derives.

9 *African Man* and *African Woman with Child* (figs. 191, 193) are among the four racial taxonomic pairs executed by Eckhout during the

era of Dutch Brazil under the leadership of Johann Maurits of Nassau-Siegen, the others being: *Tapuya Man* and *Woman*; *Mameluca Man and Woman*; and *Brazilian Man and Woman*. Eckhout and Frans Post (fig. 99) were among the emissaries who accompanied Maurits to chronicle the flora, fauna, and peoples of Brazil.

10 Saidiya Hartman, "Venus in Two Acts," *Small Axe* 12, no. 2 (2008), 11. It can be argued that "critical fabulation" as defined in this text applies to Hartman's overall scholarly praxis.

be—course-corrected via strategies of inclusion.[11] Indeed, a truly polyphonic modality must contend with the limits of curation and expography to counter the violence constitutive of museum spaces. Efforts such as this exhibition are the most successful when they acknowledge the unresolvable tensions inherent to them, so that we might also begin to imagine solutions beyond the museum sphere.

Afro-Atlantic Histories' original run began just three months after the assassination of queer activist and councilwoman Marielle Franco and was marked by the imminent threat of Jair Bolsonaro's presidency.[12] In Brazil, this politically draconian era has coincided with a measured increase in visibility and prominence for Black cultural workers and artists.[13] In late 2018, Sonia Gomes became the first living Black woman to exhibit with MASP, under the curatorship of another Black woman, Amanda Carneiro. The symbolic resonance of Gomes's sutured forms melding into Lina Bo Bardi's Casa de Vidro, a sanctified site of Brazilian modernism, should not be underestimated. Gomes's work is one of organic integration of exterior and interior, of space and body, and of disciplinary

boundaries. Yet she insists that this inclusion does not preclude a sense of unintelligibility: "Thanks to recognition, I am in a circle of privilege, but my work is marginal, and remains as such, because what marginalizes it is beyond the walls of the museum; it can be at MoMA, but it still remains marginal. Because we are talking about the work as a body, not as a place."[4] In naming the *work as a body*, as an extension of Black life, Gomes emphasizes that certain forms of knowledge escape the confines of institutional art frameworks.

One. *Who Shall Speak on Our Behalf?*

It's worth noting that the first artwork from South America to enter the collection of the Museum of Modern Art in New York was Candido Portinari's *Hill* (1933), an idyllic scene of quotidian life in an unspecified favela community, acquired in 1939. Portinari made his U.S. debut at the 1935 Carnegie International and was also the Brazilian representative at the 1939

11 Denise Ferreirra da Silva, Phanuel Antwi, and C. Riley Snorton, "Toward the End of Time," in *Saturation: Race, Art, and the Circulation of Value*, ed. C. Riley Snorton and Hentyle Yapp (Cambridge, Mass.: MIT Press, 2020), 141–53.

12 Bolsonaro's presidency has drawn parallels to the escalating

damage of the Donald Trump administration in the United States. Both figures' repressive policies and bigoted public statements emboldened a more overtly empowered white-supremacist base. Under their respective presidencies, the United States and Brazil have consistently held the highest infection and death rates during the ongoing

COVID-19 pandemic. Among those lost to the pandemic is David C. Driskell (1931–2020; figs. 169, 176), the artist and art historian whose landmark exhibition *Two Centuries of Black American Art* (1976) fundamentally shaped the discourse on Black artistic contributions in the United States. Both Brazil and the U.S. are also infamous for the staggering murder

rates of Black people at the hands of police as well as the lethal targeting of transwomen and gender-nonconforming people. (The latter point still deserves greater recognition in the context of this exhibition.)

13 In stating this, I also wish to emphasize the plurality of perspectives, strategies, and lived experiences

represented in this cultural moment. Since June 2020, the curator and educator Raphael Fonseca has been interviewing two Brazilian curators a week, amassing an archive of these diverse practices. See *1 Curadorx, 1 Hora* on YouTube, https://www.youtube.com/c/1curadorx1hora/about.

World's Fair. A significant aspect of his allure, as the writing on his work during this period reveals, was his "heroic" commitment to chronicling Black subjects. Writing in *Portinari of Brazil* (1940), journalist Florence Horn perpetuated the myth of Brazil's racial democracy, claiming that there "the negro and mulatto are treated with greater justice and understanding than they are in New York City."[5] In the same catalogue, Robert C. Smith uncritically conflated Portinari's interest in Black subjects with the imperial visual culture I began this essay discussing: "For it was the negroes who first fascinated the artists who accompanied the 17th century Dutch governor of Pernambuco, Maurice of Nassau-Siegen. Albert Eckhout and Frans Post painted exotic portraits of Brazilian slaves and filled their landscapes with colorful African figures."[6] This rhetoric was echoed in MoMA's 1943 *Latin-American Collection* catalogue, which included an introductory section, "From the Conquest to 1900," where Eckhout's *Tupí [sic] Woman* (1641) and Post's *View of Pernambuco* (ca. 1645) are reproduced.[17]

The publication marked the recent growth of this collecting area, with approximately 200 works acquired via the Inter-American Fund, an effort linked to Franklin D. Roosevelt's Good Neighbor Policy, a "Pan-American" initiative spurred by both financial and political interests.[18] Heitor dos Prazeres's *St. John's Day* (1942) was among the works acquired by Lincoln Kirstein, who was hired by MoMA to travel and make purchases on the museum's behalf. He described it as "a lovely night fiesta scene painted in permanent house paint and richly waxed with shoe polish which comes off on my shirts, for $20" (roughly equivalent to $300 today).[19]

In "Blackness at MoMA: A Legacy of Deficit," Charlotte Barat and Darby English lament that works by Black artists from the Caribbean and Latin America attracted MoMA's interest in this period far more than that by U.S.-based Black artists, because they more often fit the museum's penchant for self-taught, popular, or primitivist artists.[20] By contrast, MoMA's most recent forays into Latin American art have largely excluded the contributions of Black artists and culture. The gravest of these omissions was the absence of Rubem Valentim from *Sur Moderno: Journeys of Abstraction*, an exhibition of abstract and Concrete art developed on the occasion of a

14 Sonia Gomes, quoted in Cecilia Fajardo-Hill, "The Limit of the Invisible: Black, Feminine," in *Sonia Gomes: Life Is Reborn / Still I Rise* (São Paulo: MASP, 2018), 68.

15 Florence Horn, "Portinari of Brazil," in *Portinari of Brazil* (Detroit: Detroit Institute of Arts, 1940), 8. The exhibition traveled to MoMA, October–November 1940.

16 Robert C. Smith, "The Art of Cândido Portinari," in *Portinari of Brazil*, 10.

17 Lincoln Kirstein, *The Latin-American Collection of the Museum of Modern Art* (New York: Museum of Modern Art, 1943), 6–7. Eckhout's painting should have been labeled *Tapuya Woman* (see note 7).

18 Zilah Quezado Deckker, *Brazil Built: The Architecture of the Modern Movement* (London: Spon Press, 2001), 100. See also Irwin Gellman, *Good Neighbor Diplomacy: United States Policies in Latin America, 1933–1945* (Baltimore: John Hopkins University Press, 1979).

19 Letter from Lincoln Kirstein to Alfred Barr, June 19, 1942, quoted in Charlotte Barat and Darby English, "Blackness at MoMA: A Legacy of Deficit," in *Among Others: Blackness at MoMA* (New York: Museum of Modern Art, 2019), 27.

20 Ibid.

major gift from the Colección Patricia Phelps de Cisneros.[21] That European works like Piet Mondrian's *Broadway Boogie Woogie* (1942–43) appeared in the place of Valentim's reinforced a Eurocentric lineage for Latin American modernist production and implied that Afro-Brazilian artists such as Valentim remained on the margins during this period.[22]

Rubem Valentim was adamant that diverse influences were "inevitable, necessary, beneficial" when resulting from an active fusion and engagement rather than mere "cultural colonialism."[23] He developed a complex visual lexicon that reconfigured iconographic emblems from Candomblé and Umbanda, references from what he termed "Afro-Amerindian-Northeastern" iconology, and his own hybrid geometric forms. *Composition 12* (1962; fig. 375) is divided into three horizontal fields, creating a balanced dynamism between *orum* (the world of the orishas) and *ayê* (the earthly realm). These corresponding red horizontal areas are connected through the work's central axis, where Eshu, the messenger between the two realms, is invoked through the inverted trident form.

Two. *The Tree of Forgetting*

It is indeed a myth that Black artists—in Brazil, the U.S., and beyond—were wholly "unknown" or excluded from institutional circles and discourses in modern and contemporary art. The under-recognition of the contributions of Black artists and thinkers has required a constant effacement so that the "record" seems to be amended (again and again) every few years.

Throughout his life, Abdias Nascimento—whose qualifiers included theater director, scholar, curator, artist, and political figure—was an avid proponent of African diasporic cultures and Pan-African political solidarity. He was frequently targeted by government forces—first during the Vargas regime and later under the military dictatorship—and took up permanent residence in the United States in 1968 following a research trip. Nascimento's political exile strengthened his Pan-African allegiances and networks.[24] Already a vocal critic of the image of Brazil promoted abroad, especially as it related to Afro-Brazilian representa-

21 Inés Katzenstein and María Amalia García, eds., *Sur Moderno: Journeys of Abstraction: The Patricia Phelps de Cisneros Gift* (New York: Museum of Modern Art, 2019). While Valentim was not included in the exhibition itself, his works are featured in the accompanying publication, as well as in the aforementioned *Among Others* (see note 19), with a text by Roberto Conduru.

22 In fact, Valentim exhibited alongside Lygia Clark and Hélio Oiticica, among many other key figures, at the 1st Bienal da Bahia in December 1966 and won the Contribution to Brazilian Painting Prize. Valentim also taught at the Instituto de Belas Artes in Rio de Janeiro (1957–63) and at the Instituto de Artes da Universidade de Brasília (UnB), beginning in 1966. Like many of his counterparts, he spent several years traveling around Europe after winning a travel prize and lived in Rome from 1965 to 1966. He participated in the First World Festival of Negro Arts (FESMAN) in Dakar in 1966 before returning to Brazil.

23 Rubem Valentim, "Manifesto ainda que tardio" (1976), in *Rubem Valentim: Construções afro-atlânticas* (São Paulo: MASP, 2018), 132–34.

24 While in the United States, Nascimento taught at the Yale School of Dramatic Arts (1969) and, from 1971 to 1981, the State University of New York, Buffalo, where he founded the chair of African Culture in the New World at the school's Puerto Rican Studies and Research Center. During a temporary leave in 1976–77, he taught at

tion, Nascimento penned some of his most critical indictments during this time. Having been excluded from the Brazilian delegation at the First World Festival of Negro Arts (FESNAM) in 1966, he attended FESTAC '77 (the 2nd World Black and African Festival of Arts and Culture) while a visiting scholar at the University of Ife, where he publicly condemned Brazil's anti-Black racism and official assertions of a racial democracy.[25]

Nascimento began painting around the time he established the Museu de Arte Negra (Black Art Museum), a project that unfortunately never fully cemented. Its first exhibition was held at the Museu da Imagem e do Som (Image and Sound Museum) just prior to Nascimento's departure from the country. Painted during this early period of exile, his *Okê Oshosi* (1970; fig. 275) was a visual reworking of the Brazilian flag, turned on its side.[26] Oshosi's *ofá* (bow and arrow) anchors the work, and Nascimento replaced the positivist motto "Order and Progress" with "okê okê okê okê," an abbreviated version of Oshosi's salutation "okê, aro." Around the same time, the artist also reimagined the U.S. flag, in a work titled *Shango Takes Over* (1970; IPEAFRO, Rio de Janeiro). Rather than integrating into the flag, Shango's *oxê* (double-headed ax) supersedes it, as if striking down the U.S. empire itself. While never initiated in Candomblé, Nascimento sought to honor the cultural and political autonomy he associated with practitioners of Afro-Brazilian religions. As he described it, the orishas were the basis for his paintings because they were sources of strength for ongoing liberatory struggles.[27]

Okê Oshosi was among the works Nascimento exhibited in his solo show at The Studio Museum in Harlem in 1973, five years into the institution's founding. While the accompanying text written by the Brazilian sociologist Guerreiro Ramos referred to the specifics of Black culture in Brazil, it ended by affirming the "common divine heritage" shared by "all men."[28] The following year, Nascimento also exhibited in *Kindred Spirits: An African Diaspora* at Harvard, where he participated in a panel discussion with Charles White and the Nigerian artist Zacheus Olowonubi Oloruntoba. Nascimento and White reached a fundamental impasse when the latter insisted that the term "black art" had no clear function for artists of the diaspora and should be reserved to con-

the University of Ife in Nigeria (now Obafemi Awolowo University), in the Department of African Languages and Literatures. He returned to Brazil in 1983, becoming the country's first Afro-Brazilian congressman.

25 See Abdias Nascimento, "An Open Letter to the 1st World Festival of Negro Arts," *Présence Africaine* 30 (1966), 208–18. See also Abdias Nascimento, "Afro-Brazilian Art: A Liberating Spirit," *Black Art: An International Quarterly* 1, no. 1 (Fall 1976), 54–62. For a more detailed analysis, see Kimberly Cleveland, *Black Art in Brazil: Expressions of Identity* (Gainesville: University Press of Florida, 2013), 46–68. See also Kimberly Cleveland, "Abdias Nascimento: Afro-Brazilian Painting Connections across the Diaspora," in *Anywhere But Here: Black Intellectuals in the Atlantic World and Beyond*, ed. Kendahl Radcliffe et al. (Jackson: University Press of Mississippi, 2015), 167–86.

26 The contemporary Brazilian flag was in turn an adaptation of the imperial flag of Brazil designed by Jean-Baptiste Debret, whose depictions of enslaved Black people are also exhibited in the exhibition and referenced earlier in this text.

27 Nascimento, "Afro-Brazilian Art: A Liberating Spirit."

28 Guerreiro Ramos, "Nascimento's Artistic Faith," in *Paintings by Brazilian Artist Abdias Nascimento* (New York: Studio Museum in Harlem, 1973).

note the stylistic identities of those indigenous to the African continent.[29] By contrast, for Nascimento, the diasporic framework provided a basis of support and recognition for his intellectual and artistic contributions counter to the hegemonic Brazilian nationalist discourse he critiqued.

Three. *From Her Body Sprang Their Greatest Wealth*

As if taking to heart the visual proposition of Thomas's *A Place to Call Home*, Paulo Nazareth left Belo Horizonte, Minas Gerais, Brazil, in March of 2011 and made his way northward on foot—at times supplementing the walk by hitchhiking and by bus. Over the course of six and a half months, he traversed several thousand miles through more than fifteen countries, an endurance performance titled *News from the Americas (Journey on Foot from South America to North America)* (2011–12).

During his travels, he reflected on cultural affinities—shared language, food, customs—while also navigating his own shifting identity in the perception of those he encountered. While some easily recognized his indigenous heritage, others saw only his blackness. He was at one point read as Pakistani, at another moment Cuban, and so on, as he made his way through the Americas.[30] Along the way, he photographed himself with a range of seemingly hastily made signs, with the arbitrary syncopation of a Mel Bochner or Glenn Ligon painting: "Llevo recados a los EUA" (I carry messages to the U.S.); "NO. ME.VOY.MIGRAR.A.E.U.America" (I.will.not.migrate.to.U.S.America). In another image, he forms a protest of one in front of a line of police officers in riot gear, holding a sign that reads: "I AM an AMERICA-N ALSO." One might recognize a vague reference to the iconic "I AM A MAN" protest sign of the 1968 Memphis sanitation workers strike, as immortalized in Ernest Withers's photographs (fig. 307).

News from the Americas can be read as a literal interpretation of the physical and psychological journey a "foreign" artist makes to engage the U.S. art system and the sociopolitical stakes of the transition from one context to another. Before returning to Brazil, Nazareth presented *Banana Market / Art Market* at Art Basel Miami Beach, in December 2011. Holding up one of his many signs, he engaged fairgoers in front of an old Volkswagen van brimming with bananas: "My image of an exotic

29 Cleveland, "Abdias Nascimento," 175. See also Charles White, interview by James Hatch and Camille Billops, December 21, 1970, Altadena, Calif., in Romare Bearden and Harry Henderson, *A History* of African-American Artists: From 1792 to the Present (New York: Pantheon Books, 1993), 417.

30 *News from the Americas* is chronicled and analyzed in detail in *Paulo Nazareth: Arte Contemporânea / LTDA*, ed. Isabel Diegues and Ricardo Sardenberg (Rio de Janeiro: Editora de Livros Cobogó, 2012).

man for sale," at $1 per photographic click. The performance space was also filled with signs, photographs, and ephemera from his travels. Propped along one wall was a photograph that enhanced the dynamics at play: *For Sale* (fig. 36). Nazareth's face is covered with a skull in a manner resembling the torture devices used to punish geophagy, a resistance practice of eating dirt among enslaved peoples in the Caribbean and the Americas.[31] *Banana Market / Art Market* and the images therein—including that of the living artist—connected histories of enslavement, neo-imperialist resource extraction, and the relationship of these to contemporary art systems.

Nazareth has since extended this practice to include walking journeys on the African continent, navigating routes related to the slave trade in the project *African Notebooks* (2013–17), from which the works *Black Neger* (2012–13; fig. 306) and *Tree of Forgetting* (2013; figs. 87–89) emerged. The latter was filmed in Ouidah, in Benin, at the site of a tree in front of the home of Francisco Félix de Sousa, a Brazilian enslaver who relocated to the city to exploit the trafficking of captured Africans. Before boarding ships, enslaved men and women were forced to circle the tree as a means of cutting ties with their homeland. In the film, Nazareth walks backwards

around the tree 437 times, in a reparative attempt at reclaiming the memories of those forced to perform the ritual of forgetting.

We Were the Ashes and Now We Are the Fire

As Antropofagia continues to be praised as a successful model of plurality, there are many—myself included—who question Black and Indigenous subsumption as a side effect of the anthropophagic ethos. One cannot estrange this vanguardist principle from the official agenda of racial whitening.[32] Flávio Cerqueira's *Amnesia* (2015; figs. 258, 259) is a reflection on the Brazilian myth of miscegenation, wherein a young Black boy pours a bucket of paint over his head. While the small figure diligently accomplishes his task, it is also clear that this attempt at whitening will be unsuccessful. Cerqueira further challenges this legacy of erasure by linking blackness to the prestigious tradition of bronze sculpture and whiteness to a diluted, mass-produced latex paint. The white veneer streams down the body's bronze surface but does not cohere, a failure in a permanent state of suspension.

31 As an example, see Jean-Baptiste Debret, *Mask Used on the Negros That Have the Habit of Eating Dirt* (ca. 1820–30; fig. 37).

32 For an early study examining Brazilian racial theory pre-Antropofagia, see Thomas Skidmore, *Black into White: Race and Nationality in Brazilian Thought* (New York: Oxford University Press, 1974).

Among the most impactful contributions to *Afro-Atlantic Histories* was the intervention of the collective Frente 3 de Fevereiro, whose banner "Onde Estão os Negros?" (Where Are the Blacks?, 2005; fig. 385) was placed outside the Instituto Tomie Ohtake, and a month later, on MASP's iconic glass façade.[33] Even as it was integrated into the framework of the exhibition itself, the banner was meant as an interrogation of the institutions and their respective sites, further evidenced by the discomfort they provoked in the elite neighborhoods in which they were shown. The phrase was also understood as a demand for the permanent employment of more Black cultural workers within the institutions themselves and an interrogation of their reliance on adjunct curatorial support. The banner also referenced the limited presence of works by Black Brazilian artists within MASP's permanent collection. Since then, MASP has worked to close this gap, and many of the works by Black artists now in the collection entered by way of *Afro-Atlantic Histories*. Yet the impact of the banner remains, long after its removal, for its clear emphasis on how frameworks of reparative inclusion still replicate the structures of power constitutive of the museological project.

This text maps some successes, interventions, and ongoing challenges in affirming the cultural contributions of artists and cultural workers of the African diaspora, while speaking across, through, and within converging and diverging modes of expression. *Afro-Atlantic Histories*' chronological breadth does not signal the approximation of a reparative endpoint, but rather emphasizes the range of strategies Black people have employed amidst rearrangements of power. Black artists, scholars, and cultural workers, are aware that art institutions and the many art contexts we navigate will never be able to contain the diverse forms of Black cultural expression. Emancipation and resistance continue to take new, evolving forms. We are talking about the work as a body, not as a place.

33 The collective Frente 3 formed after the killing of a young Black man, Flávio Ferreira Sant'Ana, by police in 2004. Since 2005, they have partnered with a range of institutions in the execution of some of their direct actions. The collective has again partnered with curator Hélio Menezes on the project *Abre-Caminhos* (Open Pathways), on view at the Centro Cultural São Paulo from November 2020 to March 2021.

MAPS AND

MARGINS

Maps and Margins

Afro-Atlantic histories combine geographies, displacements, and temporalities. Starting in Africa in the 16th century, these histories began traversing the Atlantic in the direction of Europe and, even more so, the Americas. In this sense, Africa is at the heart of our project, even though it was the Europeans who arrived on the continent to exploit, colonize, and subjugate it. A fitting visual representation of these Atlantic displacements is a triangle portraying three navigation routes. Along the first route, Europeans (primarily from Portugal, Spain, Holland, England, and France) set out on the seas in vessels heading to Africa. They were searching for opportunities to exchange manufactured goods and agricultural products for imprisoned Africans who had been kidnapped and captured in the context of local wars. Along the second route, these individuals were transported and enslaved to be sold in the Americas and the Caribbean. Lastly, along the third route, commodities were taken from the colonies to be traded in Europe. This section focuses on the so-called Middle Passage of this brutal triangle between Africa and the Americas as well as the *flux* and *reflux*—terms coined by Pierre Verger—between the continents.[1] Scholar Paul Gilroy proposes the notion of a Black Atlantic—a fluid space with no specific frontier where African matrixes and identities infiltrate and occupy cultures and territories in the Americas, the Caribbean, and Europe—in which the ocean becomes a liminal territory that challenges national frontiers, and the ship a potent symbol: "a living, micro-cultural and micro-political system in motion."[2]

Here, ships are central icons. Not coincidentally, the nautical motif appears in artworks that feature both in the section Emancipations—such as by Candido Portinari (fig. 21), Paulo Nazareth (fig. 23), and Gilberto de la Nuez (fig. 29)—and in Maps and Margins, by Rosana Paulino and Emanoel Araujo. Paulino's *The Permanence of Structures* (2017; fig. 13) draws on James Phillips's *Plan and Sections of a Slave Ship* (1789; fig. 22), widely reproduced and used by both slave traders and abolitionist campaigners. Paulino creates a patchwork of skulls (referring to the pseudoscience of craniometry, which purportedly assessed the potential of races through the measurements of human heads), Portuguese tiles, and photographs by the German-Brazilian photographer Auguste Stahl. Stahl's ethnographic images of a naked Black Brazilian man, seen full-length from the side and back, were commissioned by Louis Agassiz, a US-based Swiss scientist and proponent of racial determinism, a mid-19th-century theory that endorsed the notion of biologically based racial hierarchies. Paulino's title captures the institutionalized, structural aspects of these racist ideologies, which are still widely disseminated and persistent in Brazil.

Evoking the form of a slave vessel, Araujo's *The Ship* (2007; fig. 12) is a geometric, symmetrical, black wooden structure with transversal lines. A metal chain attached to a leg cuff hangs from the diamond shape at the center. On the surface are thirty one sculptures representing human figures, carved in wood using a traditional Yoruba technique. This is another reference to Phillips's plan, which places enslaved bodies in the ship's hull. Araujo's construction also recalls traditional African sculpture, sharing formal similarities with Mambara figural carvings, replicated here on a monumental scale.

Glauber Rocha evokes the idea of a Black Atlantic in the opening shots of his film *Entranced Earth* (1967; figs. 17–19). Set to a soundtrack of the music of Candomblé (an African-based religion), the Brazilian director overlaps black-and-white aerial images of the Atlantic Ocean along the Brazilian coastline. According to Caetano Veloso, the film's initial sequence—a flight over the borders of territories and cultures—was central to the development of a number of concepts that would later shape the Tropicalismo movement: "My heart started pounding when I watched the opening scene where, to the sound of candomblé chanting—which was already present in the soundtrack of *Barravento*, Glauber's first feature—we see, from an aerial take of the sea, the Brazilian coast getting closer."[3] Cuban artist Gilberto de la Nuez also produced an aerial view of his nation. Instead of a painted map, it is a transversal bird's-eye view that encompasses a narrative about Cuban history (1977; fig. 20). Cuba was among the countries in the Americas that received the largest contingent of enslaved Africans, and was the second to last to abolish slavery, in 1886, two years before Brazil. In Nuez's painting, a number of characters, scenes, and sceneries intricately overlap, with emphasis on the clash between the barechested and chained Black

men and the white men in military uniform carrying guns. In a third aerial view, by contemporary Brazilian artist Carlos Moraes, titled *Helicopter Attack: Reaction, Flight, and Execution* (2004; fig. 16), a man, probably a policeman, flies over a favela in Rio de Janeiro aiming a rifle at the houses below. The photo reflects the violent conflict (which erupted again in 2018) between different communities and classes in the city. These clashes, not confined to urban areas, are often propelled by differences of race and skin color. It is worth noting that the favelas originated in post-abolition African neighborhoods.

Other artists allude to African ports and Atlantic routes. In *Western* (2015; fig. 14), African American artist Radcliffe Bailey portrays a dark, layered ocean from which ropes emerge to illustrate navigation routes between Africa, the Americas, and the Caribbean. The image is a complex landscape populated by traditional African sculptures. Brazilian artist Jaime Lauriano has created a set of floor mosaics featuring the names of three African points of departure for slave ships going to Brazil: Angola, Costa da Mina (Gold Coast), and Moçambique (2017; figs. 3–5). The flat sculptures are composed of Portuguese paving stone, black for the words, white for the background.

Into Bondage (1936; fig. 8) by African American artist Aaron Douglas translates into image the moment when Africans were imprisoned on their continent, before becoming slaves and being taken to the Americas. Douglas, an "anthropophagite" of the Harlem

Renaissance, cannibalized and combined references from Egyptian art, Dan masks, Art Deco, and Cubism. Here, a group of Black people, their hands shackled in chains, are marched in a line from a forest toward a slave ship visible on the horizon. In the middle of the canvas, the main character looks at a star—a symbol of hope and freedom and a reference to the North Star, which guided runaway slaves in the United States toward freedom in the North.

Multiple denominations are applied to the Americas from north to south— Latin and Anglo-Saxon, Catholic and Protestant. Given the strong African influences on the continent, we might likewise envision a Red Atlantic[4] and an Afro-America or a Yoruba America, a Bakongo America, a Makua America, a Hausa America. African American artist Hank Willis Thomas does just that by illustrating a fictional map of an Afro-American continent in *A Place to Call Home (Africa-America)* (2009; fig. 11). In this imaginary map of the Americas, the African continent replaces South America. Their similar shapes create a compelling visual deception; they are melded both formally and culturally.

Another map, titled *United States of Attica* (1971–72; fig. 15), by African American artist Faith Ringgold, alludes to one of the most violent prison rebellions in the United States, which took place in Attica prison in the state of New York. In 1971, at the height of the Vietnam War and countercultural movements, inmates, most of whom were Black, accused the white prison guards of brutal racism and demanded

better treatment. Ringgold's poster, one of her best-known works, maps the locations of racially charged rebellions, murders, and conflicts across the country, replacing the traditional red, white, and blue of the U.S. flag with green and red: colors linked to Pan-Africanism.

Finally, two large-scale textiles are juxtaposed—one made in the 18th century, the other contemporary, both showing distinct modes of African representation and global displacement. *The Two Bulls* (1723–30; fig. 9) is part of the series *Small Indies* produced at the Gobelins textile manufactory in Paris, based on paintings by Albert Eckhout and Frans Post, who lived in Pernambuco in the 16th and 17th centuries. The tapestry is a fanciful representation of the culture and nature of the Brazilian northeast, showing an oxcart and two Black men carrying a litter with a hammock over their shoulder. A cruel means of transport, litters confirmed the hierarchy imposed by slavery. In colonial images, Black men are always well outlined, their upper bodies often naked, while white men's bodies remain hidden under clothing, protected from our gaze. The tapestry, with abundant baskets of fruits and flowers, suggests a voyage through an exotic landscape:

a product of European imagination.

The appropriation of Post and Eckhout's pictures of Dutch Brazil, translated and processed by a French factory, also attests to the comings, goings, displacements, reinventions, and fabrications of visual representations. The reference to the "Indies'" in the series title highlights a geographical misconception foundational to the era of transatlantic exploration: the conflation of Southeast Asia and the Americas. The rich and elaborate tapestry, full of fine and violent marks of colonialism and slavery, contrasts with the rough-textured, dark *Hamida* (2017; fig. 10) by Ghanaian artist Ibrahim Mahama. The work is composed of pieces of burlap, used in bags made in Southeast Asia to transport Ghana's cocoa beans, then cast off and reutilized in everyday local contexts by ordinary Ghanaians. In this sense, the displacement of the material reflects the harshness of the trip, revealing a sort of patina: a refuge against the intense global transactions that cross north and south, east and west, and that pass through Ghana, from where—within the context of our Afro-Atlantic histories—a significant number of enslaved Africans in Brazil came.

1. Pierre Verger, *Flux et reflux de la traite des nègres entre le Golfe de Bénin de Todos os Santos, du XVIIe au XIXe siècle* (Paris: Mouton, 1968).

2. Paul Gilroy, *The Black Atlantic: Modernity and Double Consciousness* (Cambridge, Mass.: Harvard University Press, 1993), p. 38.

3. Caetano Veloso, *Verdade tropical* (São Paulo: Companhia das Letras, 1997), p. 105.

4. On the topic of the Red Atlantic, see Ella Shohat and Robert Stam, *Race in Translation: Culture Wars around the Postcolonial Atlantic* (New York: New York University Press, 2012), pp. 175–208.

Adriano Pedrosa, Lilia Moritz Schwarcz, and Tomás Toledo

3

4

5

**Jaime
Lauriano**

b. São Paulo, 1985;
lives in São Paulo

3–5. *Portuguese
Stones #1, #2, #3*,
2017
Portuguese stones,
iron box, and cement
100 x 150 x 10 cm
Museu de Arte de
São Paulo Assis
Chateaubriand – MASP
Gift of the artist in the
context of the *Afro-
Atlantic Histories*
exhibition, 2018
MASP.10801

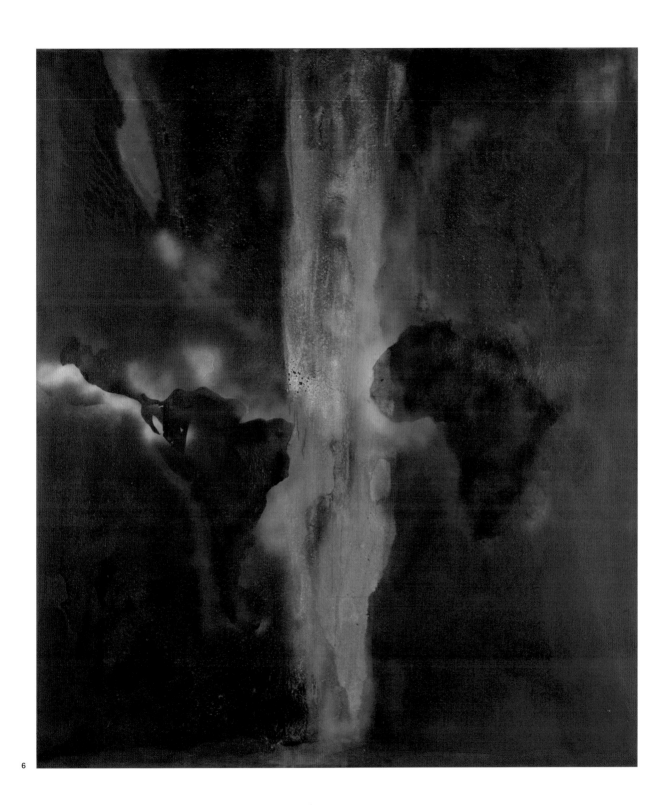

6

Frank
Bowling

b. Bartica, Guyana,
1936; lives in London

6. *Night Journey*,
1969–70
Acrylic on canvas,

212.7 x 183.2 cm
The Metropolitan
Museum of Art, New
York, Gift of Maddy
and Larry Mohr,
2011, 2011.590.2

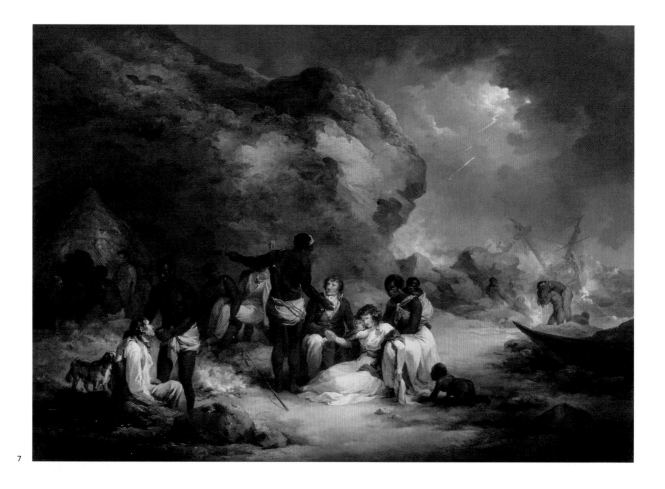

7

George
Morland

London 1763–1804
Brighton

7. *European Ship
Wrecked on the Coast
of Africa, known as
African Hospitality*,
1788–90
Oil on canvas,
87 x 122.2 cm
The Menil Collection,
Houston

Aaron
Douglas

Topeka 1899–1979
Nashville

8. *Into Bondage*, 1936
Oil on canvas,
153.5 x 154 cm
National Gallery of
Art, Washington, D.C.,
Corcoran Collection
(Museum Purchase
and Partial Gift from
Thurlow Evans Tibbs,
Jr., The Evans-Tibbs
Collection), 2014.79.17

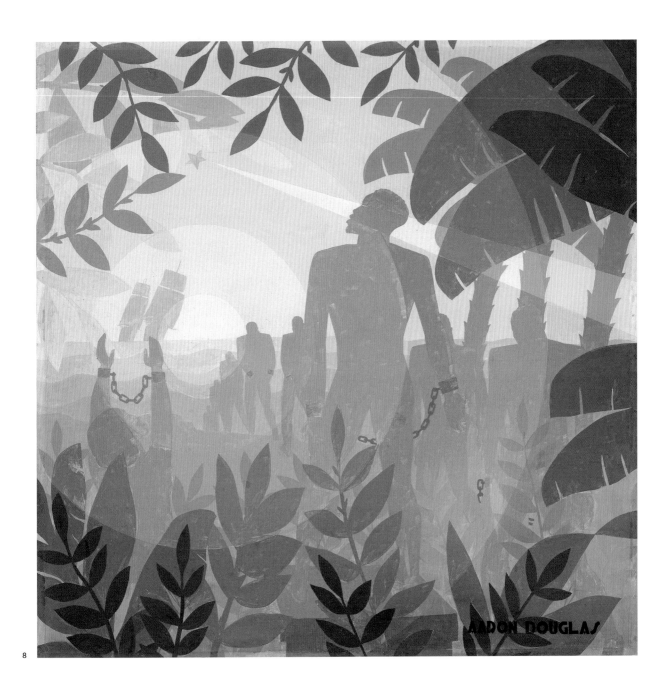

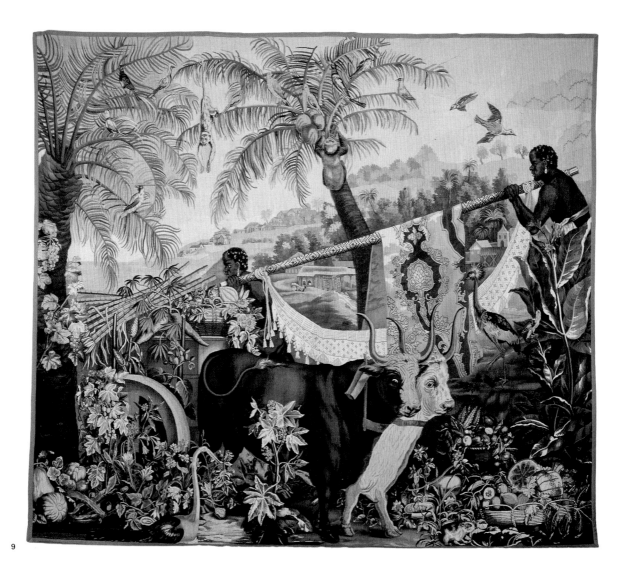

9

Gobelins Manufactory

Paris, 18th century

9. *The Two Bulls*, from the series *Small Indies*, 1723–30
Tapestry, 326 x 356 cm
Museu de Arte de São Paulo Assis Chateaubriand–MASP, Gift of Samuel Ribeiro, Silvio Álvares Penteado, Antonio Sanches de Larragoiti Junior, Rosalina Coelho

Lisboa de Larragoiti, Gladston Jafet, Ernesto Walter, Omar Radler de Aquino, Guilherme Guinle, Henry Borden, Major Kenneth McCrimmon, Louis La Saigne, Anonymous, Moinho Santista S.A., and Indústrias Químicas e Farmacêuticas Schering S.A., 1949, MASP.00219

10

Ibrahim
Mahama

b. Tamale, Ghana,
1987; lives in Tamale

10. *Hamida*, 2017
Scrap metal tarpaulin
on charcoal jute
sacks, 270 x 300 cm
Collection of the artist
and White Cube,
London

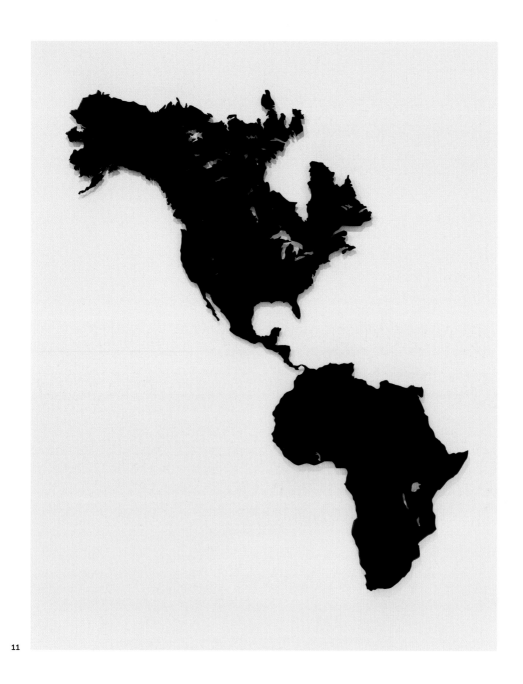

11

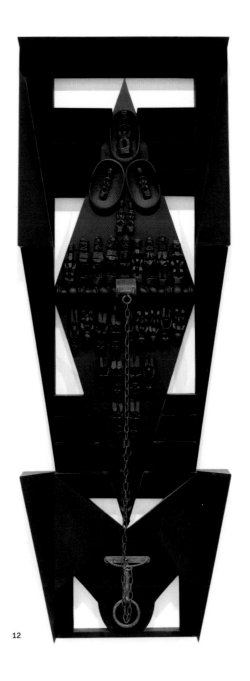

12

Hank Willis Thomas

b. Plainfield, New Jersey, 1976; lives in New York City

11. *A Place to Call Home (Africa-America)*, 2009
Polished aluminum, 203 x 167.5 cm
Collection of Paulo Vieira and José Luis Pereira, São Paulo

Emanoel Araujo

b. Santo Amaro, Bahia, 1940; lives in São Paulo

12. *The Ship*, 2007
Polychromed wood and carbon steel, 220 x 80 x 19 cm
Museu de Arte de São Paulo Assis Chateaubriand–MASP, Gift of the artist, 2018, MASP.10738

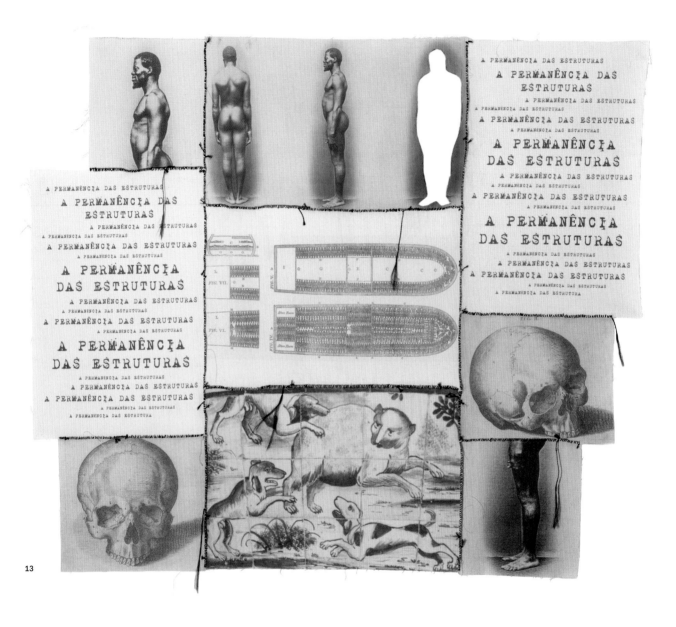

13

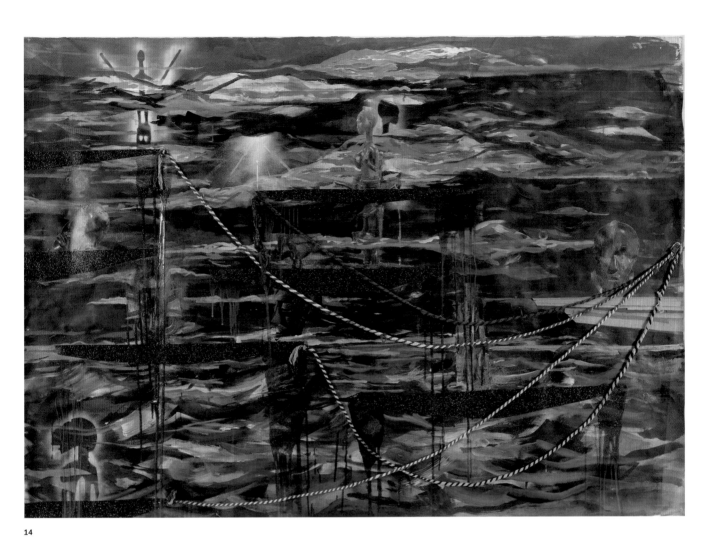

14

Rosana
Paulino

b. São Paulo, 1967;
lives in São Paulo

13. *The Permanence
of Structures*, 2017
Digital print on cut
and sewn fabric
96 x 110 cm
Museu de Arte de
São Paulo Assis
Chateaubriand – MASP
Gift of Fernando
Abdalla and Camila
Abdalla in the context
of the *Afro-Atlantic
Histories* exhibition,
2018
MASP.10810

Radcliffe
Bailey

b. Bridgeton, New
Jersey, 1968; lives in
Atlanta

14. *Western*, 2015
Mixed media on
paper, 132 x 191.5 cm
Courtesy of the artist
and Jack Shainman
Gallery, New York

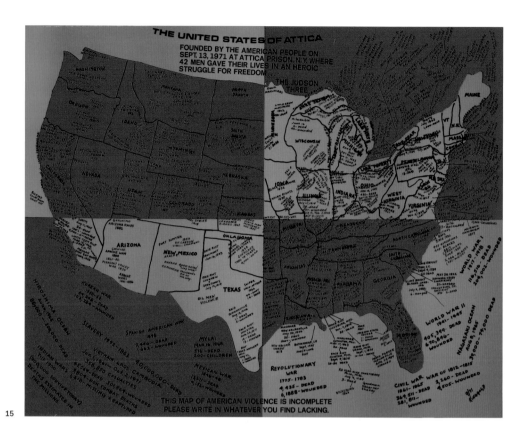

Faith
Ringgold

b. New York City,
1930; lives in
Englewood, New
Jersey

15. *United States of
Attica*, 1971–72
Offset poster,
57 x 70 cm
Collection of the
artist, courtesy of
ACA Galleries,
New York

15

Carlos
Moraes

b. Rio de Janeiro,
1960; lives in Rio de
Janeiro

16. *Helicopter Attack:
Reaction, Flight, and
Execution*, 2004
Photographic print,
50 x 70 cm
O Dia, Rio de Janeiro

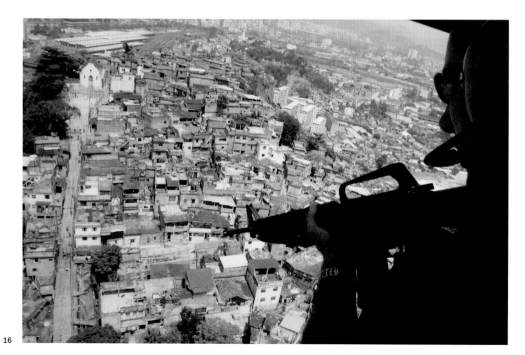

16

17

18

Glauber Rocha

Vitória da Conquista,
Bahia 1939–1981
Rio de Janeiro

17–19. Opening
frames of the film
Terra em transe
(***Entranced Earth***),
1967
Heirs of Glauber
Rocha © © Copyrights
Consultoria

19

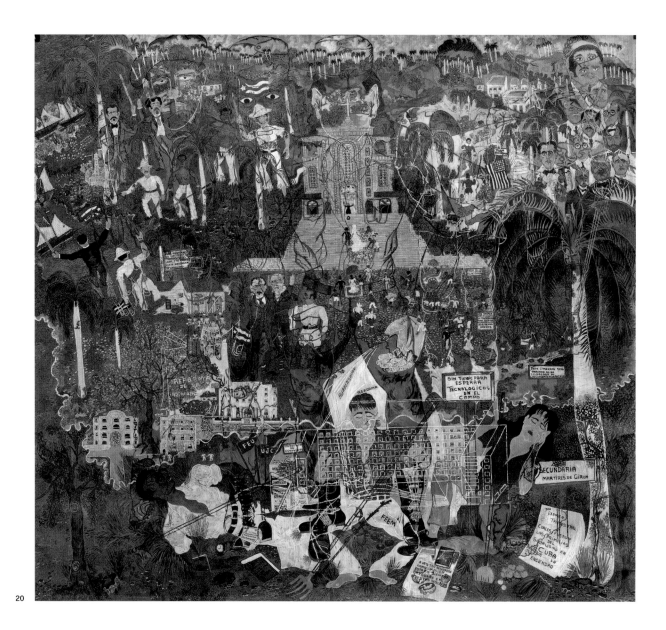

20

Gilberto de la Nuez

Havana 1913–1993
Havana

20. *First Fruits of Socialism in Cuba*, 1973
Tempera on cardboard, 92 x 103 cm
Museo Nacional de Bellas Artes, Havana

EMANCIPA-
TIONS

Emancipations

The violent everyday conditions of slavery cannot be fully grasped without taking into consideration the utopia of freedom: a permanent aspiration for the Africans who were forcibly taken to the Americas. Riots occurred during the long sea voyages, with captives rising up on board slave ships. This continued into the daily life of the slave quarters. From the 16th century onward, the Afro-Atlantic landscape witnessed uprisings, escapes, insurrections, the establishment of runaway communities, and the poisoning of plantation owners. Emancipations were not only a result of official acts and manumissions, but also gained through a long process of confrontation between slaves and masters.

With the abolition of slavery in the United States in 1863, Brazil and Cuba became the only countries in the Western world where commercial slavery remained legal. Pressure to end it came from many fronts, including newspapers, community leaders, liberal professionals, and foreign and local activists, but above all it was the enslaved Black populations who turned freedom into a reality. Abolition was not a charitable gesture. Cuba abolished the system in 1886, followed by Brazil in 1888. This would be the end of one story and the start of another, as Afro-descendant populations still fight for social inclusion today.

Interspersing works from Africa, Brazil, the Caribbean, the United States, and Europe, this section brings together images of slavery and the struggle for emancipation. Expressing the paternalism of the colonialist project, *The Secret of England's Greatness* (ca.

1863; fig. 76) by the English military painter Thomas Jones Barker depicts a fictional event in which an East African prince, probably Ali bin Nasr, the governor of Mombasa, kneels before Queen Victoria to receive a Bible. The title refers to a widely known anecdote of the time: when asked how England had acquired and maintained global power, Queen Victoria pointed to the Bible. Barker's painting celebrates not only the political domination of one continent over another, with the African subject genuflecting to the European, but also the source of the dominator's magic, Christianity.

From the 16th century onward, the colonial system was strengthened by an increase in slave traffic, and the slave ship became an icon of its power and violence. A well-known picture included in the book *Voyage pittoresque dans le Brésil* (1827–35; fig. 25) by the German traveler and artist Johann Moritz Rugendas shows slaves comfortably lodged in the hull of a ship, lounging on bunk beds and in hammocks, chatting, and napping. In contrast, the famous *Plan and Sections of a Slave Ship* (1789; fig. 22)—which, ironically, was used by both abolitionist campaigners and slave traders for widely divergent purposes—reveals the unsanitary and cramped conditions on board these vessels designed to transport large numbers of people as efficiently as possible.

Many artists have revisited the image of the slave ship, including Brazilians Candido Portinari (fig. 21) and Paulo Nazareth (fig. 23), and in the section Maps and Margins, Emanoel Araujo (fig. 12) and Rosana Paulino (fig. 13), as

well as the Cuban Gilberto de la Nuez (fig. 29). Édouard-Antoine Renard painted a slave rebellion on the open sea (1833; fig. 27), with a Black man wielding a wooden club ready to attack: on the floor we see broken shackles and the feet of a fallen white man. In this context, *Eshu's Barge* (fig. 24) by José Alves de Olinda suggests that slave ships brought not only enslaved persons to this side of the Atlantic, but also African culture, religion, and costume, represented here by Eshu, a messenger orisha who operates between spiritual and earthly realms.

Once docked, slaves were taken to markets and prepared for sale. Makeup was applied to hide marks left by the ordeal of the long journey. Two images by French traveling artist Jean-Baptiste Debret (figs. 31, 32) depict the squalid state of newcomers, the traffickers' arrogance, and the apparent ease with which masters and mistresses traded men and women in the port area of Rio de Janeiro at Valongo, the largest market and entry point for slaves in the Americas. In English painter Augustus Earle's *Gate and Slave Market in Pernambuco* (ca. 1821; fig. 28), whites subdue Black men in a cruel spectacle enacted in broad daylight. The scene suggests an open-air theater, where the street is the stage and the balconies are theater boxes. From a contemporary perspective, African American artist Nona Faustine creates portraits of herself in sites where slave markets operated. By exposing her own body, she recalls the cruelty of human trade (figs. 34, 35).

One of the most tyrannical symbols of slavery was the iron bit, a muzzle

affixed to the slave's mouth, preventing, among other things, the ingestion of soil, a practice known as *banzo* described as a symptom of "homesickness disease," but in fact a slow and painful form of escape from captivity via suicide. The mask's use in Brazil is illustrated by the Frenchmen Jacques Arago (fig. 39) and Debret (fig. 37), and in the Caribbean by Richard Bridgens (fig. 40). The subject has also been taken up by contemporary artists such as Rosana Paulino (fig. 38) and Paulo Nazareth (fig. 36).

Other instruments of punishment, like metal braces and straps, became icons of slavery's brutality as well. The "RUNAWAY BLAKC [*sic*]" in a print by Brazilian artist Frederico Guilherme Briggs is encumbered with an iron neck ring and protruding spike (1832–36; fig. 42). Another common form of discipline involved immobilization in a stock, in which a wood board with holes was clamped around a runaway's head or feet, as shown in a lithograph by Debret (1834–39; fig. 43). Contemporary artists such as Brazilians Jaime Lauriano (fig. 49) and Sidney Amaral (fig. 48), and Kara Walker (figs. 47) and Hank Willis Thomas (fig. 46) in the U.S., have elaborated the implications of such sadistic contraptions. Appropriating and updating the neck leash and stock, Amaral and Thomas instantiate the present-day regime of violence abetted by Black people's lack of voice. "Who shall speak on our behalf?" Amaral asks.

The whip was a powerful tool in the slave master's arsenal, and whippings, a model punishment for public occasions, were carried out in town squares with victims tied to a pillory adorned with the emblems of royalty or local rulers. Rugendas (fig. 44) and Debret (fig. 45) recorded this practice in Brazil. In Debret's print, a foreman whips a bound slave in front of the master's house, and another slave is lashed to a tree in the background. The Brazilian Historical and Geographic Institute censored the print because it contradicted the image of harmonious plantation life propagated by elites. A watercolor made in Brazil by Danish traveling painter and abolitionist campaigner Paul Harro-Harring (fig. 41), who visited Brazil in 1840, shows a priest blandly observing the punishment of a Black woman. Serving as evidence of the Church's collusion with the system, the image of the pillory before a mountain range also implicates both Brazilian architecture and landscape. *Scipio* (1866–68; fig. 00), a painting by Frenchman Paul Cézanne, may have been inspired by the shocking photograph *Scourged Back* (fig. 53), which circulated in *Harper's Weekly* in 1863. The subject, an ex-slave called Gordon, reveals the maze of scars left by repeated whippings. Brazilian artist Eustáquio Neves transformed the scarred back into a symbol of pride and resistance by writing the name "Zumbi" on the skin of a Black man (1995; fig. 52). Zumbi was the leader of a large runaway slave community known as Quilombo dos Palmares.

Hanging, depicted in a print by François Froger (fig. 51), was another form of punishment—and revenge. Slave masters learned various techniques through illustrated manuals,

among other means. The tables were turned during the Haitian Revolution, which shook the Afro-Atlantic world from 1791 to 1804. In a print by Marcus Rainsford (1805; fig. 50), Black revolutionaries exact revenge on white colonizers by stringing them up on gallows.

Short of outright rebellion, slaves frequently escaped, and slave owners published advertisements in newspapers in an effort to track down runaways. These ads often included the figure of a Black man carrying a bundle over his shoulders, a visual shorthand that circulated across the Afro-Americas (fig. 66). African American conceptual artist Glenn Ligon based his series *Runaways* (1993; figs. 61-64) on such ads. Inviting friends to write about him as if they were reporting a missing person to the police, he combined the 19th-century illustrations with the new descriptions in place of the original texts. Two nearly identical paintings by different artists—Theodor Kaufmann (1867; fig. 59) and François-Auguste Biard (1859; fig. 58)—depict runaways on the road to freedom. In both, we see a family of slaves made up of children and teenagers and headed by women. Kaufmann's group flees to the northern United States, Biard's into the Brazilian jungle, where one might remain hidden or even join a community of *quilombos* (escaped slaves).

During slavery and even after abolition, Black people never stopped rebelling and fighting for their rights. But even as freed men and women, they continued to make up the vast majority of the incarcerated, whether in prisons or mental asylums, as can

be seen in the 19th-century album *Gallery of the Condemned* (fig. 65). This situation, addressed in Rafael RG's work *Dark Saying* (2014; figs. 67, 68), has persisted into the 21st century.

Nineteenth-century paintings commemorating emancipation—such as those by Pedro Américo (fig. 80), Samuel Raven (fig. 82), Agostinho Batista de Freitas (fig. 84), and Alphonse Garreau (fig. 83)—disseminated across the continent an image of subservience, with freed men and women kneeling, breaking chains, and gazing at the sky in gratitude for the "gift" bestowed upon them. Sidney Amaral, on the other hand, places Black people at the center of the abolitionist narrative in *Disturbance* (2014; fig. 81), supplanting the lie of servility with images of Afro-descendant men and women as agents of their own liberation. Its contemporary and historical references include photographs by Christiano Junior and portraits of ordinary Black people in charge of their own representation produced in a formal studio setting by Militão Augusto de Azevedo (figs. 92-95). Myriad works attest to the importance of Black leaders such as Samory (Pierre Castagnez; fig. 70), Zumbi (Antônio Parreiras; fig. 77), Prince Obá (Belmiro de Almeida; fig. 78), Harriet Tubman (Ernest Crichlow; fig. 69), Lima Barreto (Dalton Paula; fig. 71), Luiz Gama (fig. 73), and José do Patrocínio (fig. 72). A multitude of photographs portray the freed population in a dignified manner: in front of their houses, in photography studios, reading and studying, sitting in fields. Over the course of their long lives, they created new types of citizenry (figs. 90, 91).

Adriano Pedrosa, Hélio Menezes, Lilia Moritz Schwarcz, and Tomás Toledo

21

Candido Portinari

Brodowski, São Paulo
1903–1962 Rio de
Janeiro

21. *Slave Ship*, 1950
Sanguine, colored
crayon, and graphite
on paper,
30.5 x 23.5 cm
Private collection,
São Paulo
Reproduction rights
kindly granted
by João Candido
Portinari

Paulo Nazareth

b. Governador
Valadares, Minas
Gerais, Brazil, 1977;
lives in Santa Luzia,
Minas Gerais

23. *Slave Ship for
Sale*, 2014
Lithograph on paper,
30 x 24 cm
Galeria Mendes Wood
DM, São Paulo

James Phillips

Cornwall, United
Kingdom 1745–1799
London

22. *Plan and Sections
of a Slave Ship*, 1789
Etching, 48 x 43 cm
Collection of Bia
and Pedro Corrêa do
Lago, Rio de Janeiro

José Alves de Olinda

b. Recife,
Pernambuco, Brazil,
1953; lives in Olinda,
Pernambuco

24. *Slave Ship*, 2014
Polychromed wood,
vegetal fiber, and
metal
70 x 101 x 20 cm
Museu de Arte de
São Paulo Assis
Chateaubriand – MASP

Gift of Adriano
Pedrosa, Amanda
Carneiro, André
Mesquita, Horrana
de Kássia Santoz,
Fernando Oliva,
Isabella Rjeille and
Tomás Toledo in the
context of the *Afro-
Atlantic Histories*
exhibition, 2018
MASP.10982

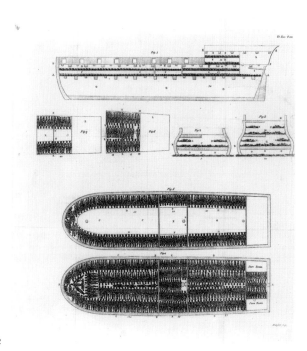

22

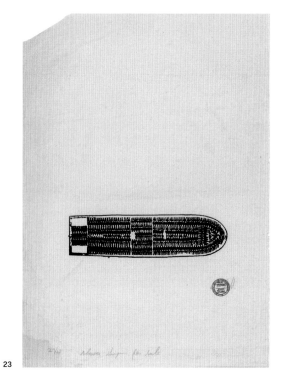

23

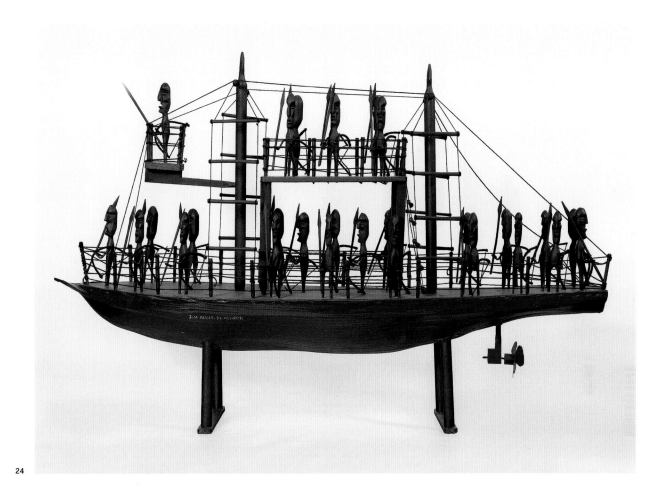

24

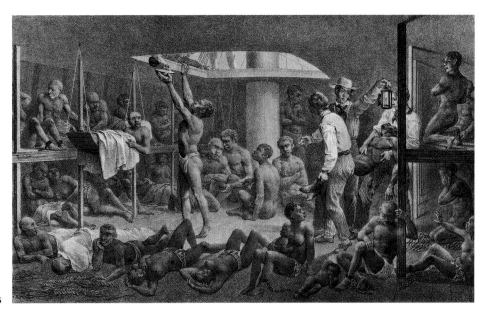

Johann
Moritz
Rugendas

Augsburg, Germany
1802–1858 Weilheim,
Germany

25. *Slaves in the
Cargo Hold of a Slave
Ship*, ca. 1835
Lithograph with
watercolor on paper,
22 x 28.5 cm
Instituto Ricardo
Brennand, Recife,
Pernambuco, Brazil

25

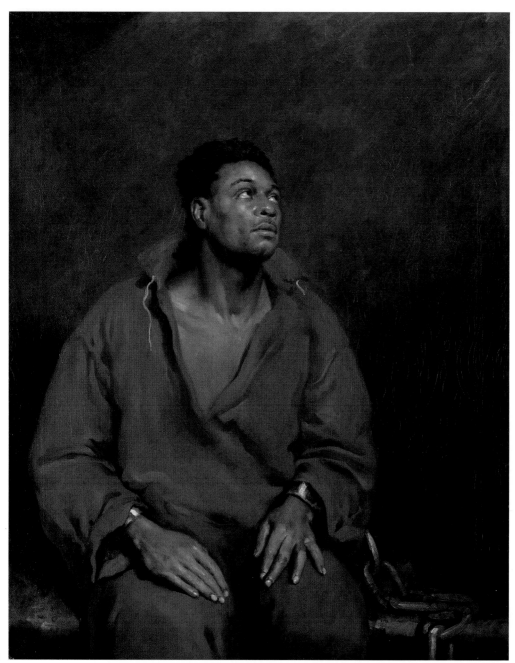

26

John Philip Simpson

London 1782–1847
London

26. *The Captive Slave*, 1827
Oil on canvas,
127 x 101.5 cm
Art Institute of
Chicago, Purchased
with funds provided
by Mary Winton
Green, Dan and Sara
Green Cohan, Howard
and Lisa Green and
Jonathan and Brenda
Green, in memory
of David Green,
2008.188

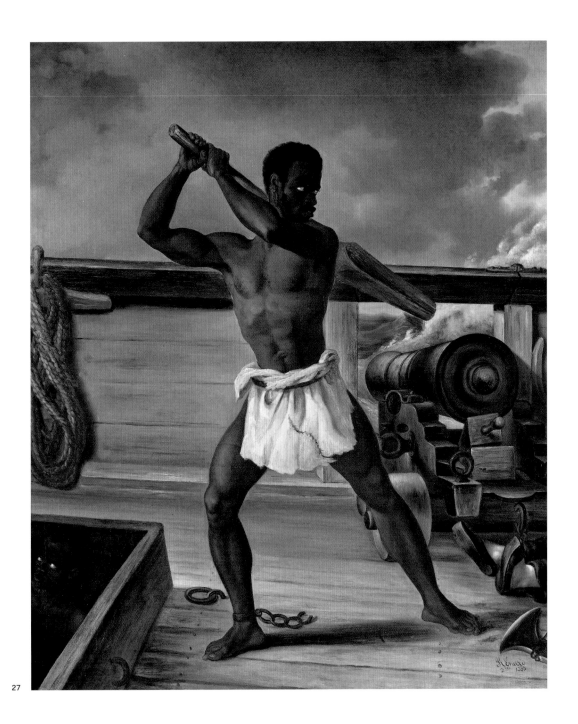

27

Édouard-Antoine Renard

France 1802–1857

27. *A Slave Rebellion on a Slave Ship*, 1833
Oil on canvas,
99 x 83 cm

Musée du Nouveau-Monde, Collections d'Art et d'Histoire, La Rochelle, France, MNM.1987.1.9

Augustus Earle

London 1793–1838
London

28. *Gate and Slave Market in Pernambuco*, ca. 1821
Oil on canvas,
47 x 70 cm
Museu Imperial de Petrópolis/Casa Geyer, Rio de Janeiro

Gilberto de la Nuez

Havana 1913–1993
Havana

29. *The Slave Traffickers*, 1977
Tempera on canvas,
75 x 100 cm
Museo Nacional de Bellas Artes, Havana

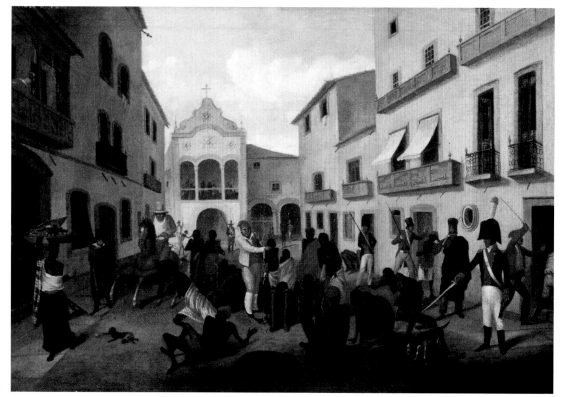

28

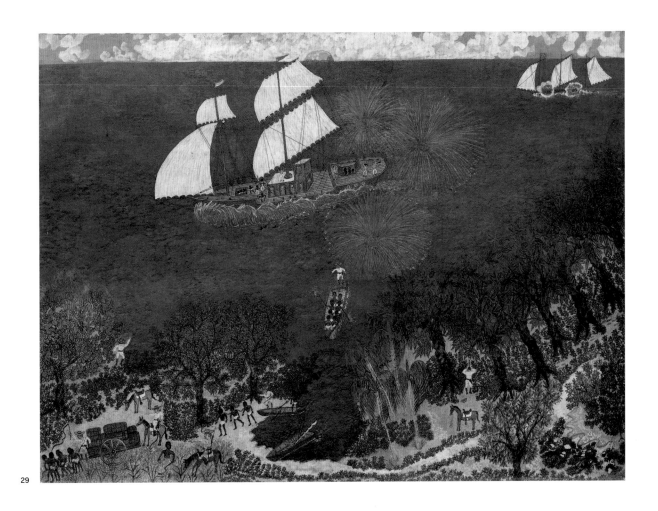

29

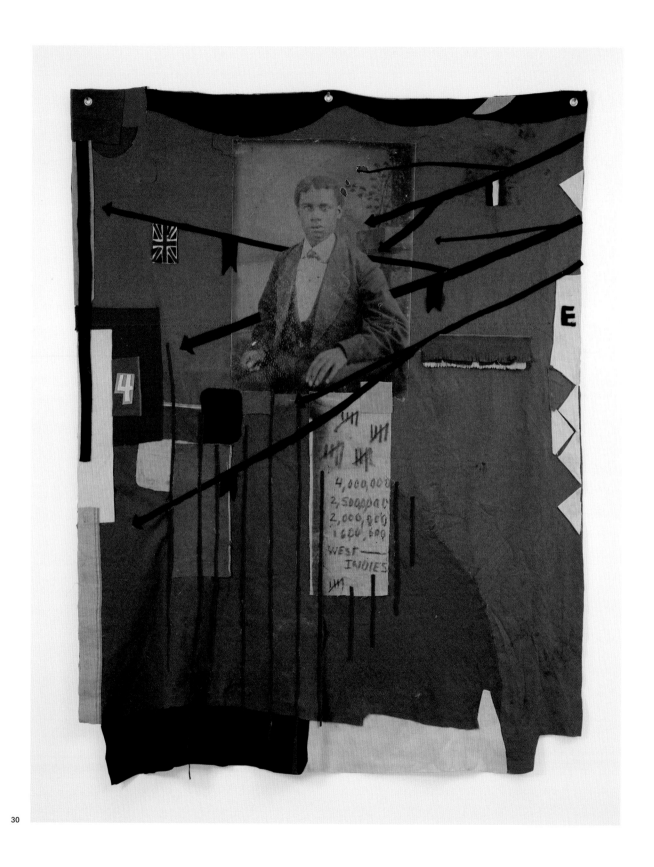

30

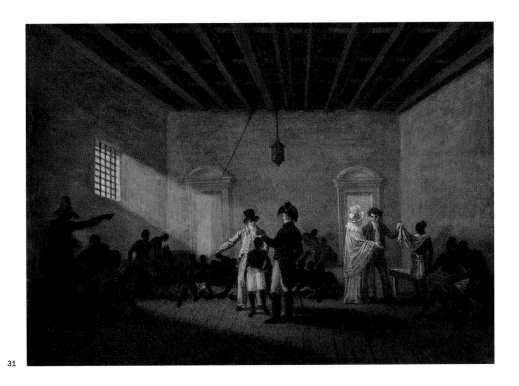

31

Jean-
Baptiste
Debret

Paris 1768–1848
Paris

31. *Valongo Slave
Market*, undated
Oil on canvas,
32.5 x 43.5 cm
Instituto Ricardo
Brennand, Recife,
Pernambuco, Brazil

32. *Market in
Valongo Street, Rio
de Janeiro*, 1835
Lithography on paper,
17.5 x 26 cm
Museus Castro
Maya–IBRAM/MinC,
Rio de Janeiro

Radcliffe
Bailey

b. Bridgeton, New
Jersey, 1968; lives
in Atlanta

30. *Untitled*, 2009
Blanket and mixed
media, 203 x 176.5 cm
Courtesy of the artist
and Jack Shainman
Gallery, New York

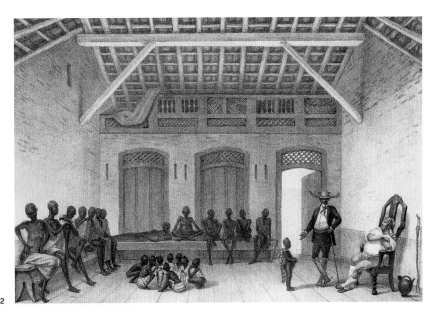

32

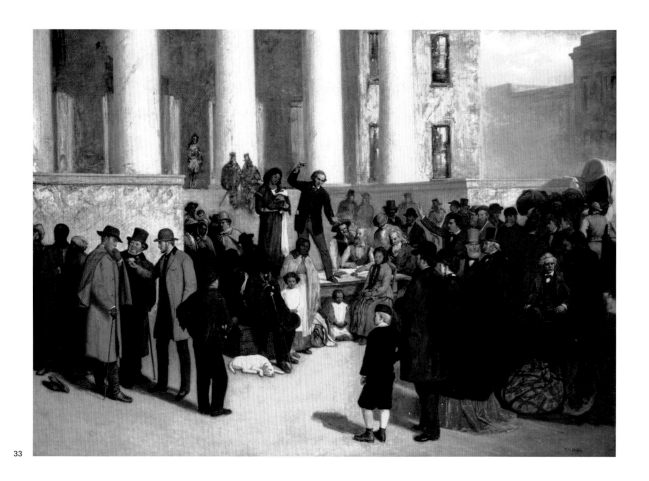

33

Thomas Satterwhite Noble

Lexington, Kentucky
1835–1907 New York City

33. *The Last Sale of Slaves in St. Louis*,
later rendition of *The American Slave Mart*
(1865), ca. 1870
Oil on canvas
Missouri Historical Society

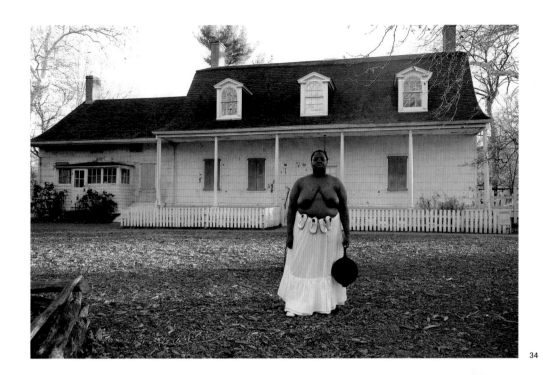

34

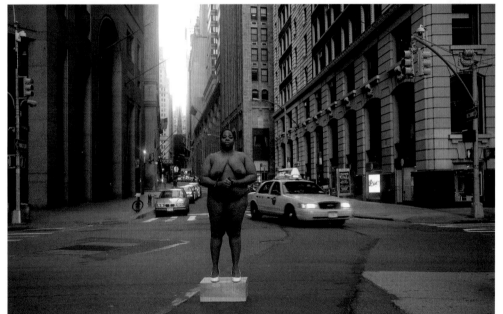

35

Nona Faustine

b. Brooklyn, 1977;
lives in Brooklyn

34. *Isabelle*, from the
series *White Shoes*,
2016
Photographic print,
68 x 101.5 cm
Collection of the
artist, Brooklyn

35. *From Her
Body Sprang Their
Greatest Wealth*,
from the series *White
Shoes*, 2013
Photographic print,
68 x 101.5 cm
Collection of the
artist, Brooklyn

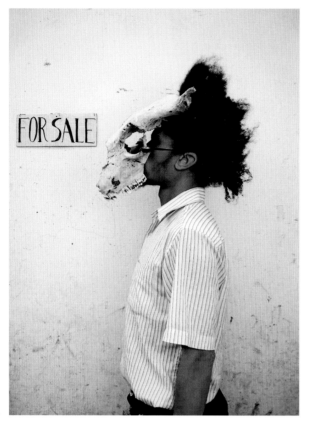

36

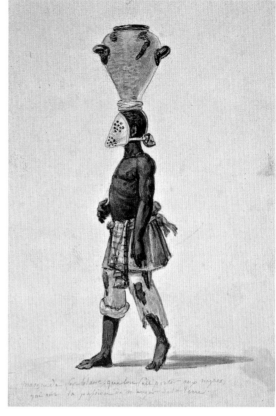

37

Paulo Nazareth

b. Governador
Valadares, Minas
Gerais, Brazil, 1977;
lives in Santa Luzia,
Minas Gerais

36. *Untitled*, from the
series *For Sale*, 2011
Photo print on cotton
paper, 93 x 70 cm
Galeria Mendes Wood
DM, São Paulo

Jean-Baptiste Debret

Paris 1768–1848
Paris

37. *Mask Used on the
Negros That Have
the Habit of Eating
Dirt*, ca. 1820–30
Watercolor,
18.5 x 12.5 cm
Museus Castro
Maya–IBRAM/MinC,
Rio de Janeiro

Rosana Paulino

b. São Paulo, 1967;
lives in São Paulo

38. *Untitled*, from the
series *Embroidery
Hoop*, 1997
Xerography and
thread on textile
mounted on
embroidery hoop,
Diam. 32 cm
Collection of
Fernando and Camila
Abdalla, São Paulo

Jacques Arago

Estagel, France
1790–1854 Rio de
Janeiro

39. *Slave Punishment*,
from *Souvenirs d'un
aveugle, voyage autor
du monde/ par M. J.
Arago ouvrage enrichi
de soixante dessins et
de notes scientifiques*,
Paris, 1839, vol. 1,
1839, pp. 120–21
Fundação Biblioteca
Nacional, Rio
de Janeiro

Richard Bridgens

United Kingdom
1785–1846 Port of
Spain, Trinidad

40. *Negro Heads,
with Punishments
for Intoxication and
Dirt-eating*, from
*West India Scenery:
With Illustrations of
Negro Character, the
Process of Making
Sugar, etc. from
Sketches Taken during
a Voyage to, and
Residence of Seven
Years in, the Island
of Trinidad*, London,
1836, pl. 20
Yale Center for British
Art, New Haven

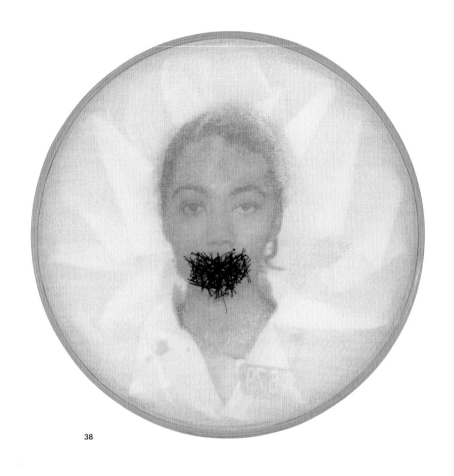

38

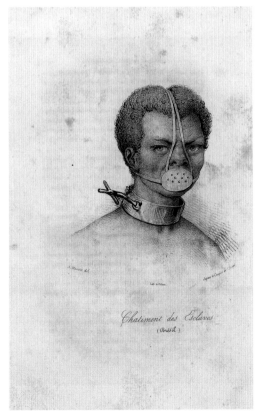

39

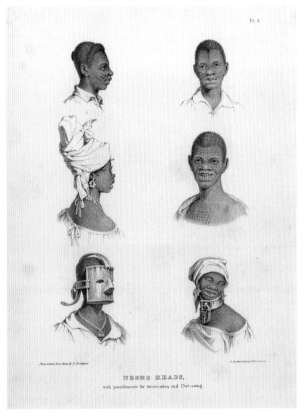

40

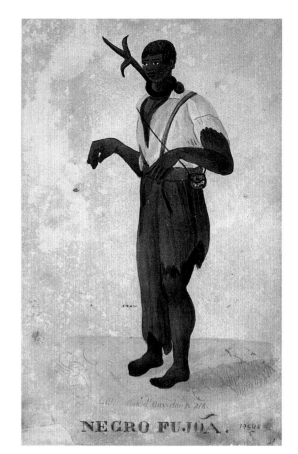

42

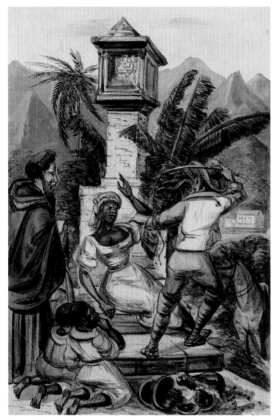

41

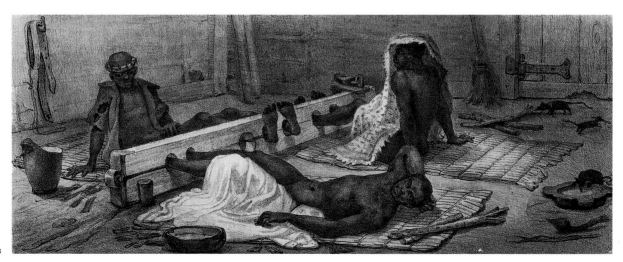

43

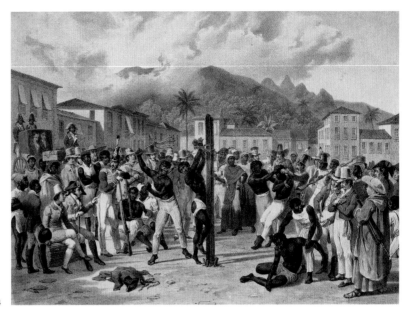

44

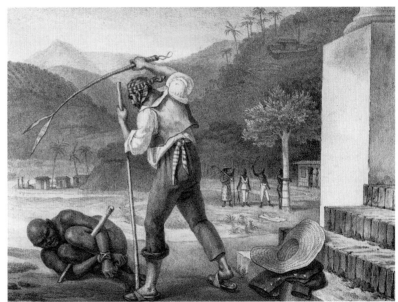

45

Paul Harro-Harring	Frederico Guilherme Briggs	Jean-Baptiste Debret	Johann Moritz Rugendas	Jean-Baptiste Debret
Wobbenbüll, Germany 1798–1870 London	Rio de Janeiro 1813–1870 Rio de Janeiro	Paris 1768–1848 Paris	Augsburg, Germany 1802–1858 Weilheim, Germany	Paris 1768–1848 Paris
41. *Slave Receiving Punishment*, ca. 1840 Watercolor and gouache on paper Instituto Moreira Salles, Rio de Janeiro, Collection Paul Harro-Harring	42. *Runaway Negro*, 1832–36 21.5 x 13.5 cm Fundação Biblioteca Nacional, Rio de Janeiro	43. *Blacks in the Stock*, 1834–39 Hand-colored lithograph, 32 x 40 cm Museus Castro Maya–IBRAM/MinC, Rio de Janeiro	44. *Public Penalty*, 1835 Lithography, 22.5 x 31 cm Museus Castro Maya–IBRAM/MinC, Rio de Janeiro	45. *Foremen Punishing Slaves*, 1835 Color lithography, 47 x 37.5 cm Museus Castro Maya–IBRAM/MinC, Rio de Janeiro

Hank Willis Thomas

b. Plainfield, New
Jersey, 1976; lives in
New York City

46. *What Goes
without Saying*, 2012
Wood pillory and
microphone,
162.5 x 167.5 x 91.5 cm
Courtesy of the artist
and Jack Shainman
Gallery, New York

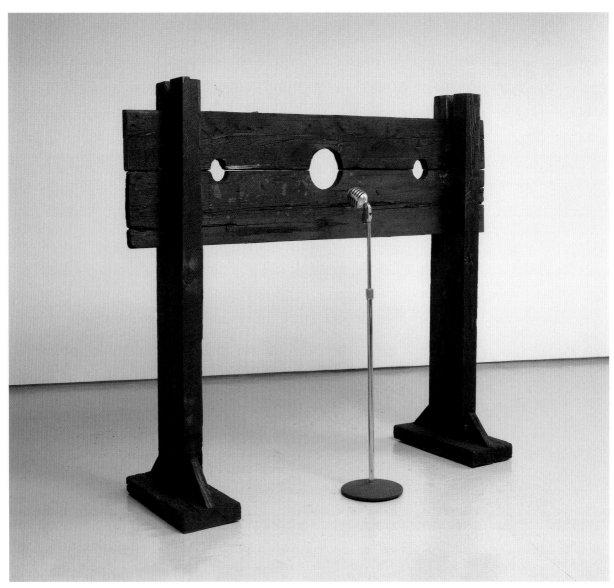

46

47

Kara Walker

b. Stockton,
California, 1969; lives
in New York City

47. *Restraint*, 2009
Etching with aquatint,
76 x 58.5 cm
Courtesy of Sikkema
Jenkins & Co.,
New York

Sidney Amaral

São Paulo 1973–2017
São Paulo

48. *Neck Leash—
Who Shall Speak on
Our Behalf?*, 2014
Watercolor and pencil
on paper, 55 x 75 cm
Private collection,
São Paulo

48

LIBERDADE! LIBERDADE!
ABRE AS ASAS SOBRE NÓS,
DAS LUTAS NA TEMPESTADE
DÁ QUE OUÇAMOS TUA VOZ

NÓS NEM CREMOS QUE ESCRAVOS OUTRORA
TENHA HAVIDO EM TÃO NOBRE PAÍS...
HOJE O RUBRO LAMPEJO DA AURORA
ACHA IRMÃOS, NÃO TIRANOS HOSTIS.

49

Jaime
Lauriano

b. São Paulo, 1985;
lives in São Paulo

49. *Freedom!
Freedom!*, 2018
Silkscreen, laser
engraving, and
pyrography on marine
plywood,
80 x 60 x 1.5 cm
Galeria Leme,
São Paulo

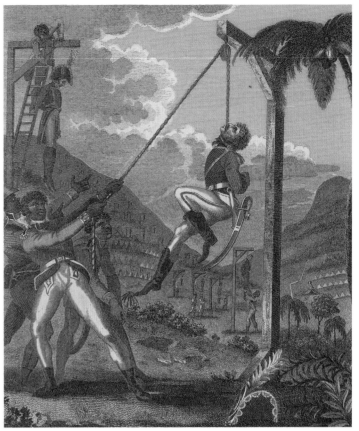

50

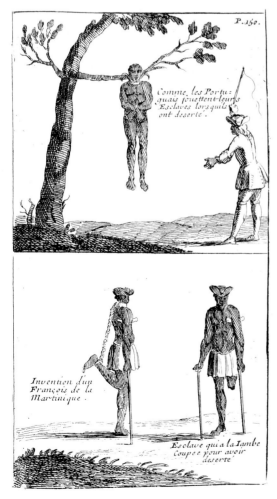

51

Marcus
Rainsford

Kildare, Ireland ca.
1758–1817 London

50. *Revenge Taken
by the Black Army
for the Cruelties
Practised on Them
by the French*, from
*An Historical Account
of the Black Empire of
Hayti*, London, 1805,
opp. p. 337
John Carter Brown
Library, Providence,
Rhode Island

François
Froger

Laval, France
1676 –1715

51. *How [the]
Portuguese Whip
their Slaves When
They Run Away*, from
*A Relation of a Voyage
Made in the Years
1695, 1696, 1697, on
the Coasts of Africa,
Streights of Magellan,
Brasil, Cayenna,
and the Antilles, by a
Squadron of French
Men of War, under the
Command of M. de
Gennes*, London, 1698
Instituto Hercule
Florance, São Paulo

Eustáquio Neves

b. Juatuba, Minas Gerais, Brazil, 1955; lives in Diamantina, Minas Gerais

52. *Untitled*, from the series *Memory Black Maria*, 1995
Gelatin silver print, 31 x 23 cm
Museu de Arte de São Paulo Assis Chateaubriand–MASP, Gift of Pirelli, 1996, MASP.01976

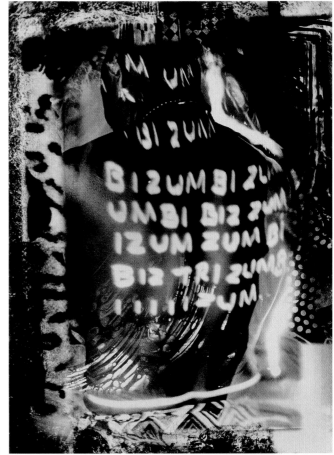

52

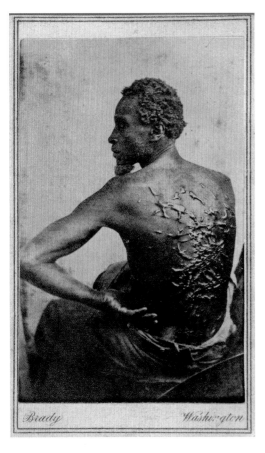

53

McPherson & Oliver

Boston 1833–1867
New Orleans

53. *Scourged Back*, 1863
Photographic print, 10 x 6 cm
International Center of Photography, New York, Collection Daniel Cowin, Purchase, ICP Acquisitions Committee, 2003

Paul Cézanne

Aix-en-Provence, France 1839–1906
Aix-en-Provence

54. *Scipio*, 1866–68
Oil on canvas
107 x 86 cm
Museu de Arte de São Paulo Assis Chateaubriand – MASP
Gift Henryk Spitzman Jordan, Drault Ernanny de Mello e Silva, Pedro Luiz Correia e Castro and Rui de Almeida, 1950
MASP.00085

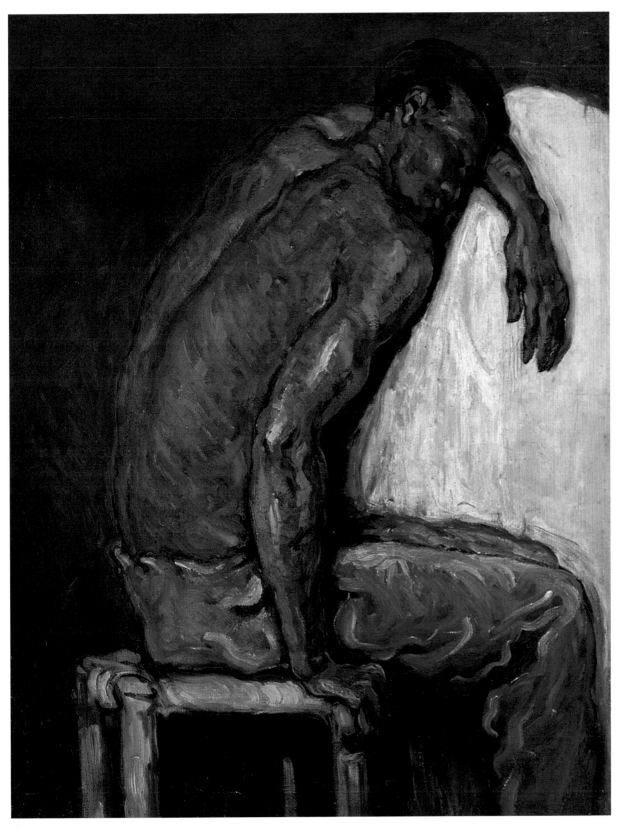

54

Joaquim Lopes de Barros

Rio de Janeiro 1816–
1863 Rio de Janeiro

55. *Costumes brasileiros*, no. 27, *Preto de lixo* [*Brazilian Customs*, no. 27, *Black Trashman*], 1840
22.5 x 18.5 cm
Casa Geyer,
Museu Imperial de Petrópolis, IBRAM/
MinC, Rio de Janeiro

Antônio Obá

b. Ceilândia, Distrito Federal, Brazil, 1983; lives in Taguatinga, Distrito Federal

56. *Tigress Figure*, 2018
Oil on cotton canvas, 40 x 54 cm
Galeria Mendes Wood DM, São Paulo

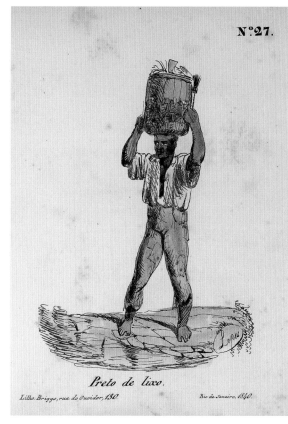

55

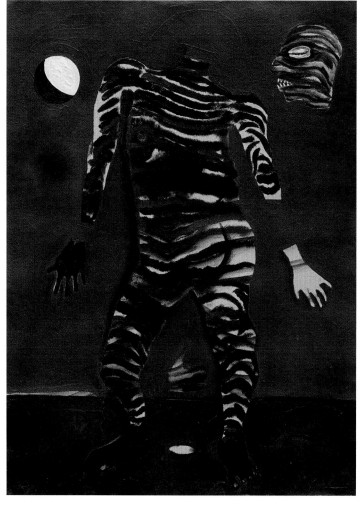

56

Sidney Amaral

São Paulo 1973–2017
São Paulo

57. *The History of Sanitation in Brazil* (*The King's Throne*) (*study*), 2014
Watercolor and pencil on paper, 38 x 28 cm
Banco Itaú, São Paulo

106

58

59

60

François-Auguste Biard

Lyon 1799–1882
Fontainebleau

58. *Slave Escape*,
1859
Oil on wood,
33 x 52 cm
Collection of Hecilda
and Sérgio Fadel,
Rio de Janeiro

Theodor Kaufmann

Uelzen, Germany
1814–1896 New York
City

59. *On to Liberty*,
1867
Oil on canvas,
91.5 x 142 cm
The Metropolitan
Museum of Art,
New York, Gift of
Erving and Joyce
Wolf, in memory of
Diane R. Wolf, 1982,
1982.443.3

John Adam Houston

North Wales 1812–
1884 London

60. *The Fugitive
Slave*, 1853
Oil on canvas,
84.1 x 152.4 cm
The Johnston
Collection,
Spartanburg

R AN AWAY, Glenn. He is black. He has very short hair and eye glasses. He has quite light skin tone (faded bronze). Not tall. No noticeable accent. Wearing a plum-colored shirt, long-sleeved, and shorts. Very casual and stylish in appearance. He is wearing a bead bracelet (stones – a mixture of black-and-white). He has big hands and fingers. When he walks his feet cross each other a little bit. When he talks, he usually has a big smile towards you, yet he faces you from a slightly different angle. He looks at you from the corner of his eyes. His voice is very calm.

12/45

61

Ran away, Glenn Ligon. He's a shortish broad-shouldered black man, pretty dark-skinned, with glasses. Kind of stocky, tends to look down and turn in when he walks. Real short hair, almost none. Clothes non-descript, something button-down and plaid, maybe, and shorts and sandals. Wide lower face and narrow upper face. Nice teeth.

12/45

62

Ran away, Glenn, a black man – early 30's, very short cropped hair, small oval wire-rimmed glasses. Wearing large black linen shirt with white buttons, dark navy shorts, black socks and shoes. Black-and-white bead bracelet and silver watch on left wrist. No other jewelry. He has a sweet voice, is quiet. Appears somewhat timid.

12/45

63

R AN AWAY, Glenn. Medium height, 5'8", male. Closely-cut hair, almost shaved. Mild looking, with oval shaped, black-rimmed glasses that are somewhat conservative. Thinly-striped black-and-white short-sleeved T-shirt, blue jeans. Silver watch and African-looking bracelet on arm. His face is somewhat wider on bottom near the jaw. Full-lipped. He's black. Very warm and sincere, mild-mannered and laughs often.

12/45

64

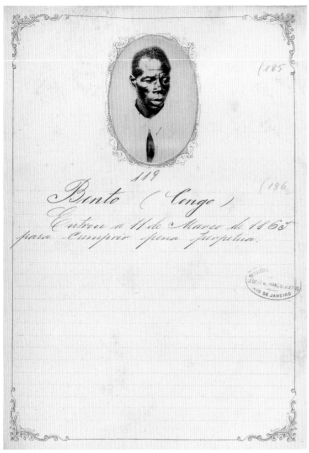

65

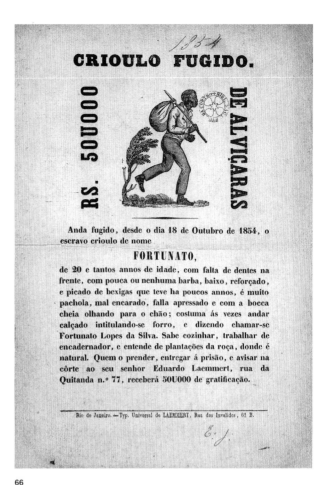

66

Glenn
Ligon

b. New York City,
1960; lives in New
York City

61-64. *Runaways*,
1993
Four of a set of 10
lithographs, each
40.5 x 30.5 cm
Private collection
Courtesy of the
artist and Luhring
Augustine, New York,
Regen Projects, Los
Angeles, and Thomas
Dane Gallery, London

65. Page from the
album *Gallery of the
Condemned*, ca. 1872
27 x 19 cm
Fundação Biblioteca
Nacional, Rio
de Janeiro

66. *"Crioulo fugido:
desde o dia 18 de
outubro de 1854, de
nome Fortunato: RS
50U000 de Alviçaras"*
[Runaway black
man: escaped on
October 18, 1854.
Name: Fortunato.
RS 50U000, from
Alviçaras], 1854
25.5 x 16 cm
Fundação Biblioteca
Nacional, Rio
de Janeiro

67

68

Rafael RG

b. Guarulhos, São
Paulo, 1986; lives
in Guarulhos, Belo
Horizonte, and Vitória

67, 68. *Dark Saying*,
2014
One of a set of six
photographs with
corresponding
documents, each
25 x 35 x 4 cm
Collection of
Fernando and Camila
Abdalla, São Paulo

Ernest Crichlow

Brooklyn 1914–2005
Brooklyn

69. *Harriet Tubman*,
1953
Oil on Masonite,
55 x 49 cm
Michael Rosenfeld
Gallery, New York

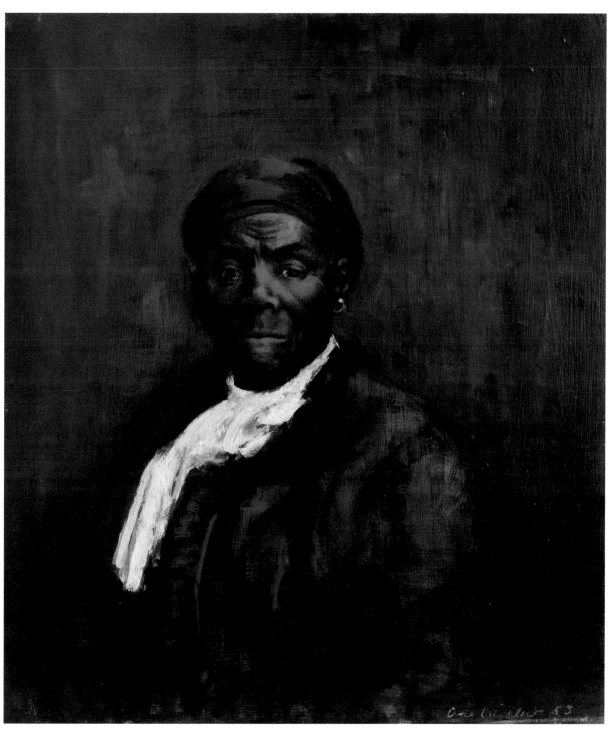

69

113

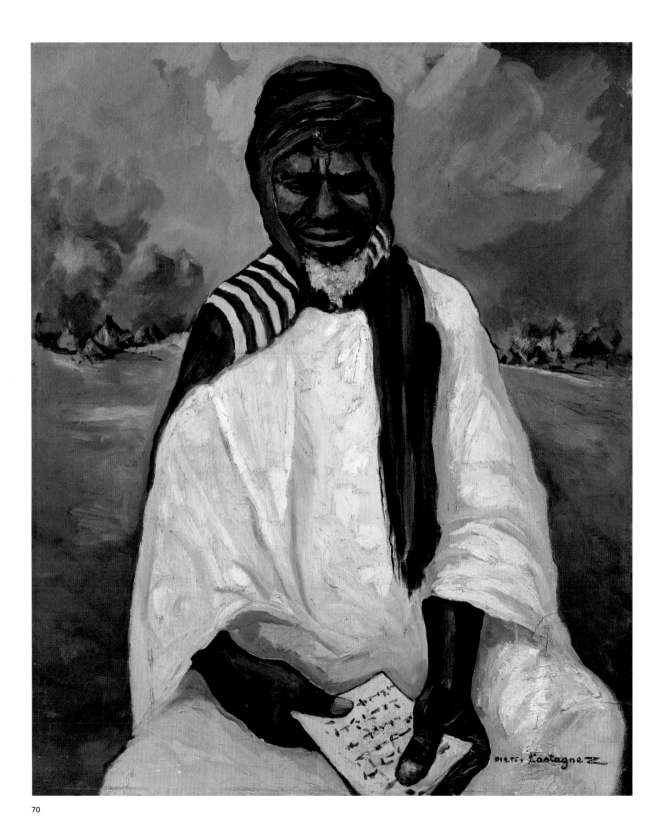

70

Pierre Castagnez

Castillonnès, France
1898–1951 Dakar

70. *Portrait of Samory*,
second quarter of the
20th century
Oil on plywood,
84.5 x 70 cm
Musée du Quai Branly–
Jacques Chirac, Paris

Dalton Paula

b. Brasília, 1982; lives
in Goiânia, Goiás,
Brazil

71. *Portrait of Lima Barreto*, 2017
Oil on book,
21.5 x 14.5 cm
Private collection,
São Paulo

Unidentified Photographer

72. *José do Patrocínio
(Abolitionist)*, 1890s
28 x 22.5 cm
Fundação Biblioteca
Nacional, Rio de Janeiro

Unidentified Photographer

73. *Portrait of Luiz
Gama*, undated
9.5 x 6.5 cm
Fundação Biblioteca
Nacional, Rio de Janeiro

71

72

73

115

Unidentified Artist

Benin

74. *Portuguese Soldier*,
19th century
Bronze, 50 x 24 x 21 cm
Museu Afro Brasil,
São Paulo

Unidentified Artist

Nigeria

75. *Portrait of Queen Victoria*, ca. 1890
Wood, 27 x 14 x 12.5 cm
Musée du Quai Branly–
Jacques Chirac, Paris

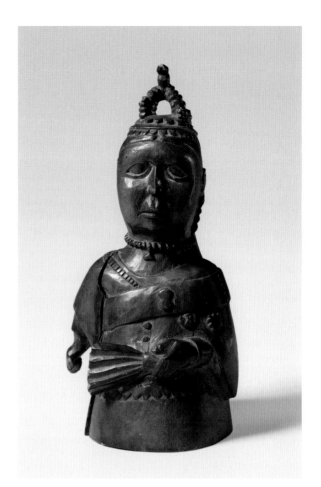

74

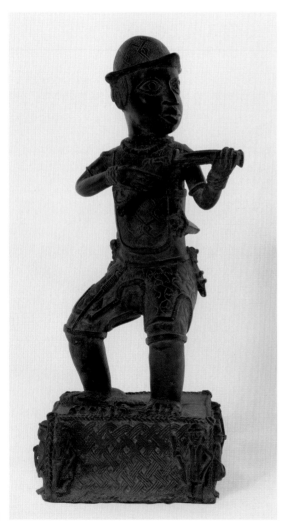

75

Thomas Jones Barker

Bath, United Kingdom
1815–1882 London

76. *The Secret of England's Greatness* (*Queen Victoria Presenting a Bible in the Audience Chamber at Windsor*), ca. 1863
Oil on canvas, 167 x 213 cm
National Portrait Gallery, London

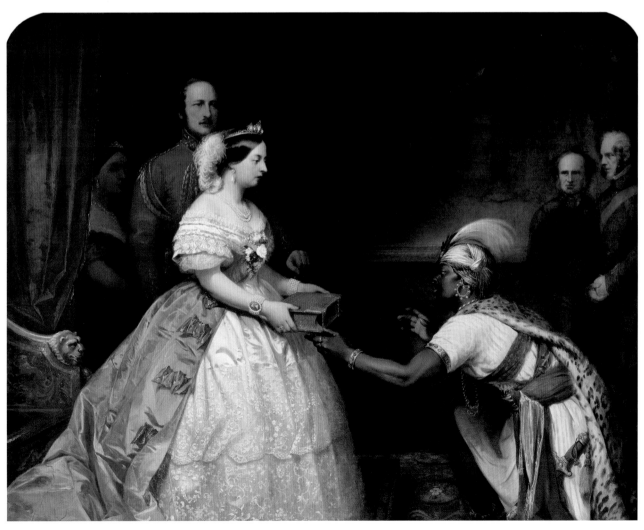

76

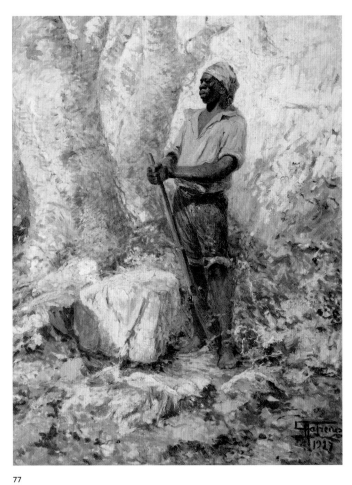

77

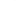

78

Antônio Parreiras

Niterói, Rio de Janeiro 1860–1937 Niterói

77. *Zumbi*, 1927
Oil on canvas,
116 x 88 cm
Governo do Estado
do Rio de Janeiro/
Secretaria de Estado
de Cultura/Fundação
Anita Mantuano de
Artes do Estado
do Rio de Janeiro–
FUNARJ/Museu
Antônio Parreiras,
Rio de Janeiro

Belmiro de Almeida

Serro, Minas Gerais,
Brazil 1858–1935
Paris

78. *Obá Prince*, 1880
Oil on wood,
15 x 23.5 cm
Museu de Arte do
Rio (MAR)/Secretaria
Municipal de Cultura
da Cidade do Rio
de Janeiro

Susan Torrey Merritt

Weymouth,
Massachusetts 1826–
1879 Weymouth

79. *Anti-Slavery
Picnic at Weymouth
Landing,
Massachusetts*, ca.
1845
Collage on paper,
66 x 91.4 cm
Art Institute of
Chicago, Gift of
Elizabeth R. Vaughan,
1950.1846

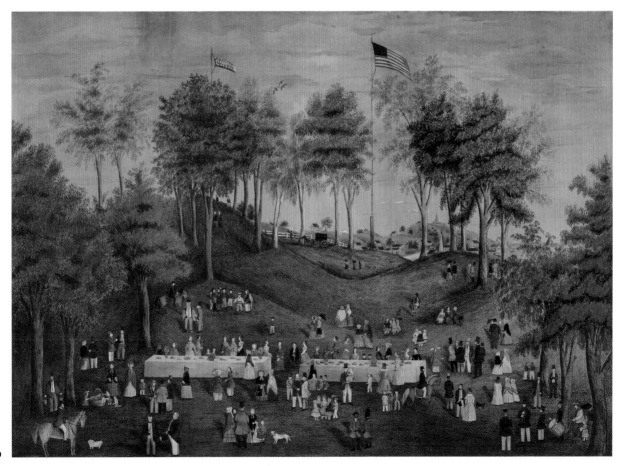

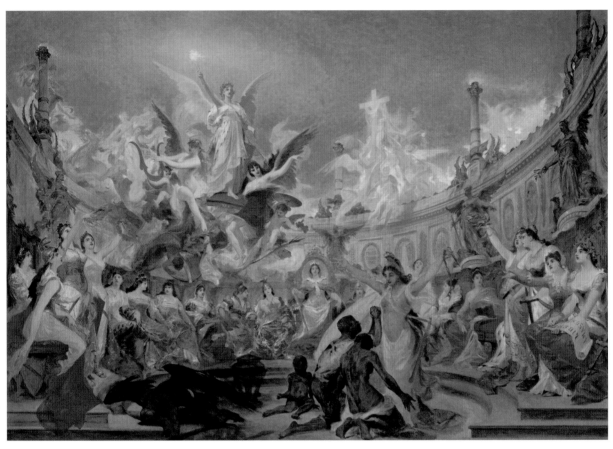

80

Pedro
Américo

Areia, Paraíba, Brazil
1843–1905 Florence,
Italy

80. *Slaves Granted
Liberation*, 1889
Oil on canvas,
140.5 x 200 cm
Palácios do Governo
do Estado de
São Paulo

Sidney
Amaral

São Paulo 1973–2017
São Paulo

81. *Disturbance*,
2014
Five drawings;
watercolor, graphite,
guoache, colored
pencil, and permanent
marker on paper,
191.5 x 327 x 4 cm
Pinacoteca do
Estado de São Paulo,
Gift of Associação
Pinacoteca Arte e
Cultura–APAC, 2017

Samuel
Raven

United Kingdom ca.
1775–1847

82. *Celebrating the
Emancipation of
Slaves in British
Dominions*, August
1834, ca. 1834
Oil on canvas,
32.5 x 23 cm
The Menil Collection,
Houston

81

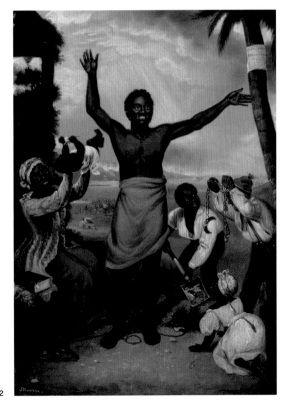

82

121

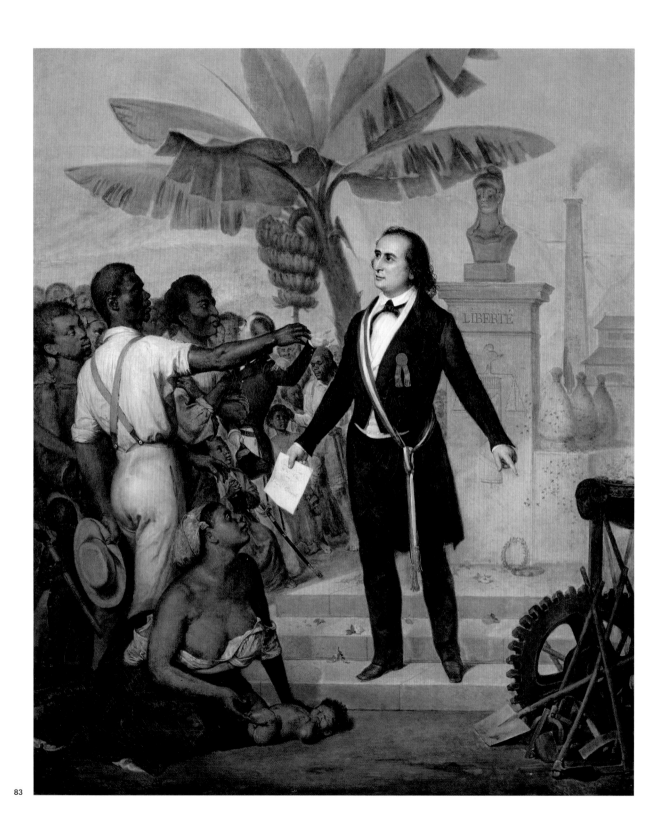

83

Alphonse Garreau

Versailles 1792–1865
Saint-Denis, Réunion

83. *Proclamation of the Abolition of Slavery in Réunion*,
ca. 1849
Oil on canvas,
127 x 107 cm
Musée du Quai Branly–Jacques Chirac, Paris

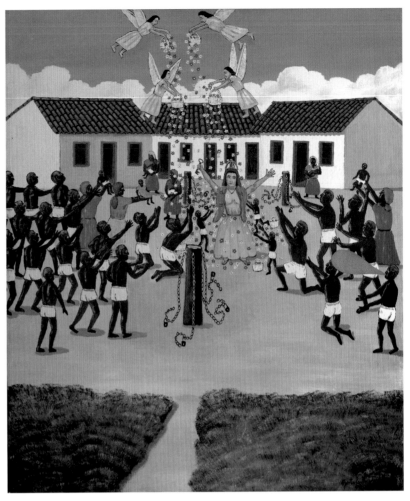

84

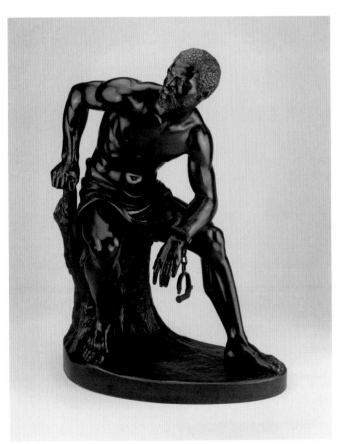

85

Agostinho Batista de Freitas

Paulínia, São Paulo
1927–1997 São Paulo

84. *Slaves Granted Liberation*, 1978
Oil on panel,
80 x 68 cm
Collection of Orandi Momesso, São Paulo

John Quincy Adams Ward

Urbana, Ohio 1830–
1910 New York City

85. *The Freedman*,
1862–63. Bronze,
50 x 40 x 24 cm
Art Institute of Chicago, Roger McCormick Endowment, 1998.1

123

86

Cameron Rowland

b. Philadelphia, 1988; lives in New York City

86. *Jim Crow*, 2017
Jim Crow rail bender, 10 x 92.5 x 40.5 cm
Courtesy of the artist and Essex Street, New York

Jim Crow is a racial slur, derived from the name of the minstrel character played by Thomas D. Rice in the 1830s. A Jim Crow is also a type of manual railroad rail bender. It has been referred to by this name in publications from 1870 to the present. The lease of ex-slave prisoners to private industry immediately following the Civil War is known as the convict lease system. Many of the first convict lease contracts were signed by railroad companies. *Plessy v. Ferguson* contested an 1890 Louisiana law segregating black railroad passengers. The Supreme Court upheld the law as constitutional. This created a precedent for laws mandating racial segregation, later to be known as Jim Crow laws.

87

88

Paulo Nazareth

b. Governador
Valadares, Minas
Gerais, Brazil, 1977;
lives in Santa Luzia,
Minas Gerais

87–89. Stills from
Tree of Forgetting,
2013
Video, 27:31 minutes

89

Federal Writers' Project

United States, 1930s

90. *Will Adams, ex-slave, Marshall, Texas*, 1937
12.5 x 8.5 cm

91. *Mrs. Mary Crane, 82 years old, ex-slave, Mitchell, Indiana*, ca. 1937–38
9.5 x 15.5 cm

Library of Congress Prints and Photographs Division, Washington, D.C.

Militão Augusto de Azevedo

Rio de Janeiro 1837–1905 São Paulo

92–95. **Studio portraits of unidentified sitters**, 1879
5.5 x 9 cm
Museu Paulista da Universidade de São Paulo, Collection Militão Augusto de Azevedo

90

91

92

93

94

95

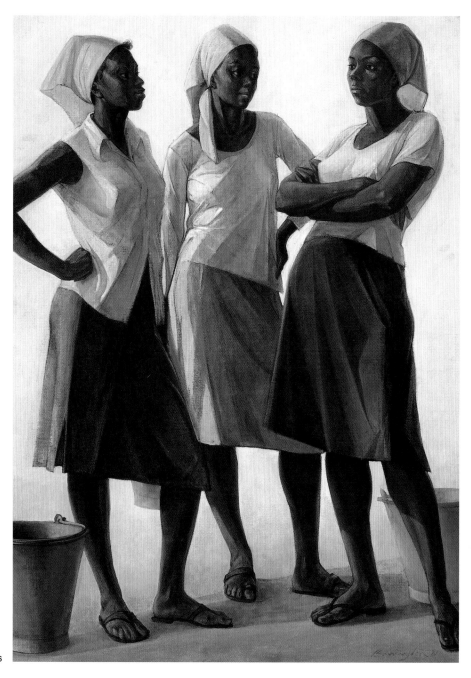

96

Barrington
Watson

Lucea, Jamaica
1931–2016 Kingston

96. *Conversation*,
1981
Oil on canvas,
127.5 x 91 cm
National Gallery of
Jamaica, Kingston

EVERYDAY

LIVES

Everyday Lives

Africans who arrived in the Americas and the Caribbean built "black territories": social and ethnic spaces created from new experiences of the diaspora. This section brings together images of daily life in Africa, the Caribbean, and the Americas, from the 17th to the 21st century.

Most of the representations produced during slavery were made by Europeans who opted to depict a lighter, more naturalized version of everyday violence. *Landscape with Anteater* (ca. 1660; fig. 99) by Frans Post shows enslaved men and women interacting with Indigenous people and a Dutch settler. This sort of image which combines an exuberant nature with a sense of placidity, and no suggestion of race or class conflict, is typical of images produced by Post. Similarly, *Governor Turgot Welcomed by the Guiana Indians in 1765* (fig. 100) depicts a harmonious encounter between indigenous, Black, and white people, this time in French Guiana.

Although slaves worked plantation fields of sugarcane, rice, cotton, and cocoa for up to twenty hours a day, images portraying these harsh working conditions are extremely rare.[1] Both Isaac Mendes Belisario from Jamaica and Victor Patricio Landaluze from Spain depicted Caribbean plantations in the 19th century: the former painted cacao plantations in Jamaica (fig. 98), and the latter, sugarcane plantations in Cuba (fig. 103). The British artist Charles Landseer, who spent four years in Brazil from 1825 to 1829, almost exclusively represented captives. In his *View of Sugarloaf from Silvestre Road* (1827; fig. 101), Black men placidly chase butterflies to be used by naturalists in their studies.

Frenchman Félix-Émile Taunay's watercolors (1823; fig. 106) give some idea of the hard work performed by captives in city ports and the routine violence that sustained the system of slavery in cities like Rio de Janeiro. In contrast, *Dungeon Point* (1819–20; fig. 105) by Henry Chamberlain is stripped of any disturbing content. Against the backdrop of Sugarloaf, Chamberlain, a member of the Royal British Artillery who reinvented himself in Brazil as a painter and illustrator, represented slaves chatting serenely—an image that could not be further from the violence perpetrated daily. Paintings like this helped to construct a picture of a sort of Arcadia in the tropics.

Some works from the 20th century by African American painters represent migration between cities and fields and displacement from homes to plantations. Harlem Renaissance artist William Henry Johnson painted scenes and customs of Afro-American communities in compositions with flat shapes, vibrant patterns, and bright colors. *At the Levee* (ca. 1943; fig. 104) depicts a group of Black people near a dam, and in *Farewell* (ca. 1942; fig. 108), a family waves to a train passing through. The railroad became a symbol of slave escapes, but in this context it is a reminder of progress and of the relationship between the city and the fields on the periphery. In *The Gleaners* (1943, fig. 107), a painting by John Biggers, the railroad does not symbolize progress, but poverty and social and economic isolation. Behind the Black family that is collecting pieces of charcoal left behind on the railroad tracks is a cluster of precarious wooden huts that evoke Brazilian favelas. In contrast, in

the background is a prosperous city with a geometric composition of shiny skyscrapers. Biggers's work echoes the well-known painting of the same title by Frenchman Jean-François Millet that depicts women harvesting wheat.

"Returning from the plantation" is a common typology of so-called popular art. Brazilian Heitor dos Prazeres shows a procession of Black and white workers—children, women, and men—carrying the day's harvest from the fields (1948; fig. 110). Their bodies almost merge, suggesting ties of intimacy among this community of workers. This sense of community is also implied in African American Faith Ringgold's *Subway Graffiti #2* (1987; fig. 112). In a reference to another popular typology, quilting, this painting shows a group of Black and white people waiting for a subway train, forming a close but transient community that will quickly dissipate once they board the train.

Romare Bearden's *Gray Interior* (1969; fig. 111) is among the artist's most complex works. A central figure of the Harlem Renaissance, Bearden began making collages in 1963, combining cutouts from magazines and photomontages into fragmented, mosaiclike compositions. Here, the gray interior consists of a constructivist assemblage of pieces of black and white benches and frames, a vase, and three men. The subdued tones and mutilated characters underscore the image's severe and melancholic atmosphere, where the only element of color is a window that gestures to a blue world beyond the interior.

It is interesting to note how features of Brazilian motifs figure in different Afro-Atlantic urban and semi-urban contexts. The favela, the territory between city and countryside appears in a series of artworks by South African Gerard Sekoto (fig. 113), by Haitian Sénèque Obin (ca. 1950; fig. 114), and by Cuban José Segura Ezquerro (ca. 1963; fig. 115). Appearing in works by both Sekoto and Obin, the composition of a central road that divides the painting is the same device used by African American Benny Andrews in *Harlem USA* (*Migrant Series*) (2004; fig. 97) to reinforce the divide between the better-off Black families wearing fashionable clothing and the immigrant families with simple suitcases and bags—a common scene on any given day in Harlem during the Depression. Two other Brazilian visual conventions include a woman balancing a vessel on her head and the image of the *baiana* (typically a Black woman from Bahia wearing a long dress and a turban), which appears in Brazilian Anita Malfatti's painting (1920–30; fig. 116). Both of these Brazilian motifs appear in different Afro-Atlantic contexts, for example, in a picture by Sekoto of two women walking down the road of a poor community (1958; fig. 117), and Grenadian Canute Caliste's island wedding scene (1970s; fig. 118). Street markets are a female domain, represented by 20th-century artists with intensely colorful, bright, and dynamic scenes populated by a myriad of characters, activities, and items. Women are seen in street markets not only in Bahia, such as in Brazilian-Argentinian Carybé's *Market* (1940s; fig. 124), Brazilian Djanira da Motta

e Silva's *Bahia Market* (1956; fig. 122), and Haitian Castera Bazile's *Haitian Market by the Sea* (1963; fig. 123). The *quitandeira* (female greengrocer) plays a central role in representations of Black cities throughout the Atlantic. The *quitandeira* is found in images of street markets in Rio de Janeiro, such as in Chamberlain's *Lapa Greengrocers* (1818; fig. 119), and in Colombia, in Frenchman François-Désiré Roulin's *Market of Mompox* (1823; fig. 120).

In Brazil, Black women are often represented exotically, with exuberant bodies, bare chests, and flashy clothing. Two African American artists, Biggers and Jacob Lawrence, take a different approach, depicting African markets and their exchanges, activities, and relationships with a great level of intensity. Biggers was one of the first Americans to travel to Africa. In his *Market Women, Ghana* (ca. 1959; fig. 126), the white dresses and turbans worn by women at the market resemble the outfits typically worn by *baianas*, highlighting another Afro-Atlantic connection. In *Meat Market* (1964; fig. 126), Lawrence presents an aerial view of a market in Osogbo, Nigeria, in his trademark style, often dubbed "dynamic cubism" for the way he combined figurative and geometric elements. In his view of the Nigerian market, the red of the meat matches the intensity of the roof tiles in a fragmented and frenetic composition.

In the 1770s, Italian-English Agostino Brunias was commissioned to paint the upper classes of the West Indies and Dominica. His portrayals of domestic slaves in these works are markedly sanitized. In *A Linen Market*

with a Linen-Stall and Vegetable Seller in the West Indies (ca. 1780; fig. 121), he suggests an untroubled coexistence between white buyers and Black sellers. The central figure of the painting is a fair-skinned woman wearing a turban arranged in a hybrid creole style typical of the Caribbean. Distinctly highlighted by her luminous position, she stands in stark contrast to the rest of the composition, in which differences are restricted to skin color and the amount of clothes worn. Similarly, in Brunias's *Free West Indian Dominicans* (ca. 1770; fig. 130), the only indication that the two Black women and a Black man, dressed in European attire, represent a different ethnic identity are their turbans and a scarf worn over the shoulders of the middle figure. In *A Mother with Her Son and a Pony* (ca. 1775; fig. 127), Brunias once again paints Black characters in impeccable European attire, practicing typical European activities. The mother stands next to her son, who wears a riding outfit and holds a pony, his bare feet the only sign of their social class. The smartly dressed but barefoot character appears again in *Servants Washing a Deer* (ca. 1775; fig. 129), which shows domestic servants performing their chore against the backdrop of wealthy colonial architecture. The work is a portrait of the power of elites who considered themselves civilized while dominating slaves who were supposedly as tranquil as the local wildlife.

Representations of everyday forms of leisure were produced by Lawrence in *Playland* (1948; fig. 125) and by Brazilian artists Alfredo Volpi in *Piolim Circus* (1930; fig. 128) and Luiz Braga in *The Favorite* (1987; fig. 131). Braga's photograph shows a harshly lit restaurant-bar in Belém where, despite the simple surroundings, the table is loaded with food. Meals also appear in the watercolors of Jean-Baptiste Debret and Roulin, Frenchmen who traveled to Brazil and Colombia, respectively. The similarity between Debret's *Brazilian Dinner* (1827; fig. 134) and Roulin's *Dinner at Santa Marta* (1823; fig. 133) is striking. The white diners do not look at the Black servants. In Debret's work, a white woman feeds naked Black children on the floor; in Roulin's, a white man feeds a dog. It was by inverting these racial differences that Brazilian painter Maria Auxiliadora represented another form of sociability at the table, this time among equals. Her *Lunchtime* (ca. 1960s; fig. 135) depicts a joyous and colorful environment—probably on the outskirts of São Paulo, where the artist lived—in which the Black characters outnumber the white.

Love matches and mismatches are juxtaposed in a pair of works featuring interracial couples. In *Oneiric Composition* (1934; fig. 140) by Brazilian Antonio Gomide, the relationship between races is depicted as a dream—or a nightmare. In contrast, the perverse *Little Master That I Love* (1840; fig. 138) by Frenchman Julien Vallou de Villeneuve shows a well-dressed white man sitting on a balcony, probably in the French Antilles. He seems hypnotized by his slave, who wears nothing but a skirt, her face turned to her beloved master. Though Vallou does not reveal her fa-

cial expression, she ostensibly speaks through the title. As a counterpoint, two iconic Brazilian modernist paintings depict Black couples: Alberto da Veiga Guignard's *Bride and Groom* (1927; fig. 139) and Ismael Nery's *Lovers* (ca. 1927; fig. 141).

Finally, a video produced by AD Junior, Edu Carvalho, and Spartakus Santiago, starring the artists themselves (2018; figs. 142–144), addresses the police violence that threatens Black Brazilians daily. The trio offer advice on how to avoid "being approached by our country's security agents who abuse their power," and if that proves impossible, how to document it. As the only video and the only artwork from the 21st century in this section, *Intervention in Rio* gains a prominent position; the narrators' voices—instructional, assertive, and political in tone—permeate our perception of all the works preceding it.

1. Stuart Schwartz, *Segredos internos* (São Paulo: Companhia das Letras, 1988).

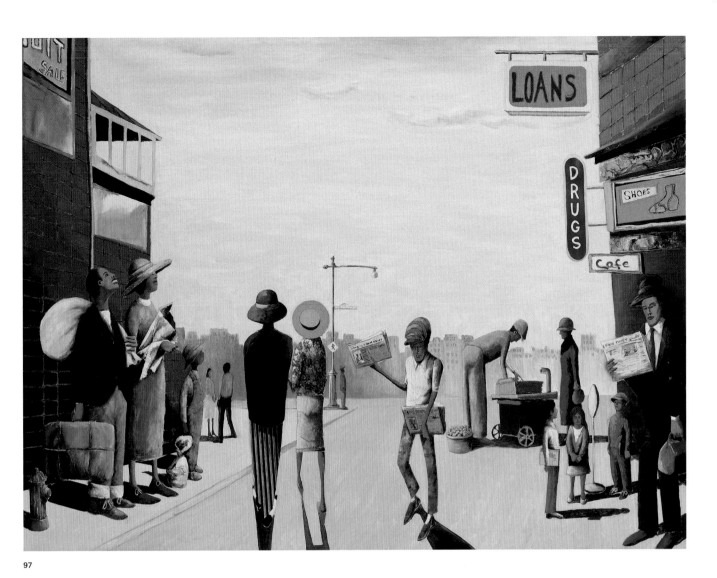

97

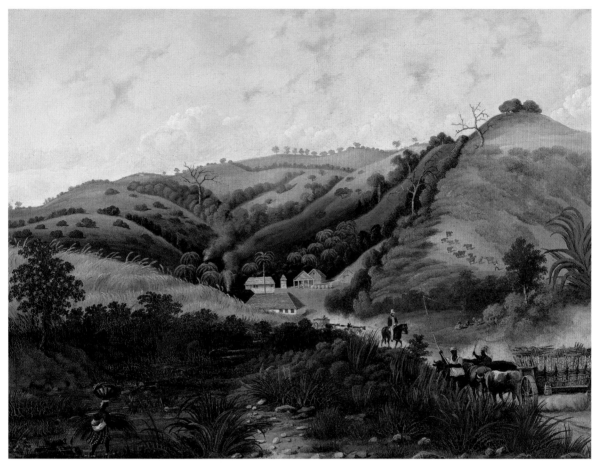

98

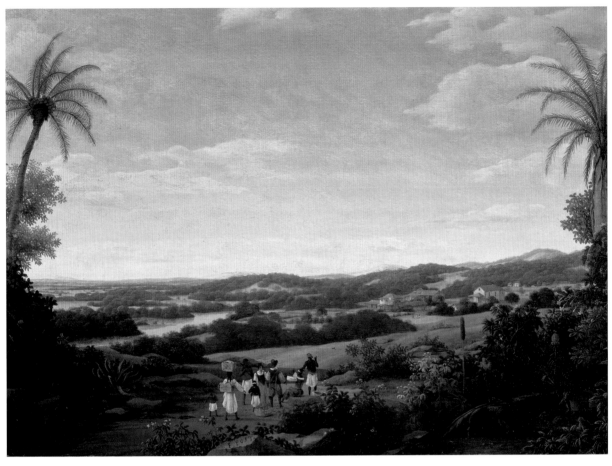

99

Isaac
Mendes
Belisario

Frans
Post

Kingston, Jamaica
1795–1849 London

Haarlem, Netherlands
1612–1680

98. *Cocoa Walk
Estate*, 1840
Oil on canvas,
46 x 61 cm
National Gallery of
Jamaica, Kingston

99. *Landscape with
Anteater*, ca. 1660
Oil on wood,
56 x 79 cm
Museu de Arte de
São Paulo Assis
Chateaubriand–
MASP, Gift of Antenor
Rezende, 1951,
MASP.00224

Jean Chauffrey

France 1911–?

100. *Governor Turgot Welcomed by the Guiana Indians in 1765*, 1936 copy of an 18th-century painting
Oil on canvas,
65.5 x 82 cm
Musée du Quai Branly–Jacques Chirac, Parisr

Charles Landseer

London 1799–1879
London

101. *View of Sugarloaf from Silvestre Road*, 1827
Oil on canvas,
78 x 106 cm
Fundação Estudar, on loan to Pinacoteca do Estado de São Paulo

100

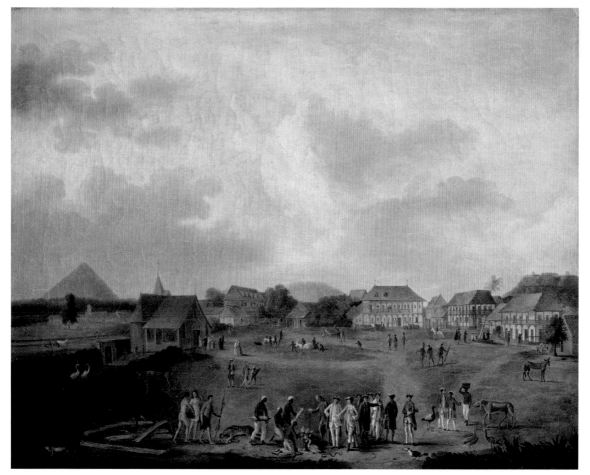

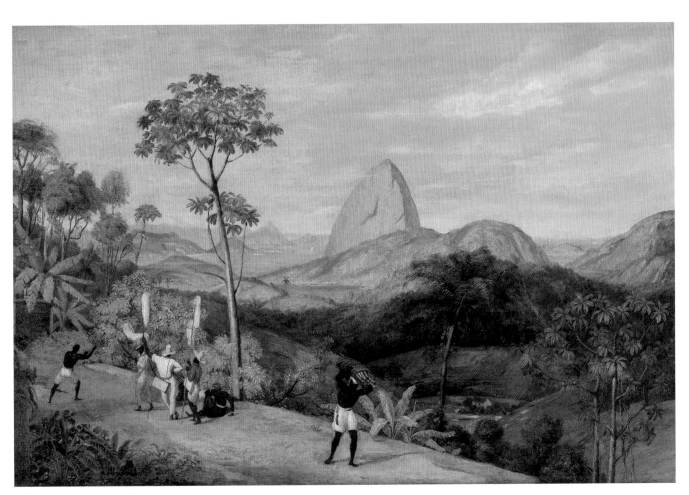

101

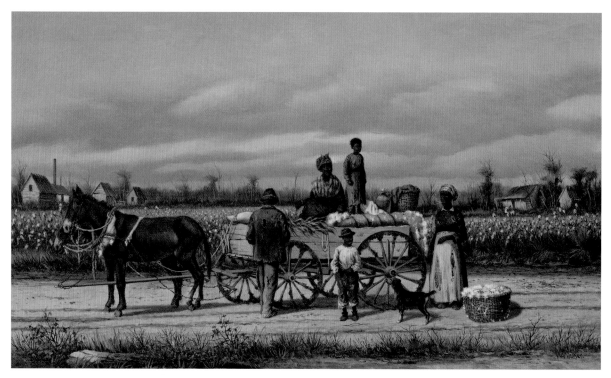

102

William
Aiken
Walker

Victor
Patricio
Landaluze

Charleston 1839–
1921 Charleston

Bilbao, Spain 1828–
1889 Havana

102. **Noon Day Pause
in the Cotton Field**,
ca. 1885
Oil on canvas,
35.6 x 61.3 cm
The Johnson
Collection,
Spartanburg

103. **Cane Cut**,
undated
Oil on canvas,
51 x 61 cm
Museo Nacional de
Bellas Artes, Havana

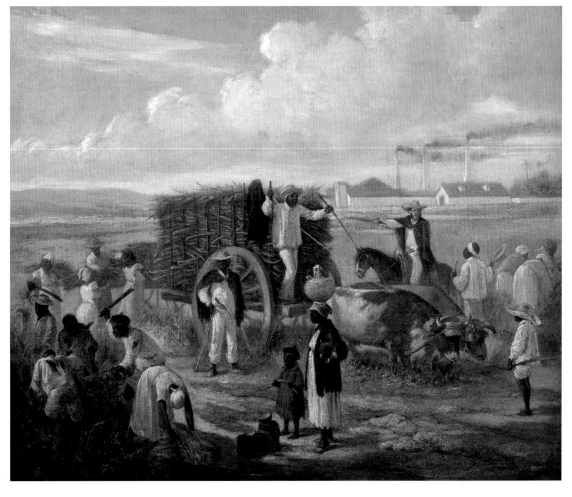

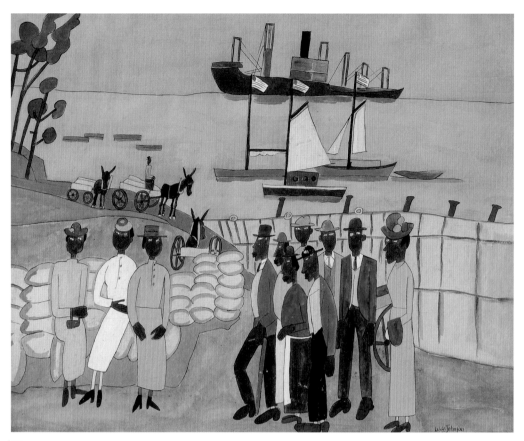

104

William
Henry
Johnson

Henry
Chamberlain

Félix-Émile
Taunay

Florence, South
Carolina 1901–1970
Central Islip, New
York

104. *At the Levee*,
ca. 1943
Oil on cardboard,
40 x 50.5 cm
Clark Atlanta
University Art
Museum

London 1796–1844
Bermuda

105. *Dungeon Point*,
1819–20
Oil on canvas,
26.5 x 32.5 cm
Museu de Arte de
São Paulo Assis
Chateaubriand–
MASP, Gift of Yan de
Almeida Prado, 1987,
MASP.00821

Montmorency, France
1795–1881 Rio de
Janeiro

106. *Don Manuel
Beach*, ca. 1823
Watercolor on paper,
48 x 52 cm
Pinacoteca do
Estado de São Paulo,
Collection Brasiliana/
Fundação Estudar,
Gift of Fundação
Estudar

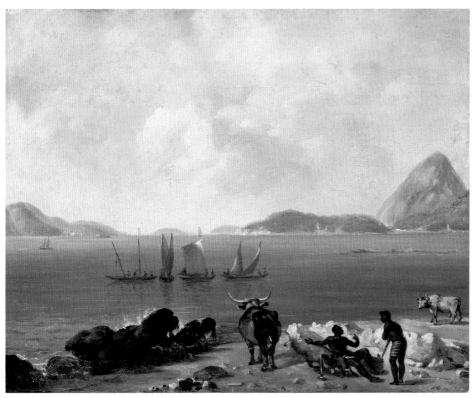

105

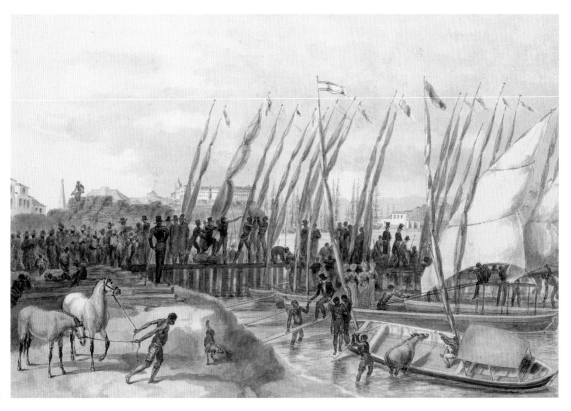

106

107

John T.
Biggers

William
Henry
Johnson

Gastonia, North
Carolina 1924–2001
Houston

Florence, South
Carolina 1901–1970
Central Islip, New
York

107. *The Gleaners*,
1943
Oil on canvas,
69 x 101.5 cm
Estate of John T.
Biggers and Michael
Rosenfeld Gallery,
New York

108. *Farewell*, ca.
1942
Tempera on paper,
73.5 x 68 cm
Clark Atlanta
University
Art Museum

108

109

Clementine Hunter

Natchitoches Parish, Louisiana ca. 1886–1988 Natchitoches Parish

109. *Untitled*, ca. 1970
Oil on cardboard, 6.2 x 37.3 cm
The Museum of Fine Arts, Houston, Gift of Anne Wilkes Tucker in honor of Alice C. Simkins, 2008.224

Heitor dos Prazeres

Rio de Janeiro 1898– 1966 Rio de Janeiro

110. *Untitled* (**Return from the Plantation**), 1948
Oil on canvas, 30 x 50 cm
Museu de Arte de São Paulo Assis Chateaubriand– MASP, Gift of Maurício Buck, 2016, MASP.01651

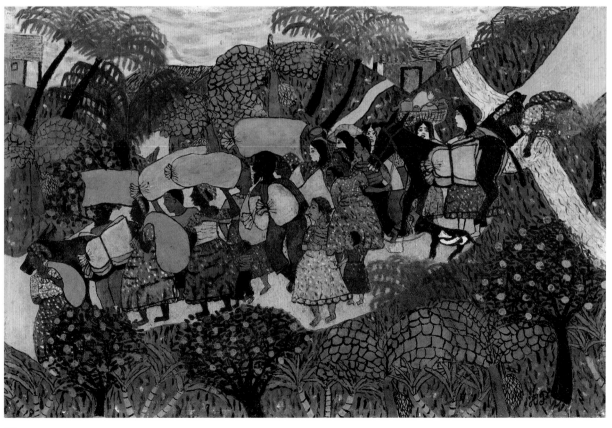

110

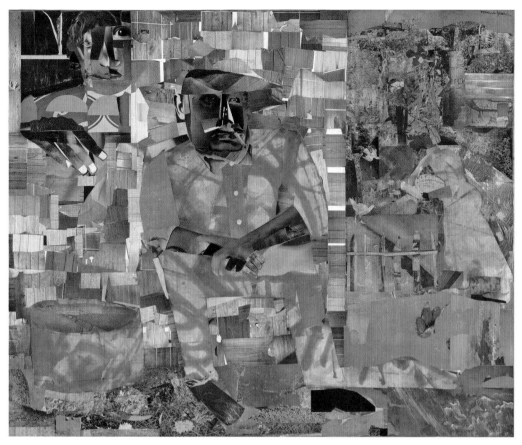

111

Romare
Bearden

Charlotte, North
Carolina 1911–1988
New York City

111. *Tomorrow I May
Be Far Away*, 1967
Collage of various
papers with charcoal,
graphite, and paint
on paper mounted to
canvas,
116.8 x 142.2 cm
National Gallery of
Art, Washington, D.C.,
Paul Mellon Fund,
2001.72.1

Faith
Ringgold

b. New York City,
1930; lives in
Englewood,
New Jersey

112. *Subway Graffiti
#2*, 1987
Acrylic on canvas with
pieced, dyed, and
painted fabric,
152 x 213 cm
Collection of
Charlotte Wagner,
courtesy of ACA
Galleries, New
York, and Pippy
Houldsworth Gallery,
London

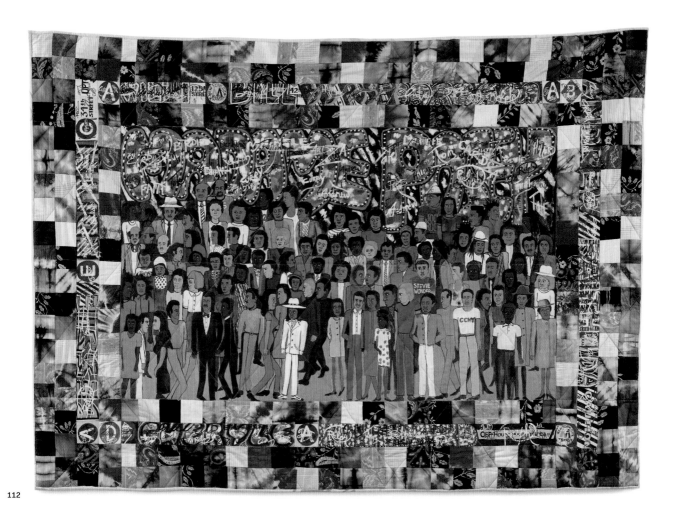

112

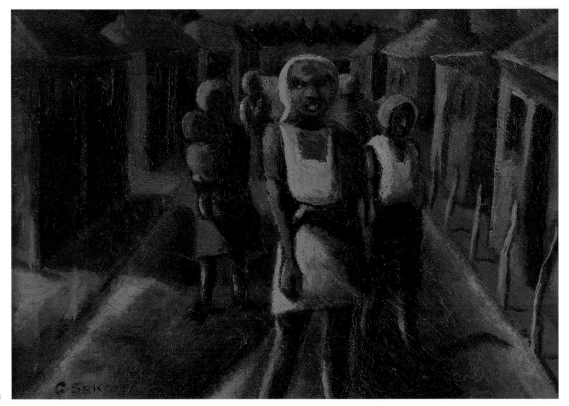

113

Gerard Sekoto

Botshabelo, South
Africa 1913–1993
Nogent-sur-Marne,
France

113. *Raw Light,
Lemba*, mid-20th
century
Oil on canvas,
35 x 50 cm
Collection of Natale
Labia, London

Sénèque Obin

Cap-Haitien, Haiti
1893–1977 Cap-
Haitien

114. *On the Road to
Carrefour des Pères*,
ca. 1950
Oil on Masonite,
40.5 x 51 cm
ZQ Art Gallery,
New York

José Segura Ezquerro

Almería, Spain 1897–
1963 Havana

115. *Untitled*, from
the series *Patterns of
Cuba*, ca. 1963
Oil on canvas,
67 x 85 cm
Museo Nacional de
Bellas Artes, Havana

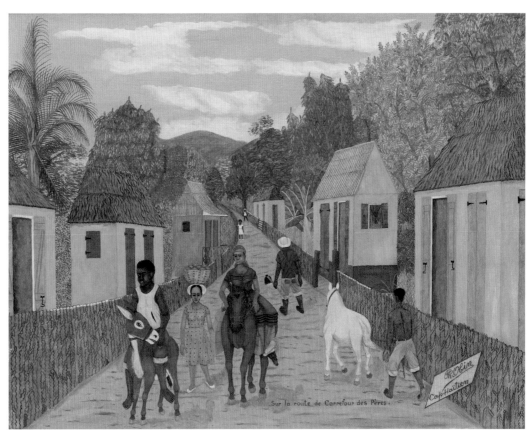

114

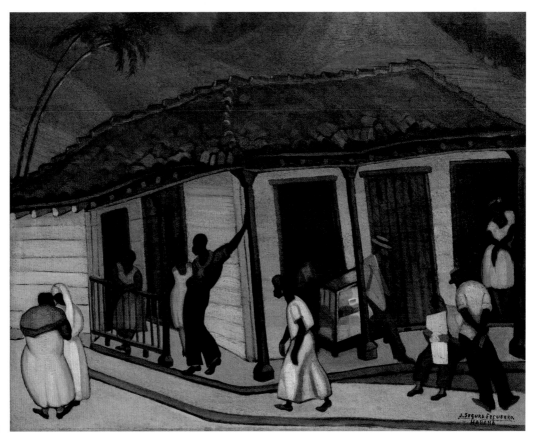

115

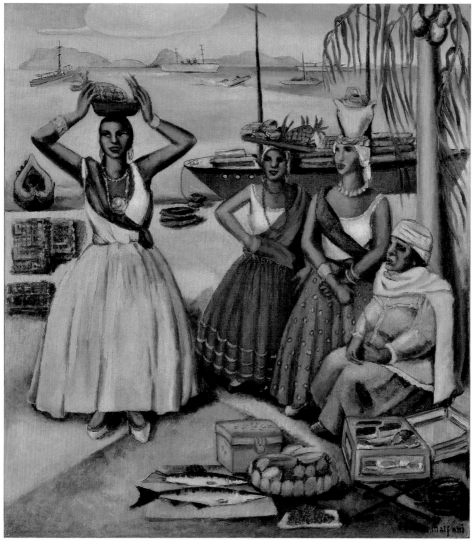

116

Anita Malfatti

São Paulo 1889–1964
São Paulo

116. *Baianas*,
1920–30
Oil on canvas,
101 x 90 cm
Collection of Airton
Queiroz, Fortaleza,
Ceará, Brazil

Gerard Sekoto

Botshabelo, South
Africa 1913–1993
Nogent-sur-Marne,
France

117. *Two Women in
the Road*, 1958
Oil on canvas,
60 x 80 cm
Grosvenor Gallery,
London

Canute Caliste

Grenada 1914–2006
Carriacou, Grenada

118. *Wedding in
Carriacou*, 1970s
Oil on Masonite,
51 x 62 cm
ZQ Art Gallery,
New York

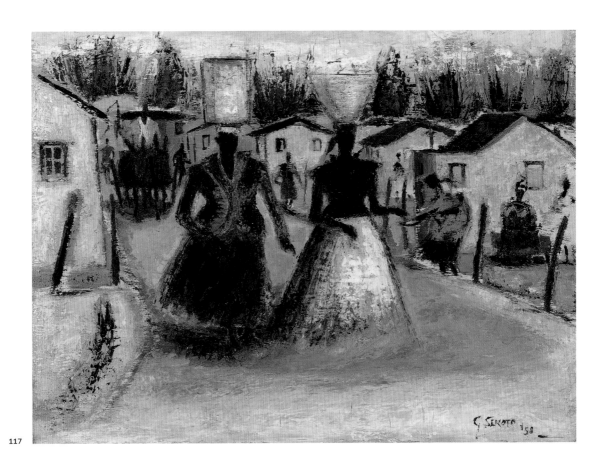

117

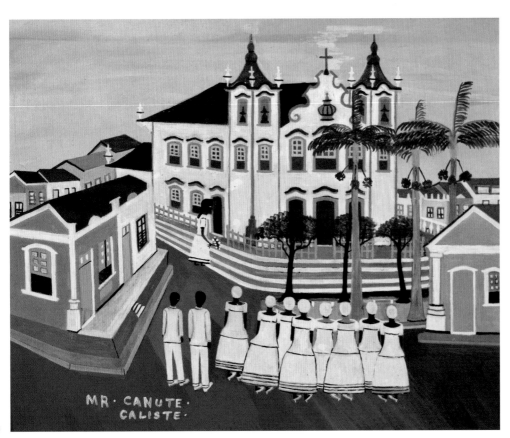

118

153

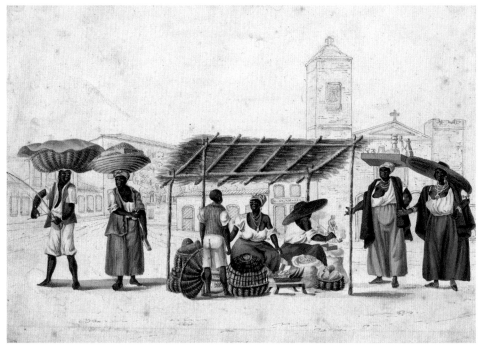

119

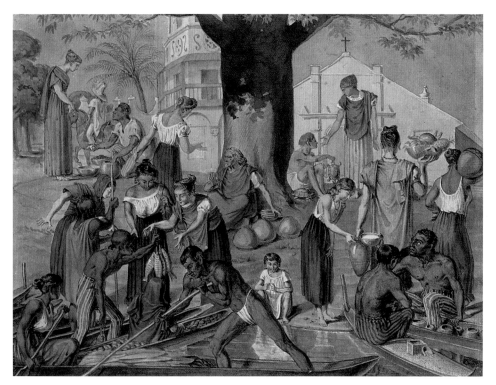

120

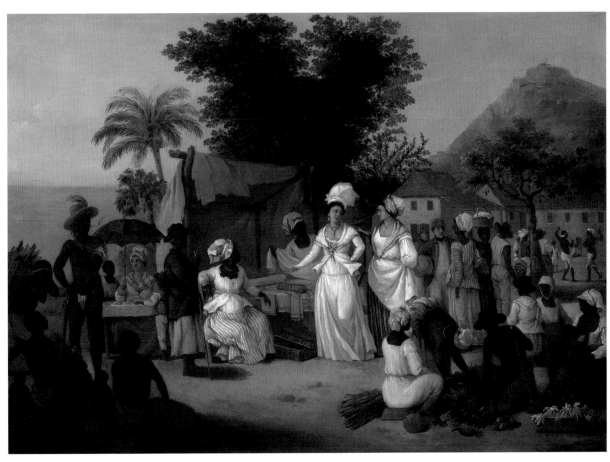

121

Henry Chamberlain

London 1796–1844
Bermuda

119. *Lapa Greengrocers*, 1818
Watercolor, 17.5 x 28 cm
Museu de Arte de São Paulo Assis Chateaubriand–MASP, Gift of Yan de Almeida Prado, 1981, MASP.04823

François-Désiré Roulin

Rennes, France 1796–1874 Paris

120. *Shores of the Magdalena. Market of Mompox*, 1823
Watercolor on paper, 20.5 x 27 cm
Banco de la República, Bogotá

Agostino Brunias

Rome ca. 1730–1796
Roseau, Dominica

121. *A Linen Market with a Linen-Stall and Vegetable Seller in the West Indies*, ca. 1780
Oil on canvas, 55 x 76 cm
Yale Center for British Art, New Haven, Paul Mellon Fund

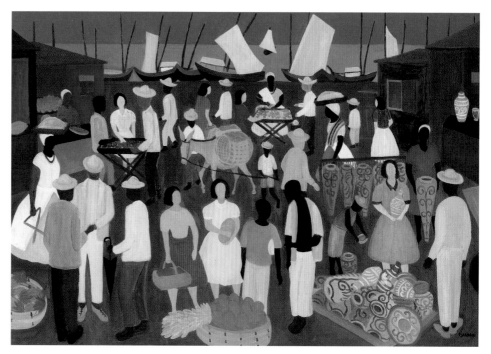

122

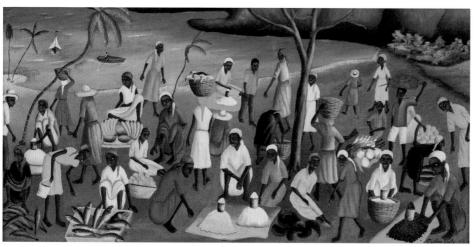

123

Djanira da
Motta e Silva

Avaré, São Paulo
1914–1979 Rio de
Janeiro

122. *Bahia Market*,
1956
Oil on canvas,
80 x 116 cm
Private collection,
Salvador, Bahia

Castera
Bazile

Jacmel, Haiti
1923–1966 Port-au-
Prince

123. *Haitian Market
by the Sea*, 1963
Oil on Masonite,
30.5 x 61 cm
ZQ Art Gallery,
New York

Carybé

Lanús, Argentina
1911–1997 Salvador,
Bahia

124. *Market*, 1940s
Oil on canvas,
185 x 122 cm
Private collection,
Salvador

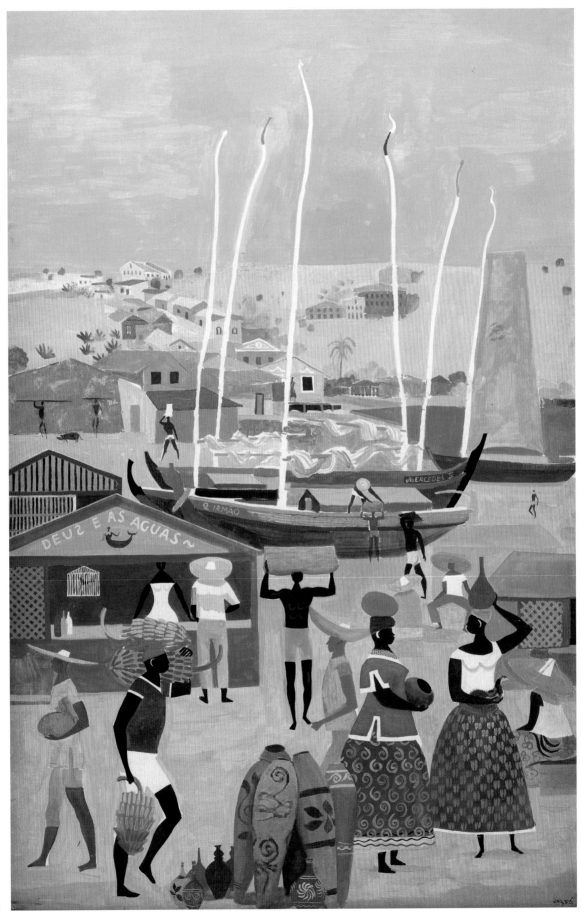

124

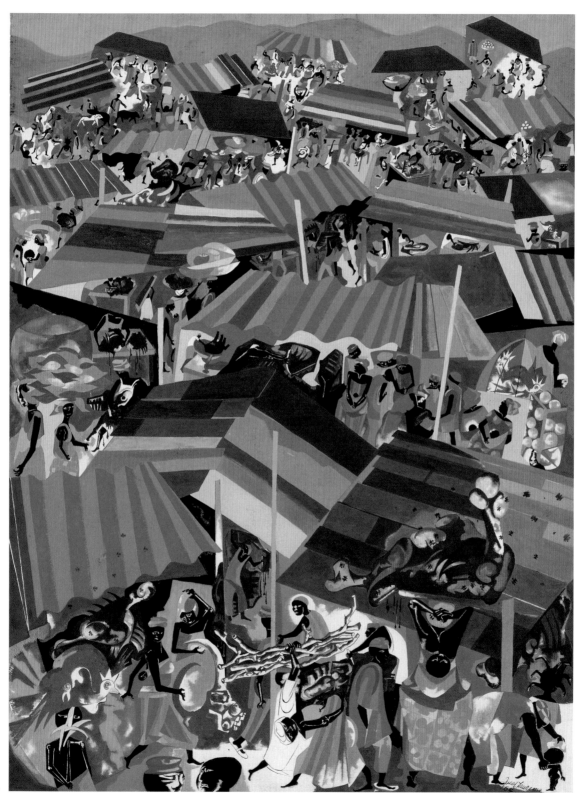

125

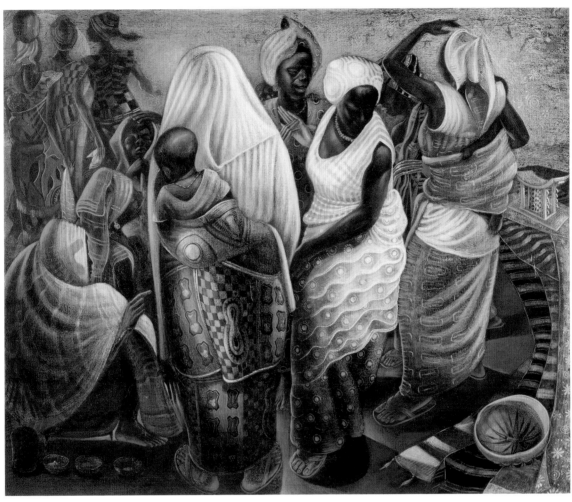

126

Jacob Lawrence

Atlantic City 1917–2000 Seattle

125. *Meat Market*, 1964
Tempera and gouache on paper, 77 x 58 cm
Courtesy of Michael Rosenfeld Gallery, New York

John T. Biggers

Gastonia, North Carolina 1924–2001 Houston

126. *Market Women, Ghana*, ca. 1959
Oil on canvas, 101.5 x 122 cm
Courtesy of Michael Rosenfeld Gallery, New York

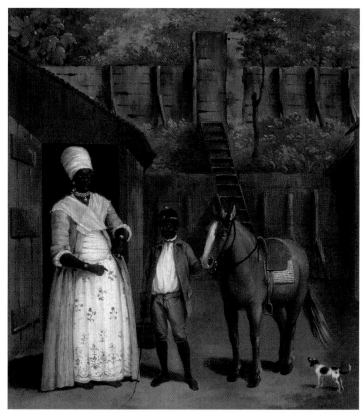

127

Agostino Brunias

Rome ca. 1730–1796
Roseau, Dominica

127. *A Mother with Her Son and a Pony*, ca. 1775
Oil on canvas,
33 x 28 cm

129. *Servants Washing a Deer*, ca. 1775
Oil on canvas,
32 x 28.5 cm

130. *Free West Indian Dominicans*, ca. 1770
Oil on canvas,
31 x 24 cm

Yale Center for British Art, New Haven, Paul Mellon Fund

Alfredo Volpi

Lucca, Italy 1896–1988 São Paulo

128. *Piolim Circus*, 1930
Tempera on canvas,
47 x 38 cm
Collection of Airton Queiroz, Fortaleza, Ceará, Brazil

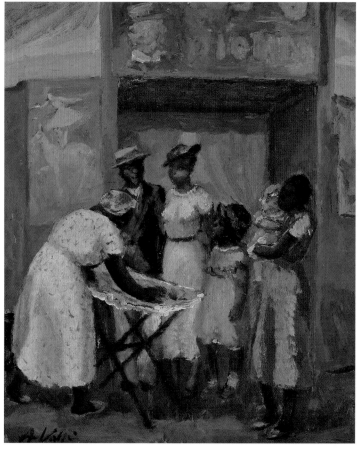

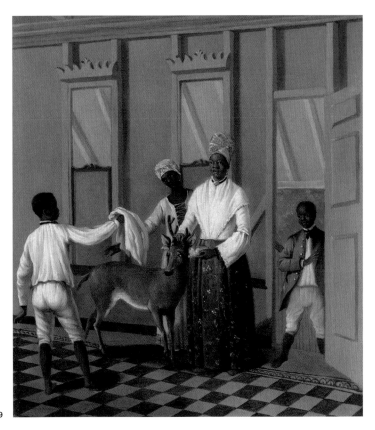

129

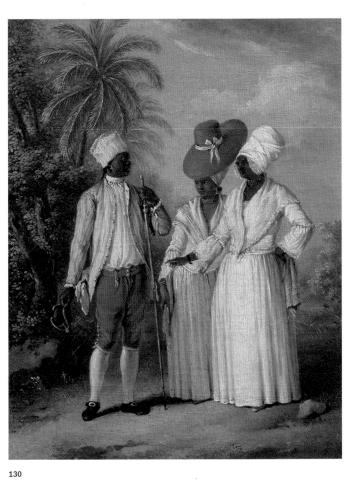

130

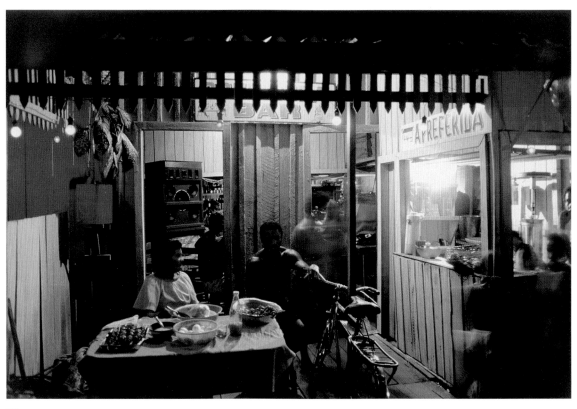

131

Luiz
Braga

b. Belém, Pará, Brazil,
1956; lives in Belém

131. *The Favorite*,
1987
Chromogenic print,
29 x 40 cm
Museu de Arte de
São Paulo Assis
Chateaubriand–
MASP, Gift of Pirelli,
1992, MASP.04823

Jacob
Lawrence

Atlantic City 1917–
2000 Seattle

132. *Playland*, 1948
Egg tempera on
wood, 61 x 51 cm
Clark Atlanta
University Art
Museum

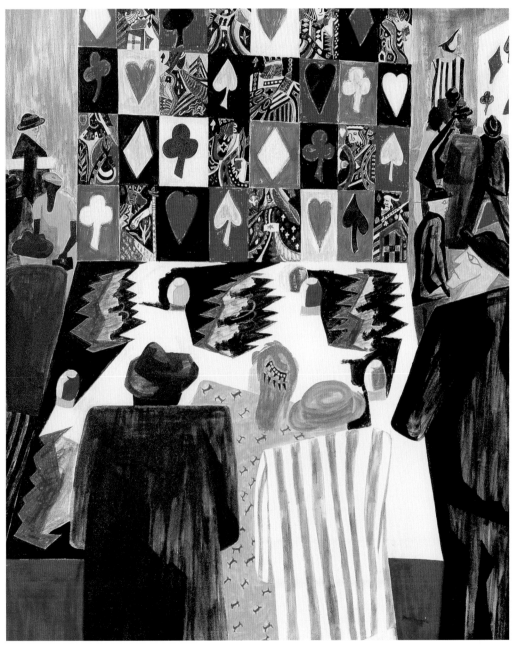

132

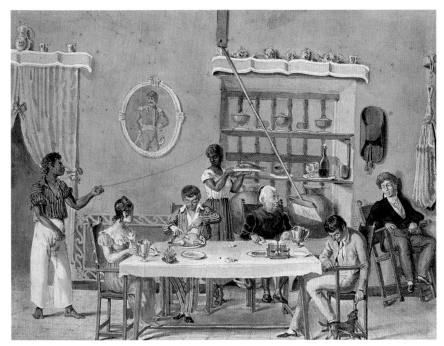

133

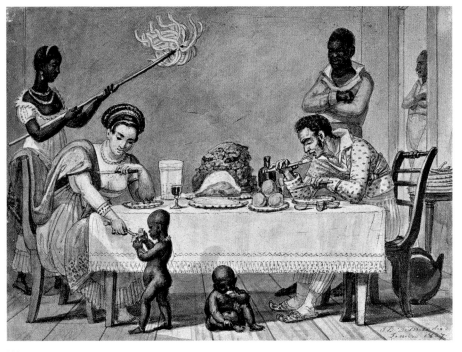

134

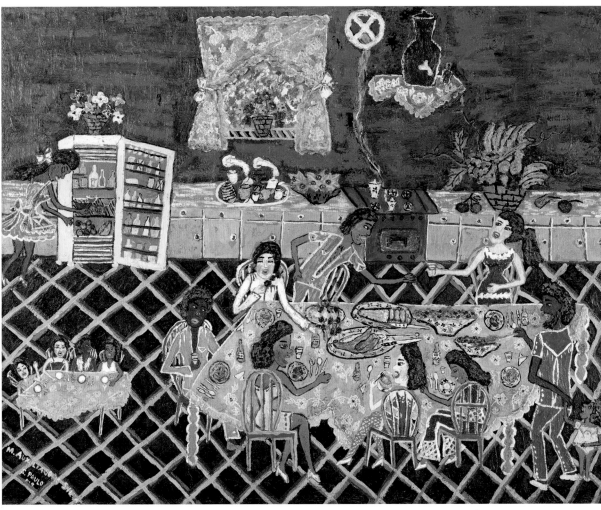

135

François-
Désiré
Roulin

Rennes, France
1796–1874 Paris

133. *The Dinner at
Santa Marta*, 1823
Watercolor on paper,
20.5 x 26.5 cm
Banco de la
República, Bogotá

Jean-
Baptiste
Debret

Paris 1768–1848
Paris

134. *A Brazilian
Dinner*, 1827
Watercolor on paper,
18 x 23 cm
Museus Castro
Maya–IBRAM/MinC,
Rio de Janeiro

Maria
Auxiliadora

Campo Belo, Minas
Gerais, Brazil 1935–
1974 São Paulo

135. *Lunchtime*,
undated
Oil on canvas,
65 x 81 cm
Collection of Irapoan
Cavalcanti,
Rio de Janeiro

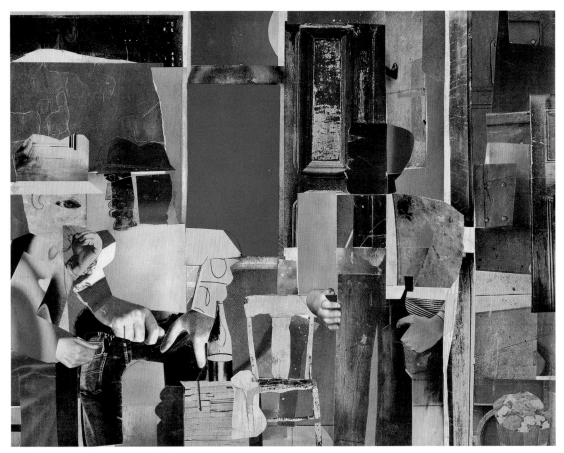

136

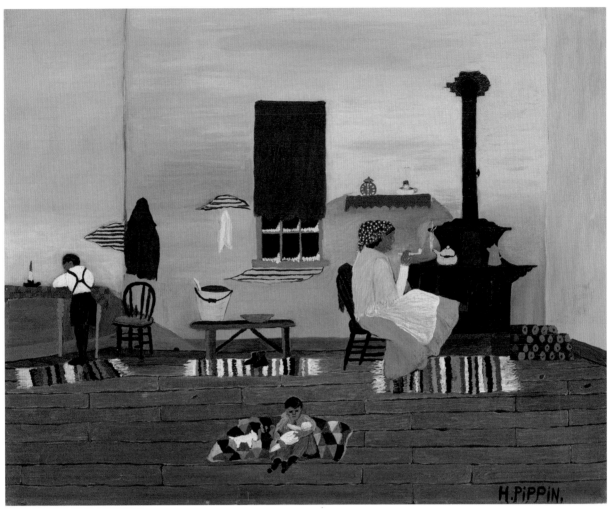

137

Julien Vallou de Villeneuve

Boissy-Saint-Léger,
France 1795–1866
Paris

138. *Little Master That I Love*, 1840
Oil on canvas,
47 x 59 cm
Musée d'Aquitaine,
Bordeaux

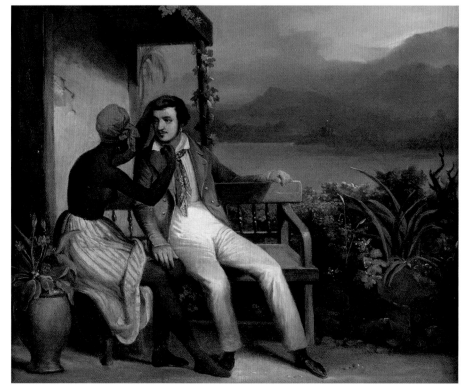

138

Alberto da Veiga Guignard

Nova Friburgo, Rio de
Janeiro 1896–1962
Belo Horizonte, Minas
Gerais, Brazil

139. *Bride and Groom*, 1927
Oil on wood,
58 x 48 cm
Museus Castro
Maya–IBRAM/MinC,
Rio de Janeiro

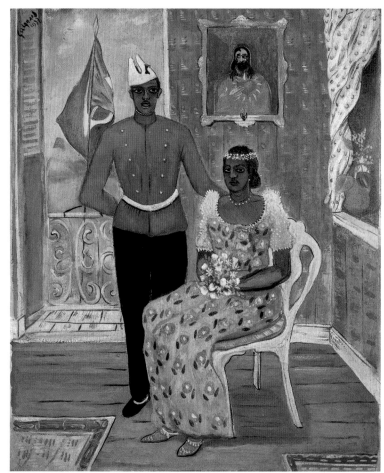

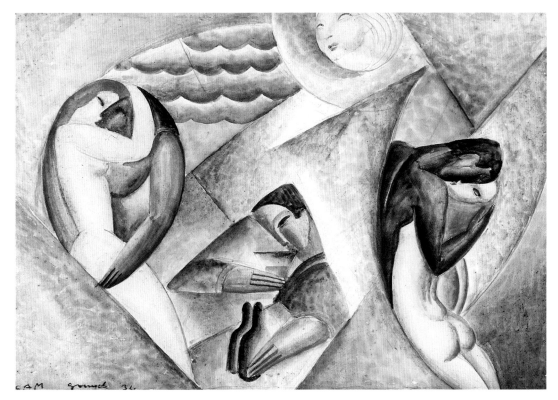

140

Antonio Gomide

Itapetininga, São Paulo 1895–1967 Ubatuba, São Paulo

140. *Oneiric Composition*, 1934 Watercolor and graphite on paper, 32 x 46 cm Collection of Hecilda and Sérgio Fadel, Rio de Janeiro

Ismael Nery

Belém, Pará, Brazil 1900–1934 Rio de Janeiro

141. *Lovers*, ca. 1927 Oil on canvas, 58.5 x 58.5 cm Private collection, Rio de Janeiro

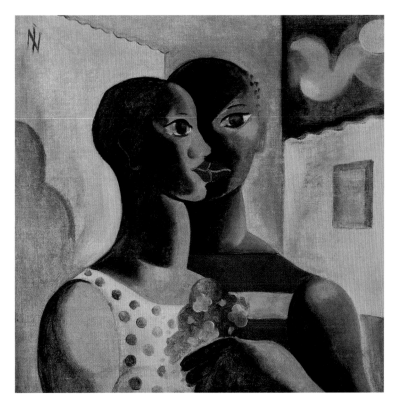

141

142

143

144

Spartakus Santiago, Edu Carvalho, and AD Junior

142–144. *Stills from Intervention in Rio: How to Survive an Improper Approach*, 2018

Video
3:26 minutes
Museu de Arte de São Paulo Assis Chateaubriand – MASP

Gift of the artists in the context of the *Afro-Atlantic Histories* exhibition, 2018
MASP.10812

"This video talks about being approached by our country's security agents who abuse their power during a police encounter.

We're here making this video to give you some tips because unfortunately we – black people – are targets of abuse and retaliation.

So if you are black pay attention to what we're saying.

Avoid leaving the house late at night. Unfortunately at night, in the eyes of other people, you're not only black but also a criminal, and dangerous.

Do not leave home without documentation. Make sure you take your ID or work permit in your bag, wallet or backpack.

Tell your friends where you're going. Let them know you're back home. Send them your location by Facebook or WhatsApp so they know where to look for you, where to find you.

Always take your cell phone and make sure it's charged. You can use it not only to make calls but also to record things. And you can also share your location with friends and family.

If you're walking around with an expensive device, like a cell phone or a camera, don't forget to take the receipt. This can be very useful in case of an unlawful or unjust apprehension.

If you're stopped by the police in a public environment, please, film the event with your phone. This is still the best way to get information about who stopped you, how they stopped you and why they stopped you.

And here's a tip, not only mine, but also from William Boner: have your phone horizontally and don't block the audio output as we need to be able to hear what the human being that approached you is saying. Try to record as much as you can, like date, place. If there are victims, get them too, victims, witnesses...

Avoid carrying drills or long umbrellas in public spaces. It seems stupid but many people look at these from far and think they are fire weapons. To avoid any problems, choose smaller umbrellas that can be folded and placed in a bag.

If you feel uncomfortable with the way you were approached, file a police report. And, remember, without your permission no one can check your phone unless a judge has ordered the apprehension. Right now, it's important to have as much information as possible so you can make a good account on your police report. So try to record the face, the ID, the uniform, the car, not only the car, its license plate too.

This is very important so you know whom you are dealing with, and so you can report the person in case there is any abuse of power.

If a public safety officer approaches you, don't make any abrupt movements and don't confront them. We know that in situations like this you end up being retaliated by the military or police officer, so don't fall for it.

Always carry the phone number of a friend or lawyer who can help you in case of an unfair intervention or even a completely arbitrary apprehension.

Always walk around with someone else, particularly if you are a woman, gay or trans.

Do not speed up the car when the police signal you to stop. Stop the car and place your hands on the steering wheel. Make sure you always have the car documents at hand.

If you need to take something from your bag or glove compartment ask permission to do so as the policeman might find that you are trying to get a gun to defend yourself.

Oh I almost forgot... never carry bleach or disinfectant in your backpack or bag.

With or without intervention, the instructions in this video have a set audience. These are our tips to help you. If you can, please share this video, tag your friends. And let's avoid deaths during these conflicts.

I'm Spartakus. I'm Edu Carvalho, reporter for *Favela da Rocinha*. My name is AD Junior, thanks for watching and see you soon!"

RITES
AND

RHYTHMS

Rites and Rhythms

This section focuses on the rites, rhythms, celebrations, ceremonies, and religions that have circulated throughout the Afro-Atlantic since the 16th century, expanding on the themes examined in Everyday Lives. Rhythms linked to rituals often facilitated channels of communication among Afro-descendants who crossed the frontiers created by European colonization.

A central figure in the historic relationship between painting and Afro-Atlantic rhythms is Heitor dos Prazeres, a Brazilian singer, composer, and painter who was also a pioneer of samba in Rio de Janeiro. In *Musicians* (ca. 1936; fig. 156), two figures dance and play traditional instruments. In *Merengue* (1937; fig. 146), Dominican artist Jaime Colson portrays a ball where people dance to the sound of merengue, music that is integral to Dominican culture and linked to African roots. Inspired by the French minuet, merengue emerged in the 19th century, combining the rhythm of African drums with "creole dances." Born in the Dominican Republic, the genre expanded across the Caribbean, Puerto Rico, and Haiti, ultimately reaching Venezuela and Angola.

Pedro Figari depicted Afro-Uruguayan customs, characters, and dances, often with nostalgic idealization. One of his most common subjects was Candombe, a pivotal cultural manifestation in his country. Candombe appeared in the 18th century from the merging of rhythms mainly derived from East and equatorial Africa, brought by Africans who disembarked on the river Plate. The music is based on rhythms of the *tangó* or *tambó* drum, a name that designates both

the dance and the places where the music is played. These activities were repressed in Uruguay until the end of the 19th century. In Figari's *Candombe* (ca. 1930; fig. 148), from the MASP collection, nine celebrants dance to music played on an instrument that looks like an *atabaque*, a type of drum used in Yoruba ceremonies.

Dirk Valkenburg depicted plants, birds, and Black and Indigenous people during his official visit to the Dutch colony of Suriname in the early 18th century at the behest of a plantation owner. In *Ritual Slave Party on a Sugar Plantation in Surinam* (1706–8; fig. 147), a group of Blacks of different genders, ages, and body type and wearing varied outfits play drums and calabashes outdoors. Very few Dutch colonial paintings are so careful in their scientific observation. The characters' gleaming skin and healthy bodies seem to reveal a perverse concern to portray slaves from the point of view of productivity.[1]

French photographer Vincent Rosenblatt documented a contemporary ritual: *funk carioca*, a dance music genre from Rio de Janeiro. In *Rio Funk Ball #22* (2006; fig. 149), four virile, bare-chested Black men hug; only one face is visible. Funk, which emerged on the international music scene in the 1960s, combines different Afro-American music genres into a pulsating, syncopated dance rhythm. In turn, *funk carioca* is a 1980s re-creation influenced by a new rhythm: Miami bass, which introduced eroticized lyrics and even quicker beats. Carlos Vergara, in an image from his series *Carnival* (1972; fig. 150), produced at the height

of the Brazilian military dictatorship, captured members of Cacique de Ramos, a traditional Carnival street troupe founded in 1961 in the Rio neighborhood of Ramos, in the city's north zone. Vergara recorded new ways of representing Black empowerment by showing three half-naked Black men outdoors, with the word POWER written in white on their chests, looking directly at, and challenging, the photographer's lens. The word conjures a sort of political street art on their skin.

One of the first known representations of Carnival was produced by French artist Jean-Baptiste Debret. *Carnival* (1823; fig. 151) shows how the event unfolded on the streets of Rio: with barefoot slaves, faces painted white, throwing limes. Accompanying text in Debret's book *Voyage pittoresque et historique au Brésil* (1834–39) states that a third of Brazil's white population joined the party. However, it is worth noting that Debret's data and images are not always reliable.

Carnival is a frequent subject in Brazilian modernist painting. One of the artists who most thoroughly explored the theme was Emiliano Di Cavalcanti, who was himself considered a "nonwhite" person.[2] It could not have been more fertile ground for a modernist painter whose main concern was to construct emblems of Brazilian identity in paint: full of color and movement, it allowed for complexity and local inflection (when compared to Euro-American modernism). *Carnival* (1969; fig. 152) exemplifies the work of Di Cavalcanti's later years, as his colors and patterns became more intense, his brushstrokes

and lines freer, imbuing the scene with exuberance and vivacity.

Powerful and infectious, Carnival spread along the Black Atlantic coast and acquired multiple forms. In Haiti, Sénèque Obin was connected to the Centre d'Art in the capital Port-au-Prince. Key to the development of Haitian arts, the center hosted debates and exhibitions with the participation of local artists, intellectuals, and foreign visitors such as André Breton. In Obin's *Carnival* (ca. 1956; fig. 153), a dense crowd of costumed and masked characters occupies a small village with only a few brightly colored houses set against emerald green hills. Ellis Wilson, an African American artist who belonged to the Harlem Artists Guild, traveled to Haiti in 1952 on a Guggenheim travel grant. The trip changed his life. *Carnival* (mid-1950s; fig. 155), likely based on his experiences there, is a bird's-eye view of four colorfully dressed stilt-walkers with elongated bodies. Palm fronds overhead suggest a tropical context.

In Cuba, Carnival was painted by René Portocarrero, a ceramist, sculptor, painter, and muralist who traveled throughout the Caribbean, Europe, and the United States and worked with Wifredo Lam. *Carnival Figure* (1962; fig. 154), from the series *Colors of Cuba*, shows a character in the middle of the canvas painted in an expressionistic style using yellow, red, brown, and black tones. The exuberant and intricate costume, featuring several accessories, seems to multiply and merge into the background by means of strongly marked strokes on the painting's surface.

Other popular rites have spread via Afro-Atlantic routes, including the Three Kings Day Party. From at least 1850 on, the Spaniard Victor Patricio Landaluze lived in Cuba, where he produced *Three Kings Day in Havana* (fig. 160). The same celebrations can be seen in 20th-century Brazilian paintings such as Lula Cardoso Ayres's *Composition* (1972; fig. 159) and Noemia Mourão's *Untitled* (fig. 161).

Isaac Mendes Belisario's *Sketches of Character: In Illustration of the Habits, Occupation, and Costume of the Negro Population in the Island of Jamaica* (1837–38; figs. 157, 158) added to the corpus of publications following voyages made by artists to the Americas and the Caribbean. In Belisario's case, the material was collected shortly after the 1834 abolition of slavery in Jamaica. His lithographs illustrate Black characters in elaborate themed costumes—e.g., "French Set-Girls," "Koo Koo"—attending street parties. African street parties were often linked to religious rituals that took different configurations in Afro-Atlantic territories. These rituals, performed in honor of orishas and Black saints, are central to Candomblé, Macumba, and Umbanda in Brazil, Voodoo in Haiti, Revivalism in Jamaica, and Santería in Cuba.

Eshu, the orisha of communication and of order and discipline who mediates between divine and earthly realms, appears here in two traditional Yoruba sculptures in the MASP collection (figs. 162, 163) and a painting by Abdias Nascimento. As a poet, activist, actor, playwright, teacher, and twice senator of the state of Rio de Janeiro, Nascimento played a

crucial role in the Afro-Brazilian culture of his time. In his *Eshu Dambalah* (1973; fig. 164), the deity projects his spears in a geometric composition, highlighting the double image of the serpent, which represents an important *loa* (spirit) in Voodoo rituals.

Shango, the orisha of justice, thunder, and fire, is represented in 19th-century sculptures from Benin and Bahia (figs. 165, 166), and in the works of Pierre Verger, a French-Brazilian photographer, ethnologist, and *babalawo* (Yoruba priest). Verger's photographs here document two rituals in honor of Shango, one in Ouidah, Benin, the other in Salvador, Brazil, in the 1940s (figs. 167, 168). The same deity appears in the works of two African American artists, *Notes from Tervuren* (2015; fig. 170) by Radcliffe Bailey and *Shango* (1972; fig. 169) by David Driskell, as well as an illustration by Brazilian artist Celina (fig. 171). Paintings dedicated to Iemanjá, the mother of fish and the goddess of fertility, maternity, water, children, and the elderly, were produced by Portocarrero (1962; fig. 173), Maria Auxiliadora (1974; fig. 172), and Edsoleda Santos (2015; fig. 174). In all three cases, she is portrayed as a Black deity. *Oshosi Hunting* (fig. 175) by Rafael Borjes de Oliveira depicts the orisha of forests and the hunt. The Caboclo, an Afro-Amerindian entity, appears in a sculpture formerly in the collection of the Italo-Brazilian architect and intellectual Lina Bo Bardi (fig. 180).

Black saints feature in Portocarrero's *Saint Barbara* (1962; fig. 182) and Alfredo Volpi's *Saint Benedict* (1960s; fig. 183). In *Slum Christ* (1955; fig. 179), Brazilian Octávio Araújo depicts Christ crucified in a favela, the heads of two policemen looming in the foreground, a shantytown scaling the hill behind. This painting was part of the famous competition "Black Christ" promoted by Nascimento's Experimental Black Theater in 1955.

A number of African-based rituals appear in works such as *Ceremony* (ca. 1978; fig. 187) by Haitian Rigaud Benoit; *Revivalists* (1969; fig. 188) by Jamaican Mallica "Kapo" Reynolds; *The Oracle* (1949; fig. 177) by Cuban Roberto Diago; *Women from Bahia* (1957; fig. 189) by Brazilian-Argentinian Carybé; *Amalá in the Forest* (1971; fig. 186) by Brazilian Rosina Becker do Valle; and Auxiliadora's *Candomblé* (1966–68; fig. 184). Ceremonies, food, accessories, offerings, deities, trances, instruments, and priests dominate representations produced on the African continent, which were re-created throughout the Afro-Atlantic. Despite their diverse origins, they share the use of African languages in their songs, references to African deities, cosmogonies, and conceptions of nature.

1. Charles Ford et al., "The Slave Colonies," in *The Image of the Black in Western Art—Volume III: From the Age of Discovery to the Age of Abolition*, ed. David Bindman and Henry Louis Gates (Cambridge, Mass.: Harvard University Press, 2010), 243–44.

2. Paolo Herkenhoff, "Identidade em trânsito," in *Arte brasileira na coleção Fadel: Da inquietação do moderno à autonomia da linguagem* (Rio de Janeiro: Andrea Jakobsson Estúdio, 2002), 46–55.

Maria Auxiliadora

Campo Belo, Minas
Gerais, Brazil 1935–
1974 São Paulo

145. *Untitled*, 1968
Mixed media on
canvas, 50 x 65 cm
Museu de Arte de
São Paulo Assis
Chateaubriand – MASP
Gift of Teresa Bracher
in the context of the
exhibition *Histories of
Dance*, 2020-21
MASP.11212

Jaime Colson

Puerto Plata,
Dominican Republic
1901–1975 Santo
Domingo

146. *Merengue*, 1937
Oil on canvas,
52 x 68 cm
Museo Bellapart,
Santo Domingo

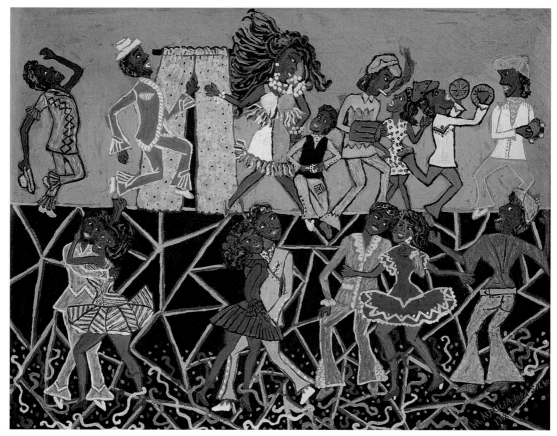

145

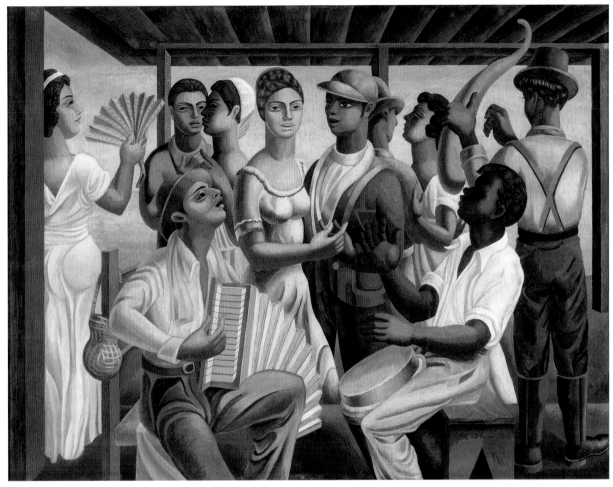

146

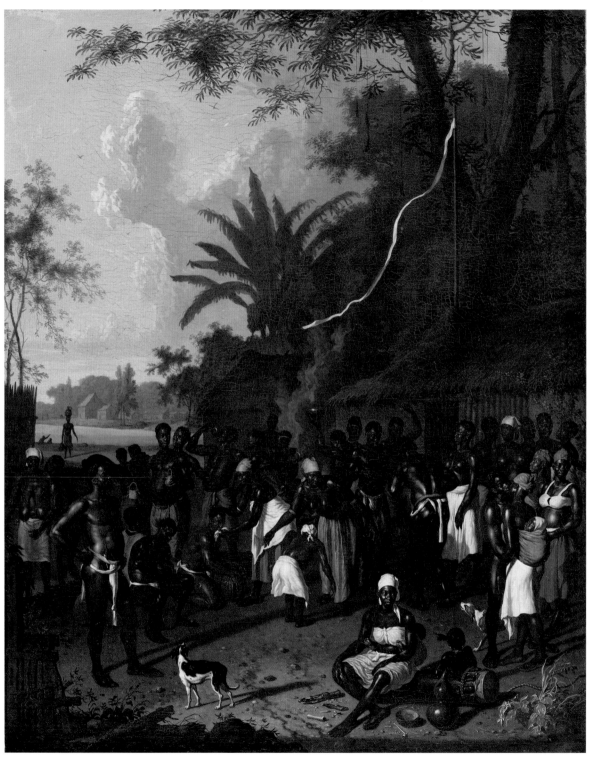

147

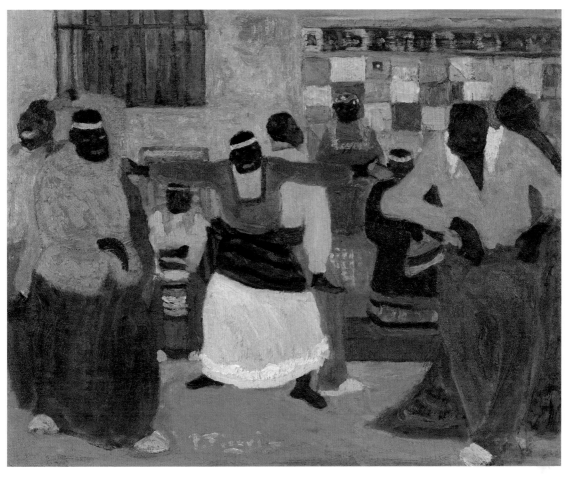

148

Dirk
Valkenburg

Amsterdam 1675–
1721 Amsterdam

147. *Ritual Slave
Party on a Sugar
Plantation in
Surinam*, 1706–8
Oil on canvas,
58 x 46 cm
Statens Museum
for Kunst (SMK),
Copenhagen

Pedro
Figari

Montevideo 1861–
1938 Montevideo

148. *Candombe*, ca.
1930
Oil on cardboard,
39.5 x 49.5 cm
Museu de Arte de
São Paulo Assis
Chateaubriand–
MASP, Purchased
with funds provided
by Grupo Segurador
Banco do Brasil
e Mapfre, 2017,
MASP.01653

149

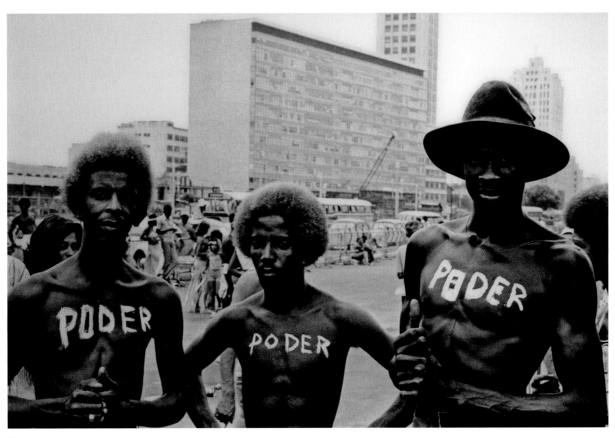

150

Vincent Rosenblatt

b. Paris, 1972; lives in Rio de Janeiro

149. *Rio Funk Ball #22*, 2006
Fine Art Print, pigmented ink on (R) Baryta paper, 100 x 66 cm
Collection of the artist, Rio de Janeiro

Carlos Vergara

b. Santa Maria, Rio Grande do Sul, Brazil, 1941; lives in Rio de Janeiro

150. *Untitled*, from the series *Carnival*, 1972
Methacrylate, 101 x 151 cm
Private collection, São Paulo

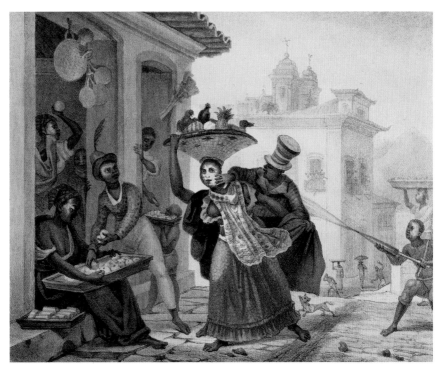

151

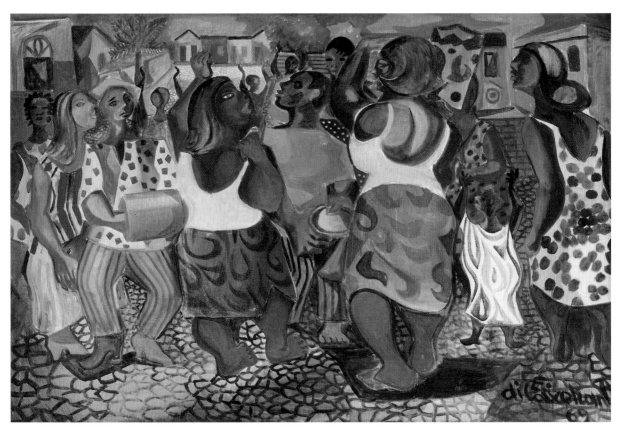

152

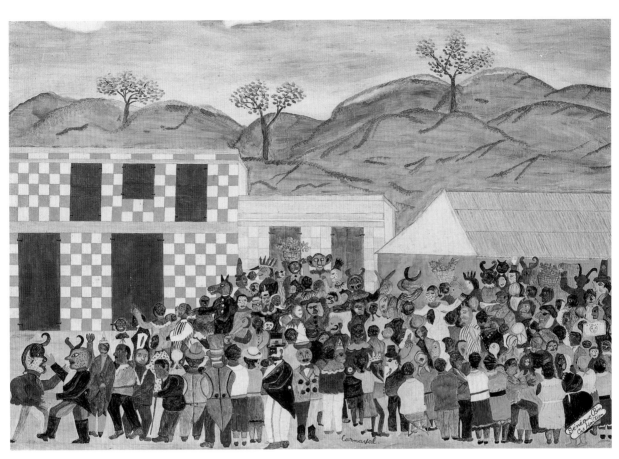

153

Jean-
Baptiste
Debret

Paris 1768–1848
Paris

151. *Carnival*, 1823
22 x 18 cm
The New York Public
Library

Emiliano Di
Cavalcanti

Rio de Janeiro 1897–
1976 Rio de Janeiro

152. *Carnival*, 1969
Oil on canvas,
96 x 146 cm
Private collection,
São Paulo

Sénèque
Obin

Cap-Haitien, Haiti
1893–1977 Cap-
Haitien

153. *Carnival*, 1956
Oil on Masonite
53 x 76 cm
Museu de Arte de
São Paulo Assis
Chateaubriand – MASP
Gift of Lais H. Zogbi
Porto and Telmo
Giolito Porto in the
context of the *Afro-
Atlantic Histories*
exhibition, 2018
MASP.10883

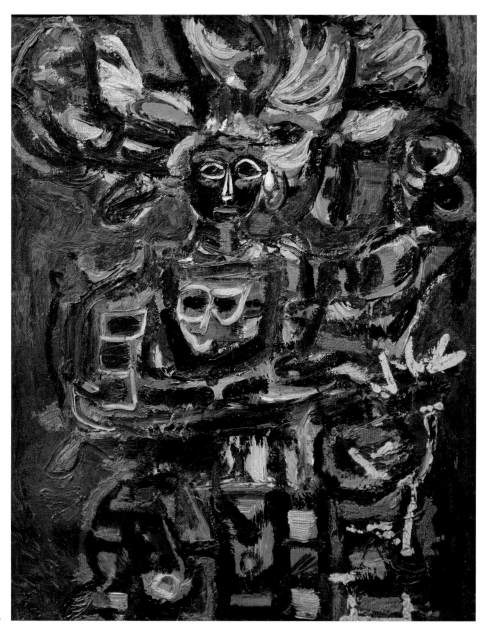

154

René
Portocarrero

Ellis
Wilson

Havana 1912–1985
Havana

Mayfield, Kentucky
1899–1977 New York
City

154. *Carnival Figure*,
frm the series *Colors
of Cuba*, 1962
Oil on canvas,
51 x 41 cm
Museo Nacional de
Bellas Artes, Havana

155. *Carnival*,
ca. 1950
Oil on Masonite,
107 x 71 cm
Courtesy of Michael
Rosenfeld Gallery,
New York

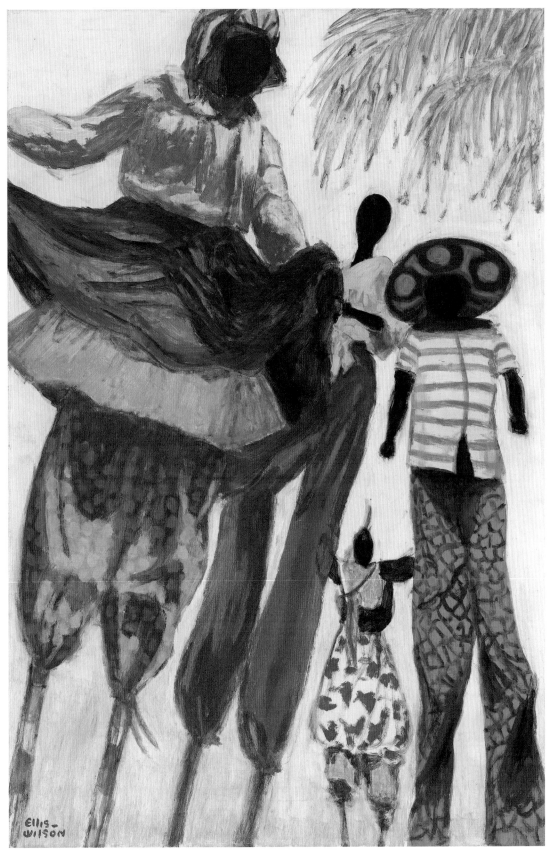

155

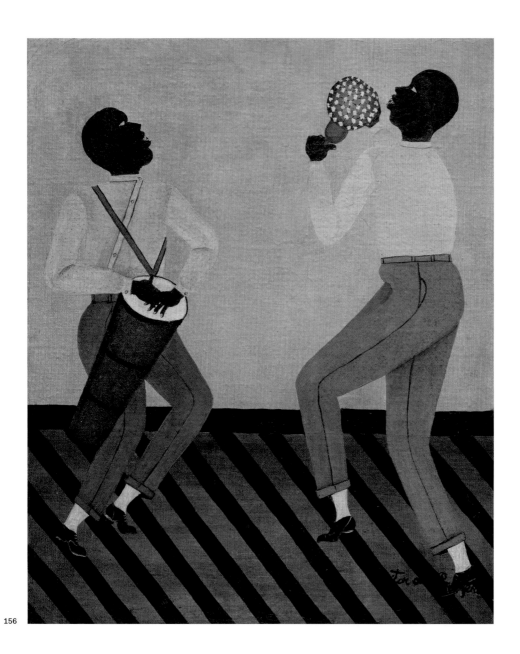

156

Heitor dos
Prazeres

Rio de Janeiro 1898–
1966 Rio de Janeiro

156. *Musicians*,
1950s
Oil on canvas
46 x 38 cm

Museu de Arte de
São Paulo Assis
Chateaubriand – MASP
Gift of Rafael Moraes
in the context of the
exhibition Histories of
Dance, 2020
MASP.11001

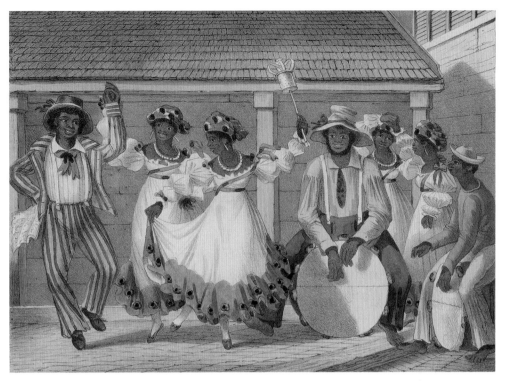

157

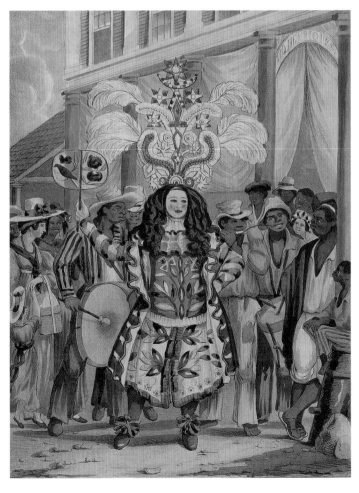

158

Isaac Mendes Belisario

Kingston, Jamaica
1795–1849 London

157, 158. **French Set-Girls** and **Koo Koo, or Actor-Boy**, from *Sketches of Character: In Illustration of the Habits, Occupation, and Costume of the Negro Population in the Island of Jamaica*,

Kingston, 1837–38
Lithographs,
24.5 x 33 cm (157),
37.5 x 26 cm (158)
Yale Center for British Art, New Haven, Paul Mellon Fund (157)
National Gallery of Jamaica, Kingston, Collection of the Hon. Maurice Facey and Mrs. Facey (158)

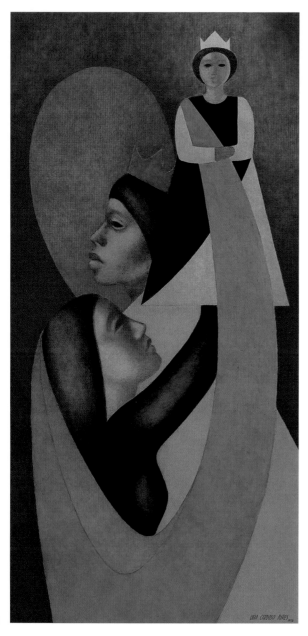

159

Lula Cardoso Ayres

Recife, Pernambuco, Brazil 1910–1987 Recife

159. *Composition*, 1972
Acrylic on canvas, 119 x 60 cm
Museu de Arte de São Paulo Assis Chateaubriand– MASP, MASP.00588

Victor Patricio Landaluze

Bilbao, Spain 1828– 1889 Havana

160. *Three Kings Day in Havana*, mid-19th century
Oil on canvas, 51 x 61 cm
Museo Nacional de Bellas Artes, Havana

Noemia Mourão

Bragança Paulista, São Paulo 1912–1992 São Paulo

161. *Untitled* (*Kings Party*), undated
Oil on canvas, 54.5 x 46.5 cm
Private collection, São Paulo

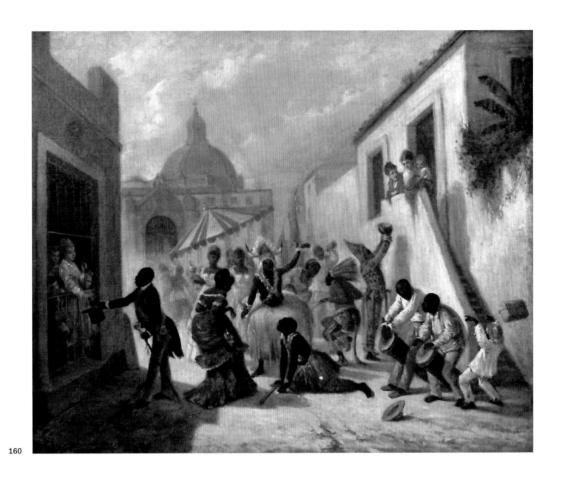

160

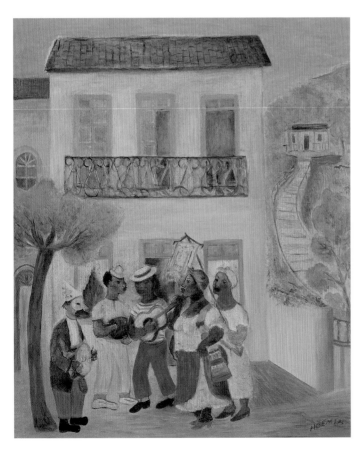

161

189

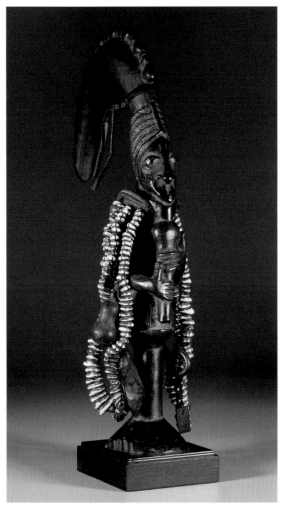

162

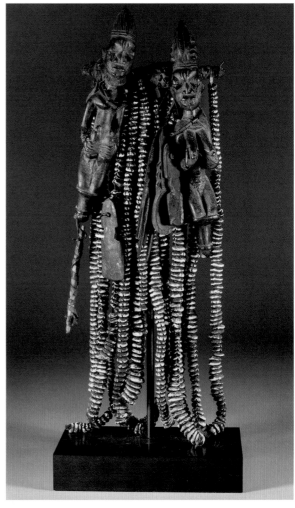

163

Unidentified Artist

162. *Eshu*, undated
Wood, metal, leather, and shells
Museu de Arte de São Paulo Assis Chateaubriand–MASP, Gift of Cecil Chow Robilotta and Manoel Roberto Robilotta, in memory of Ruth Arouca and Domingos Robilotta, 2012, MASP.01588

Unidentified Artist

163. *Pair of Eshus*, 20th century
Polychromed wood, natural fiber, leather, shells, beads, and ceramic
Museu de Arte de São Paulo Assis Chateaubriand–MASP, Gift of Cecil Chow Robilotta and Manoel Roberto Robilotta, in memory of Ruth Arouca and Domingos Robilotta, 2012, MASP.01572

Abdias Nascimento

Franca, São Paulo
1914–2011 Rio de Janeiro

164. *Eshu Dambalah*, 1973
Acrylic on canvas, 102 x 51 cm
Instituto de Pesquisas e Estudos Afro-Brasileiros (Ipeafro), Rio de Janeiro

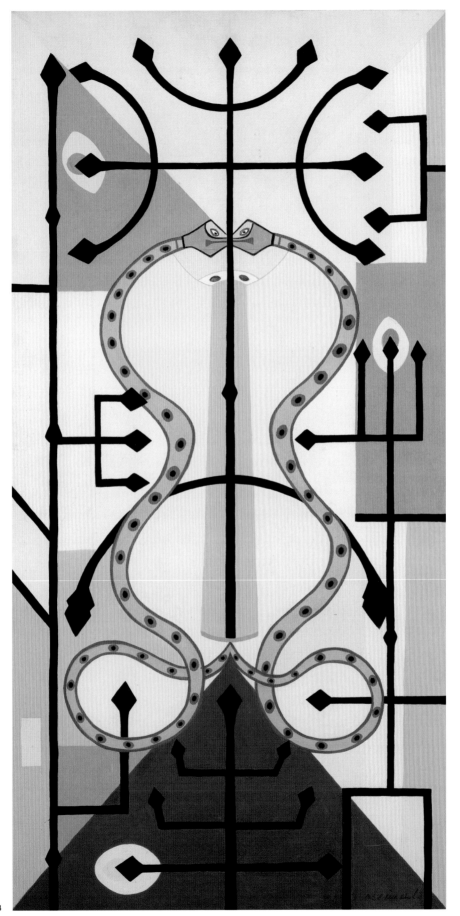

191

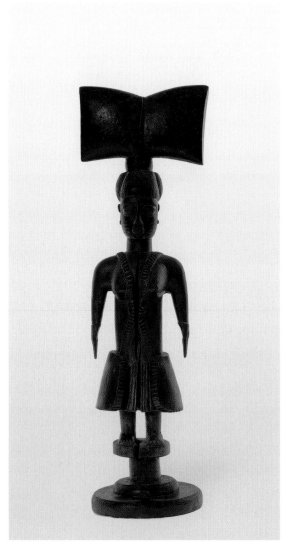

165

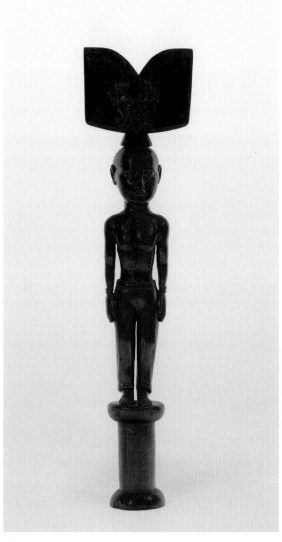

166

Unidentified
Artist

Benin and Nigeria

165. *Oxê of Shango—*
Orisha's Tool,
19th century
Wood, 53 x 16 x 15.5 cm
Museu Afro Brasil,
São Paulo

Unidentified
Artist

Bahia

166. *Oxê of Shango—*
Orisha's Tool,
19th century
Wood, 57 x 14 x 7.5 cm
Museu Afro Brasil,
São Paulo

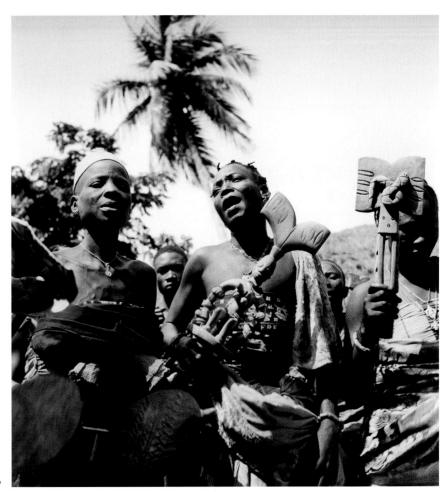

167

Pierre Verger

Paris 1902–1996
Salvador, Bahia

167. *Nagô Ceremony, Ouidah, Benin*, 1948–49

168. *Candomblé Joãozinho da Gomeia*, 1946
Photographic prints, each 40 x 40 cm
Fundação Pierre Verger, Salvador

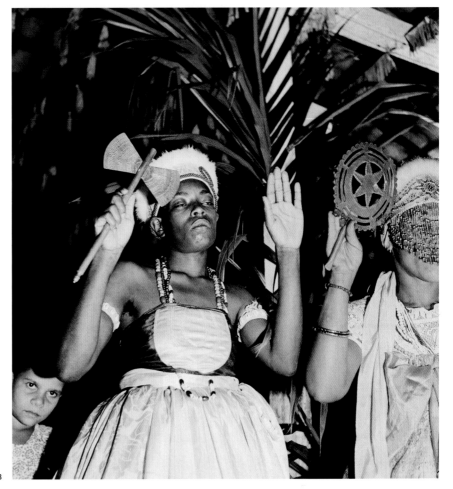

168

169

David C. Driskell

Eatonton, Georgia
1931–2020
Hyattsville, Maryland

169. *Shango*, 1972
Egg tempera and
gouache on paper,
61 x 45.5 cm
Courtesy of DC Moore
Gallery, New York

Radcliffe Bailey

b. Bridgeton, New
Jersey, 1968; lives in
Atlanta

170. *Notes from
Tervuren*, 2015
Gouache, collage, and
ink on sheet music,
30.5 x 24 cm
Private collection,
New York, courtesy
of the artist and Jack
Shainman Gallery,
New York

Celina

171. *Shango*, undated
Oil on paper,
50 x 60 cm
Private collection,
São Paulo

170

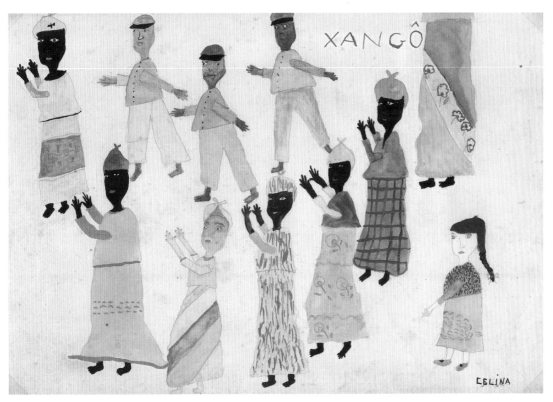

171

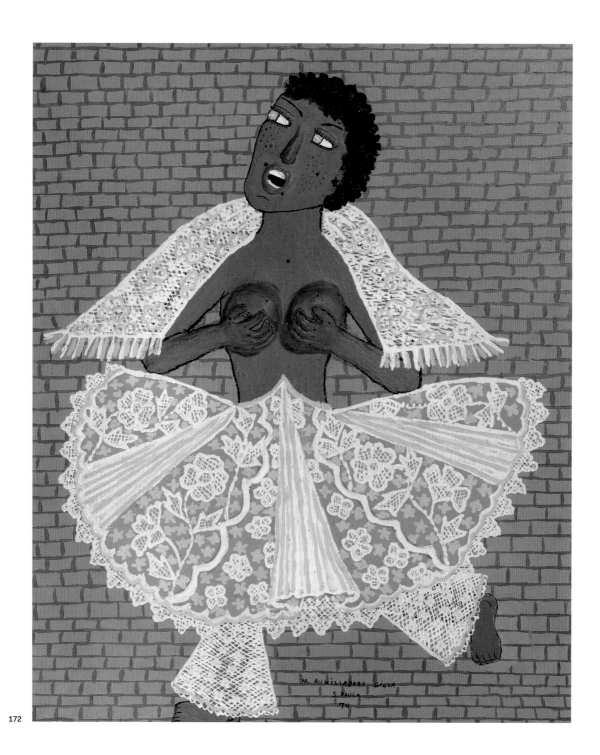

172

Maria Auxiliadora

Campo Belo, Minas
Gerais, Brazil 1935–
1974 São Paulo

172. *Iemanjá Holding
Her Breasts*, 1974
Oil on canvas,
65 x 55 cm
Collection of Irapoan
Cavalcanti,
Rio de Janeiro

173

René
Portocarrero

Havana 1912–1985
Havana

173. *Iemanjá*, 1962
Oil on canvas,
48 x 38 cm
Museo Nacional de
Bellas Artes, Havana

174

175

Edsoleda Santos

b. Salvador, Bahia,
1939; lives in Salvador

174. *Iemanjá II*, 2015
Acrylic and watercolor
on paper, 29 x 37 cm
Collection of the
artist, Salvador

Rafael Borjes de Oliveira

Santo Amaro da
Purificação, Bahia ca.
1912–?

175. *Oshosi Hunting*,
undated
Oil on wood,
53 x 80 cm
Museu de Arte de
São Paulo Assis
Chateaubriand–
MASP, Gift of
the artist, 1952,
MASP.00348

176

David C.
Driskell

Eatonton, Georgia
1931–2020
Hyattsville, Maryland

176. *Current Forms:
Yoruba Circle*, 1969
Acrylic on canvas,
112.5 x 86.5 cm
Courtesy of DC Moore
Gallery, New York

Roberto
Juan Diago
y Querol

Havana 1920–1955
Madrid

177. *The Oracle*, 1949
Oil on canvas,
150 x 89 cm
Museo Nacional de
Bellas Artes, Havana

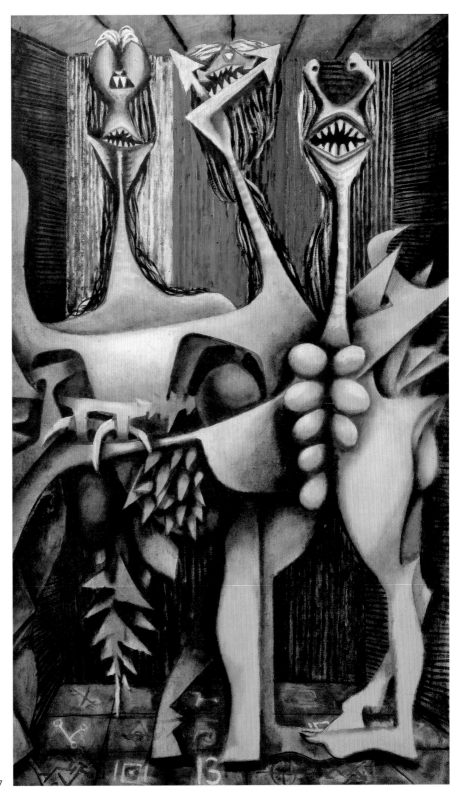

177

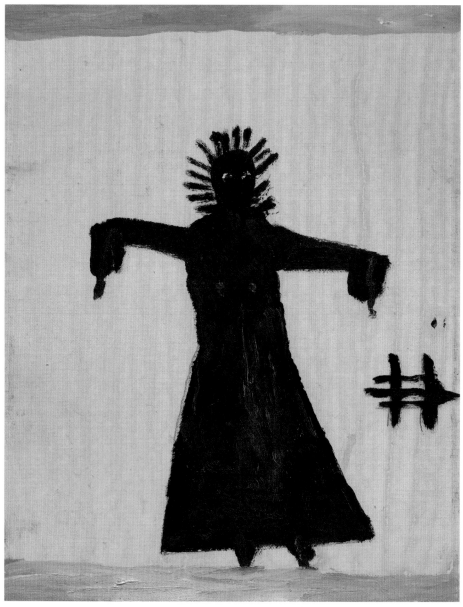

178

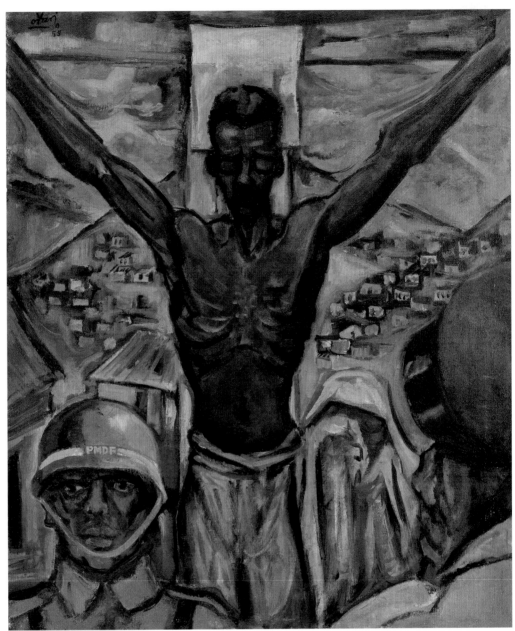

179

Clementine Hunter

Natchitoches Paris,
Louisiana ca. 1886–
1988 Natchitoches
Parish

178. **Black Jesus**, ca.
1985
Oil or acrylic on
canvas board,
36 x 28 cm

National Museum
of African American
History and Culture,
Smithsonian
Institution,
Washington, D.C., Gift
of Henley A. Hunter,
Kathey N. Hunter, and
Anne Kathryn Hunter,
2012.168

Octávio Araújo

Terra Roxa, São Paulo
1926–2015 São Paulo

179. **Slum Christ**,
1950
Oil on canvas,
64 x 53 cm
Instituto de Pesquisas
e Estudos Afro-
Brasileiros (Ipeafro),
Rio de Janeiro

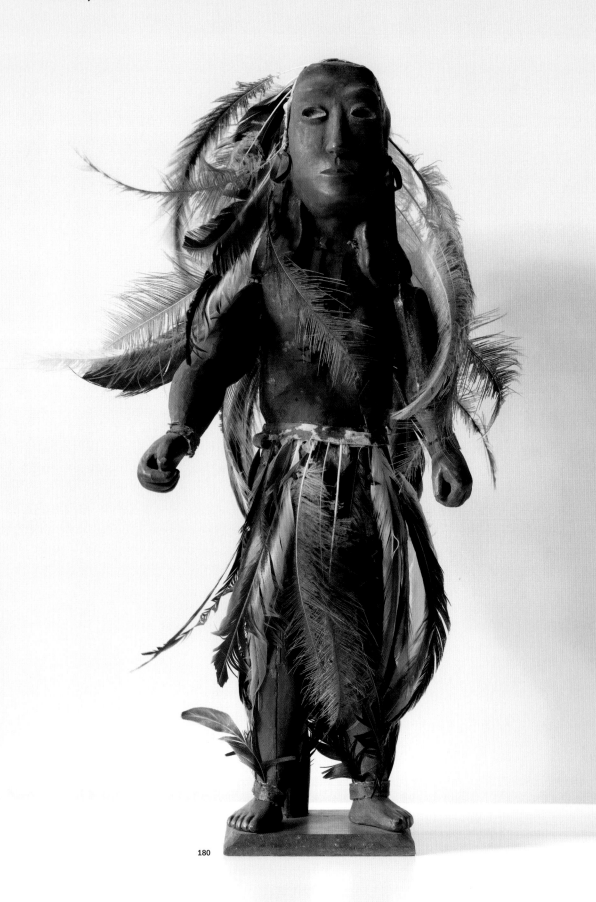

180

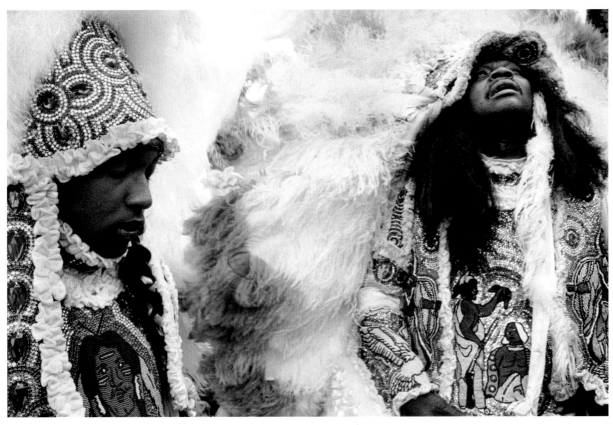

181

Unidentified Artist

Marilyn Nance

180. *Caboclo*, undated
Polychromed wood and feathers,
56 x 34 x 34 cm
Instituto Bardi/Casa de Vidro, São Paulo

b. New York City, 1953; lives in New York City

181. *The White Eagles, Black Indians of New Orleans*, 1980
Gelatin silver print,
50.8 x 61 cm
Light Work, Syracuse

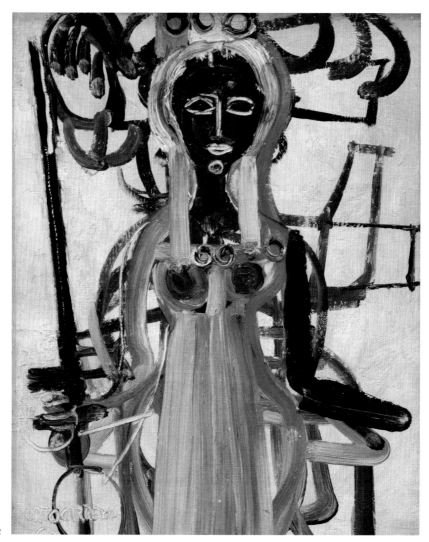

182

René
Portocarrero

Havana 1912–1985
Havana

182. *Saint Barbara*,
1962
Oil on canvas,
51 x 41 cm
Museo Nacional de
Bellas Artes, Havana

Alfredo
Volpi

Lucca, Italy 1896–
1988 São Paulo

183. *Saint Benedict*,
1960s
Tempera on canvas,
135 x 67 cm
Private collection,
São Paulo

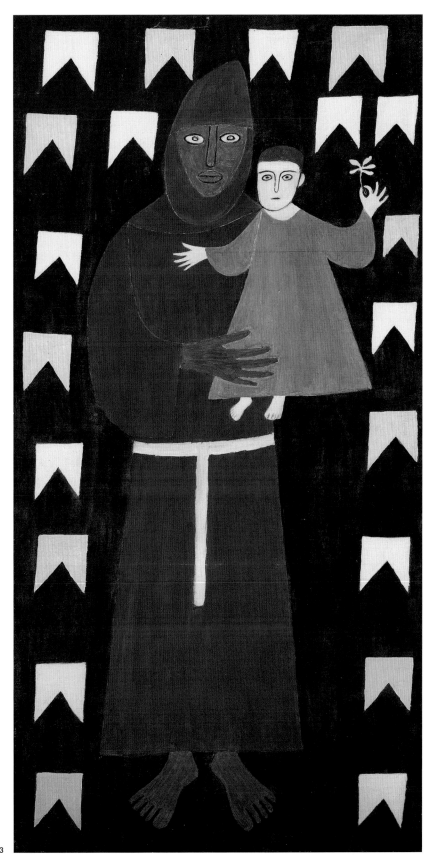

183

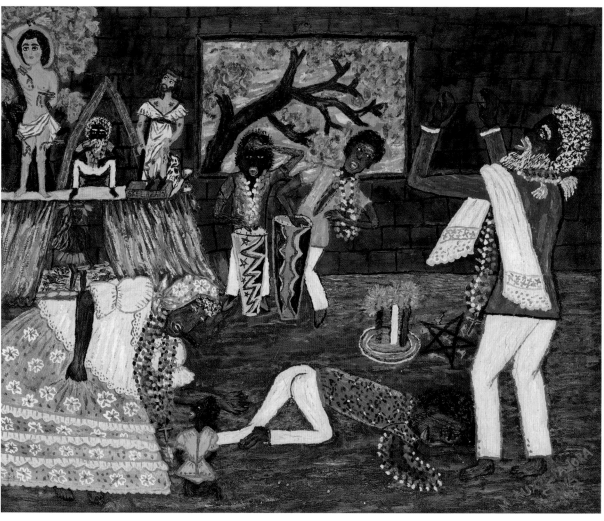

184

Maria
Auxiliadora

Campo Belo, Minas
Gerais, Brazil 1935–
1974 São Paulo

184. *Candomblé*,
1968
Oil on canvas
50 x 60 cm
Museu de Arte de
São Paulo Assis
Chateaubriand – MASP

Gift of Lais H. Zogbi
Porto and Telmo
Giolito Porto in the
context of the Afro-
*Atlantic Histories
exhibition*, 2018
MASP.10732

Wilson
Bigaud

Port-au-Prince 1913–
2010 Petit-Goâve,
Haiti

185. *Untitled
(Ceremony)*, ca. 1947
Oil on board,
51 x 61 cm
ZQ Art Gallery,
New York

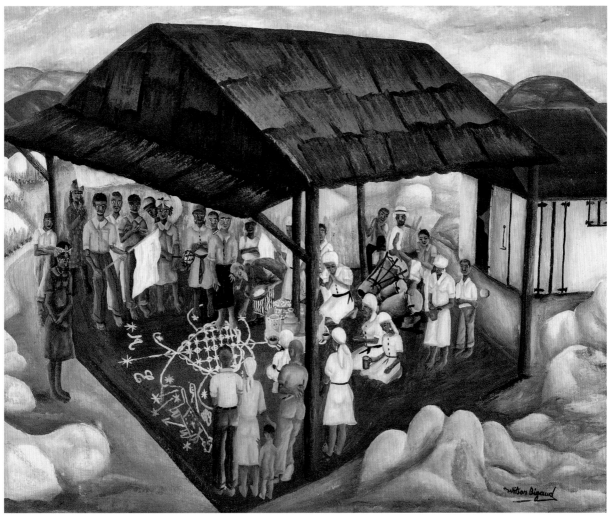

185

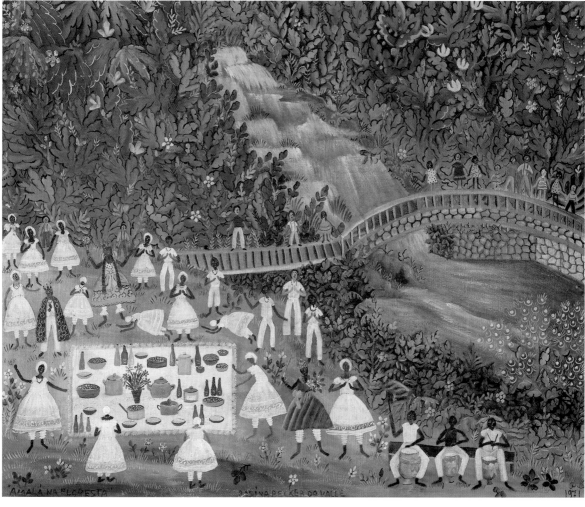

186

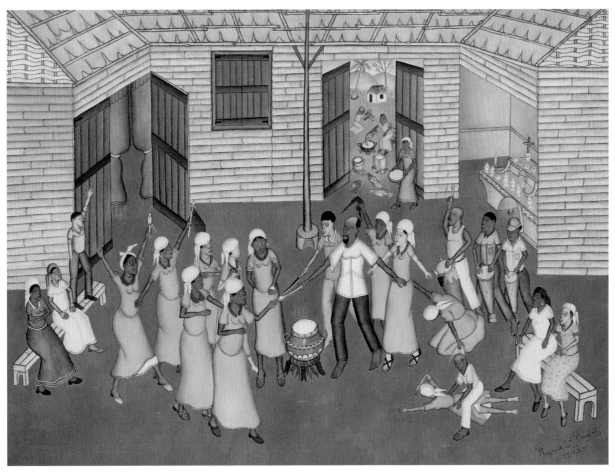

187

Rosina
Becker do
Valle

Rio de Janeiro 1914–
2000 Rio de Janeiro

186. *Amalá in the
Forest*, 1971
Oil on canvas,
60 x 73 cm
Private collection,
São Paulo

Rigaud
Benoit

Port-au-Prince
1911–1986 Port-au-
Prince

187. *Ceremony*,
ca. 1978
Oil on masonite,
61 x 76 cm
ZQ Art Gallery,
New York

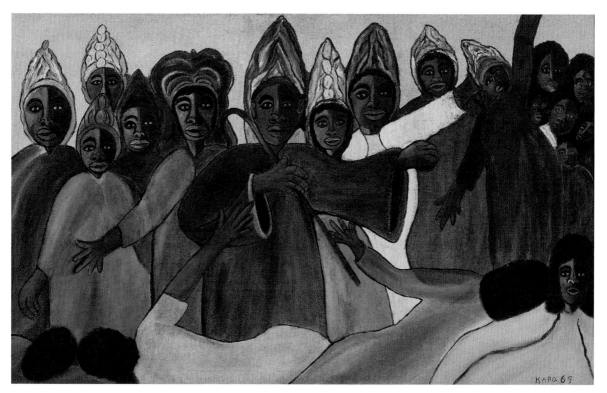

188

Mallica
"Kapo"
Reynolds

Carybé

Saint Catherine,
Jamaica 1911–1989

Lanús, Argentina
1911–1997 Salvador,
Bahia

188. *Revivalists*, 1969
Oil on hardboard,
76 x 122.5 cm
National Gallery of
Jamaica, Kingston

189. *Women from
Bahia*, 1957
Oil on wood,
200 x 230 cm
Collection of Patrício
Santana, Salvador

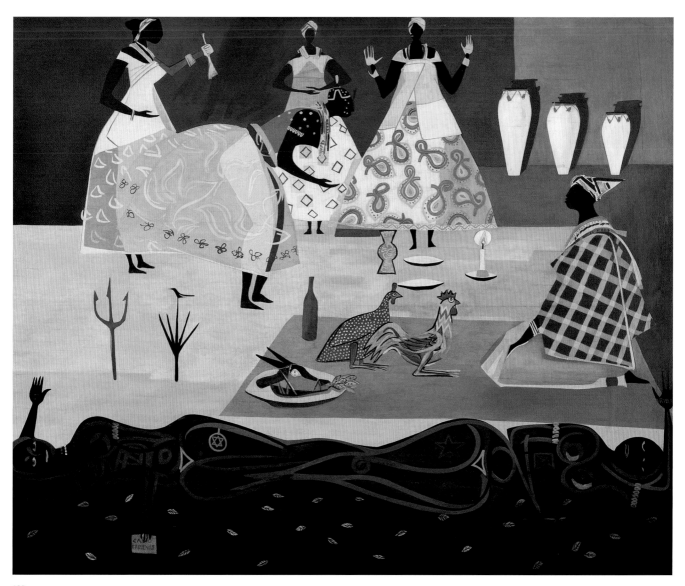

189

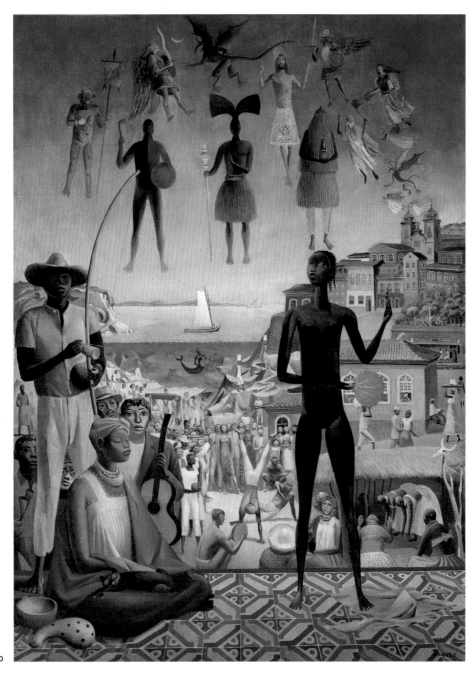

190

Carybé

Lanús, Argentina
1911–1997 Salvador,
Bahia

190. *Alexandrina and
Her City*, 1944
Oil on canvas,
110 x 80 cm
Collection of Adriana
Varejão, Rio
de Janeiro

PORTRAITS

Portraits

Portrait collections in European and U.S. museums typically feature images of royals, government officials, religious leaders, and local elites. These are almost all portraits of white people, and usually men. Representations of Black men and women are rare, and individual portraits even rarer. This form of social invisibility suffered by Afro-descendant men and women prevails in image conventions, which often reiterate gender, race, class, and regional stereotypes that permeate all sectors of society. This section presents a large selection of portraits of Black subjects produced by artists from different places and periods in a variety of mediums.

Commissioned specifically for *Afro-Atlantic Histories*, the portraits of João de Deus Nascimento and Zeferina (2018; figs. 194, 195) by Brazilian artist Dalton Paula commemorate Black leaders whose voices have been excised from official versions of history and whose likenesses were never re-

corded. Born to a freed Black woman, João de Deus, a tailor, was a leader of the Bahian Conspiracy of 1798. Also known as the Tailors' Conspiracy, this separatist rebellion, with predominantly Black participation, demanded independence from Portugal and the end of slavery. João de Deus organized artisans, soldiers, traders, students, and intellectuals around the ideals of the French Revolution (1789) and pursued both racial and gender equality, pioneering agendas at the time. When the Portuguese crown discovered the conspiracy, its leaders were executed. Zeferina, an enslaved woman from Angola, was brought to Brazil as a child in the 19th century. She eventually rebelled against the regime and escaped to Quilombo do Urubu, a runaway community located in the area around today's Saint Bartholomew Park on the outskirts of Salvador. An icon of resistance, Zeferina played a key role in the *quilombo* and was granted the titles of queen, warrior, and chief by the community. She

planned an uprising with runaways and Indigenous people in which they intended to invade Salvador, kill white people, and declare freedom. The insurrection, launched on Christmas 1826, was violently demobilized by imperial forces. Zeferina was arrested and sentenced to death. Paula's portraits give a face to these resistance icons whose biographies and contributions should be recognized in Brazilian history books.

Dutchman Albert Eckhout lived in Brazil for seven years (1637–44) during the period of Dutch rule, hired by the colony's governor Johan Maurits to paint the flora, fauna, and local population. His series of four pairs of ethnographic portraits of Brazilian people is well known. Reproduced here are *African Man* and *African Woman with Child* (both 1641; figs. 191, 193). Despite the clearly Brazilian setting, these portraits have often been interpreted as African, probably because the subjects were among the first generation of Africans in Brazil. Moreover, the paintings were long considered an accurate depiction of reality. Today we know that they mix the real and the imaginary. Eckhout borrowed from European ethnographic and portrait conventions, as well as *casta* paintings produced in Spanish America and allegorical works representing the four continents. The artist offers a softened view of the "Dutch tropics": the couple do not seem to be slaves, although the same Black woman appears in a watercolor by German artist Zacharias Wagener with a property number branded on her chest. The portraits have a hybrid quality, combining African, "Brazilian," and European elements. The woman's accessories—a straw hat similar to those worn by the Fula people of West Africa, earrings, a beaded necklace, a pearl pendant, a red coral necklace, a gold or brass bracelet, and a beaded wristlet—blend African and European ornamentation. The basket with Brazilian fruits held aloft in her right hand displays African craftwork, possibly from Angola or Congo. The tree is probably a carnauba palm, native to the Brazilian northeast. Her chest is bare and her body sharply delineated against the gray sky. A red belt and patterned skirt, possibly from the Akan people of Ghana, reveal the painter's intention to highlight her African background. The child next to her is holding a corncob in one hand. Corn was not a native species, but its cultivation in Brazil had already begun. Perched on the boy's other hand is a New World bird, the red-masked parakeet. Seacraft on the horizon symbolize the ongoing Dutch colonization of the tropics. Slaves work on the beach at the right, a scene often interpreted as a *quilombo*.

African Man also contains hybrid elements. The shells on the ground may refer to the beaches of Recife, but the tree resembles an African date palm. The elephant tusk at lower right is not from an animal found in Brazil. An Akan machete is belted to the man's waist, and his spears seem Indigenous. The pink shell attached to the machete is from the Canary Islands. This object was very valuable among the Akan people due to its perceived supernatural powers, including the ability to protect from lightning. Some elements highlight the virile

and phallic nature of the image. The long machete, its feather tassel (also Ghanaian), and the palm evoke the phallus. Both figures, majestic despite their bare feet, are linked by the creeping ground vegetation, scattered with white flowers, and a common Afro-Atlantic horizon line, which traverse both paintings when they are viewed as pendants.

Contemporary U.S. artist Ellen Gallagher responded to Eckhout's portraits in a watercolor produced for *Afro-Atlantic Histories*. Gallagher has a keen interest in the Black Atlantic. The liquid reference is contained in her title, *Watery Ecstatic* (2018; fig. 192). The image suggests an underwater landscape. For Gallagher, the permanent wounds of trauma reside in the "sea" of the body, according to Natasha Trethewey. The vegetation refers directly to that in Eckhout's *African Man* and *African Woman*, along with his well-known still life *Manioc*. Although Gallagher's work would not be classified as traditional portraiture, its proportions and imagery suggest a full-length rendition of a figure, especially when juxtaposed to Eckhout's pictures, whose dimensions are similar.

Don Miguel de Castro, an envoy from the Kingdom of Congo to the Dutch court in Recife, aimed to engage with Holland via Brazil, a gesture that demonstrates the circuit of power between Africa, the Americas, and Europe across the Afro-Atlantic. His portrait (ca. 1643; fig. 200) is one of three paintings by an unidentified artist who also depicted the diplomat's servants, Diego Bemba and Pedro Sunda, in smaller, less complex works.

The most striking feature here is the sitter's proud stance. He gazes directly at the viewer. His elaborate clothing is typical of the period (the large white collar, for instance, is seen in many portraits by Rembrandt and Frans Hals). He wears a black hat with a band of jewels and a bright red feather. A decorative silver strap crosses his embroidered blouse. On the one hand, this is a faithful representation of a free African who traveled to Brazil during slavery; on the other, it is a Europeanized travesty, as demonstrated by his wealthy clothes and Dutch accessories.

The same might be said of *Francis Williams, the Scholar of Jamaica* (ca. 1745; fig. 198). The artist is unknown but likely was Jamaican. Williams was sent to study in London by the duke of Montagu. He was one of the few Black men to receive an English education at the time. Upon his return to Jamaica, he founded a school for Blacks in Spanish Town, the capital of the British colony. In the painting, Williams wears a white wig in the style of the English aristocracy, and is surrounded by globes and books written by Isaac Newton and John Locke. The image follows European conventions of the scholar portrait, but it is cast in a vernacular style, perhaps with satirical intentions.

Alchitrof, Emperor of Ethiopia (1568; fig. 206) is part of a group of at least 280 portraits of dignitaries, poets, and artists—such as Dante, Leonardo da Vinci, and Catherine de' Medici—executed by Italian Cristofano dell'Altissimo and based on different documents. The emperor appears in an exotic and fanciful representation that combines Black and Indigenous aspects and

reflects the European imaginary from the period of the early invasions. He holds a mirror, suggesting the allure of European objects, and wears jewels in his pierced ears and lips, as well as a colorful feathered headdress.

Another Europeanized painting is *Portrait of an African* (ca. 1758; fig. 196), in which a Black man in the latest English attire looks out confidently at the viewer. The sitter was formerly thought to be Olaudah Equiano, a Nigerian writer and abolitionist. Recent research points to his identity as Ignatius Sancho. A writer and composer who was born on a slave ship, then "gifted" to a family in London, Sancho eventually worked in the Montagu household, where he received an education. As a distinguished man of letters, he was also portrayed by Thomas Gainsborough in a painting that now belongs to the National Gallery of Canada. *Portrait of an African* was initially attributed to the English artist Joshua Reynolds, but today it is given to the Scottish painter Allan Ramsay.

Reynolds's style is characterized by fluid brushwork and luminous color. In the unfinished *Portrait of a Man* (ca. 1770; fig. 212), the sitter seems to erupt from undefined matter, his commanding gaze conveying the natural drama unfolding behind him. Reynolds rarely painted Blacks, making the prominence he grants the present subject even more remarkable. The man is probably Francis Barber, born a slave in Jamaica but freed by his master, Johnson, who subsequently made him his heir.

Anonymous heroes take the spotlight in a gallery of Black character studies by Frenchman Théodore Géricault,

who made at least ten such portraits, of which four are reproduced here. *Portrait of a Young Mestiza* (1815–17; fig. 210) bears traces of Géricault's enthusiastic orientalism: a beige fabric covers the sitter's hair, her vague gaze directed to something outside the scene, giving her an air of mystery. *Study of a Model* (ca. 1818–19; fig. 209) is an oil sketch for the artist's masterpiece, *The Raft of the Medusa* (1819). The model, a Haitian man named Joseph who frequently posed for the artist, wears a shirt similar to those worn by the survivors of the notorious shipwreck of the *Medusa* off the African coast in 1816. His mournful countenance is rendered with a sensitive touch: his eyes are teary, and his gaze, directed off-canvas, suggests inner turmoil. Brown, gray, and beige tones merge with his dark skin, while white and beige brushstrokes highlight his forehead, lips, and chin. *Portrait of the Carpenter of the Medusa* (1818; fig. 208)—another preparatory study—achieves a similar effect: the extremely dark background contrasts with the model's lit face and the sheen of his blouse. Toward the end of his short life, Géricault embarked on a series of studies for a monumental indictment of the slave trade, the *Traité des Noirs*, expanding on themes already present in the *Raft*. The Romantic exoticism of *Portrait of a Negro* (1822–23; fig. 211), with its suggestion of African royalty in the red, gold-trimmed tunic, is tempered by the man's gentle expression.

Hyacinthe Rigaud had a stellar career as a painter in the French court of Louis XIV, specializing in "pomp portraits," official likenesses notable

for meticulous treatment of sumptuous costume and accessories. The boy in the painting reproduced here (ca. 1697; fig. 207) appears in similar clothing in a Rigaud portrait of François-Louis de Bourbon, prince of Conti. The motif of the Black slave in such official portraits reflected the status of the sitter and his power to traffic in humans. Here, the boy wears a slave collar, livery outfit, and orientalizing turban. Still, removed from the context of the Conti portrait, one might read this standalone work as a (highly Europeanized) representation of an African arms-bearer. Rigaud accords his Black sitter the same treatment as his wealthy clientele. The boy's demeanor is noble and unassuming, and the artist applies the same painterly devices—glistening palette and satiny texture of skin and fabric—for which he was renowned.

In our roundup of Black portraiture, several sitters achieved famed in different capacities. Brazilian academician Victor Meirelles painted Henrique Alves de Mesquita (1862; fig. 214), composer, conductor, organist, trumpeter, and inventor of the *habanera* (Brazilian tango). However, the artist obscured his sitter's color, as well as the interest in popular music that made him famous. Alves's formal attire includes a top hat, which rests on the stone bench with his orchestra baton, and a sculpture and fountain in the background place him in the "civilized" European world.

Written and visual documents of Black nationalists in 19th-century South America are scarce, but one of them is a portrait of Peruvian independence hero José Olaya Balandra (1828; fig. 197) by José Gil de Castro. Olaya, acting undercover as an emissary, was arrested, tortured, and sentenced to death without disclosing his mission. The artist, called "El Mulato," portrays Olaya full-length in an arid landscape, dressed in a white jacket, trousers, and Muslim cap. Written on the document in his hand are Olaya's last words before execution: "If I had a thousand lives, I would gladly give them all for my nation." The red banner above is inscribed "Patriot D. José Olaya served his homeland with glory and honored his birthplace."

In 1791, Haiti became the first Latin American country to gain independence. Haitian envoy Jonathas Granville sat for a portrait in Baltimore, Maryland (1824; fig. 213) while there to promote the emigration of freed Blacks to his country, which needed skilled labor. A newspaper from the period described Granville as a "very well educated and intelligent gentleman." His engagement with local elites was cordial, as he enjoyed a certain diplomatic immunity. The portrait, by Philip Tilyard, was likely commissioned by the Baltimore Emigration Society, which encouraged the emigration of Blacks as a way to defuse the animosity between poor white workers and ex-slaves in the region.[1]

Brazilian academic painter José Correia de Lima, who trained under Jean-Baptiste Debret, produced the exceptional *Portrait of the Intrepid Sailor Simão, Stoker on the Pernambucana Steamer* (ca. 1853; fig. 201), one of the most important representations of Black people in the 19th century. The *Pernambucana* sank off the coast of Santa Catarina, Brazil, in 1853. Simão Manuel Julião Alves, born a free Black

in Cape Verde, rescued thirteen of the approximately 100 people on board by swimming them to shore. He was given a hero's welcome in Rio de Janeiro by Emperor Pedro II and was granted a gold medal and a bust at Praça do Comércio. In the image, Simão's backlit figure emerges from a blue spot in the otherwise dark background. His kind expression conveys his humanity, and the marine blue blouse and crewman's rope allude to the strength behind his heroic feat. Another unprecedented 19th-century portrait, also Brazilian, is the extraordinary *Woman from Bahia* (ca. 1850; fig. 205). Neither the painter nor the sitter have been identified, but the image's large scale and refined composition attest to the importance of both the woman and the commission. Its execution coincides with the year of the official end of slave trafficking in Brazil. The majestic *baiana* is serene and elegant in a velvety black gown and white gloves, with eleven necklaces draped around her neck and shoulders. She is probably a former slave, but her creole jewels and hair ornaments indicate her power and status.

Antônio Rafael Pinto Bandeira, a grandchild of slaves and a student at the Imperial Academy of Fine Arts in Rio, is one of the few known Black painters of the 19th century in Brazil. His *Head of a Man* (1891; fig. 222) displays the mastery of his brushwork in a palette of brown, beige, yellow, and ocher tones. Colleagues described him as a melancholic man, which he confirmed when, at the age of thirty-three, he took his own life by throwing himself from a ferry on Guanabara Bay. It was reported that his suicide was triggered by a lover's rejection due to racial prejudice. Pinto Bandeira specialized in still life but produced a few portraits such as this. The sitter, one side of his face shrouded in darkness, exudes the hushed sadness of many other subjects in this section, like *The Boy* (1917; fig. 223) by Arthur Timótheo da Costa. From a humble background, Timótheo studied at the National School of Fine Arts and lived in Paris for a year thanks to a travel grant. He and his brother João were among the few Black Brazilian artists to gain recognition in their lifetimes. Painted less than twenty years after the abolition of slavery in Brazil, *The Boy* demonstrates Timótheo's rejection of academicism and embrace of the modern. The melancholic child is delineated in wide brushstrokes and masses of color that blur contours in the same earthy palette as that of Pinto Bandeira.

In the 20th century, the figure of the mulatta—a woman of Black and white ancestry—became a powerful symbol of an idealized local mixed culture celebrated by modernist artists and intellectuals, often with problematic implications in Brazil, Colombia, Cuba, and other Latin American and Caribbean countries.[2] The etymological root of the word *mulata* is "mule," a hybrid and sterile animal, the offspring of a horse and a donkey. From this perspective, *mulatto*, along with *pardo* (brown) and *moreno* (dark), can be understood as a racist euphemism for Black.

In Enrique Grau Araújo's painting *The Mulatta from Cartagena* (1940; fig. 221), an iconic image in Colombian art, the mulatta, posed languidly among the flora of the tropical coastline, stands for the whole of Afro-Caribbean cul-

ture. The palette, dominated by tones of orange, red, brown, and ocher, links the disparate elements of the painting. The figure's sensuous body is accentuated with striations of shading. Her white, low-cut dress hitches up as she reclines in a seductive manner, suggesting a flirtatious encounter with someone off-canvas. All the elements are eroticized, all spell abundance. The exception is the ceramic vessel referencing Indigenous craft, where the artist chose to sign his name.[3]

Emiliano Di Cavalcanti also painted sexualized mulattas surrounded by fruits and flowers. One of the great Brazilian modernists, he portrayed the type for more than five decades starting in the 1920s—on hammocks and balconies, in the streets and favelas, at the edge of town, at samba parties and Carnival; naked and seminaked—totaling hundreds of representations that often objectify and eroticize the bodies of Black women, most of them nameless (the white women in his paintings are always identified). *Mulatta* (1952; fig. 220) is unique. There is no hint of seductiveness in this Black woman's demeanor and everyday clothing. She sits upright, in an ordinary domestic setting, gazing at the viewer with confidence. Her sleeveless shirt, buttoned to the neck, has delicate patterns of foliage on a colorful background, forming a sort of painting within a painting, in a style typical of Di Cavalcanti's late phase in the 1950s.

Gilberto Hernández Ortega's *Female Merchant* (1976; fig. 241) was produced in the last years of the Dominican painter's life. His expressionistic style is evident in the strong, rapidly applied gestural strokes that distort the human figure. Despite the white low-cut dress, the woman is not voluptuous; her slim, schematic profile neutralizes eroticization. Painted on a bluish black background, she wears a massive hat bedecked with white and orange flowers, bananas, red fruits, and large green leaves. The loose vegetal opulence contrasts with her slender figure. Surrealist overtones reflect the artist's interest in magical elements of popular culture, such as imagery of traders and magicians, as well as blackness and miscegenation, which began after he met Wifredo Lam—a Cuban artist and key figure in Afro-Atlantic modernism—when he traveled to the Dominican Republic in 1941.

Artist and intellectual Archibald J. Motley Jr. played a central role in the Harlem Renaissance. *The Octoroon Girl* (1925; fig. 202) belongs to a series of portraits of Black women with different skin tones, such as *The Quadroon* (1927). The titles replicate pseudo-scientific racial categories used in the United States based on a person's supposed amount of African blood: one-eighth and one-fourth, respectively. In these hierarchical classifications, lighter skin tones were equated with wealth, higher social status, and conventional beauty standards. Here, Motley poses the woman in a comfortably appointed room flanked by markers of privilege, a book and a painting. The red collar, cuffs, and buttons of her fashionable dress complement her radiant, pink-toned flesh.

Loïs Mailou Jones was an influential African American artist and teacher. She traveled to Africa and the Caribbean, where she discovered many of the thematic and aesthetic elements

that would thereafter define her work. Jones combined realistic portraits and backgrounds inspired by African textile patterns. Subverting a classic European portrait type that represents the passage of time through the depiction of successive generations of family members, *Egyptian Heritage* (1953; fig. 236) shows the heads of three women with varying skin tones against a montage of Egyptian hieroglyphics. The composition points to the artist's own African heritage; the woman portrayed in the middle of the canvas is probably Jones's own mother, while the regal head on the right depicts Nefertiti. Gary Simmons's *Nubian Queen* (1993; fig. 237) likewise summons ancestral roots, in this case inflected by Pan-Africanism. The backdrop of kente cloth evokes Kwame Nkrumah's symbol of Ghanaian independence and African identity in the 1960s. Superimposed on the geometric patterns in red, orange, green, blue, black, and white is the silhouette of the head of a Nubian queen. Nubia, one of the earliest civilizations, ruled a large region along the Nile south of Egypt.

Dark Rapture (James Baldwin) (1941; fig. 216) is the first of a number of portraits that African American artist Beauford Delaney painted of his countryman, the writer James Baldwin. The artist and his sitter—both gay Black men—were longtime friends and expatriates in Paris. Here, Baldwin is pictured as a teenager, when he was still living in Harlem. Naked, with a long muscular torso, he sits upright in a setting both indoor and outdoor: the bed seems to float in a moonlit garden. Figure and landscape are painted in thick, vibrant brushstrokes of intense tones, creating interpenetrating chromatic fields.

Baldwin's black body is articulated with swathes of red, orange, yellow, blue, purple, and green. *Dark Rapture* is also the title of a film released by Universal Pictures in 1938 documenting an expedition to Africa; a jazz song recorded in the same year by Count Basie with vocals by Helen Humes; and Felix Bryk's 1939 book subtitled *The Sex Life of the African Negro*, which includes a chapter on homosexuality—all of which resonate with Delaney's portrait. It is a loving statement on the homoerotic relationship between the two men underwritten by an awareness of the barriers—racial and sexual—each faced.

The Artist (1959; fig. 243) by Heitor dos Prazeres is an ambiguous, plural portrait. The figure of the title, in red beret and white shirt, is likely Prazeres himself; thus what we see is a self-portrait. However, the character of a man with gray hair and beard calmly smoking a pipe suggests the *preto velho*. In Umbanda, an Afro-Brazilian religion, *preto velhos* are the spirits of old slaves who live in the *senzala* (slave quarters). They are considered sages who offer counsel and pass on ancient stories to the young. If Prazeres indeed depicted himself here, then it was to convey something of his own multivalent gifts—as an artist, composer, samba musician, and capoeira fighter who lived the reality of the favelas and frequented Umbanda houses in Rio.

A stock type in the representation of Black men is the heroic laborer, as he appears in the works of Candido Portinari and Edna Manley, two white artists who played a key role in the development of modern art in their respective contexts: Brazil and Jamaica.

Portinari's *Coffee Worker* (1934; fig. 233) is an iconic painting of Brazilian modernism: the towering figure of a Black man, with huge hands and bare feet, rolled-up shirtsleeves and trousers, gripping a hoe against the backdrop of plantation fields. The image elicits dual readings. If on the one hand the Black man is bound to the realm of manual labor and agriculture (to the detriment of his intellectual cultivation), he also represents power in work and the transformation of land. He may not be the owner, but his creation, the coffee plantation, stretches behind him to the horizon (in the 1930s, coffee was Brazil's main export). His outsized musculature denotes his strength. This picture of dignified virility became an emblem of national identity, even though it was delivered via an Italian-Brazilian painter. *Diggers* (1936; fig. 232), a wood relief by the British-Jamaican Manley, similarly exalts manual labor. The stylized figures of three men conjoined in a line, each wielding an ax in rhythmic, choreographed motion, symbolize union and solidarity, working toward a common objective of transforming Jamaica, a country that would not achieve independence for another three decades, in 1962. *The Prophet* (1935; fig. 235), another of Manley's wood sculptures, is a naked, heavily muscled man with arms raised in a gesture of victory or a call to action. In the mid-1930s, uprisings against harsh living conditions swept the Caribbean colonies. Independence revolts erupted in Jamaica in 1938, but Manley's work anticipated the insurrectionist climate and the country's aspirations. She and her husband, Norman Manley, were leaders in the liberation struggle, he as the founder of the People's National Party, and she as the "mother of Jamaican art."

In *Amnesia* (2015; figs. 258, 259), a bronze sculpture by Flávio Cerqueira from São Paulo, a Black child pours a bucket of white paint over his head. Rivulets of liquid run down his body but do not stick to it. The work refers to Brazil's "whitening" policy promoted well into the 20th century as a solution to the demographic predominance of Blacks. The government incentivized European immigration, prohibited African immigration, and encouraged interracial mixing on the assumption that, white blood being "superior," blackness would gradually be extinguished. Cerqueira's title and his use of a noble, nearly indestructible material linked to ancient traditions and rarely seen in contemporary art, speaks to the deliberate forgetting of histories and his project of excavating and restoring gaps in the official historical narrative.

The portraits in this section tell many stories; they generate microhistories and trigger diverse readings. Juxtaposed, the characters in these works evoke a plethora of roles that dialogue with and traverse one another in multilayered narratives stimulating fresh reflections and associations.

1. Hugh Honour, "The Atlantic Triangle," in *The Image of the Black in Western Art, from the American Revolution to World War I: Slaves and Liberators* (Cambridge, Mass.: Harvard University Press, 2012).

2. Melissa Blanco Borelli, *She Is Cuba: A Genealogy of the Mulata Body* (New York: Oxford University Press, 2016).

3. Rocío Aranda-Alvarado, "The Body in Caribbean Art," in *Caribbean Art at the Crossroads of the World* (New York: El Museo del Barrio, 2012).

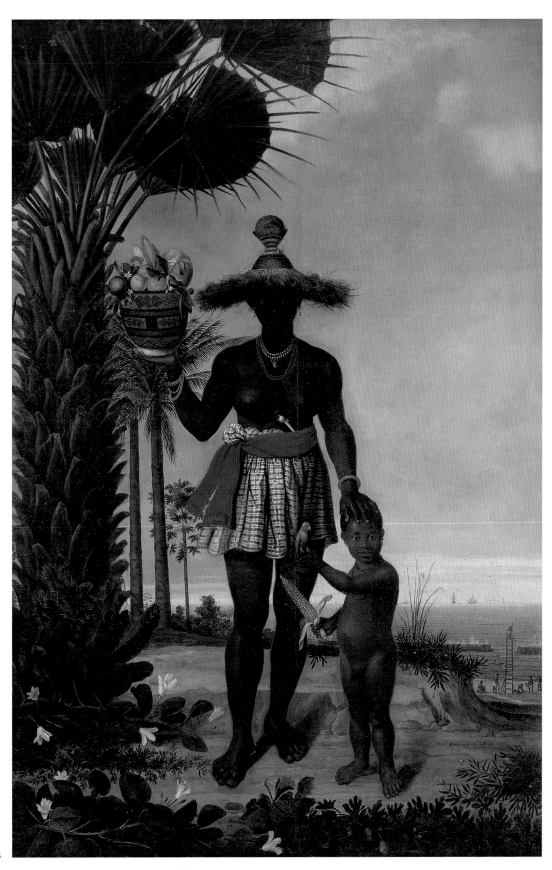

Albert
Eckhout

Groningen,
Netherlands
ca. 1610–1665
Groningen

191. *African Woman
with Child*, 1641
Oil on canvas,
282 x 180 cm
Nationalmuseet,
Copenhagen

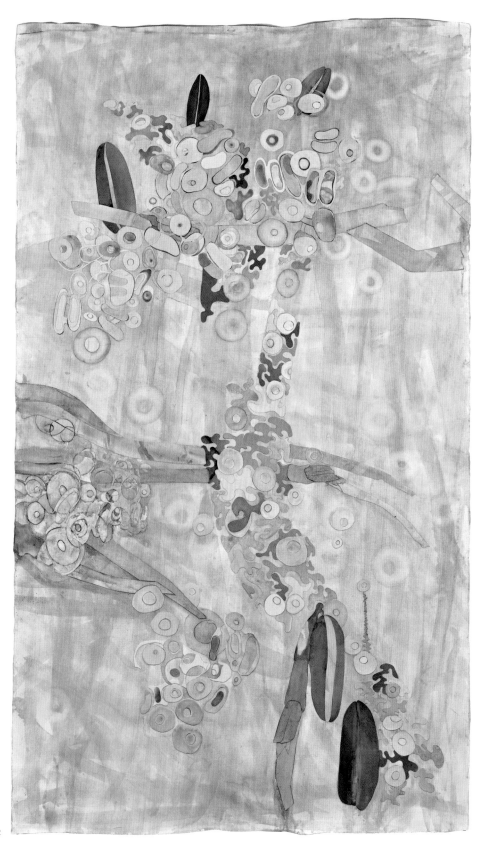

Ellen Gallagher

b. Providence, Rhode
Island, 1965; lives in
New York City and
Rotterdam

192. *Watery Ecstatic*,
2018
Watercolor, oil, pencil,
varnish, and cut paper
on paper,
229.5 x 139.5 cm
Courtesy of the artist
and Hauser & Wirth

Albert Eckhout

Groningen,
Netherlands ca.
1610–1665 Groningen

193. *African Man*,
1641
Oil on canvas,
273 x 167 cm
Nationalmuseet,
Copenhagen

192

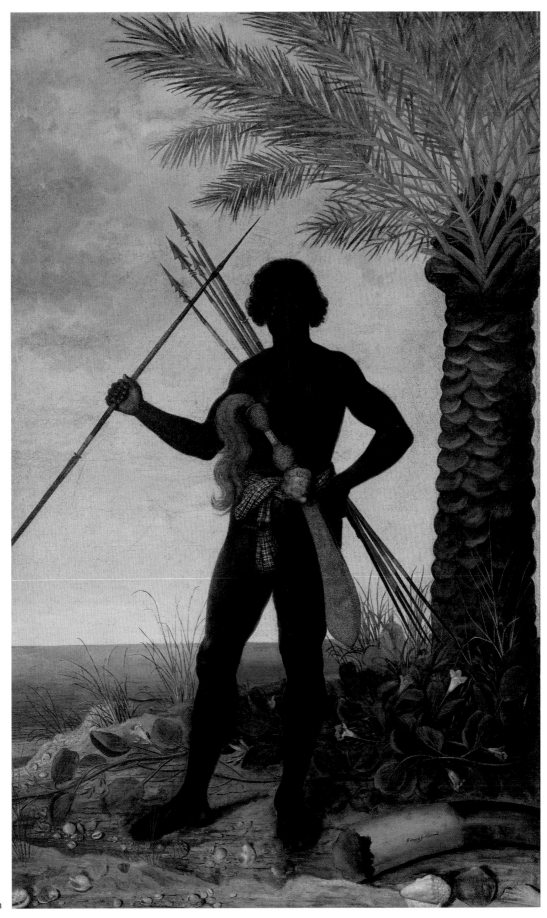

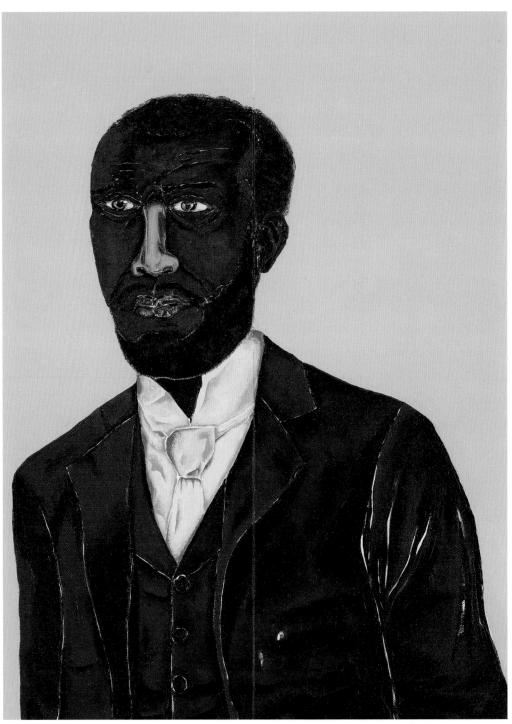

194

Dalton
Paula

b. Brasília, 1982; lives
in Goiânia, Goiás, Brazil

194. *João de Deus
Nascimento*, 2018
Oil on canvas
59 x 44 cm
Museu de Arte de
São Paulo Assis

Chateaubriand – MASP
Gift of the artist in
the context of the
Afro-Atlantic Histories
exhibition, 2018
MASP.10809

195. *Zeferina*, 2018
Oil on canvas
59 x 44 cm
Museu de Arte de
São Paulo Assis
Chateaubriand – MASP

Gift of the artist in the
context of the *Afro-
Atlantic Histories*
exhibition, 2018
MASP.10808

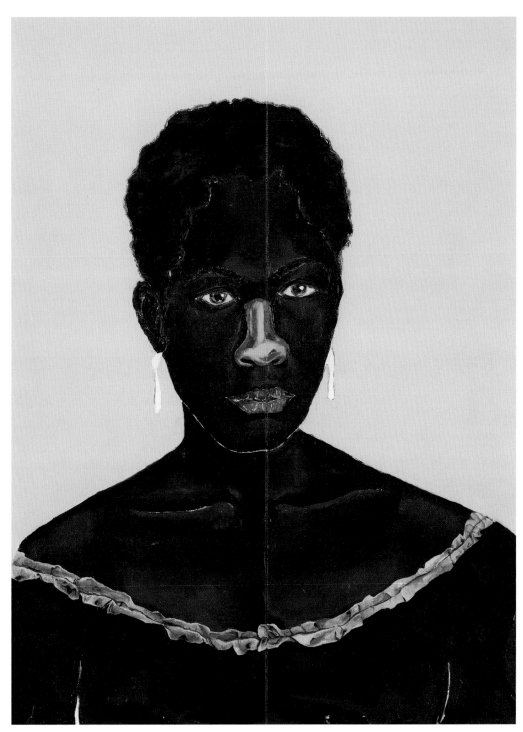

195

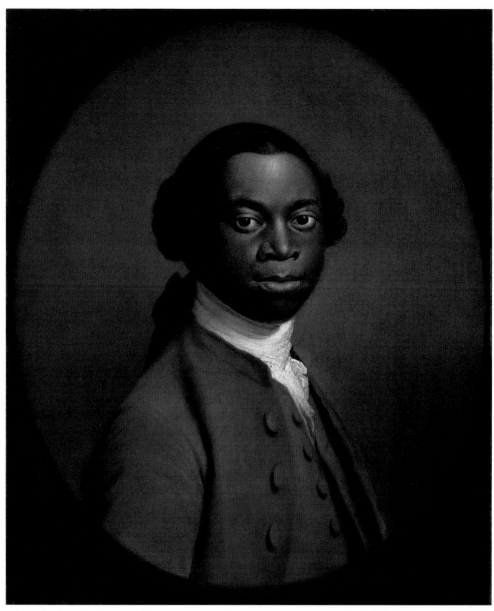

196

Attributed to

Allan Ramsay

José Gil de Castro

Edinburgh 1713–1784
Dover United Kingdom

Lima 1785–1841 Lima

196. *Portrait of an African (probably Ignatius Sancho)*, ca. 1758
Oil on canvas, 62 x 51.5 cm
Royal Albert Memorial Museum & Art Gallery, Exeter, United Kingdom

197. *Portrait of José Olaya Balandra*, 1828
Oil on canvas, 204 x 137.5 cm
Museo Nacional de Arqueología, Antropología e Historia del Perú–Ministerio de Cultura, Lima

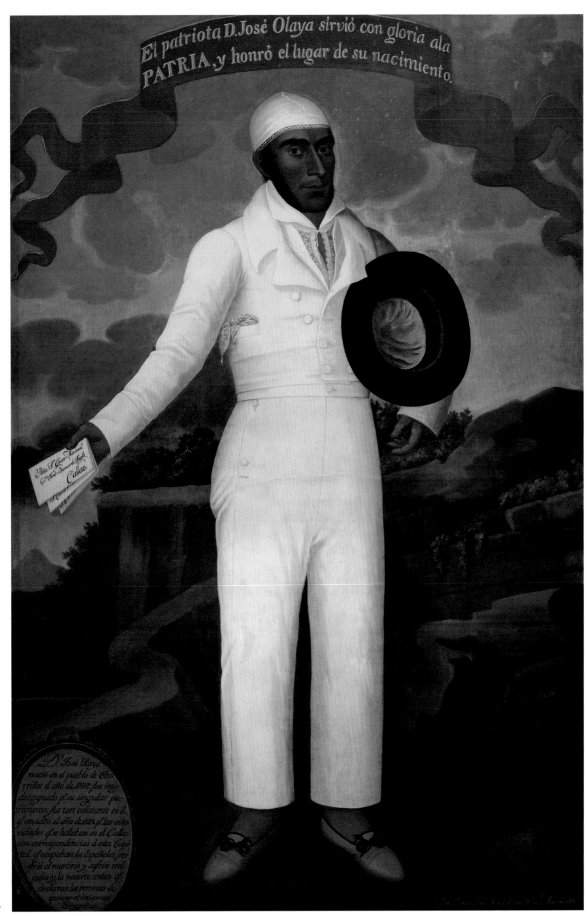

El patriota D. José Olaya sirvió con gloria a la PATRIA, y honró el lugar de su nacimiento.

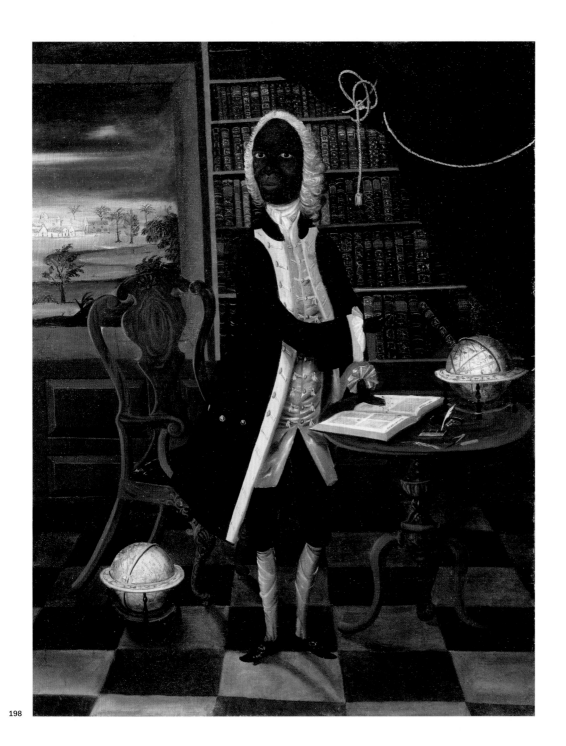

198

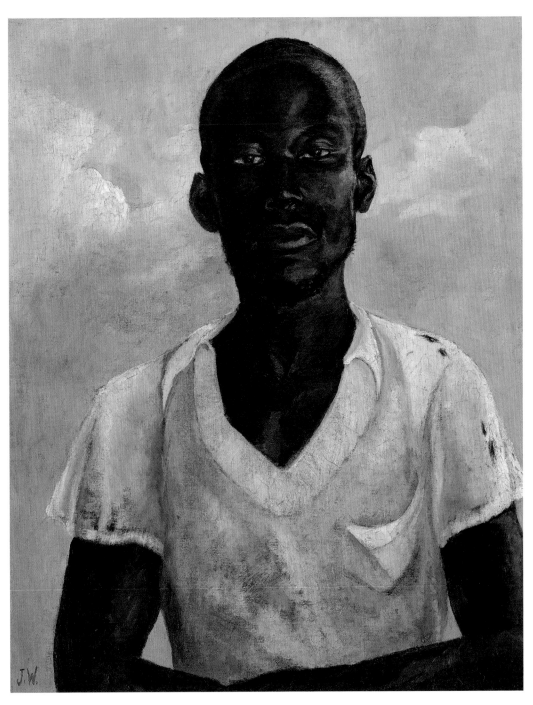

199

Unidentified Artist

198. *Francis Williams, the Scholar of Jamaica*, ca. 1745
Oil on canvas, 66 x 50 cm
Victoria and Albert Museum, London, Gift of Viscount Bearsted M.C. and Spink and Son Ltd., through the National Art Collections Fund, 1928

John Wood

Jamaica

199. *Fisherman*, 1944
Oil on fiberboard, 67.5 x 53.5 cm
National Gallery of Jamaica, Kingston

Unidentified Artist

Netherlands

200. *Don Miguel de Castro, Emissary of Kongo*, ca. 1643
Oil on panel, 85 x 73 cm
Statens Museum for Kunst (SMK), Copenhagen

José Correia de Lima

Rio de Janeiro 1814–1857 Rio de Janeiro

201. *Portrait of the Intrepid Sailor Simão, Stoker on the Pernambucana Steamer*, ca. 1853

Oil on canvas, 93 x 72.5 cm
Museu Nacional de Belas Artes–IBRAM/ MinC, Rio de Janeiro

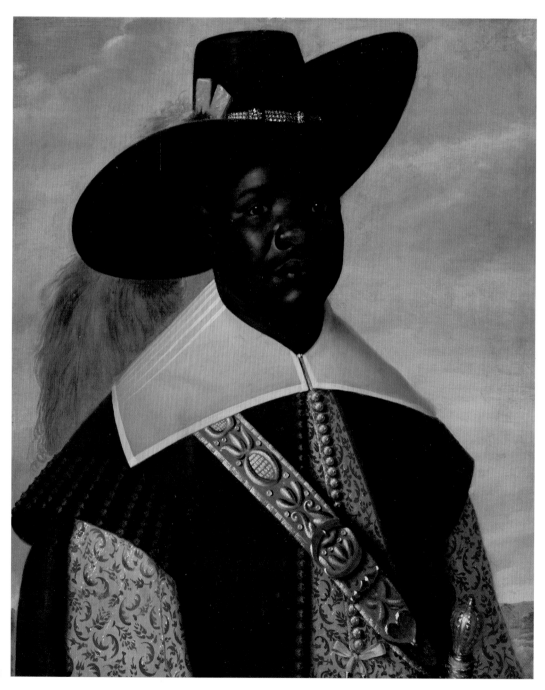

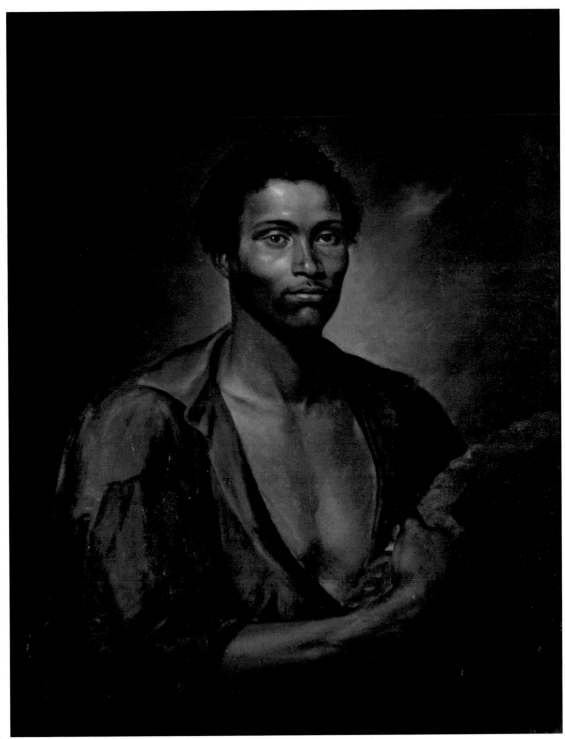

201

202

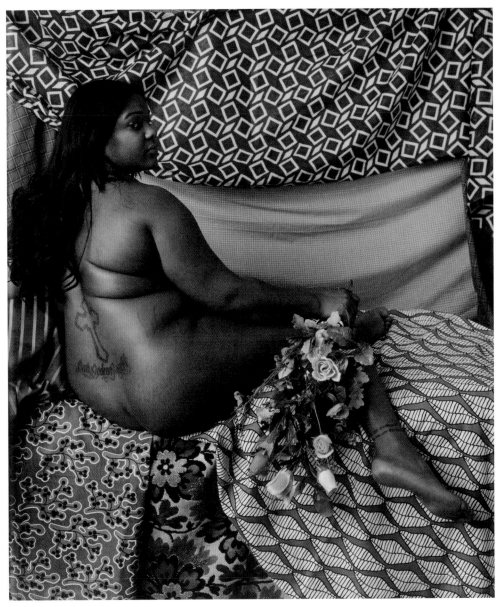

203

Archibald J. Motley Jr.

New Orleans 1891–1981 Chicago

202. *The Octoroon Girl*, 1925
Oil on canvas,
96.5 x 77 cm
Courtesy of Michael Rosenfeld Gallery,
New York

Mickalene Thomas

b. Camden, New Jersey 1971; lives in New York City

203. *Melody: Back*, 2011
Diffusion transfer print (Polaroid),
62.2 x 52.7 cm
National Gallery of Art, Washington, D.C.,
Charina Endowment Fund and Peter Edwards Rose Gutfeld Fund, 2020.3.1

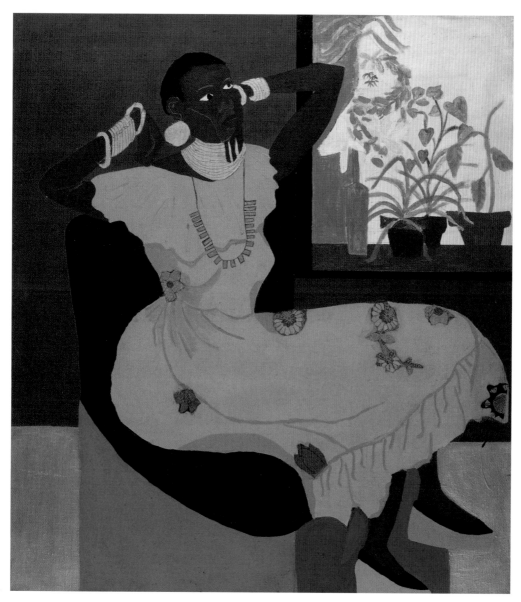

204

Dindga McCannon

b. New York City,
1947; lives in New
York City

204. *Empress
Akweke*, 1975
Acrylic on canvas,
91 x 81 cm
Brooklyn Museum,
Gift of R.M. Atwater,
Anna Wolfrom Dove,

Alice Fiebiger,
Joseph Fiebiger,
Belle Campbell
Harriss, and Emma L.
Hyde, by exchange,
Designated Purchase
Fund, Mary Smith
Dorward Fund, Dick
S. Ramsay Fund,
and Carll H. de Silver
Fund, 2012.80.31

Unidentified Artist

205. *Woman from
Bahia*, ca. 1850
Oil on canvas,
96 x 77.5 cm
Museu Paulista
da Universidade de
São Paulo

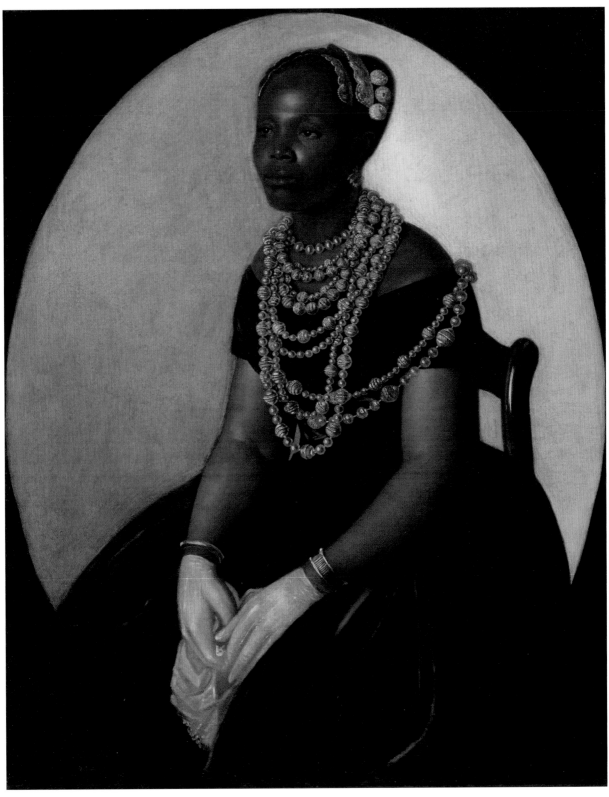

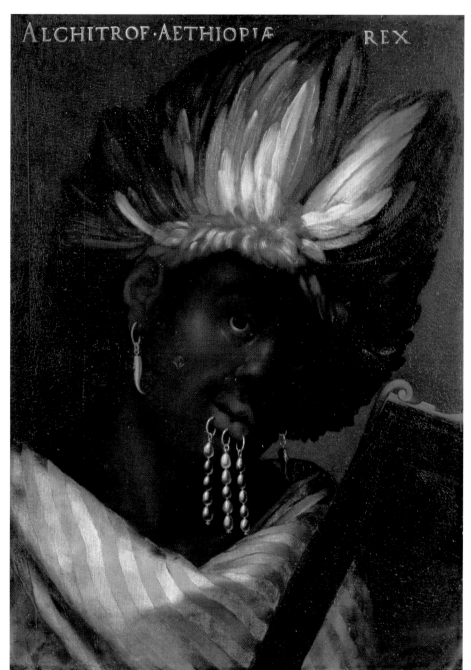

206

ALCHITROF·AETHIOPIÆ REX

Cristofano
dell'Altissimo

Florence, Italy 1525–
1605 Florence

206. *Alchitrof, Emperor
of Ethiopia*, 1568
Oil on panel, 59 x 42 cm
Galleria degli Uffizi,
Florence

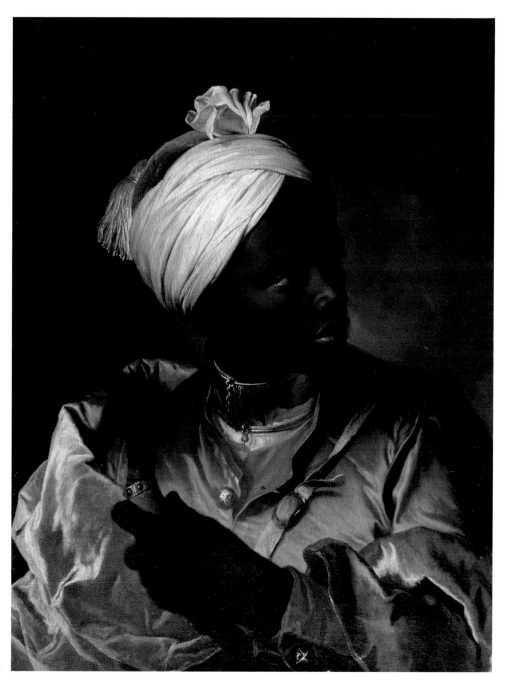

207

Hyacinthe Rigaud

Perpignan, France
1659–1743 Paris

207. *Black Youth
Holding a Bow*, ca.
1697
Oil on canvas,
57 x 43.5 cm
Musée des Beaux-Arts,
Dunkirk, France

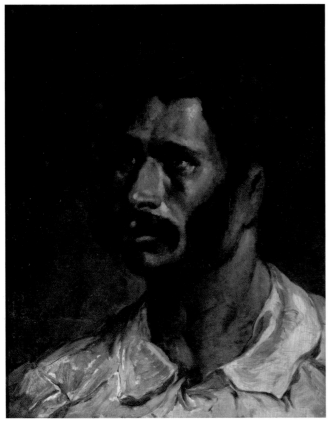

208

Théodore Géricault

Rouen, France 1791–
1824 Paris

208. *Portrait of the Carpenter of the Medusa*, 1818
Oil on canvas,
46.5 x 39 cm
Musée des
Beaux-Arts, Rouen
© La-Belle-Vie/
Réunion des Musées

209. *Study of a Model*, ca. 1818–19
Oil on canvas,
47 x 39 cm
J. Paul Getty
Museum, Los Angeles

210. *Portrait of a Young Mestiza*,
1815–17
Oil on canvas,
41 x 31.5 cm
Musée Bonnat-Helleu,
Bayonne, France

211. *Portrait of a Negro*, 1822–23
Oil on paper mounted
on canvas, 54 x 46 cm
Albright-Knox Art
Gallery, Buffalo,
New York, James G.
Forsyth and Charles
W. Goodyear Funds,
1952

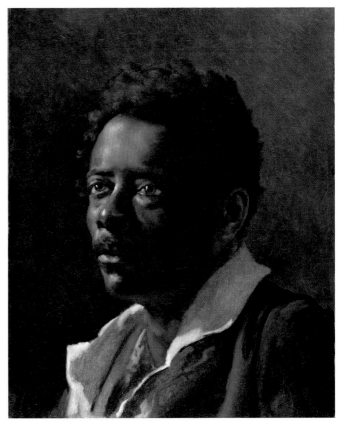

209

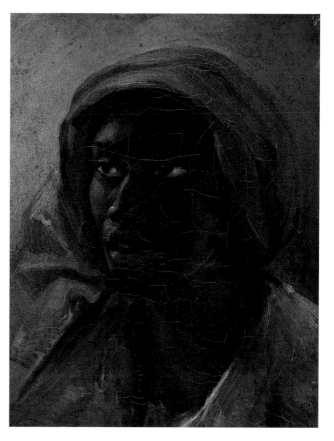

210

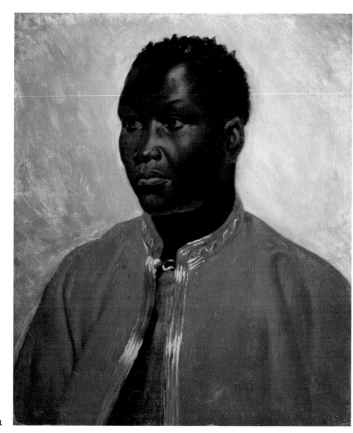

211

243

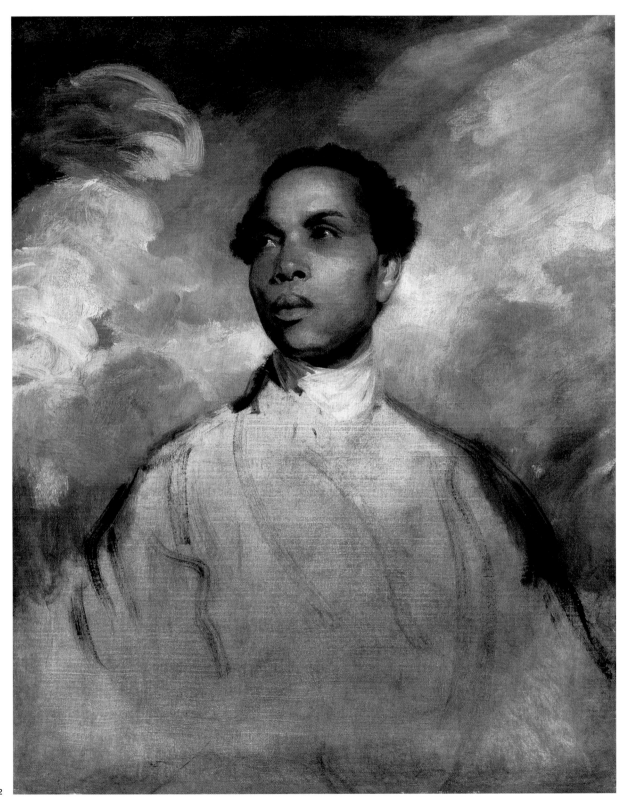

212

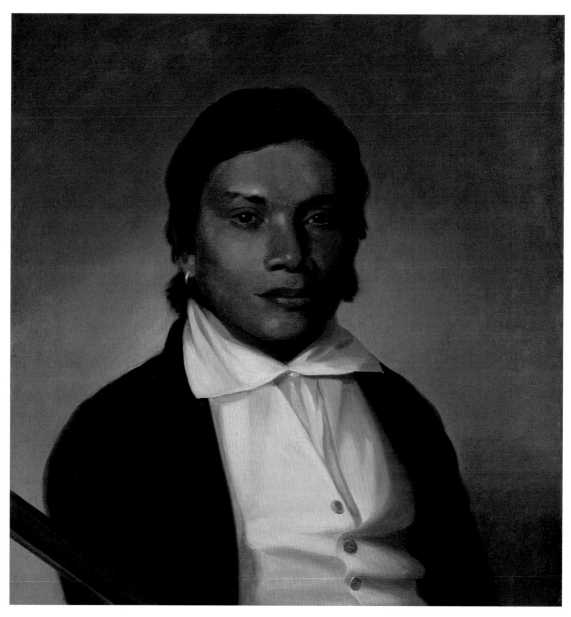

213

Joshua Reynolds

Plympton, United
Kingdom 1723–1792
London

212. *Portrait of
a Man, probably
Francis Barber*, ca.
1770
Oil on canvas,
78.5 x 64 cm
The Menil Collection,
Houston

Philip Tilyard

Baltimore 1785–1830
Baltimore

213. *Jonathas
Granville*, 1824
Oil on canvas,
51 x 48.5 cm
Baltimore
Museum of Art

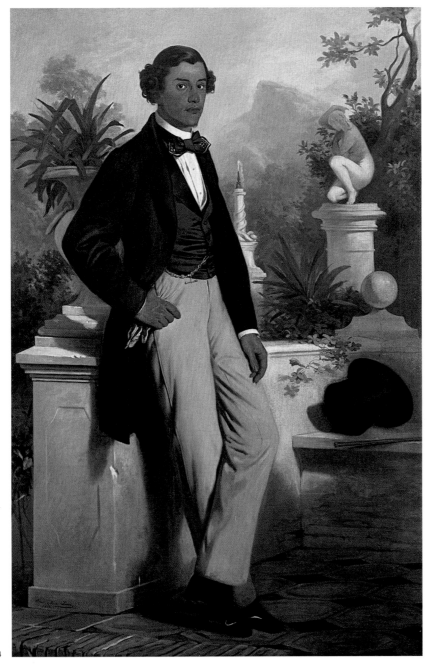

214

Victor Meirelles

Florianópolis, Santa
Catarina, Brazil
1832–1903
Rio de Janeiro

214. *Portrait of
Conductor Henrique
Alves de Mesquita*,
1862
Oil on canvas,
193 x 130 cm
Collection of Hecilda
and Sérgio Fadel,
Rio de Janeiro

Barkley L. Hendricks

Philadelphia 1945–
2017 New London,
Connecticut

215. *George Jules
Taylor*, 1972
Oil on canvas,
232.3 x 153 cm
National Gallery of
Art, Washington,
D.C., William C.
Whitney Foundation,
1973.19.2

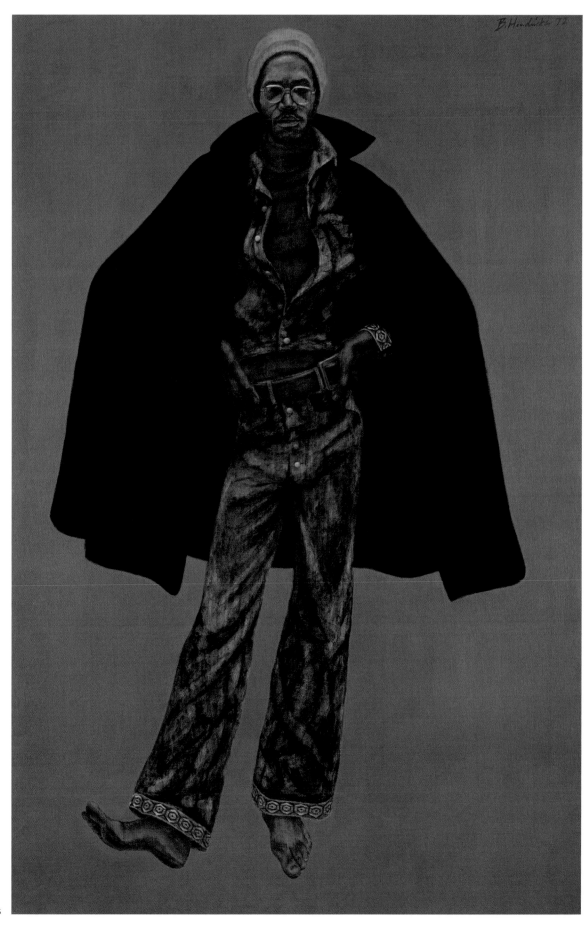

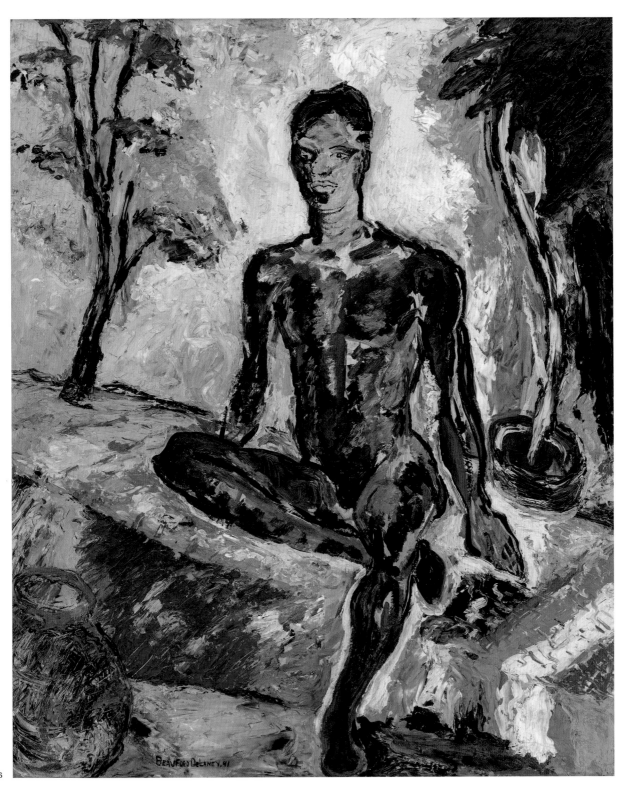

216

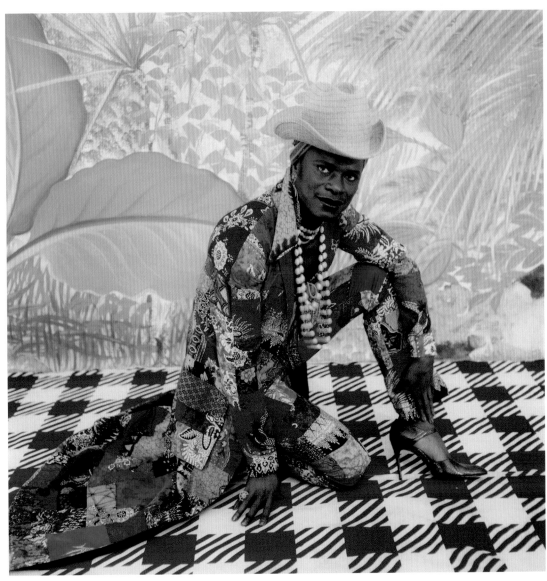

217

Beauford Delaney

Knoxville, Tennessee
1901–1979 Paris

216. **Dark Rupture (James Baldwin)**,
1941
Oil on Masonite,
86.5 x 71 cm
Courtesy of Michael
Rosenfeld Gallery,
New York

Samuel Fosso

b. Kumba, Cameroon,
1962; lives in Bangui,
Central African
Republic

217. **Self-Portrait (as Liberated American Woman of the '70s)**,
1997, printed 2003
Chromogenic print,
86.9 x 86.2 cm
The Museum of
Fine Arts, Houston,
Museum purchased
funded by Nina and
Michael Zilkha,
2004.809

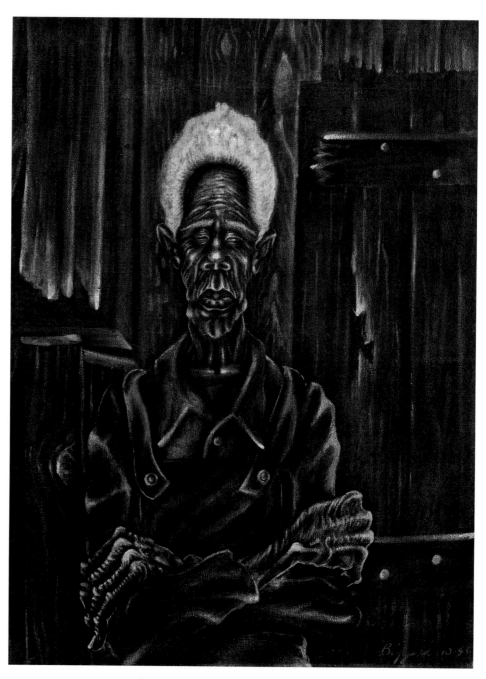

218

John T.
Biggers

Gastonia, North
Carolina 1924–2001
Houston

218. *Sharecropper*,
1945
Oil on canvas,
61 x 46 cm
Courtesy of Michael
Rosenfeld Gallery,
New York

Cícero
Dias

Escada, Pernambuco,
Brazil 1907–2003
Paris

219. *Black Man*,
1920s
Oil on canvas,
79 x 52 cm
Private collection,
Salvador, Bahia,
Brazil

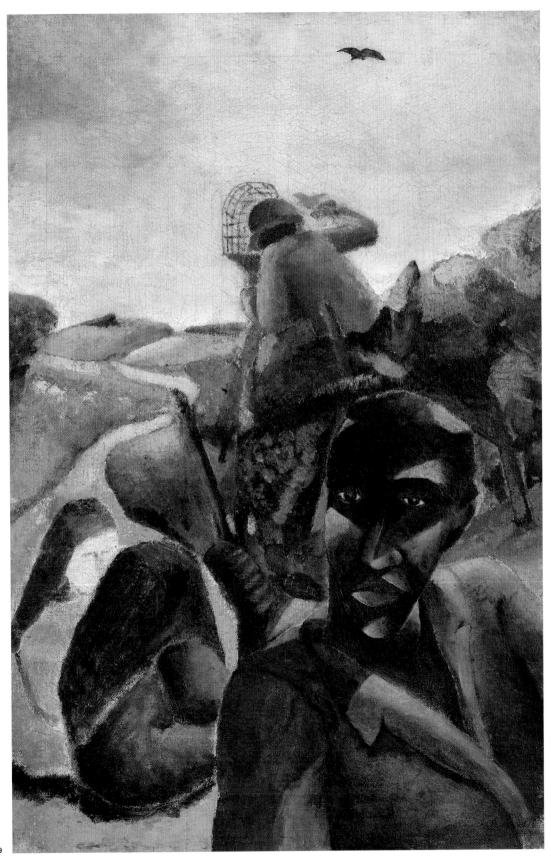

219

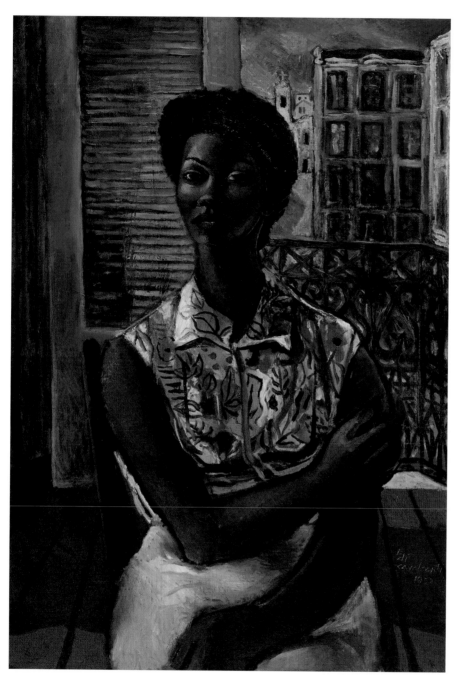

220

Emiliano Di Cavalcanti

Rio de Janeiro 1897–
1976 Rio de Janeiro

220. *Mulatta/Woman*,
1952
Oil on canvas
97 x 68 cm
Museu de Arte de
São Paulo Assis
Chateaubriand– MASP

Long-term loan in
honor of former
board members of B3
Brasil Bolsa Balcão
B3 Brasil Bolsa
Balcão Long-term
loan
C.01218

Enrique Grau Araújo

Panama City 1920–
2004 Bogotá

221. *The Mulatta
from Cartagena*,
1940
Oil on canvas,
71 x 61 cm
Museo Nacional de
Colombia/Ministerio
de Cultura, Bogotá

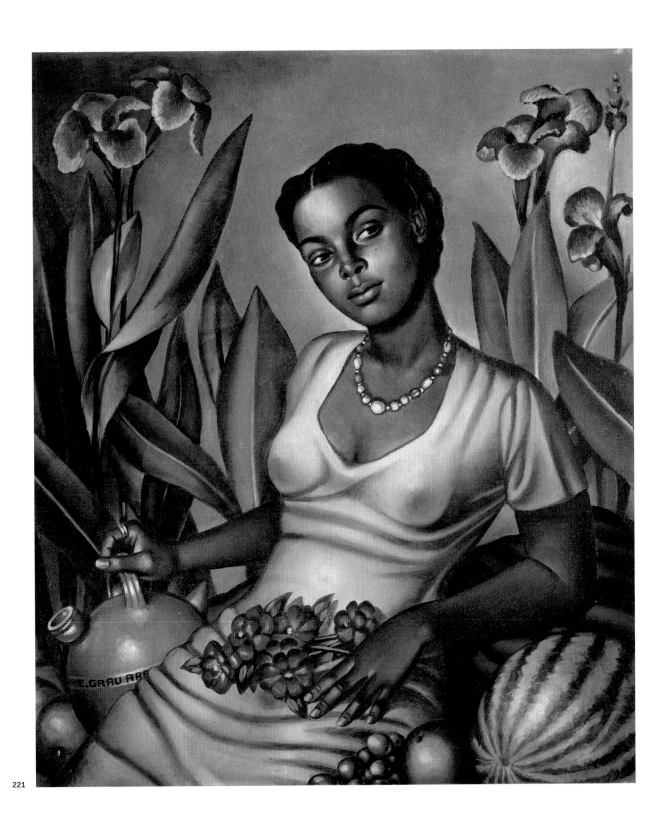

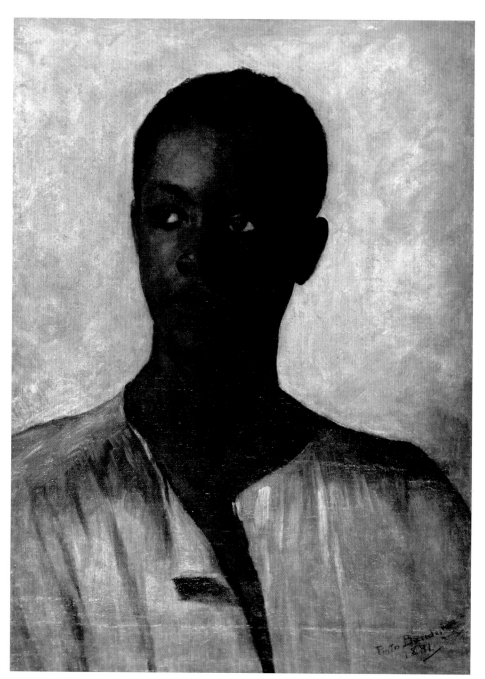

222

Antônio Rafael Pinto Bandeira

Niterói, Rio de Janeiro
1863–1896 Rio
de Janeiro

222. *Head of a Man*,
1891
Oil on canvas,
54 x 39 cm

Museu Antônio
Parreiras/Governo
do Estado do Rio de
Janeiro/Secretaria de
Estado de Cultura/
Fundação Anita
Mantuano de Artes
do Estado do Rio de
Janeiro–Funarj, Niterói

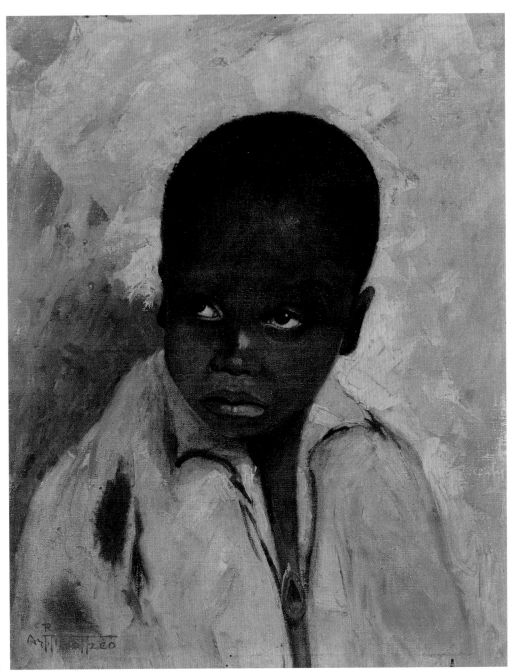

223

Arthur Timótheo da Costa

Rio de Janeiro 1882–
1922 Rio de Janeiro

223. *The Boy*, 1917
Oil on canvas,
47 x 36 cm

Museu de Arte de
São Paulo Assis
Chateaubriand–
MASP, Anonymous
gift, 2016,
MASP.01629

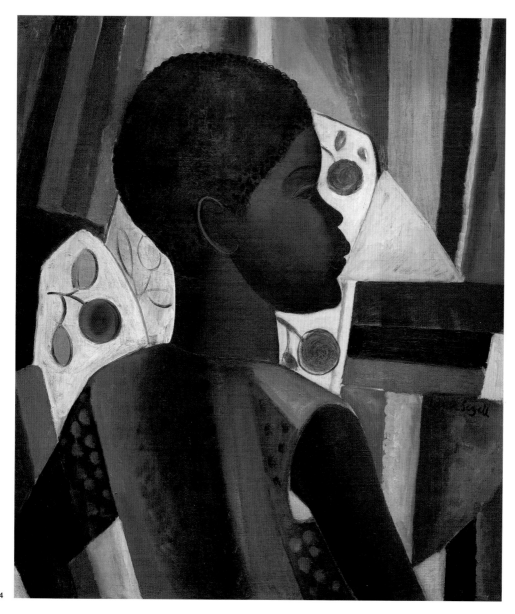

224

Lasar
Segall

Vilnius, Lithuania
1891–1957 São Paulo

224. *Zulmira's
Profile*, 1928
Oil on canvas,
62.5 x 54 cm
Museu de Arte
Contemporânea da
Universidade de
São Paulo

Juana
Borrero

Havana 1877–1896
Key West, Florida

225. *Little Rascals*,
1896
Oil on canvas,
76 x 52.5 cm
Museo Nacional de
Bellas Artes, Havana

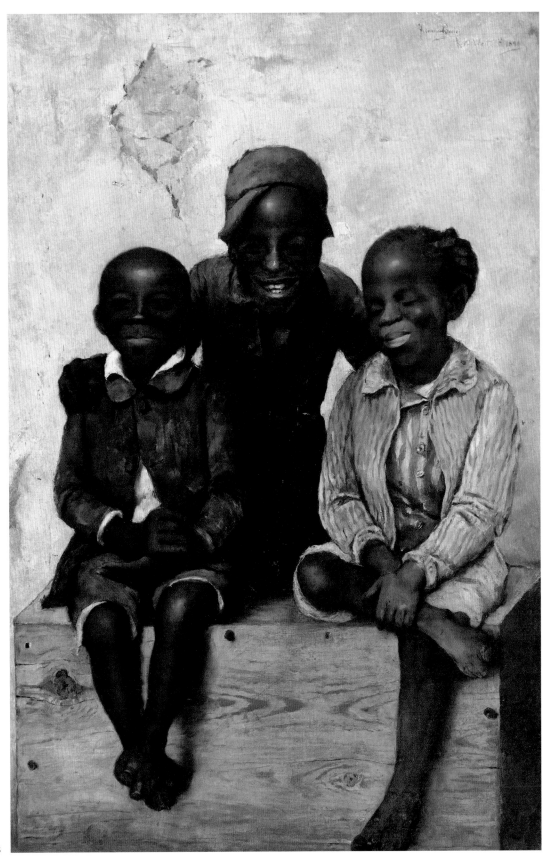

225

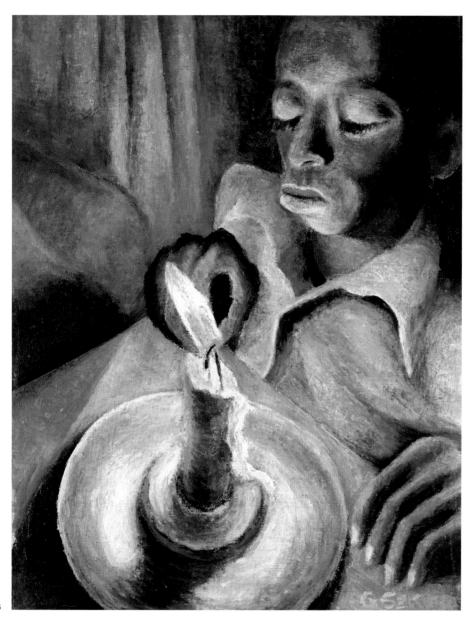

226

Gerard
Sekoto

Botshabelo, South
Africa 1913–1993
Nogent-sur-Marne,
France

226. **Boy and the
Candle**, 1943
Oil on canvas,
46 x 36 cm
National Museum
of African Art,
Smithsonian
Institution,
Washington, D.C.,
Museum purchase

Osmond
Watson

Kingston, Jamaica
1934–2005 Kingston

227. **Johnny Cool**, 1967
Oil on canvas,
85 x 71 cm
National Gallery of
Jamaica, Kingston

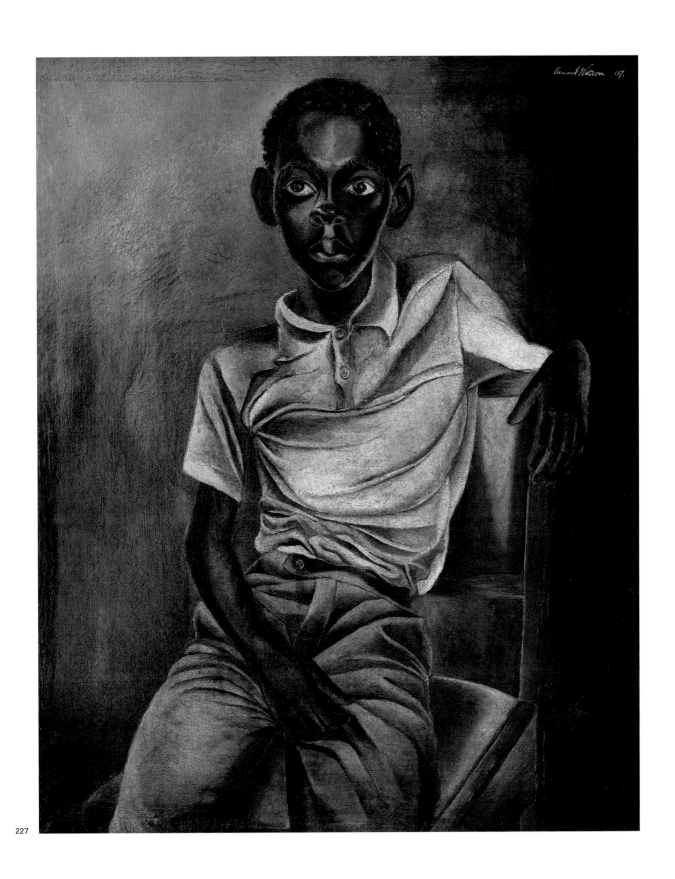

227

259

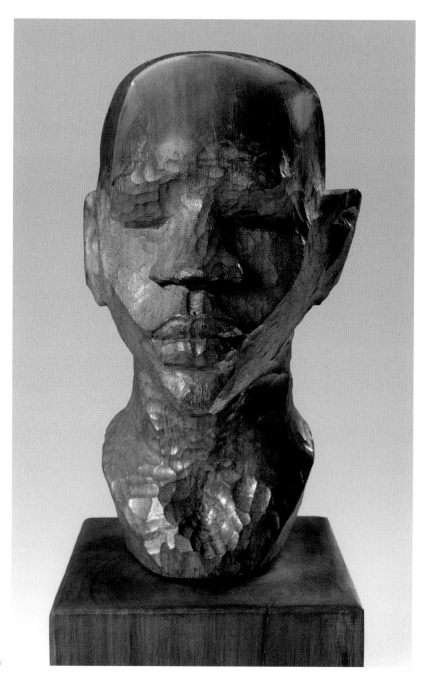

228

Ben
Enwonwu

Onitsha, Nigeria
1917–1994 Ikoyi,
Nigeria

228. *Boy*, ca. 1945
Wood, 60 x 20 x 24 cm
Grosvenor Gallery,
London

Mallica
"Kapo"
Reynolds

Saint Catherine,
Jamaica 1911–1989

229. *Gene*, 1970
Oil on hardboard,
61 x 51 cm
National Gallery of
Jamaica, Kingston,
Larry Wirth Collection

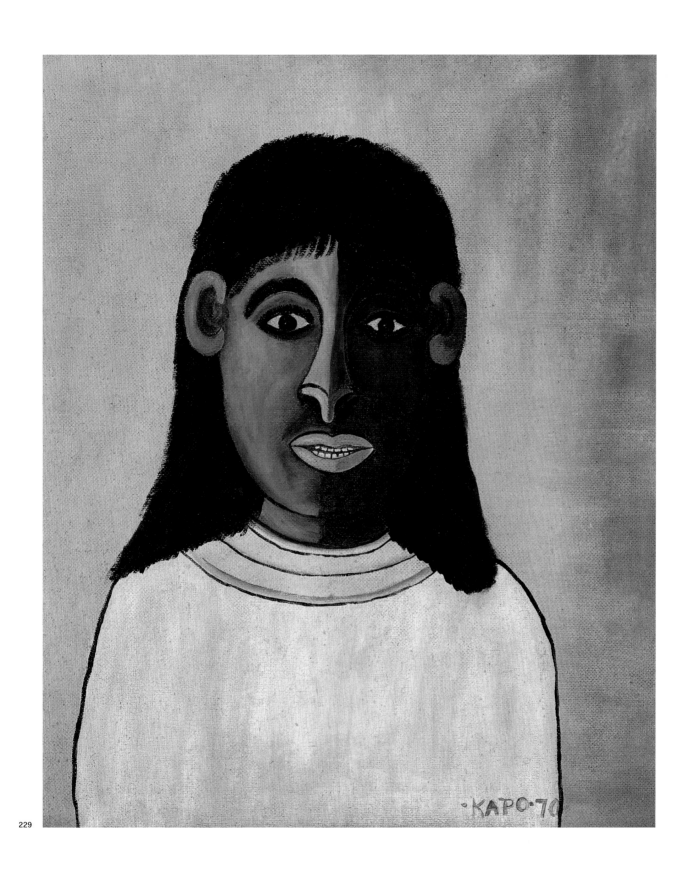

229

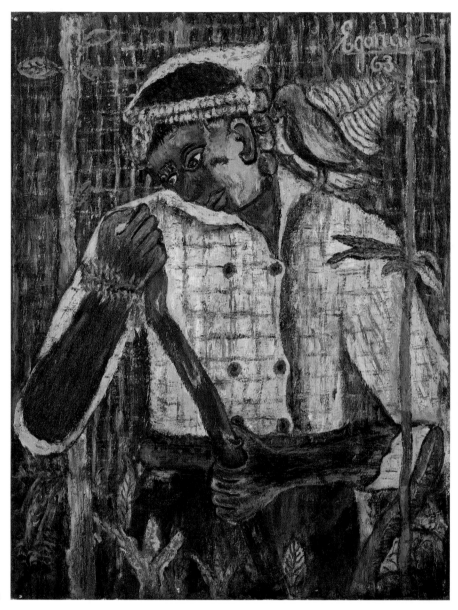

230

Uzo
Egonu

Onitsha, Nigeria
1931–1996 London

230. *Boy with
Budgerigar*, 1963
Oil on canvas board,
91 x 71 cm
Estate of the artist,
London

Lynette
Yiadom-
Boakye

b. London, 1977; lives
in London

231. *Speaker for the
Right*, 2013
Oil on canvas,
185 x 165 cm
Private collection,
Rio de Janeiro

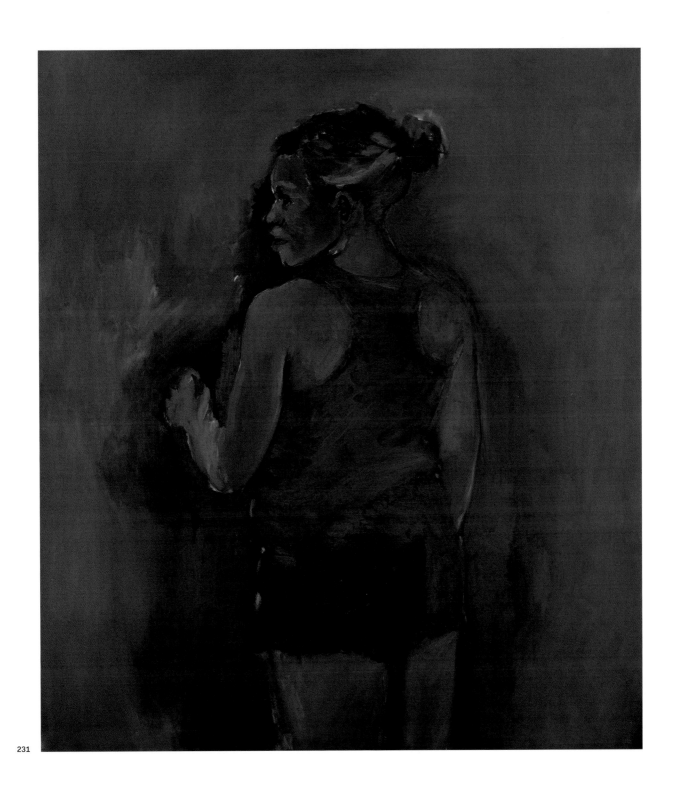

231

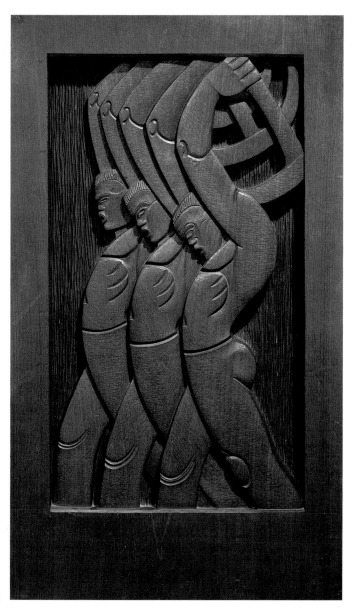

232

Edna
Manley

Bournemouth, United
Kingdom 1900–1987
Kingston, Jamaica

232. *Diggers*, 1936
Wood,
95.5 x 56 x 5 cm
National Gallery of
Jamaica, Kingston,
The Edna Manley
Memorial

Candido
Portinari

Brodowski, São Paulo
1903–1962 Rio de
Janeiro

233. *Coffee Worker*,
1934
Oil on canvas,
100 x 81 cm
Museu de Arte de
São Paulo Assis
Chateaubriand–
MASP, Gift of José
Maria Whitaker, 1964,
MASP.00519
Reproduction rights
kindly granted by João
Candido Portinari

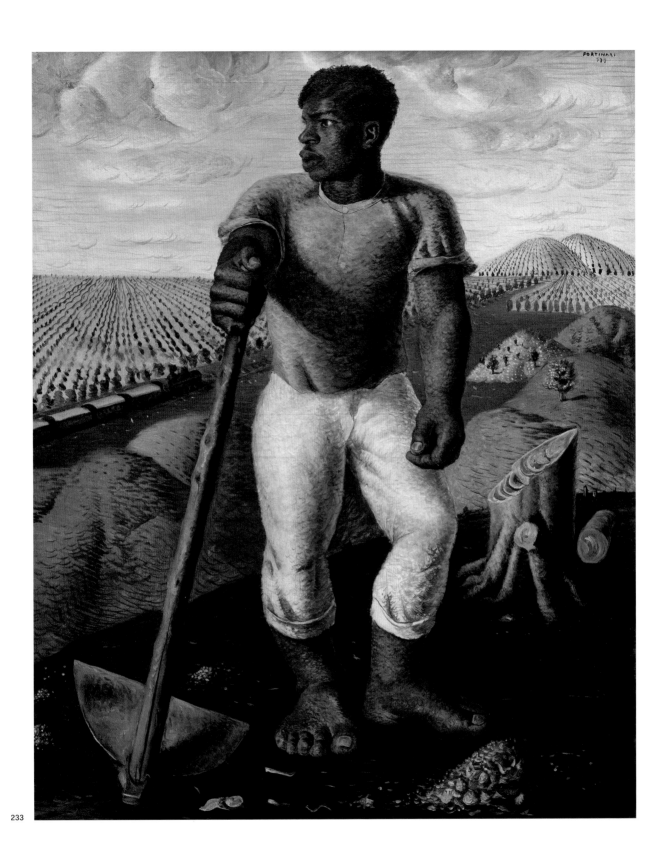

233

Rosina Becker do Valle

Rio de Janeiro 1914–
2000 Rio de Janeiro

234. *Indian from
the Forest* (*Caboclo*),
1963
Oil on canvas
80 x 55.5 cm
Museu de Arte de
São Paulo Assis
Chateaubriand – MASP
Gift of Lais H. Zogbi
Porto e Telmo Giolito
Porto in the context
of the *Afro-Atlantic
Histories* exhibition,
2018
MASP.10799

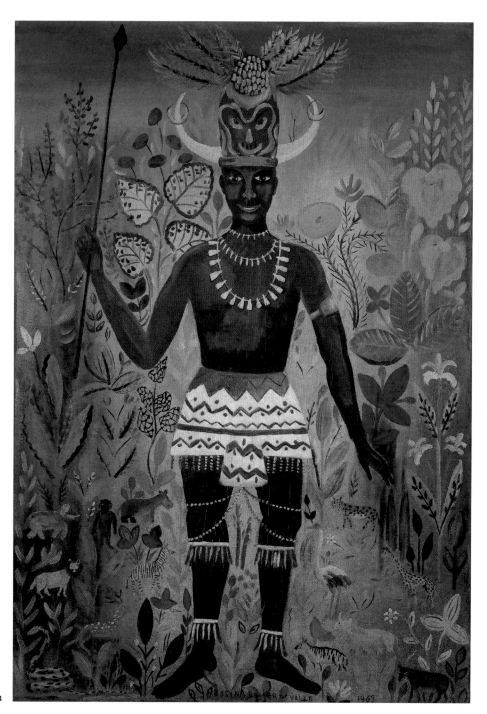

234

Bournemouth, United
Kingdom 1900–1987
Kingston, Jamaica

235. *The Prophet*,
1935
Wood,
77.5 x 30 x 20 cm
National Gallery of
Jamaica, Kingston

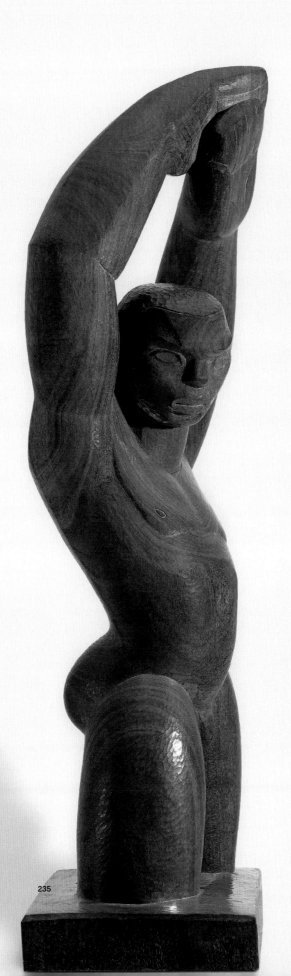

235

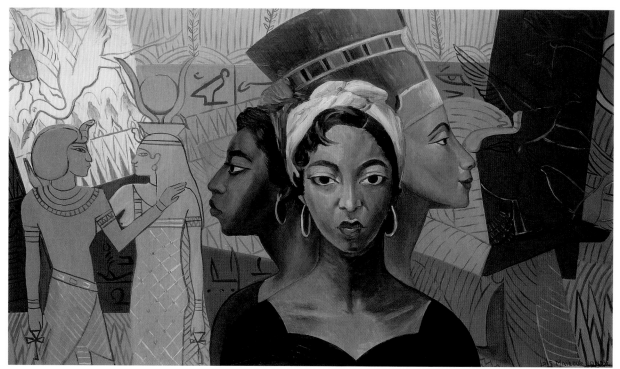

236

Loïs Mailou
Jones

Boston 1905–1998
Washington, D.C.

236. *Egyptian
Heritage*, 1953
Oil on Masonite,
60.5 x 103 cm
Clark Atlanta
University Art
Museum

Gary
Simmons

b. New York City,
1964; lives in Los
Angeles

237. *Nubian Queen*,
1993
Latex on tarpaulin,
244 x 244 cm
Courtesy of the artist
and Metro Pictures,
New York

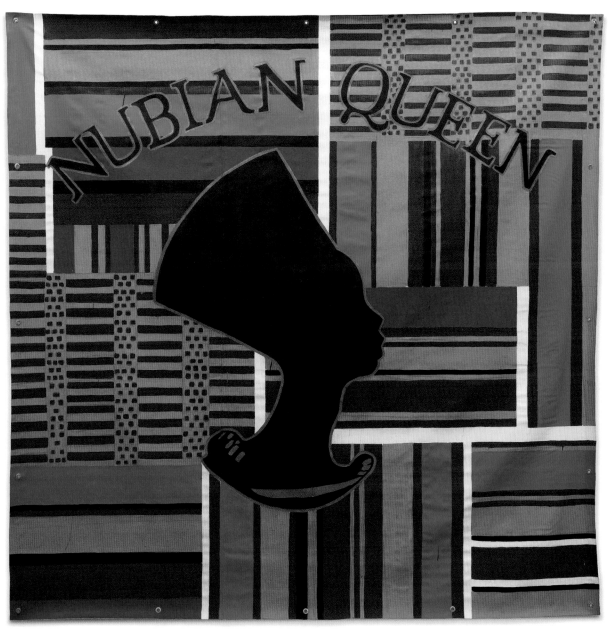

237

Dumile Feni

Worcester, South
Africa 1942–1991
New York City

238. *Composition for
a Memoriam*, 1969
Ink and black ballpoint
pen on paper,
141 x 73.5 cm
Grosvenor Gallery,
London

Benny Andrews

Plainview, Georgia
1930–2006 New York
City

239. *Study for
Portrait of
Oppression* (*Homage
to Black South
Africans*), 1985
Oil on canvas with
painted fabric and
paper collage,
111 x 72 cm
Estate of the
artist and Michael
Rosenfeld Gallery,
New York

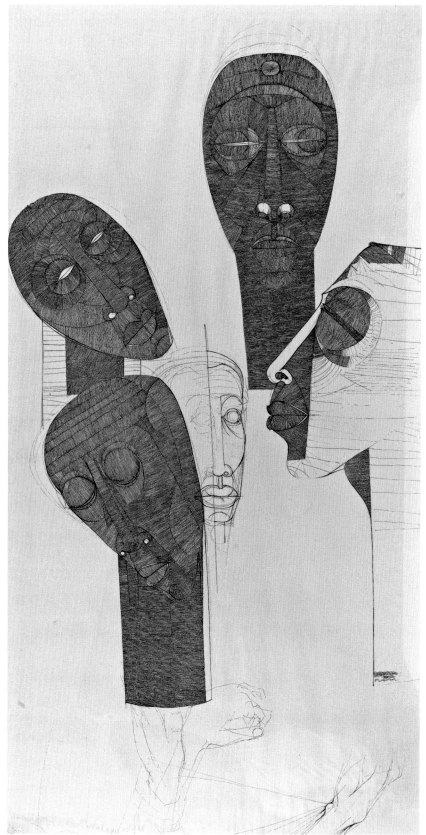

238

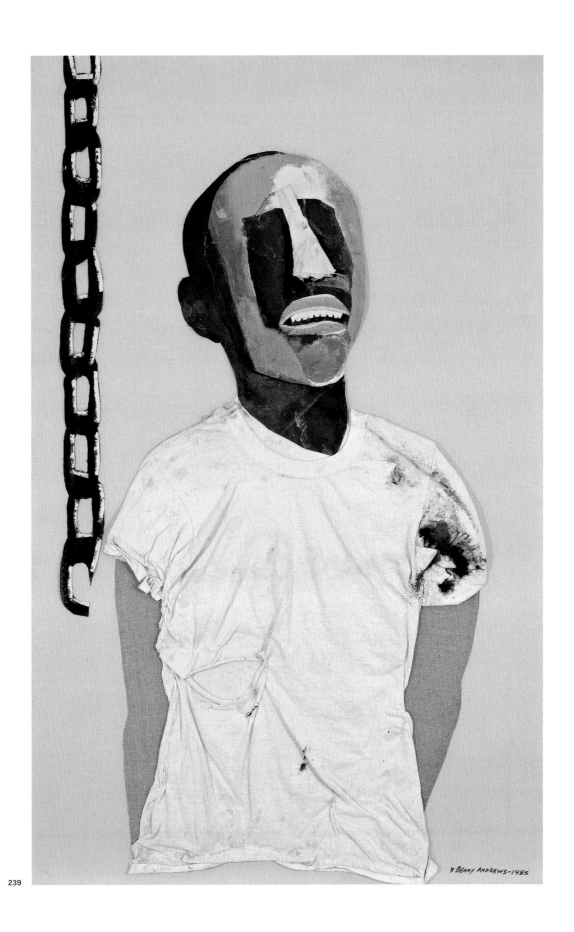

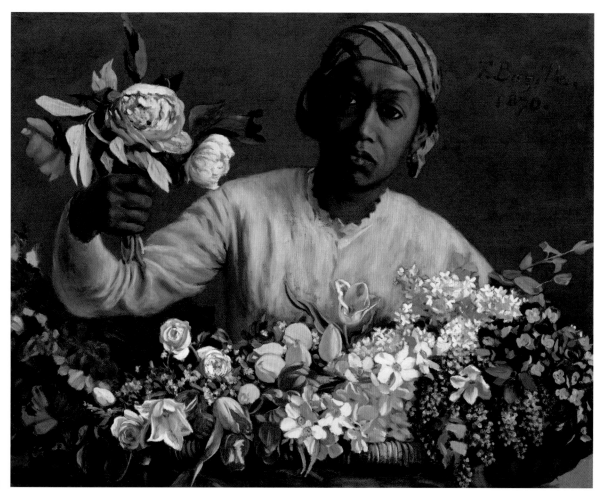

240

Frédéric Bazille

Montpellier, France 1841–1870 Beaune-la-Rolande, France

240. *Young Woman with Peonies*, 1870
Oil on canvas,
60 x 75 cm
National Gallery of Art, Washington, D.C., Collection of Mr. and Mrs. Paul Mellon,
1983.1.6

Gilberto Hernández Ortega

Baní, Dominican Republic 1923/24–1979 Santo Domingo

241. *Female Merchant*, 1976
Oil on canvas,
117 x 88 cm
Museo Bellapart, Santo Domingo

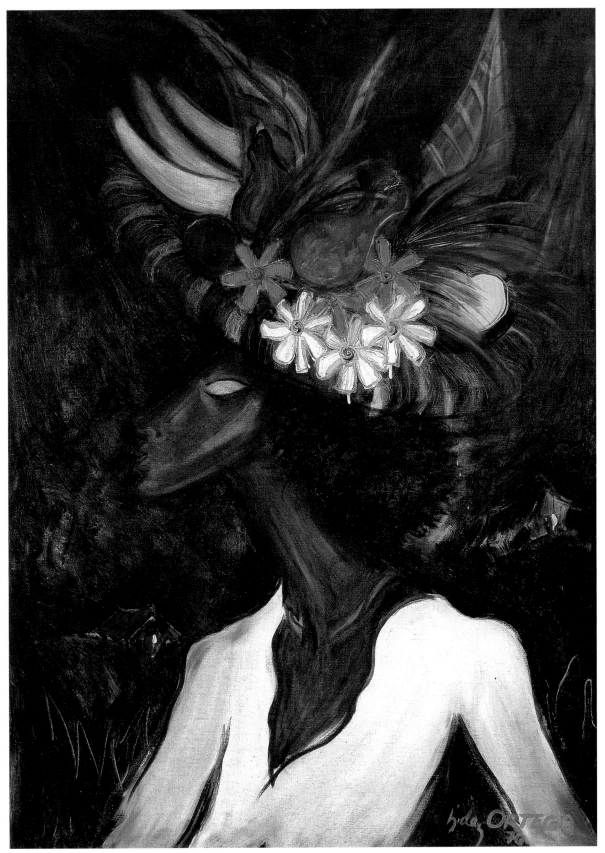

241

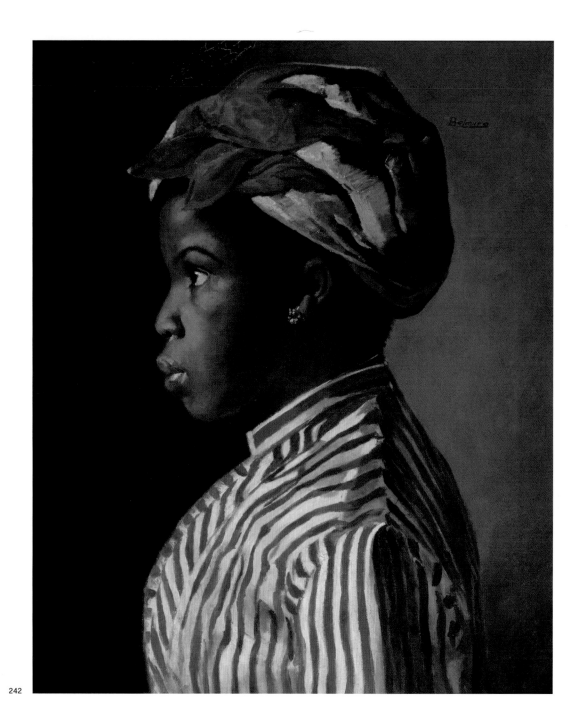

242

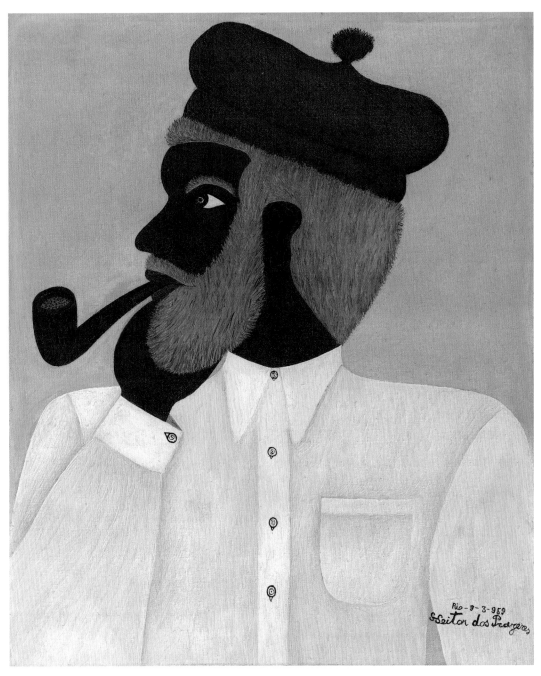

243

Belmiro de
Almeida

Serro, Minas Gerais,
Brazil 1858–1935 Paris

242. *Figure of a Young
Black Woman*, 1880s
Oil on canvas,
46 x 38 cm
Museu de Arte do
Rio (MAR)/Secretaria
Municipal de Cultura
da cidade do
Rio de Janeiro

Heitor dos
Prazeres

Rio de Janeiro 1898–
1966 Rio de Janeiro

243. *The Artist*, 1959
Oil on canvas,
45.5 x 38 cm
Museu de Arte de
São Paulo Assis
Chateaubriand–
MASP, Purchased
with funds provided
by Grupo Segurador
Banco do Brasil
e Mapfre, 2017,
MASP.01652

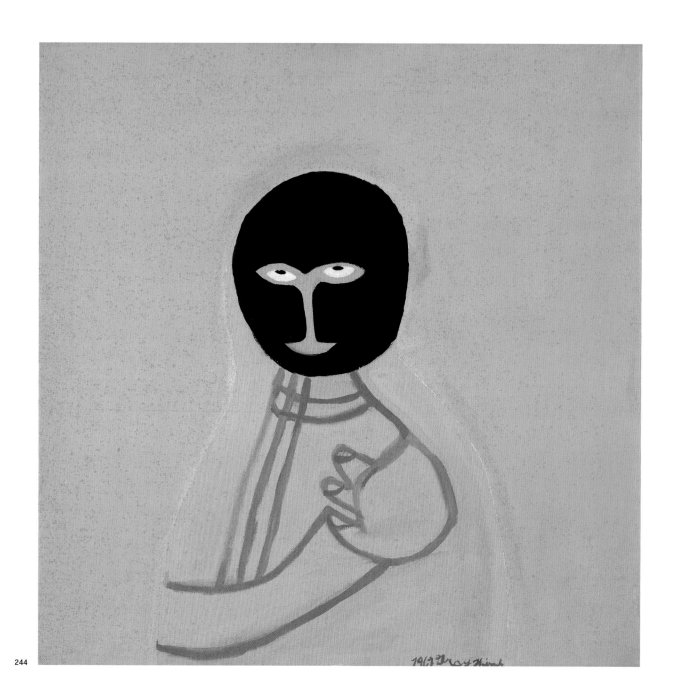

244

Iracy
Hirsch

Brazil ?

244. *Babalu* (*Figure
with Black Mask*),
1967
Oil on canvas,
80 x 80 cm
Museu de Arte de
São Paulo Assis
Chateaubriand–
MASP, Acquisition,
1967, MASP.00589

Toyin Ojih
Odutola

b. Ife, Nigeria, 1985;
lives in New York City

245. *All These
Garlands Prove
Nothing X*, 2013
Pen and marker on
paper, 35.5 x 43 cm
Jack Shainman
Gallery, New York

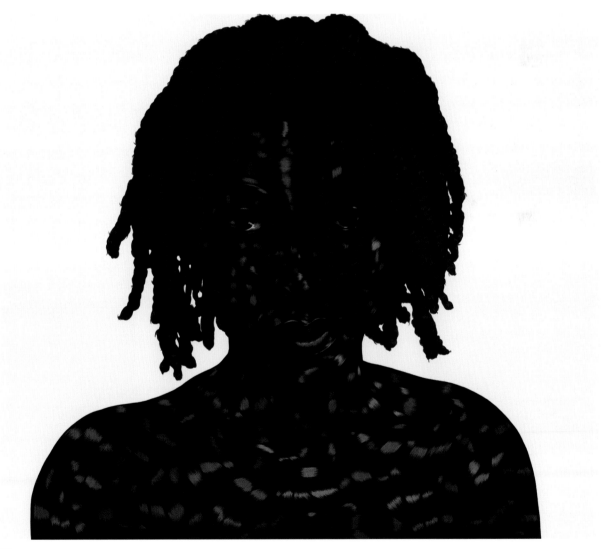

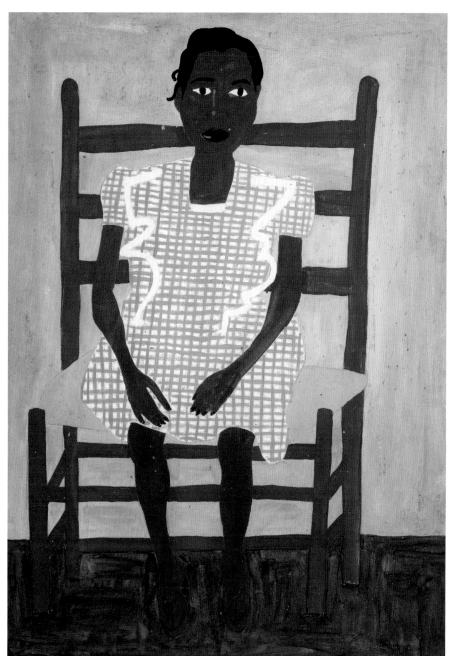

246

William Henry Johnson

Florence, South
Carolina 1901–1970
Central Islip,
New York

246. *Little Girl in
Green*, ca. 1941
Oil on cardboard,
57.5 x 81 cm
Clark Atlanta
University Art Museum

Hayward Oubre

New Orleans 1916–
2006 Winston-Salem,
North Carolina

247. *Untitled*, 1950
Oil on canvas,
101.9 x 61 cm
The Johnson
Collection,
Spartanburg

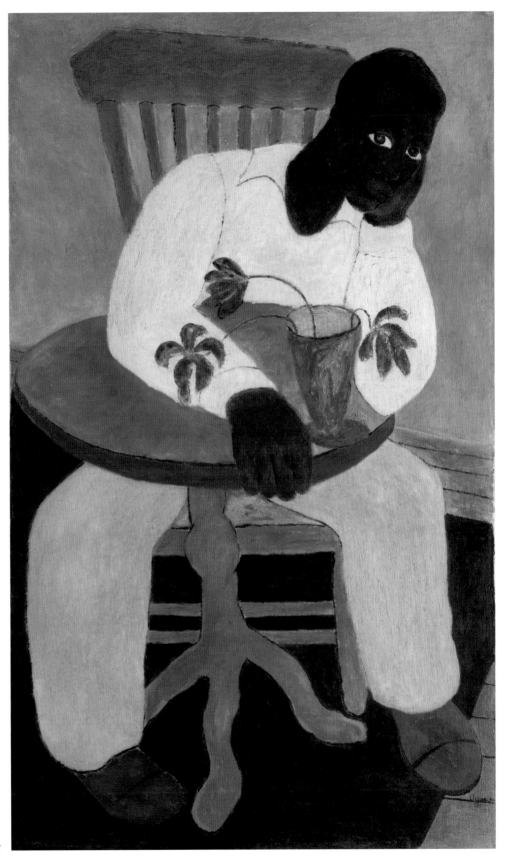

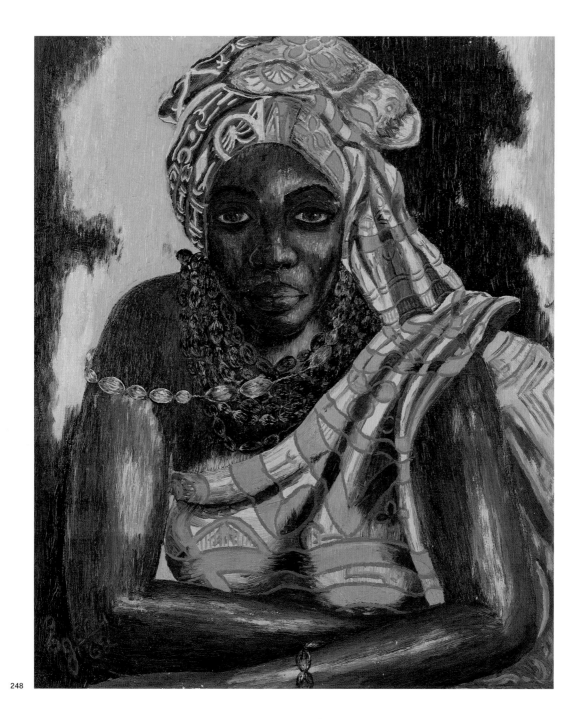

248

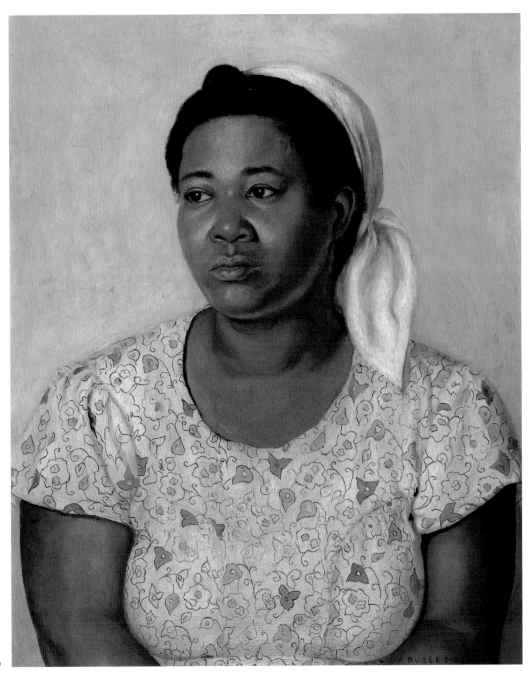

249

Uzo Egonu

Onitsha, Nigeria
1931–1996 London

248. *Guinean Girl*,
1962
Oil on canvas,
76 x 63.5 cm
Estate of the artist,
London

Roberto Burle Marx

São Paulo 1909–1994
Rio de Janeiro

249. *Untitled*, 1930s
Oil on canvas on
wood, 66 x 55 cm
Museu de Arte de
São Paulo Assis
Chateaubriand–
MASP, Gift of Lais
H. Zogbi Porto and
Telmo Giolito Porto,
2018, MASP.10736

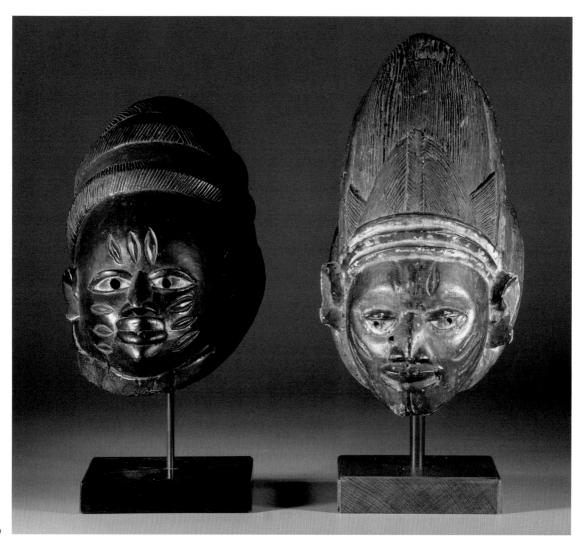

250

Unidentified Art

Yoruba, Nigeria

250. *Guelede Masks*,
20th century
Polychromed wood,
45.5 x 20 x 31 cm (left),
40 x 22 x 31 cm (right)
Museu de Arte de
São Paulo Assis
Chateaubriand–MASP,
Gift of Cecil Chow
Robilotta and Manoel
Roberto Robilotta,
in memory of Ruth
Arouca e Domingos
Robilotta, 2012,
MASP.01574, .01584

Romare Bearden

Charlotte, North
Carolina 1911–1988
New York City

251. *The Black
American in Search
of His Identity*, 1969
Collage of various
papers, newspaper,
gouache, and
photostat on
paperboard,
37 x 30.5 cm
Collection of Halley
K. Harrisburg and
Michael Rosenfeld
Gallery, New York

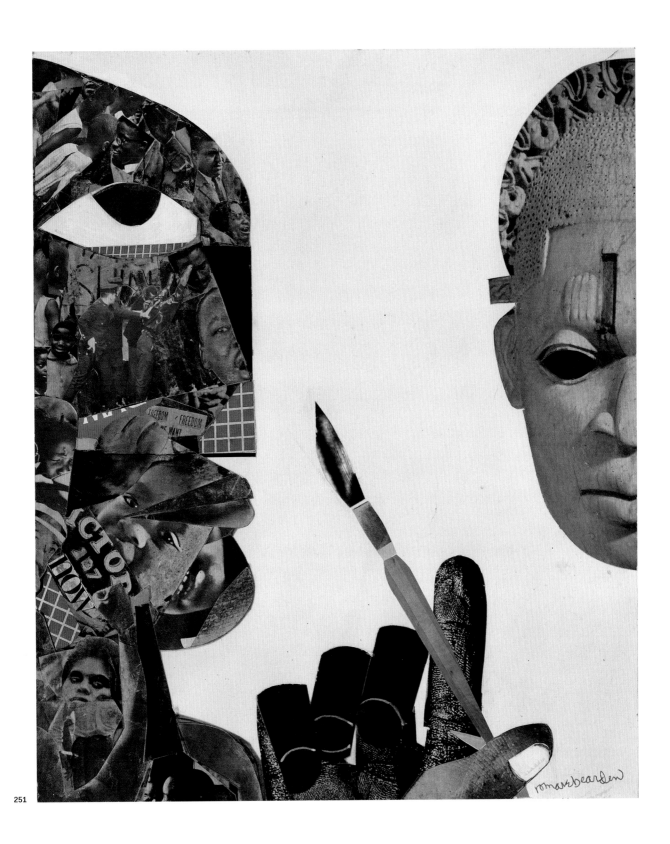

251

252

253

Norman Lewis

New York City 1909–
1979 New York City

252. *Carved Bobbin
(Guru)*, 1935
Pastel on sandpaper,
35 x 22 cm

253. *Dan Mask*, 1935
Pastel on sandpaper,
46 x 32 cm

Courtesy of Michael
Rosenfeld Gallery,
New York

Dimitri Ismailovitch

Kiev, Russia 1892–
1976 Rio de Janeiro

254. *Bamoun Dance
Mask, Yoruba
Cameroon*, undated
Oil on canvas,
90 x 71.5 cm
Collection of Eduardo
Mendes Cavalcanti,
Rio de Janeiro

D. Ismailovitch
1941.

254

255

256

257

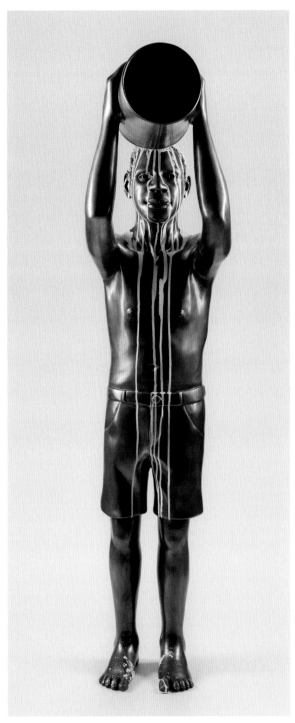

258

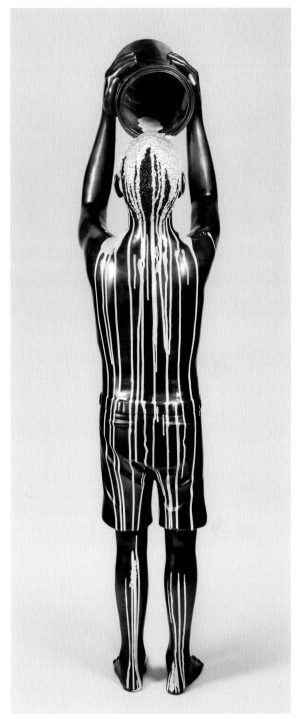

259

287

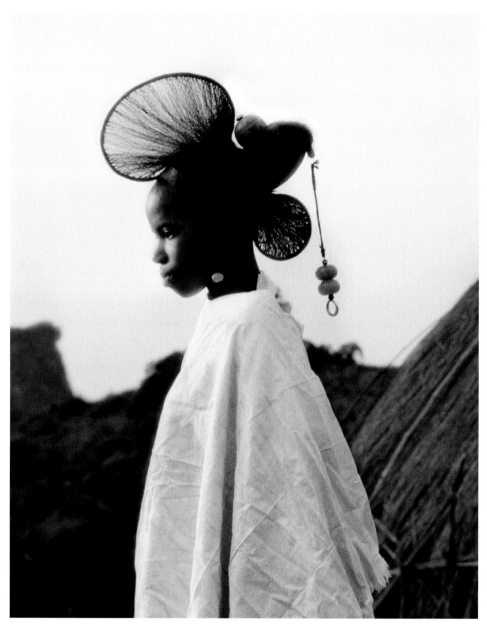

260

Gaspar
Gasparian

São Paulo 1899–1966
São Paulo

260. *Untitled*,
1954/2006
Analog print,
50 x 40 cm
Collection of Gaspar
Gasparian, São Paulo

RESISTANCES AND

ACTIVISMS

Resistances and Activisms

"We have dared to be free, let us be thus by ourselves and for ourselves." These words from Haiti's 1804 Declaration of Independence proclaim—in the first-person plural—freedom as a mission and a destiny. Commemorating the occasion, Jean-Jacques Dessalines, the first ruler of liberated Haiti, solemnly declared in a message to its newly minted citizenry: "Independence or death . . . May these sacred words bring us together, and may they be a sign of our struggles and our union." It was not until 1822 that Pedro I, the first king of the Empire of Brazil, took up the cry. But within a year of Haitian independence, portrait medallions of Dessalines were circulating among Black militias in Rio de Janeiro. From a sugar colony to the first New World country to abolish slavery, Haiti destabilized the entire colonial system and became a symbol of Black power: slaves could indeed dare to overthrow their masters and seize their freedom. "To be one's own master" is the motto that guides this section of *Afro-Atlantic Histories*, which posits a dialogue among artworks by different authors across time and geography that deploy Afro-Atlantic strategies of resistance and activism.

From the time of their arrival in the Americas, Africans and their descendants sabotaged the enslaving regime by constructing politics in their own language. Insurgent tactics included destroying sugar mills, burning plantations, stealing, negotiating, and poisoning. Potions made with Guinea hen weed (*Petiveria alliacea*)—also known as the "tame-the-master" herb—were served to masters as sedatives, causing convulsions and death. Dalton Paula recalls this resistance

tactic in *Paratudo* (2015; fig. 267), an installation made with thirteen bottles containing *cachaça*—the popular sugarcane-based brandy—and Guinea hen weed. This infusion also makes reference to the medicinal properties of the herb, which explains its presence in *garrafadas*, home remedies sold in street markets. In Afro-Brazilian religious rituals, it is believed to bring good luck and ward off the evil eye. The small sequined and bead-covered bottles used in Haitian Voodoo (figs. 270-73) play the double role of weapon and amulet. As altar offerings, they honor *loa* (entities of the Voodoo pantheon); in other contexts, they can be used in *travay maji* (which in Haitian creole means "work of magic"). Ambiguities and resignifications also inspired Jaime Lauriano's *Pesadão* (2012; fig. 269), which substitutes Molotov cocktails for drinks sold from street carts. Displayed alongside a manual printed on a flannel cloth explaining the device, the artwork triggers the feeling that it might explode at any moment.

Escape, both individual and collective, was another form of resistance, along with the establishment of Black settlements. Wherever slavery existed, so did *quilombos*: runaway slave communities. The largest in Brazil, Quilombo dos Palmares, in the region of Serra da Barriga, drew thousands of people. It was there, in 1983, that intellectual and militant Abdias Nascimento delivered a fiery speech to a mostly Black audience commemorating the death of the Palmares leader Zumbi (fig. 321). Many *quilombos* became symbols of the antiracist struggle and have survived through generations, and their inhabitants, called *quilombolas*, have been documented by historian Flávio Gomes (1996; fig. 291) and artist André Cypriano (2005; fig. 292). These images reveal another pillar of everyday resistance: the Black family, a theme that encompasses the Afro-Atlantic context in Aline Motta's *Bridges over the Abyss #3* (2017; fig. 294).

The actions of both enslaved and freed Black populations influenced social behaviors, religion, family ties, institutions, and politics. An unflattering portrayal of Haiti's new ruler Dessalines shows him crowned and enthroned in sumptuous European regalia surrounded by slavish Black subjects (1806; fig. 264). The image was part of Napoleon's campaign to undermine the ideals of the Haitian revolution and incite counterrevolutionary action against the new government. In different contexts and places, artists have appropriated the symbols of nobility and royalty for positive representations of Black leaders. In a photograph of Huey P. Newton (1967; fig. 266), the Minister of Defense of the Black Panther Party poses in a wicker peacock chair holding a rifle in one hand, a spear in the other. The chair sits on a zebra rug and is flanked by African shields. Maria Bibiana do Espírito Santo appears in Pierre Verger's photo as a queen, with nature as her palace (1948; fig. 261). Known as Mãe Senhora, Bibiana was the mother of the Candomblé house Ilê Axê Opô Afonjá and a descendant of the noble Aspiá family of the Oyo and Ketu kingdoms in Africa. In Afro-Brazilian religions, thrones are reserved for the exclusive use of high priests or kings and queens crowned in popular par-

ties called *folguedos*. Adenor Gondim captures this tradition in a group portrait of the Sisterhood of Our Lady of the Good Death, with Judge Perpétua in the place of honor surrounded by four leaders (1990s; fig. 263).

This religious sisterhood of Black women, whose origins date back to the beginning of the 19th century, reappears in J. Cunha's *Black Resistance Organizations* (1995; fig. 279) alongside pictorial tributes to various *quilombos*, social movements, Black festivals, and the rhythms of *afoxé*. Cunha's textile banner was worn at Carnival by thousands of members of the Afro street band Ilê Aiyê in Salvador. Textiles narrating historical events and figures have been a common format among the Fon (Dahomey) people of Benin since the 17th century. In Alphonse Yémadjè's *Emblems of the Abomey Kings* (1995; fig. 278), each fabric square contains the attributes of a royal house chief and a proverb. In Haiti, Dahomeyan, Kongo, and European symbols overlap in flags used in Haitian Voodoo rituals. George Valris's flag (fig. 274) incarnates Baron Samedi, a *loa* linked to the cult of ancestors who holds the power of life and death. Abdias Nascimento repurposed native symbols and the Brazilian flag, converting its horizontal orientation to the vertical and replacing its positivist slogan "Order and Progress" with the Yoruba word *okê* (fig. 275), a greeting used by Oshosi, the deity of hunting and abundance whose attributes are the bow and arrow.

Textiles from across Africa and its diaspora depict histories of resistance and activism, expressing notions

of cultural, political, religious, and artistic identity. The colorful geometric-patterned *kente* cloth, woven since the 17th century by the Akan people of Ghana (fig. 266), was adopted by Kwame Nkrumah, the first president of independent Ghana, as a symbol of the nation and Pan-Africanism. Brazilian artist Arthur Bispo do Rosário, a resident of the Colônia Juliano Moreira psychiatric hospital in Rio de Janeiro, unwove discarded staff uniforms to create a tapestry of hallucinatory memories of his encounters with psychologist Rosangela Maria Grilo Magalhães (1980s; fig. 277). To make *Who's Afraid of Aunt Jemima?* (1983; fig. 280), Faith Ringgold assembled fifty-six squares of fabric featuring half-length portraits and handwritten texts within a frame of African patterns. In this, her first "story quilt," the artist rewrote the life of Aunt Jemima, the ur-Black "mammy," transforming her into a successful businesswoman, and in the process challenging the derogatory stereotypes attached to African American women. Emma Amos's *Liberty/Don't Forget Me* (1986/2010; fig. 324) inverts another significant allegory by substituting the female body of the Statue of Liberty for that of a Black man.

Another inversion of stereotypical images of Black characters occurs in Titus Kaphar's *Space to Forget* (2014; fig. 284), a reinterpretation of Jorge Henrique Papf's well-known photograph (1899; fig. 283). Kaphar replaces the little white "lady" of Papf's original picture, who rides a Black nanny, with a blank cutout, a void with no identity in an affluent room. The nanny holds a duster in her hand

whose bristles blend with the grains on the wood floor, a reference to the temporal and geographical continuities of Black life: from post-abolition Recife to the contemporary U.S. The same characters appear as red silhouettes in Rosana Paulino's *Social Fabric* (2010; fig. 281). Here, sixteen pieces of fabric are sewn together to form a tattered tableau illustrating the violence and forms of degradation Blacks face from birth. A black silhouette alludes to the 19th-century trope of the wet nurse: an anonymous Black woman holds her small white master or mistress on her lap or back, as in the 19th-century photographs of Alberto Henschel (fig. 286) and Solomon Nunes Carvalho (fig. 287).

Sidney Amaral explores Black maternity and social violence in *Black Mother, or The Fury of Iansã* (2014; fig. 298). Inspired by a scene from the film *Cristo Rey* (2013) by Dominican filmmaker Leticia Tonos, Amaral portrays a Black mother wearing the color red, associated with Iansã, the orisha of lightning and bravery. Tattooed on her arm is the Adinkra symbol *aya* ("fern" among the Ashanti people), denoting endurance and resourcefulness, which defies the official badge—the flag of the state of São Paulo—on the policeman's shirtsleeve. Police violence is also addressed in No Martins's *Villain* (2017; fig. 297), Tiago Sant'Ana's *Deletion #1* (2017; figs. 300–303), and Nina Chanel Abney's *Penny Dreadful* (2017; fig. 299), the latter set in Chicago and explicitly denouncing Donald Trump.

Demonstrations, banners, and posters have played a central role in strategies of antiracist activism. The 1963 March on Washington for Jobs and Freedom, in which Martin Luther King Jr. gave his famous "I have a dream" speech, is remembered in one of Alma Thomas's rare figural works (1964; fig. 315). Maurício Simonetti registers the banner commemorating the tenth anniversary of the Brazilian Unified Black Movement during the march for the 100th anniversary of abolition in São Paulo (1988; fig. 314), and Sheila Pree Bright highlights the prominent role of trans people in Black Lives Matter demonstrations (2015; fig. 313). In *Condition Report* (2000; figs. 308, 309), Glenn Ligon revisits his 1988 oil painting of the protest placard I AM A MAN—used at Black workers' strikes in Memphis in 1968—incorporating a conservator's annotations on the current condition of the work. In Paulo Nazareth's photograph *Black Neger* (2012–13; fig. 306), two Black men pose with signs reading NEGER and PRETO, historically racist insults and classification criteria whose meanings have been proudly reformulated by Black liberation movements. This valorization of words also runs through the verses of Afro-Peruvian poet Victoria Santa Cruz in the musical performance *They Shouted Black at Me* (1978; figs. 310–312). The terms reappear in Bruno Baptistelli's *Language* (2015; fig. 305) in a subtle modulation of tones. Moisés Patrício features his own hands raised in a gesture of offering, holding objects or inscribed with words, in the series *Do You Accept It?* (2014–18; figs. 327, 328), while Antônio Obá's handprints, absorbed in wood like a stain, mobilize themes of history and racial and identity in his series *Ex-votos* (2017; figs. 318-320).

293

Finally, this section pays homage to Marielle Franco (1979–2018), Tyisha Miller (1979–1998), Amarildo Souza (1965–2013), Trayvon Martin (1995–2012), and other victims of racism whose lives have been truncated by imprisonment and/or murder. Norman Lewis's *Untitled* (1968; fig. 316) shows the dead body of Malcolm X laid out on the ground. Emory Douglas celebrates the legacy of Black Panther Fred Hampton, killed by police in 1969, with the activist's words: "You can murder a liberator but you can't murder liberation" (ca. 1969; fig. 337). Marsha Johnson, founder of S.T.A.R (Street Transvestite Action Revolutionaries), appears next to a drag queen in Andy Warhol's series *Ladies and Gentlemen* (1975; fig. 338). Felix Beltran's poster *Libertad para Angela Davis* (1971; fig. 336), commissioned by the Propaganda Department of the Cuban Communist Party, uses Pop art to support the campaign to free the activist. Street posters with the logos of the Black Panther Party (fig. 331) and the Campaign to Free Rafael Braga (2014; fig. 332), a young man whose imprisonment became emblematic of Brazilian institutional racism, suggest the circulation of visual protest strategies across the Black Atlantic, as well as the ongoing struggle for full and dignified freedom, achieved in the first person.

Pierre Verger

Paris 1902–1996
Salvador, Bahia

261. *Mrs. Maria Bibiana do Espírito Santo, "Mother" of the Candomblé House Axé Opó Afonjá*, 1948

Gelatin silver print, 40 x 40 cm
Museu de Arte de São Paulo Assis Chateaubriand–MASP, Gift of Pirelli, 1992, MASP.01799

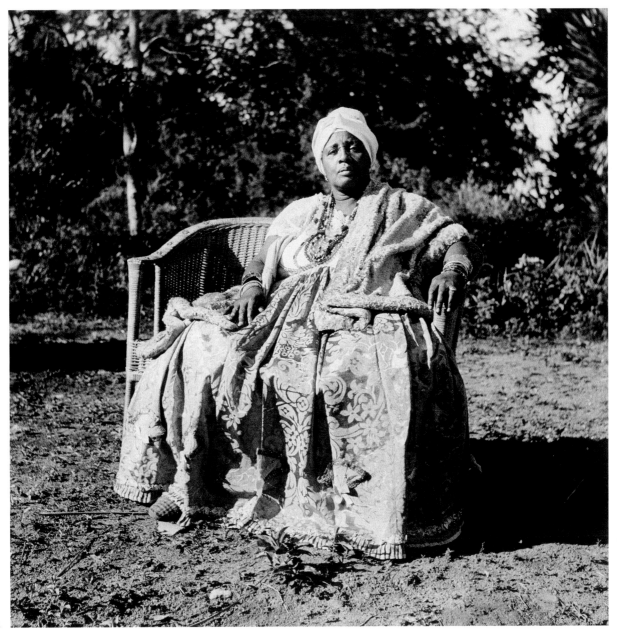

261

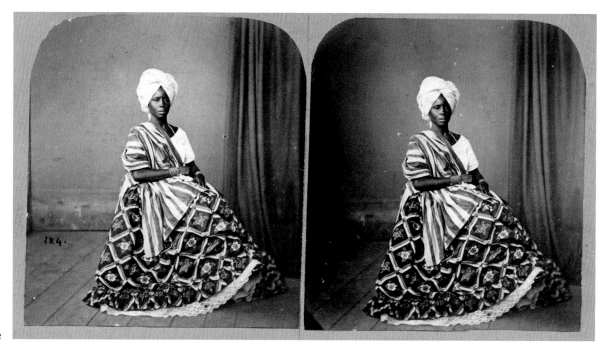

262

Revert
Henry
Klumb

Adenor
Gondim

Berlin 1825–1886

262. *Untitled*, ca. 1864
Stereoview on paper,
8.5 x 16.5 cm,
each 7 x 7 cm
Collection of Ruy
Souza e Silva,
São Paulo

b. Ruy Barbosa,
Bahia, 1950; lives in
Salvador, Bahia

263. *Untitled*, from
the series *Sisterhood
of Our Lady of the
Good Death*, 1990s
Photographic print,
50 x 60 cm
Collection of the
artist, Salvador

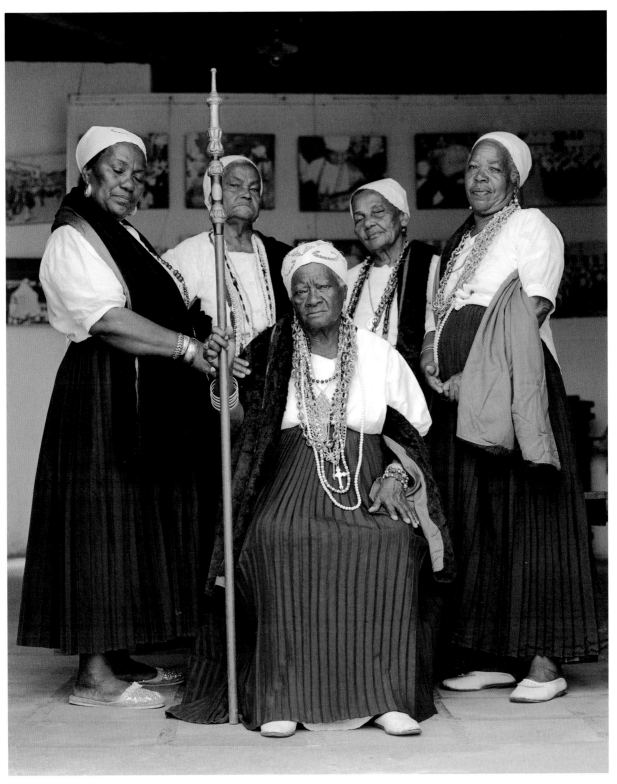

263

Unidentified Artist

264. *Coronation of Juan Santiago Desalines, First Emperor of Haiti*, from Louis Dubroca, *Vida de J. J. Dessalines: Gefe de los negros de Santo Dominigo; con notes muy circumstanciadas sobre el origen caracter y atrocidades de los principales gefes de aquellos rebeides desde el prinicipio de la insurrección en 1791*, Mexico City, 1806
15 x 11 cm
John Carter Brown Library, Providence, Rhode Island

Alfred Weidinger

b. Schwanenstadt, Austria, 1961; lives in Leipzig, Germany

265. *Fon Ndofoa Zofoa III, King of Babungo*, 2012
Photographic print, 99 x 147 x 4.5 cm
Associação Museu Afro Brasil, São Paulo

Attributed to Blair Stapp

United States

266. *Huey Newton*, 1967
Lithograph on paper, 89 x 58.5 cm
Collection of Merrill C. Berman, New York

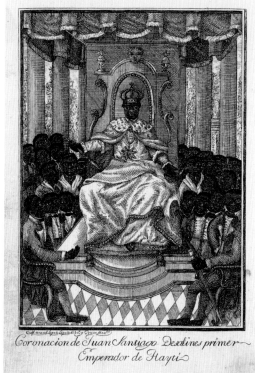

264

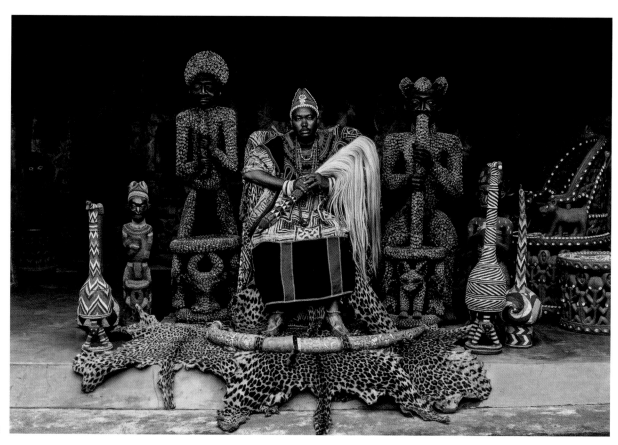

265

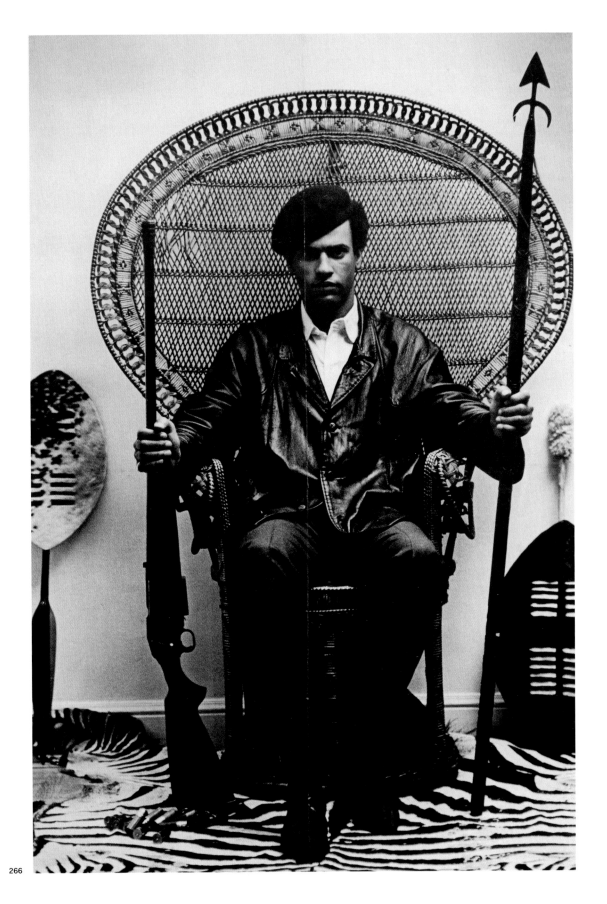

299

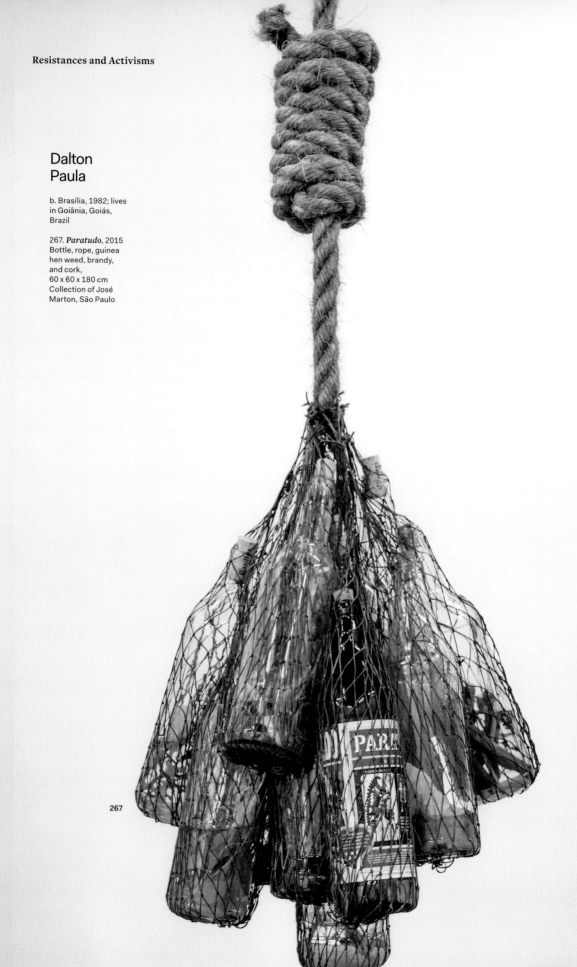

Dalton Paula

b. Brasília, 1982; lives in Goiânia, Goiás, Brazil

267. *Paratudo*, 2015
Bottle, rope, guinea hen weed, brandy, and cork,
60 x 60 x 180 cm
Collection of José Marton, São Paulo

267

Jaime Lauriano

b. São Paulo, 1985;
lives in São Paulo

268. *Burn After
Reading*, 2012
Silkscreen on flannel,
27.5 x 37 cm
Private collection,
São Paulo

269. *Pesadão*, 2012
45 glass bottles,
gasoline, cotton
fabric, clamp,
rubber bands, tape,
polystyrene box and
cart, 60 x 65 x 120 cm
Galeria Leme,
São Paulo

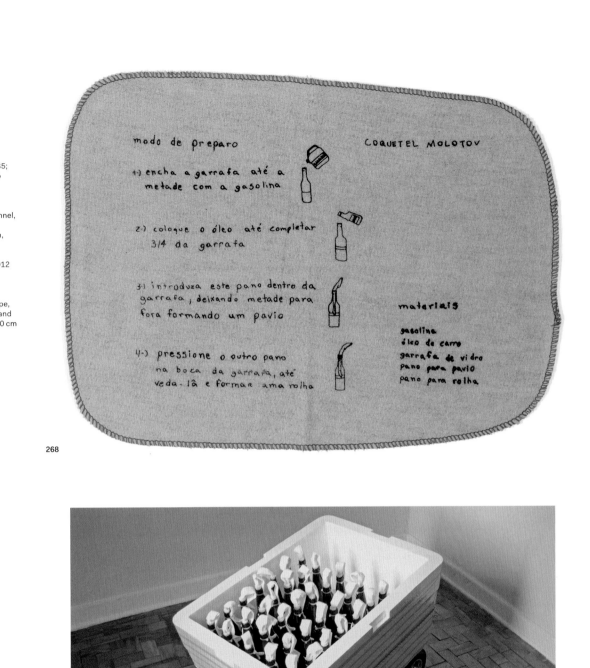

268

269

270

271

272

273

274

Unidentified Artists

270-73. *Voodoo Bottles* (*Haiti*),
undated
Associação Museu
Afro Brasil, São Paulo

George Valris

b. Cavaillon, Haiti,
1950; lives in Port-au-Prince

274. *Baron Samedi*,
undated
Mixed media,
90 x 63 cm
Associação Museu
Afro Brasil, São Paulo

302

Abdias Nascimento

Franca, São Paulo
1914–2011 Rio de
Janeiro

275. *Okê Oxóssi*, 1970
Acrylic on canvas
92 x 61 cm
Museu de Arte de
São Paulo Assis
Chateaubriand – MASP
Gift of Elisa Larkin
Nascimento | IPEAFRO
in the context of the
Afro-Atlantic Histories
exhibition, 2018
MASP.10811

275

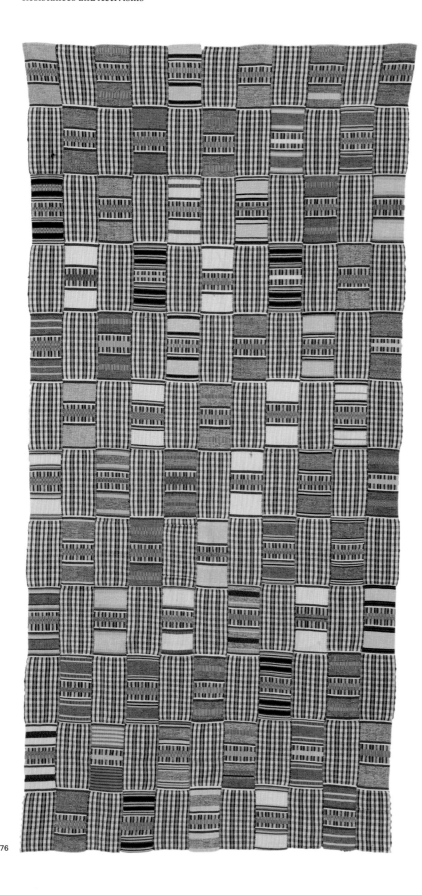

276

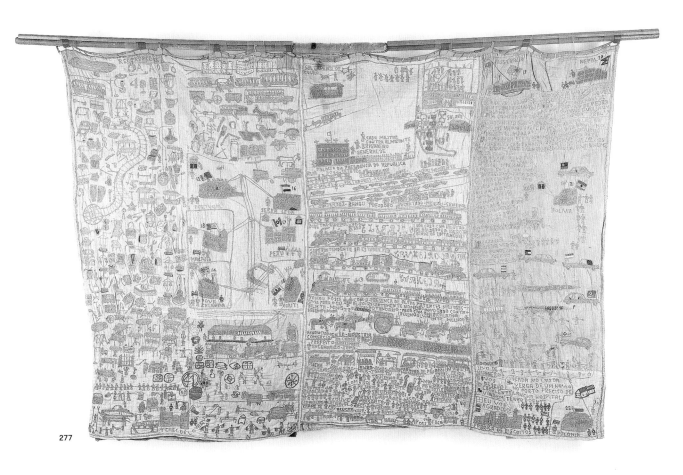

277

Unidentified Artist

Akan people

276. *Kente*, undated
Textile, 187.5 x 92 cm
Private collection,
São Paulo

Arthur Bispo
do Rosário

Japaratuba, Sergipe,
Brazil 1909 or 1911–
1989 Rio de Janeiro

277. *Rosangela Maria
Avenue*, 1980s
Wood, plastic, and
embroidered fabric
(double-sided),
189 x 120 cm
Museu Bispo
do Rosário Arte
Contemporânea,
Rio de Janeiro

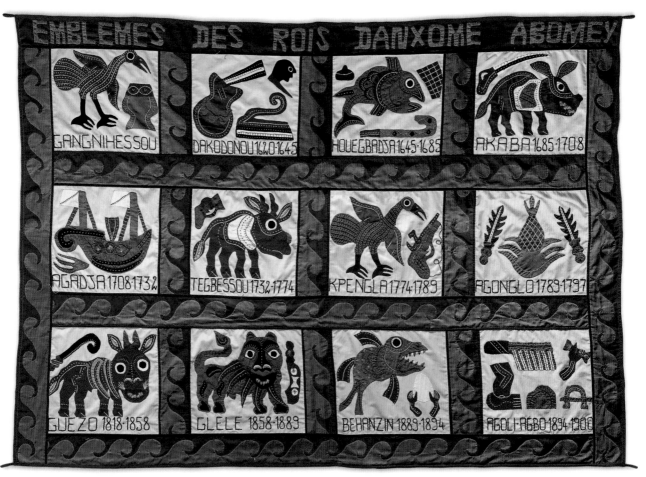

EMBLEMES DES ROIS DANXOME ABOMEY

GANGNIHESSOU | DAKODONOU 1620-1645 | HOUEGBADSA 1645-1685 | AKABA 1685-1708

AGADSA 1708-1732 | TEGBESSOU 1732-1774 | KPENGLA 1774-1789 | AGONGLO 1789-1797

GUEZO 1818-1858 | GLELE 1858-1889 | BEHANZIN 1889-1894 | AGOLI-AGBO 1894-1900

278

Alphonse
Yémadjè

Benin 1916–2012
Cotonou, Benin

278. *Emblems of
the Abomey Kings*,
undated
Textile, 147 x 200 cm
Private collection,
São Paulo

J.
Cunha

b. Salvador, Bahia,
1947; lives in Salvador

279. *Black Resistance
Organizations—Ilê
Aiyê*, 1995
Textile, 120 x 147.5 cm
Collection of the
artist, Salvador

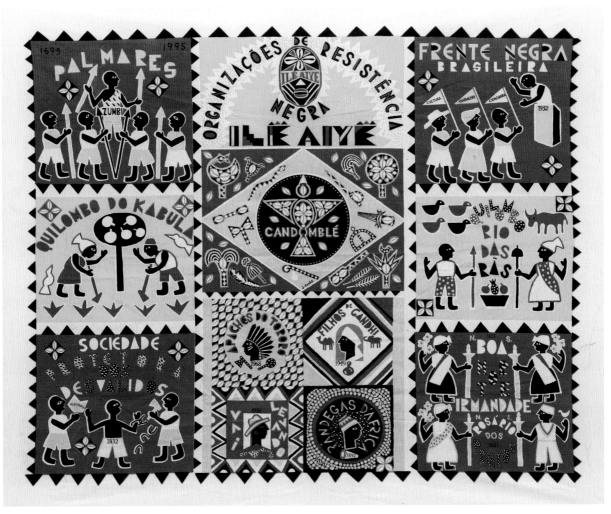

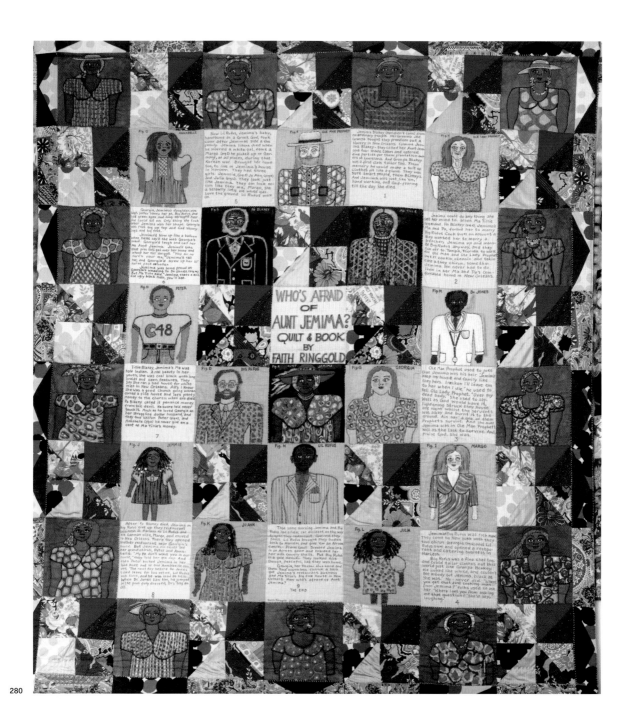

280

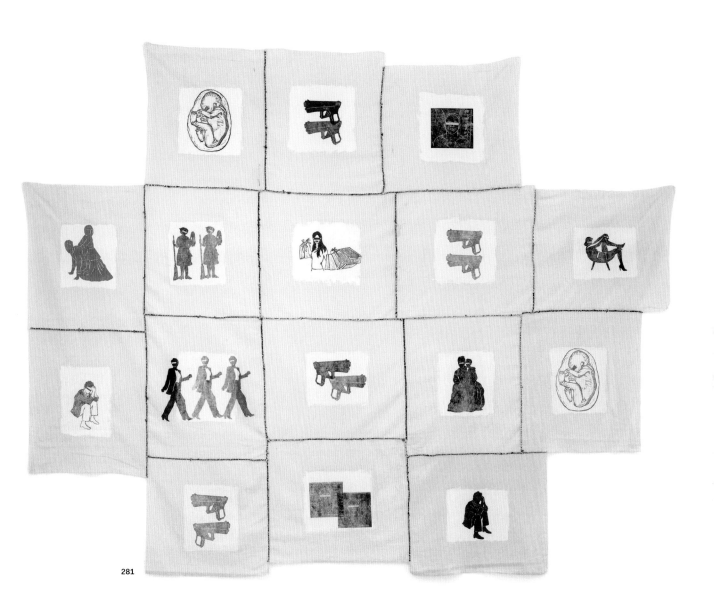

281

Faith
Ringgold

b. New York City,
1930; lives in
Englewood, New
Jersey

280. *Who's Afraid of
Aunt Jemima?*, 1983
Acrylic on canvas,
dyed, painted, and
pieced fabric,
228.5 x 203 cm
Private collection,
courtesy of ACA
Galleries, New York

Rosana
Paulino

b. São Paulo, 1967;
lives in São Paulo

281. *Social Fabric*,
2010
Colored monotype,
linoleum, and sewing
on fabric,
280 x 300 cm
Collection of
Fernando and Camila
Abdalla, São Paulo

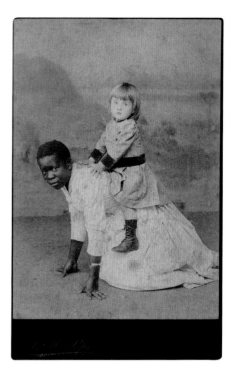

283

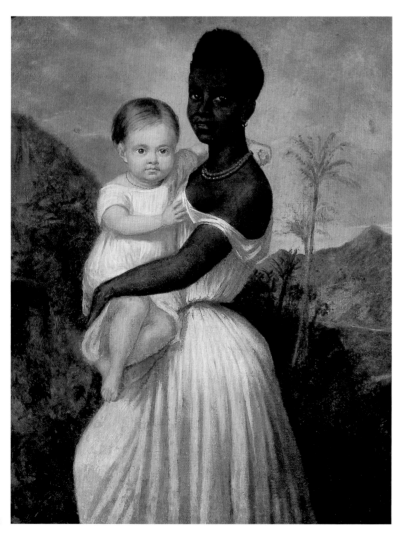

282

310

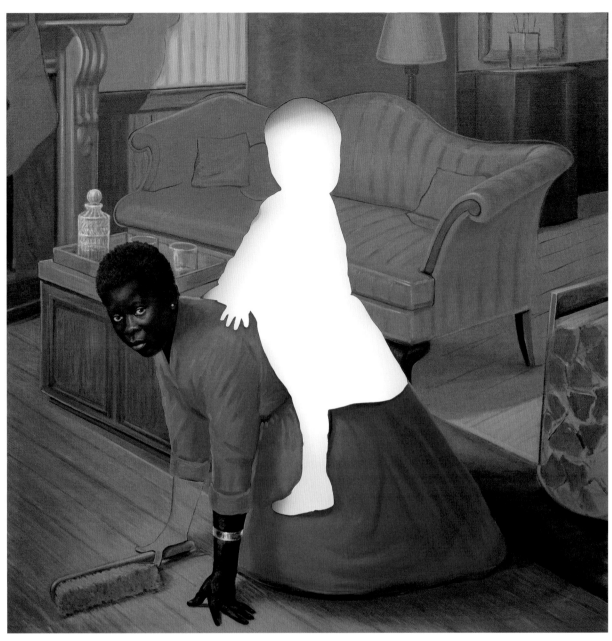

284

Unidentified Artist

282. *Wet Nurse with Child on Her Lap (Catarina and the Boy Luis Pereira de Carvalho)*,
undated
Oil on canvas, 55 x 44 cm
Museu Imperial de Petrópolis, IBRAM/MinC, Rio de Janeiro

Jorge Henrique Papf

Berlin 1863–1920
Petrópolis, Rio de Janeiro

283. *Nanny Playing with Child in Petrópolis, Rio de Janeiro, Brazil*, 1899
20 x 22 cm
Collection of G. Ermakoff,
Rio de Janeiro

Titus Kaphar

b. Kalamazoo, Michigan, 1976; lives in New Haven

284. *Space to Forget*, 2014
Oil on canvas, 162.5 x 162.5 cm
Collection of Nick Cave

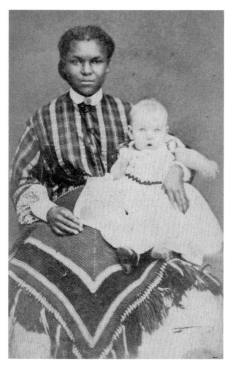

285

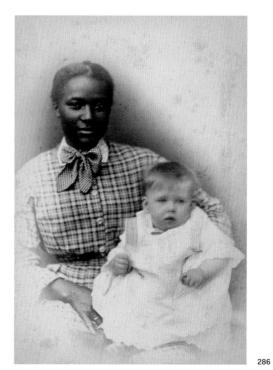

286

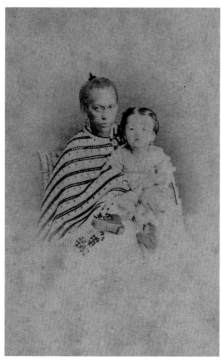

287

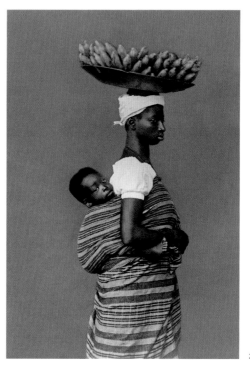

288

Disbrow & Few

Albion, New York

285. *Mary Allen Watson, June 15, 1866*, 1866
10 x 6 cm
Library of Congress Prints and Photographs Division, Washington, D.C.

Alberto Henschel

Berlin 1827–1882 Rio de Janeiro

286. *Maria Cavalcanti de Queirós Monteiro with Petrolina, Midwife and Wet Nurse*, undated
9 x 6 cm
Fundação Joaquim Nabuco, Coleção Francisco Rodrigues, Recife, Pernambuco, Brazil

Solomon Nunes Carvalho

Charleston, South Carolina 1815–1897 Pleasantville, New York

287. *Young African American Woman Holding a Baby*, 1870–80
16.5 x 11 cm
Library of Congress Prints and Photographs Division, Washington, D.C.

Marc Ferrez

Rio de Janeiro 1843–1923 Rio de Janeiro

288. *Portrait of a Black Woman with Child on Her Back and Banana Basket on Her Head*, ca. 1884
Photographic print, 12.5 x 9 cm
Instituto Moreira Salles/Marc Ferrez/Collection Gilberto Ferrez, Rio de Janeiro

Elizabeth Catlett

Washington, D.C. 1915–2012 Cuernavaca, Mexico

289. *Standing Mother and Child*, 1978
Bronze with copper alloy on wood base, 41.9 x 10.2 x 11.4 cm
The Museum of Fine Arts, Houston, Museum purchase funded by the African American Art Advisory Association, 95.658

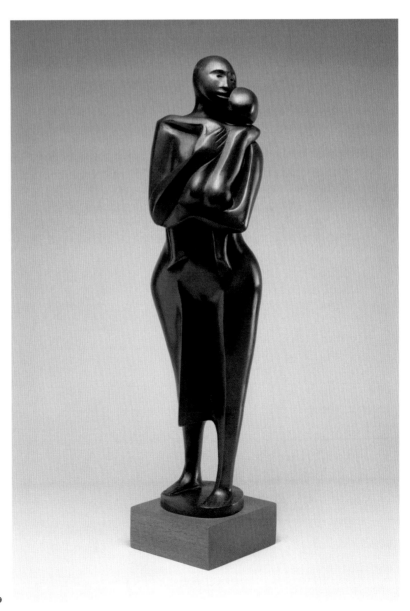

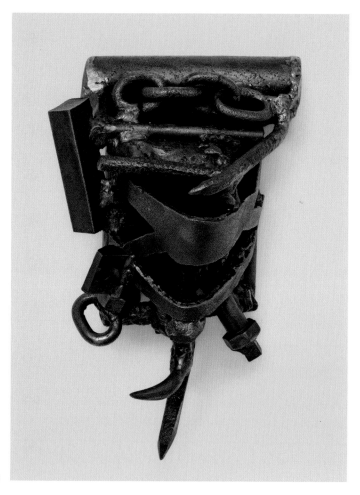

290

Melvin
Edwards

b. Houston, 1937;
lives in New York City
and Dakar

290. *Palmares*, 1988
Steel
33 x 20.5 x 165 cm
Museu de Arte de
São Paulo Assis
Chateaubriand – MASP
Gift of the artist, 2019
MASP.10814

Flávio
Gomes

b. Rio de Janeiro,
1964; lives in Rio de
Janeiro

291. *Uncle Marco,*
Quilombo Leader,
Itamori, 1996
Photographic print,
40 x 60 cm
Collection of
Flávio Gomes

André
Cypriano

b. Piracicaba, São
Paulo, 1964; lives in
New York City and Rio
de Janeiro

292. *Kalunga Mother*
& Baby, from the
portfolio *Quilombolas:*
Traditions and
Culture of Resistance,
Quilombo Kalunga,
Cavalcante, Goiás,
Brazil, 2005
Photographic print,
50 x 75 cm
Collection of the artist,
New York and
Rio de Janeiro

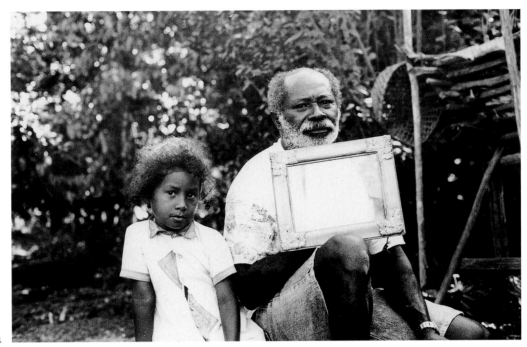

291

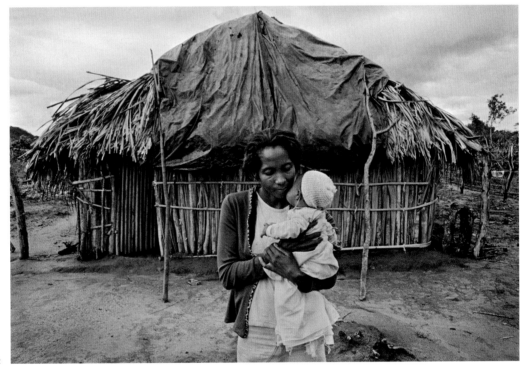

292

315

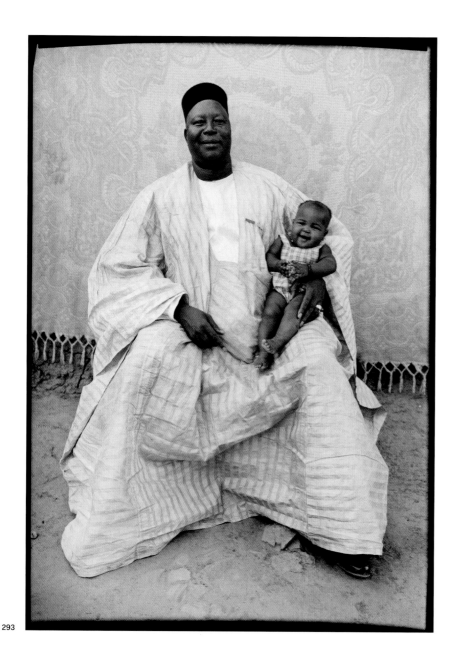

293

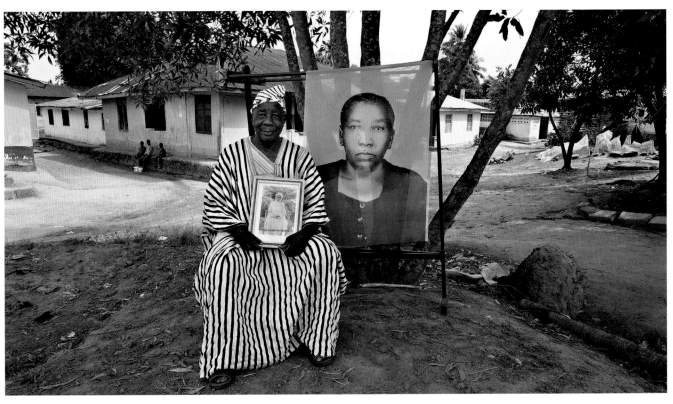

294

Seydou
Keïta

Bamako, Mali 1921–
2001 Paris

293. *Untitled*, 1949
Modern gelatin silver
print, 56.5 x 39.5 cm
Gilberto
Chateaubriand/
Museu de Arte
Moderna do Rio de
Janeiro, courtesy of
CAAC–The Pigozzi
Collection, Geneva, ©
Seydou Keïta SKPEAC
(The Seydou Keïta
Photography Estate
Advisor Corporation)

Aline
Motta

b. Niterói, Rio de
Janeiro, 1974; lives in
São Paulo

294. *Bridges over the
Abyss #3*, 2017
Photographic print,
70 x 40 cm
Collection of the
artist, São Paulo

295

296

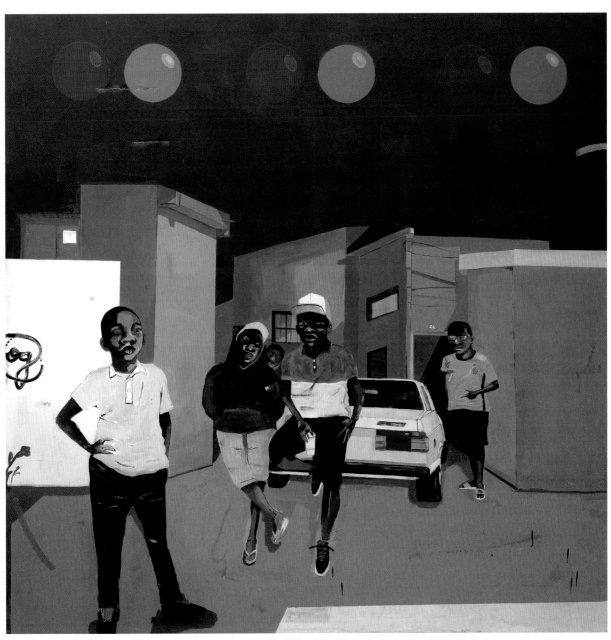

297

Janaína Barros

b. São Paulo, 1976;
lives in São Paulo

295. *Psychoanalysis
of Cafuné: A Prologue
on Patches, Affections,
and Territories*, 2018
Drawing and collage
Text: Blessed shall be
the fruit of your womb
and the fruit of your
ground and the fruit of
your cattle, the increase
of your herds and the
young of your flock
Collection of the artist,
São Paulo

Tatewaki Nio

b. Kobe, Japan, 1971;
lives in São Paulo

296. *Dr. Lanre with
His Family in Ibadan,
Nigeria*, 2017
Inkjet print on cotton
paper, 46 x 56.5 cm
Collection of the artist,
São Paulo

No Martins

b. São Paulo, 1987;
lives in São Paulo

297. *Villain*, 2017
Acrylic on panel,
150 x 150 cm
Collection of
Fernando and Camila
Abdalla, São Paulo

Sidney
Amaral

São Paulo 1973–2017
São Paulo

298. *Black Mother,
or The Fury of Iansã*,
2014
Acrylic on canvas,
140 x 211 cm
Pinacoteca do Estado
de São Paulo, Gift of
Cleusa de Campos
Garfinkel, 2015

Nina Chanel
Abney

b. Chicago, 1982;
lives in New York City

299. *Penny Dreadful*,
2017
Acrylic and spray
paint on canvas,
213.5 x 305 cm
Courtesy of Jack
Shainman Gallery,
New York

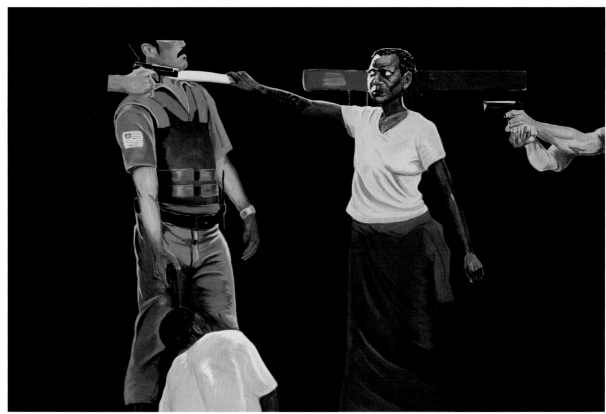

298

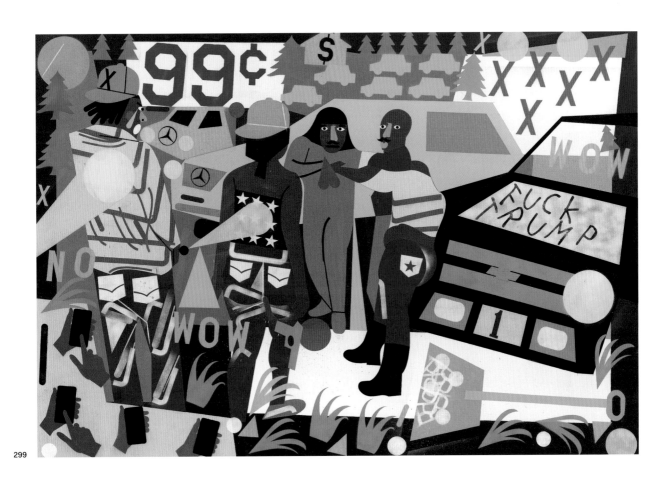

299

300

301

302

303

Tiago Sant'Ana

b. Santo Antônio de Jesus, Bahia, 1990; lives in Salvador, Bahia

300–303. Stills from *Deletion #1—Cabula*, 2017
Video, 48 minutes
Collection of the artist, Salvador

Rogério Reis

b. Rio de Janeiro, 1954; lives in Rio de Janeiro

304. **Untitled**, from the series *On the Tarpaulin Rio de Janeiro (1987–2002), Campo Grande (1997)*, 1986–2001
Mineral pigment print on cotton paper,
50 x 60 cm
Collection of the artist, Rio de Janeiro, courtesy of Galeria da Gávea, Rio de Janeiro

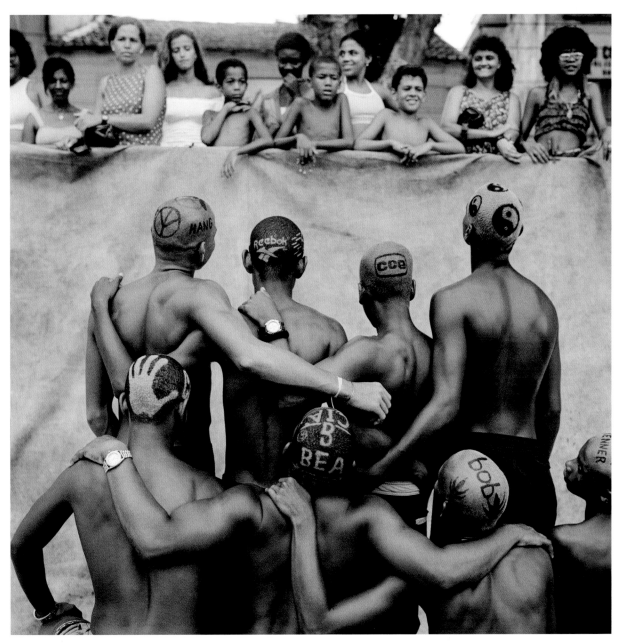

304

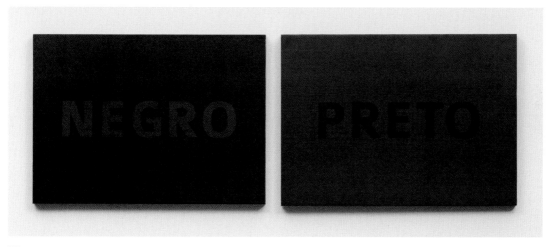

305

Bruno
Baptistelli

b. São Paulo, 1985; lives
in Budapest

305. *Language*, 2015
Offset print on wood
board, each
42 x 59 cm
Museu de Arte de
São Paulo Assis
Chateaubriand – MASP
Gift of the artist in the
context of the Afro-
*Atlantic Histories
exhibition*, 2018 - 2021
MASP.11206

Paulo
Nazareth

b. Governador
Valadares, Minas
Gerais, Brazil, 1977;
lives in Santa Luzia,
Minas Gerais

306. *Black Neger*,
2012–13
Photo print on cotton
paper, 75 x 100 cm
Galeria Mendes Wood
DM, São Paulo

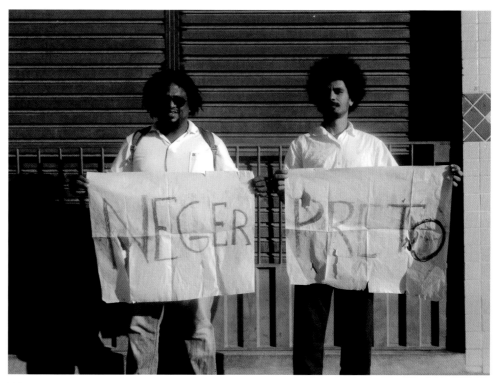

306

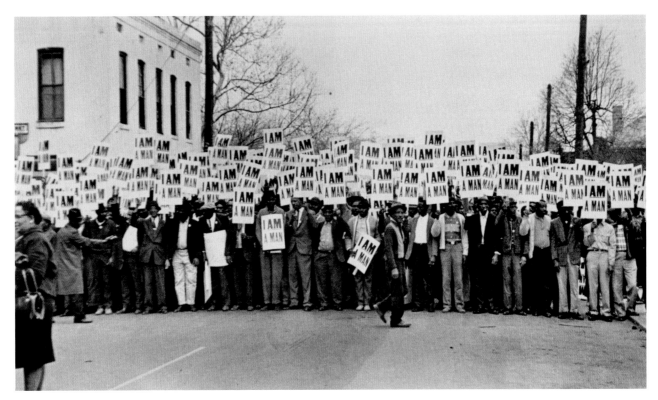

307

Ernest C. Withers

Memphis 1922–2007
Memphis

307. *I Am a Man, Sanitation Workers Strike, Memphis, Tennessee*, March 28, 1968, printed 1994
Gelatin silver print, 27.7 x 47.8 cm
The Museum of Fine Arts, Houston, Museum purchase funded by the African American Art Advisory Association, 98.225.1

Glenn Ligon

b. New York City, 1960; lives in New York City

308, 309. *Condition Report*, 2000
Iris print and Iris print with serigraph, each 81.5 x 58 cm
Courtesy of the artist and Luhring Augustine, New York, Regen Projects, Los Angeles, and Thomas Dane Gallery, London

308

309

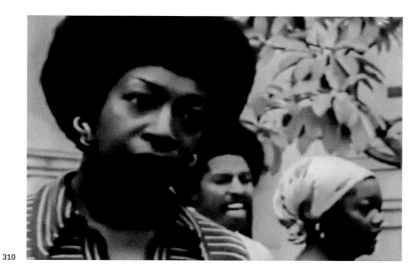

310

311

312

Victoria
Santa Cruz

La Victoria, Peru
1922–2014 Lima

310–312. Stills from
*They Shouted Black
at Me*, 1978
Video of performance,
from the documentary
*Victoria—Black and
Woman*, directed by
Torgeir Wethal
Video, 21 seconds
Courtesy of Odin
Teatret Archives,
Holstebro, Denmark,
and Hammer
Museum, Los Angeles

Sheila Pree Bright

b. Waycross, Georgia, 1967; lives in Atlanta

313. *#1960 Now*, 2015
Archival inkjet print, 30 x 30 cm
Courtesy of the artist, Atlanta

Maurício Simonetti

b. Santo André, São Paulo, 1959; lives in São Paulo

314. *Demonstration in São Paulo, 100th Anniversary of the Abolition*, 1988
Photographic print, 50 x 60 cm
Collection of the artist, São Paulo

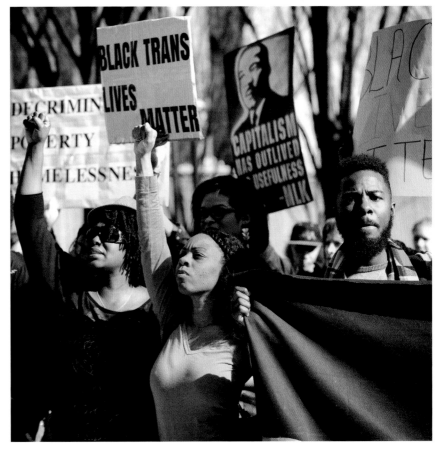

313

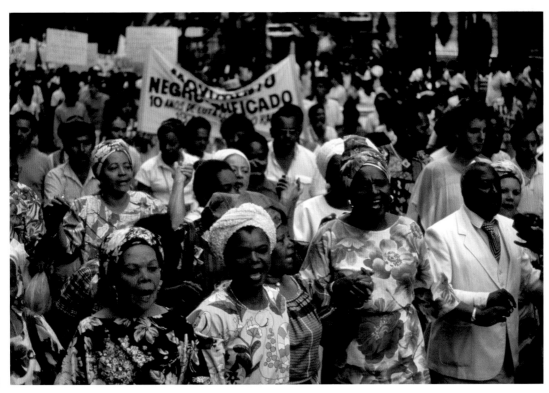

314

Alma Thomas

Columbus, Georgia
1891–1978
Washington, D.C.

315. *March on Washington*, 1964
Acrylic on canvas,
78.5 x 99 cm
Courtesy of Michael
Rosenfeld Gallery,
New York

Norman Lewis

New York City 1909–
1979 New York City

316. *Untitled
(Assassination of
Malcolm X)*, 1968
Oil on canvas,
127.5 x 180.5 cm
Estate of the
artist and Michael
Rosenfeld Gallery,
New York

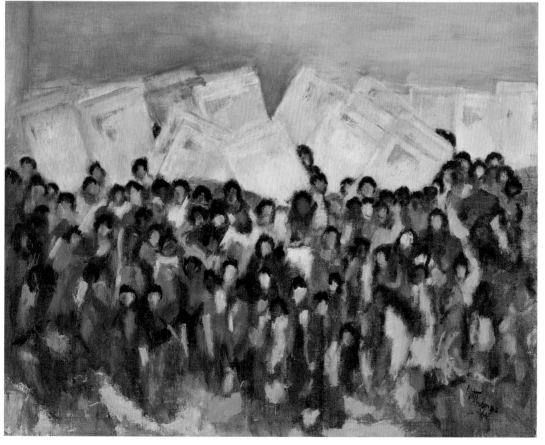

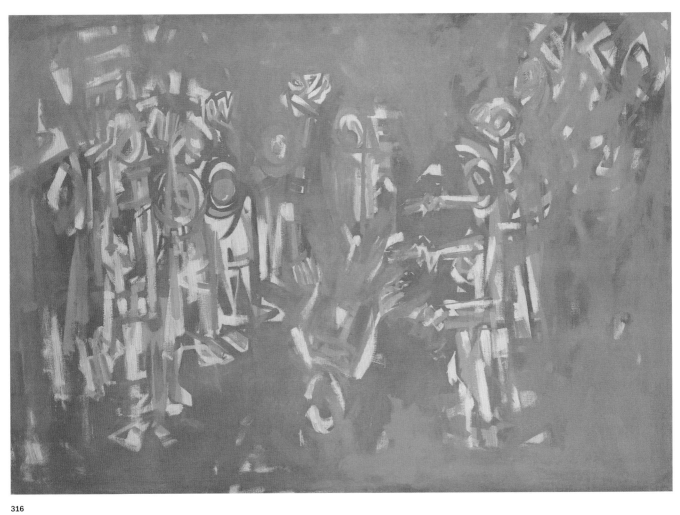

316

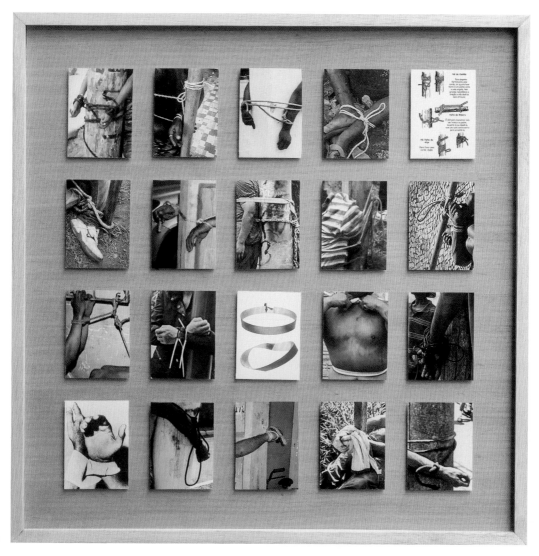

317

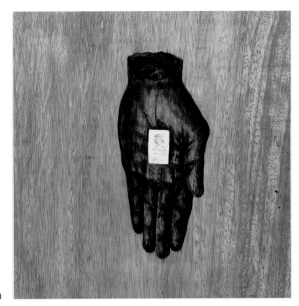

318

319

Jaime Lauriano

b. São Paulo, 1985; lives in São Paulo

317. *Concrete Experience #1 (Hands Dialogue)*, 2017
Prints extracted from digital newspapers, art exhibition catalogues, survival manuals, and plywood box, 60 x 60 x 4 cm
Courtesy of Galeria Leme, São Paulo

Antônio Obá

b. Ceilândia, Distrito Federal, Brazil, 1983; lives in Taguatinga, Distrito Federal

318. *Amnesia*, from the series *Ex-votos*, 2017
Bitumen and acrylic on wood, 27.5 x 28 cm

319. *Ex-cravo*, from the series *Ex-votos*, 2017
Bitumen and nails on wood, 27.5 x 28 cm

320. *Identity*, from the series *Ex-votos*, 2017
Bitumen and mirror on wood, 27.5 x 28 cm

Courtesy of the artist and Galeria Mendes Wood DM, São Paulo

320

321

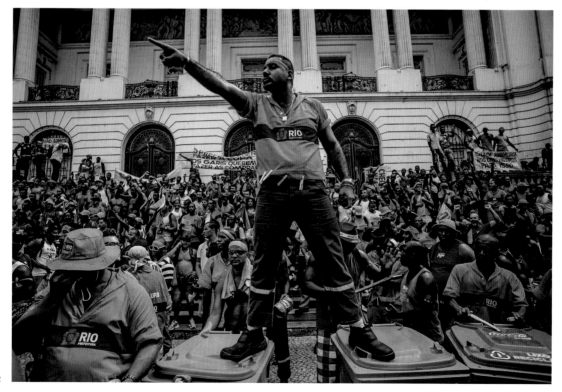

322

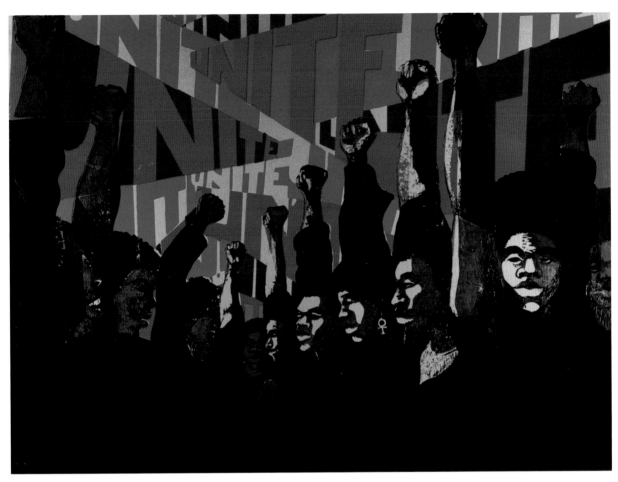

323

Elisa Larkin Nascimento

b. Buffalo, New York; lives in Rio de Janeiro

321. *Abdias Nascimento Gives a Speech in Serra da Barriga, Alagoas, on November 20, 1983, the Anniversary of the Death of Zumbi dos Palmares*, 1983
Photographic print, 50 x 60 cm
Instituto de Pesquisas e Estudos Afro-Brasileiros (Ipeafro), Rio de Janeiro

Mídia Ninja

Brazil

322. *Other Carnivals: The Strike of Rio de Janeiro's Street Sweepers*, 2015
Photographic print, 50 x 60 cm
Courtesy of Mídia Ninja

Barbara Jones-Hogu

Chicago 1938–2017
Chicago

323. *Unite* (*First State*), 1969
Poster, 56.5 x 76 cm
Lusenhop Fine Art, Chicago

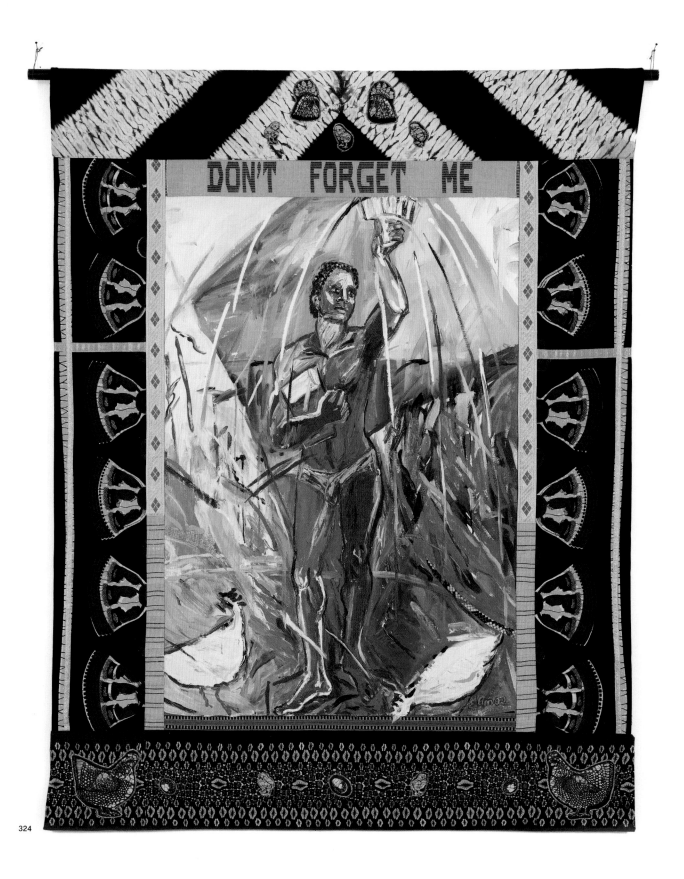

DON'T FORGET ME

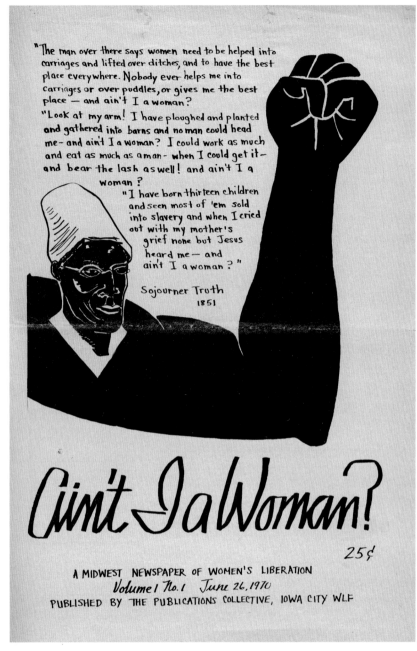

325

Emma
Amos

b. Atlanta, 1937; lives
in New York City

324. *Liberty/Don't
Forget Me*, 1986/2010
Acrylic on linen
with African textile
borders, 203 x 160 cm
Courtesy of the artist
and Ryan Lee Gallery,
New York

325. Cover of *Ain't I a
Woman? A Midwest
Newspaper of
Women's Liberation*,
Iowa City, volume 1,
1970
Museu de Arte de
São Paulo Assis
Chateaubriand–MASP

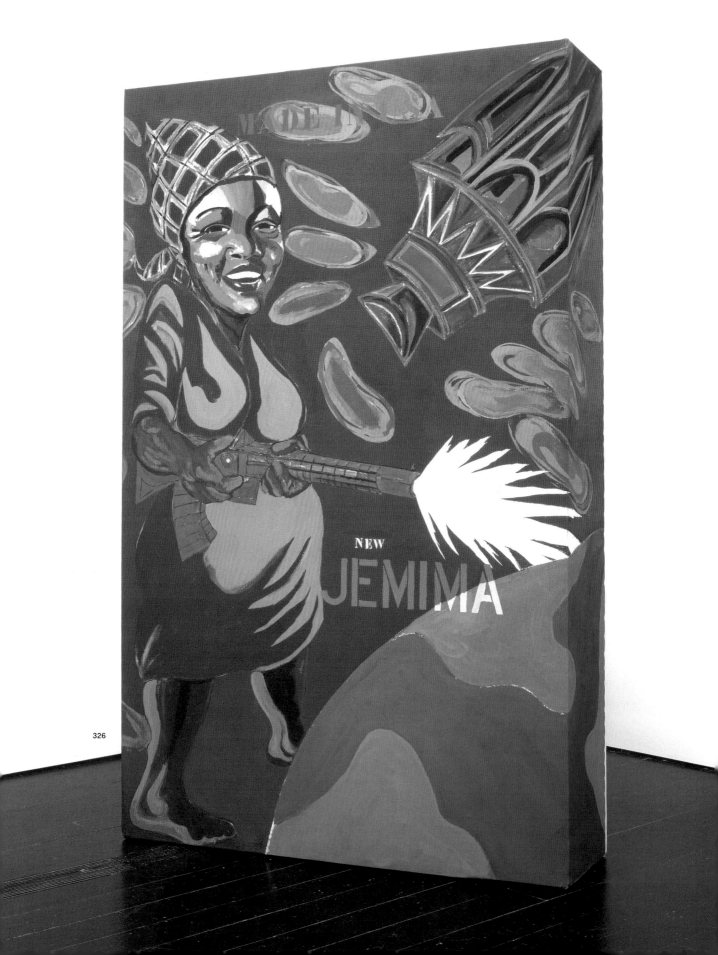

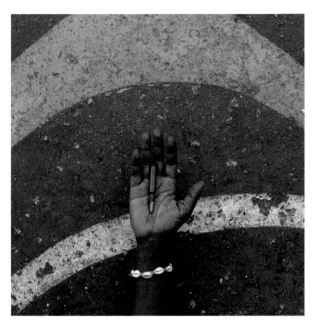

327

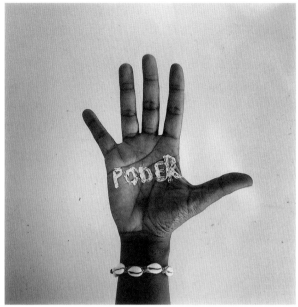

328

Joe
Overstreet

Conehatta,
Mississippi 1933–
2019 New York City

326. *The New
Jemima*, 1964–70
Acrylic on canvas
over plywood
construction,
260 x 154.3 x 43.8 cm
The Menil Collection,
Houston

Moisés
Patrício

b. São Paulo, 1984;
lives in São Paulo

327, 328. *Untitled*,
from the series
Do You Accept It?,
2014–18
Digital photo prints,
each 30 x 30 cm
Collection of
Fernando and Camila
Abdalla, São Paulo

329

Theaster Gates

b. Chicago, 1973; lives in Chicago

329. *Race Riot, Telebe*, 2011
Wood, fire hose, and glass, 66 x 70 x 42 cm
Private collection, São Paulo

Alison Saar

b. Los Angeles, 1956; lives in Los Angeles

330. *Fanning the Fire II*, 1989
Lead and painted tin nailed over wood armature,
246.4 x 76.2 x 55.9 cm
The Museum of Fine Arts, Houston, Gift of Jeanne and Michael Klein in honor of the African American Art Advisory Association, 97.210.A,.B

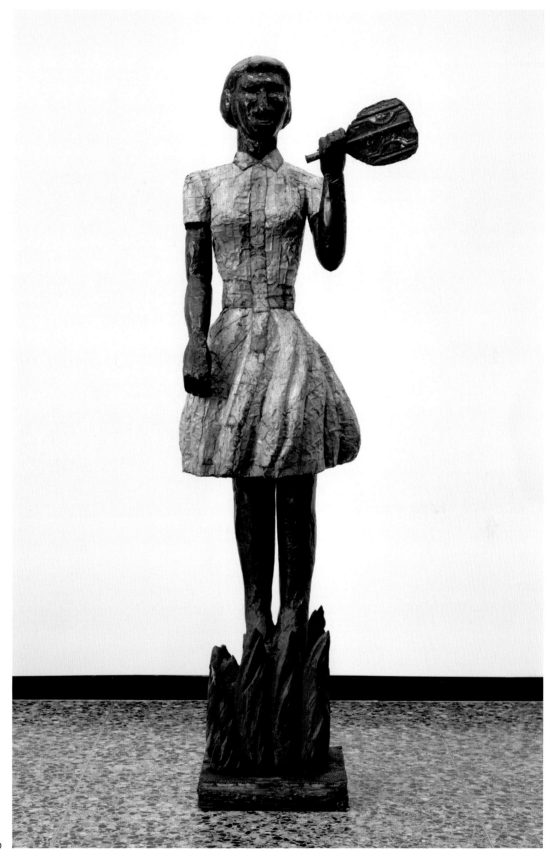

339

331

332

Logos

331. Black Panther
Party, undated
Poster, 50 x 50 cm
Designed by Dorothy
Zellnar

332. Campaign for
the Release of Rafael
Braga, 2014
Poster, 50 x 50 cm
Courtesy of
Campanha pela
Liberdade de Rafael
Braga

Frente 3 de Fevereiro

Brazil

333. *Brasil Negro
Salve* (*Hail Black
Brazil*), May 14, 2005
São Paulo FC x
Atlético Paranaense
Estádio Morumbi, São
Paulo

334. *Onde Estão os
Negros?* (*Where Are
the Blacks?*), August
14, 2005
Corinthians x Ponte
Preta Estádio Moisés
Lucarelli, Campinas,
São Paulo

335. *Zumbi Somos
Nós* (*We Are Zumbi*),
November 20, 2005

Stills of Bandeira
Video
6'55"
Black Consciousness
Day Corinthians x
Internacional Estádio
Pacaembu, São Paulo
Museu de Arte de
São Paulo Assis
Chateaubriand – MASP
Gift of the artists in
the context of the
Afro-Atlantic Histories
exhibition, 2020
MASP.11136

333

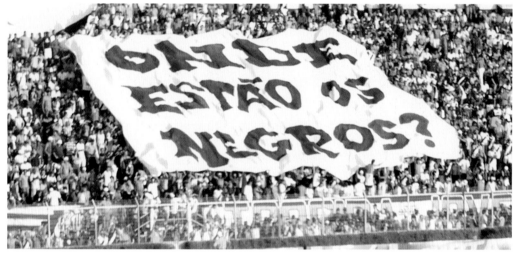

334

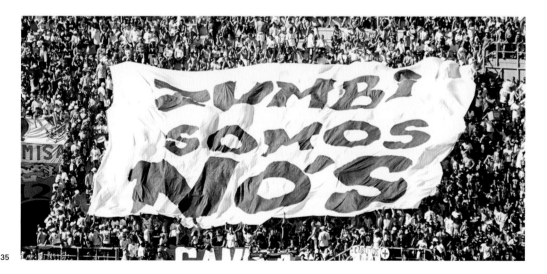

335

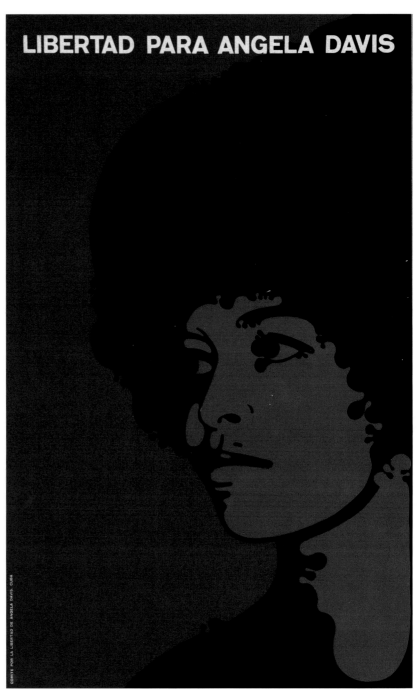

336

Felix Beltran

b. Havana, 1938; lives in Mexico City

336. *Libertad para Angela Davis*, 1971
Offset print,
57 x 35 cm
Internationaal Instituut voor Sociale Geschiedenis, Amsterdam

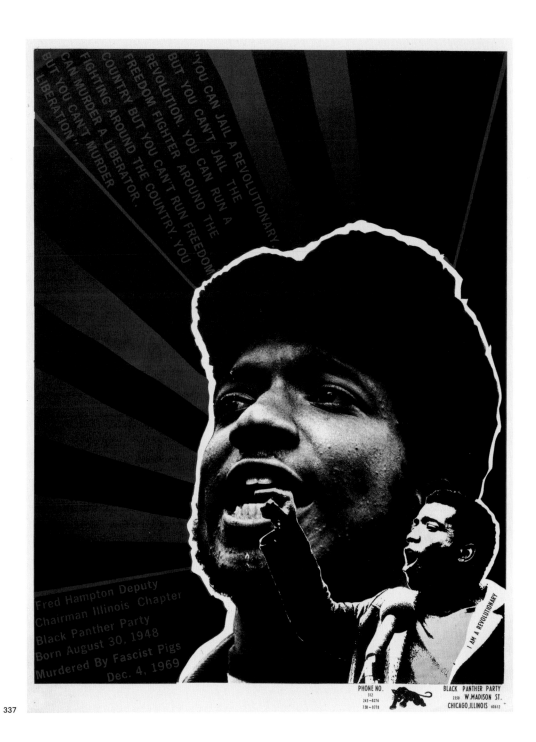

337

Emory Douglas

b. Grand Rapids,
Michigan, 1943; lives
in New York City

337. *Fred
Hampton—Can't
Murder Liberation*,
ca. 1969
Poster, 53 x 40.5 cm
Emory Douglas Art,
San Francisco

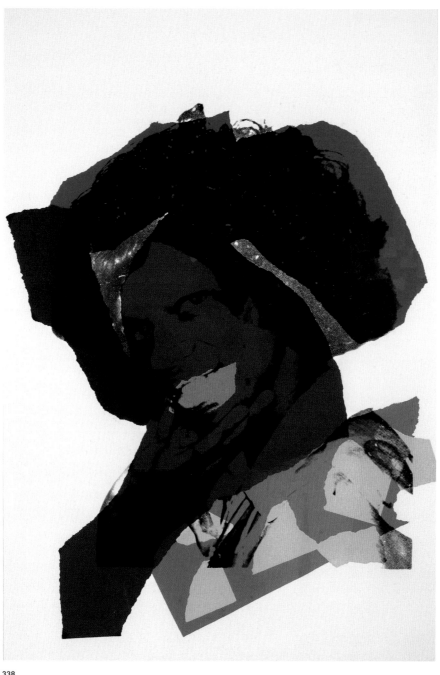

338

Andy
Warhol

Pittsburgh 1928–
1987 New York

338. *Untitled*, from
the series *Ladies and
Gentlemen*, 1975
Silkscreen on paper,
111 x 73 cm
Private collection,
São Paulo

ROUTES AND TRANCES:

AFRICAS, JAMAICA, BAHIA

Analysis of Afro-Atlantic cultural production over several historical periods opens up opportunities to create more democratic, nonhegemonic discourses around art. This section explores a number of Black Atlantic diasporic pathways that have generated diverse forms of art since 1960 in different locations and countries. Afro-American religions, the Rastafarian movement, the hippie counterculture, and psychedelia have inspired cultural manifestations united by ecologies of belonging and characterized by their mutability and fluidity. These dissident elements have injected into Afro-descendant contemporary arts a dynamic nomadism of hybrid visual forms. Here we survey cultural phenomena through routes that are often neglected or are simply unseen because of their links to African cultures and the Black diaspora in the Americas.

Afro-American religions—including Candomblé in Brazil, Santería in Cuba, and Voodoo in Haiti—began in the Black Atlantic. Candomblé is subdivided into nations: Ketu or Nagô, which originated in Yoruba culture; Jejé, which developed among Fon and Ewe slaves; and Bantu, from Congo-Angola. Practitioners within these sects worship orishas, voduns, and nkisis, respectively. Another religious and cultural formation is Rastafarianism in Jamaica, which emerged in the 1930s among Blacks and descendants of enslaved Africans. Rastas claim Ethiopia's emperor Haile Selassie I as a representative of Jehovah (Jah) on Earth. A self-described political-social movement that has created an Afro-American aesthetic and way of life, Rastafarianism prohibits alcohol and tobacco, allows only the ritual consumption of cannabis, and encourages vegetarianism.

The counterculture movements of the 1960s were transformational, challenging hegemonic European culture and politics. The hippie momvement, which established communes and embraced mind-expanding drugs as vehicles to a new consciousness, inspired psychedelic perceptions in scores of young African Americans. Youth culture generated alternative art forms, expressing countercultural values through guerrilla theater and musical genres such as psychedelic rock. The dissonant chords of Jimi Hendrix's guitar marked a generation of artists like Edinízio Ribeiro Primo.

The following works are organized heterogeneously around juxtapositions illustrating analogies and tensions. Mário Cravo Júnior, a seminal modernist artist in Bahia, was at the forefront of research into Afro-Brazilian culture. His "heads" (figs. 344-347) embody the single principle of human essence in Yoruba cosmogony: inside the *ori* (head) resides the portal between earthly and divine worlds. The wood sculptures of Agnaldo Manoel dos Santos (fig. 352), here removed from the "primitivist" context that defined the artist, echo the mysteries of ancestral crossings that are reflected in the several different Africas of Bahia. Imbued with the classicism of African aesthetics, Manoel's work was awarded the international prize in sculpture at Festac '66 in Dakar. Manoel was religious (per Bahians: he had *axé*) and was consecrated as an *ogan* priest, like the artist Mestre Didi, who was an *assogba* (supreme priest) of the Ilê Axé Opô Afonjá temple and an Alapinin (also supreme priest) of the Amoreira temple on Itaparica Island. Didi's artis-

tic output (figs. 339-341) was inspired by the orishas of the earth, presided over by Nanã, the patron deity of agriculture. The sculptures of Cravo, Manoel, and Didi dialogue with two large-scale installations: *Moving* (2005; fig. 371) by Marepe and *Bend Skin* (2017; fig. 370) by Cameroonian artist Pascale Marthine Tayou, which take similar approaches to the theme of migratory dislocation.

Juarez Paraíso's eight-foot totems from the 1980s (fig. 350), composed of gourds, whelk shells, polyester resin, and fiberglass, celebrate the imagery of Brazil's northeast region and the formal solutions of Afro-Indigenous aesthetics. The striking assemblage of organic and synthetic materials references the artisanal output of the hippie counterculture and its back-to-the-earth principles.

Vicentina Julião, Nadia Taquary, and Edsoleda Santos explore cosmogonies and their deities. Julião comes from an important family of wood carvers of Prados, Minas Gerais, and her work represents an edenic world in which humans and nature coexist in perfect harmony (fig. 349). Taquary's materials also include whelk shells and threads commonly used to join beads, referencing *axé*, the ritualistic ornaments worn by practitioners of Candomblé (fig. 361). Her poetic constructions feature color spectrums that signify and propose new iconographies for African deities worshipped in Bahia. Santos culls the Afro-Brazilian religious universe for thematic material with the sensitivity and wisdom of a believer. Although not initiated into Candomblé, the artist produces

delicate watercolor paintings that illustrate the myths of such deities as Obaluaê, Shango, Oxum, Ibeji, Iemanjá, Nanã, and Oxalufã (fig. 357).

Benin-born artist Cyprien Tokoudagba began his career helping to restore the Abomey Historical Museum after UNESCO designated it a World Heritage Site in 1985. The building's bas-reliefs comprise narrative chronicles of enormous documentary significance for our knowledge of the Dahomey empire and the customs and rituals of the Fon people. Tokoudagba replicated the wall carvings, a journey into precolonial culture that deeply informed his own art. His paintings are iconographic representations of the vodun deities (figs. 354, 355), a term that is formed by two verbs in the Fon language: *vo*, "to rest," and *dun*, "to take water." The vodun philosophy inspires a state of calmness, self-control, and patience to face crises; the action of "resting to take water" from a mythical lagoon represents our existence.

These paintings dialogue across the Atlantic with the wood carvings of the Pai Thomas Inn in Cachoeira, a city in Bahia's Recôncavo region (figs. 00, 00). Formerly named Vila de Nossa Senhora do Rosário do Porto de Cachoeira do Paraguaçu, the city hosted the first rural aristocracy in the Americas and became a strategic hub of African-origin populations descended from slaves. In the late 1970s, many wood sculptors left their mark on Cachoeira's cultural scene, among them Boaventura da Silva Filho, called Louco. Contracted by a shop owner named Pai Thomaz, Louco and

his descendants carved large panels and furnishings for his new venture: an inn at 25 de Junho Square. The ensemble, representing a panoply of deities worshipped by Fon, Yoruba, Bantu, and Afro-Indigenous peoples, constitutes one of the most important contributions to Afro-Brazilian religious art ever made.

The sculptures of Chico Tabibuia and João Cândido da Silva exemplify widely different approaches to Afro-Brazilian forms of expression. Tabibuia is named for an Atlantic Forest tree, and his Eshu figures exude a corporeal presence that could only be achieved by someone who has incorporated such spirits (fig. 348). Cândido, a native of Minas Gerais who made his home in Embu, São Paulo, is the brother of painter Maria Auxiliadora. His wood creations embody the noble imaginary of the Afro-Brazilian heritage (fig. 369).

Arthur Bispo do Rosário, Sonia Gomes, Martinho Patrício, and Jaime Fygura expand the scope of materials and techniques presented here, supporting diverse meanings and repertoires. For fifty years, Bispo remade the world from his room in a mental asylum on the outskirts of Rio, urged on by a divine voice that compelled him to create; here, he embroidered a universe in which he figures as the son of a supreme god (fig. 360). Gomes also builds worlds. Her fabric objects (fig. 359) resemble the twisted cloth pads used by Black Brazilians atop their heads to support the weight of water cans, but also dazzlingly decorated Rastafarian dreadlocks. Her art incorporates textiles that evoke the

crossbred character of Afro-Baroque Catholicism, as do Patrício's satin wall sculptures: Catholic "rosaries" that take the form of African masks (fig. 362). For many decades, Fygura roamed the streets of Salvador in homemade metal masks, armor, and leather rags embedded with black cyberpunk spikes that transformed him into a mysterious being (fig. 363). After being run over by a car and experiencing financial difficulties, the artist, whose work spoke to the experience of Black Brazilians on the outskirts of society, started selling his clothes, armor, and masks.

Jaime Lauriano is inspired by Black diasporic activism. Using strategies of appropriation and dislocation, he examines institutionalized violence and the past and present of Blacks in Brazil. Here, wood plaques carved by Black hippies carry politically charged phrases, one a call to action, the other a reminder of how Black identity is criminalized (figs. 367, 368).

The last group includes Black artists intimately linked to Tropicalist visuality and later with the Manguebeat movement. Edinízio Ribeiro Primo and Dicinho, members of the so-called Jequié group in Bahia, were active in Tropicalismo's formative years. Ribeiro's studio in São Paulo was a center of the art scene where Tropicalists, the rock band Os Mutantes, Ney

Matogrosso, and others gathered. His graphic creations (fig. 356) appeared on books and album covers, and he worked with Kompass Cultura Galeria de Arte, owned by art critic Harry Laus, and Regina Boni's vanguard boutique Dromedário Elegante. Painter and designer Dicinho produced the famous cover of Gal Costa's 1969 album, a Tropicalist classic blending Brazilian and psychedelic sounds. His later work, which includes sculpture and was inspired by vernacular traditions (fig. 366), featured in exhibitions at MASP and Sesc Pompeia under the curatorship of Lina Bo Bardi. Brothers J. Cunha (fig. 364) and Babalu (fig. 358) expand the concepts of Afro-Brazilian art into the pop universe. Cunha creates the visual identity of the Carnival group Ilê Aiyê in Salvador. Babalu's large-scale paintings are wild profusions of color and signs. Acre native Félix Farfan, now living in Recife, made important contributions to the aesthetics of the Manguebeat movement. His collages and objects marry elements of the Maracatu Carnival tradition to global contemporary art forms (fig. 353).

As a conclusion to this ride through contemporary Afro-Brazilian art, I cite Achille Mbembe: "There is a precolonial African modernity that still has not been considered by contemporary creativity."[1] Through those routes and trances, we are managing to build a new creative sensibility.

1. Achille Mbembe, "Afropolitanisme," *Le Messager* (Douala, Cameroon), December 25, 2005.

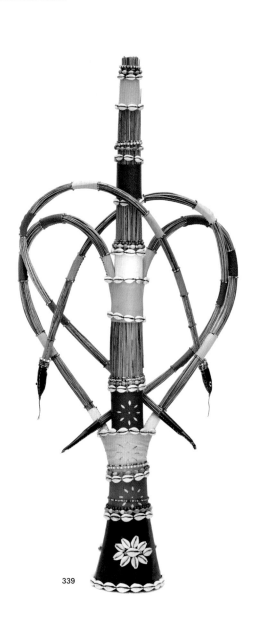

339

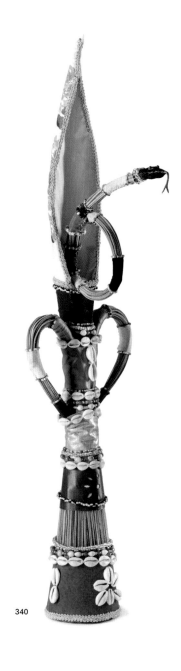

340

Mestre Didi

Salvador, Bahia 1917–
2013 Salvador

339. *Opa Exin Kekere
– Small Spear Scepter*,
1980s
Palm tree vein, painted
leather, shells and
beads
96 × 44 × 16 cm
Museu de Arte de
São Paulo Assis
Chateaubriand – MASP,
Gift of Ana Dale, Carlos
Dale Junior, Antonio

Almeida, Thais Darzé,
and Paulo Darzé in the
context of the *Afro-
Atlantic Histories*
exhibition, 2018
MASP.10756

340. *Ope Olodo Ejo –
River Serpent Palm*,
undated
Straw, painted leather
and colored beads

73 × 20 × 25 cm
Museu de Arte de
São Paulo Assis
Chateaubriand – MASP
Gift of Ana Dale, Carlos
Dale Junior, Antonio
Almeida, Thais Darzé,
and Paulo Darzé in
the context of the
Afro-Atlantic Histories
exhibition, 2018
MASP.10757

341. *Sasara Ati Aso
Ailo*, 1960
Palm tree vein,
painted leather,
shells, and beads
66 x 23 x 13 cm
Museu de Arte de
São Paulo Assis
Chateaubriand – MASP
Gift of Ana Dale,
Carlos Dale Junior,
Antonio Almeida,

Thais Darzé, and
Paulo Darzé in the
context of the *Afro-
Atlantic Histories*
exhibition, 2018
MASP.10755

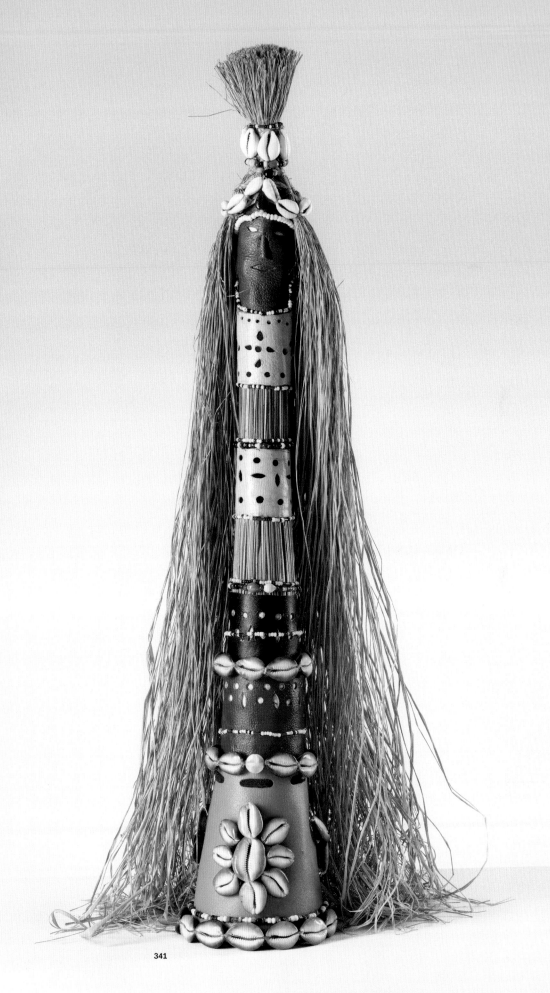

341

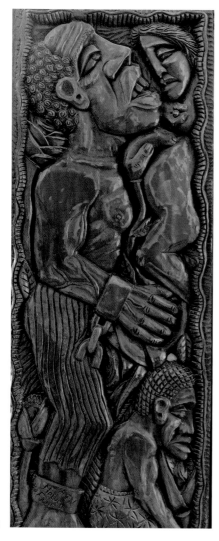

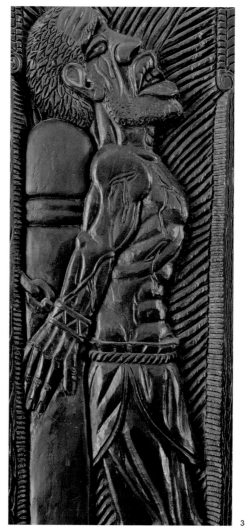

342

343

Artist Collective of Cachoeira

Brazil

342, 343. *Murals from Pousada Pai Thomaz*, ca. 1980
Wood
Collection of
Pousada Pai Thomaz,
Cachoeira, Bahia

Mário Cravo Júnior

b. Salvador, Bahia,
1923; lives in Salvador

344. *Untitled*, 1986
Polychromed wood
and metal scrap,
56 x 48 x 32 cm

345. *Untitled*, 1982
Polychromed wood
and iron billet
39 x 23 x 23 cm
Museu de Arte de
São Paulo Assis
Chateaubriand – MASP
Gift of Thais Darzé

and Paulo Darzé in the
context of the *Afro-Atlantic Histories*
exhibition, 2018
MASP.10804

346. *Untitled*, 1985
Polychromed wood
48 x 16 x 18 cm
Museu de Arte de
São Paulo Assis
Chateaubriand – MASP
Gift of Thais Darzé
and Paulo Darzé in the
context of the *Afro-Atlantic Histories*

exhibition, 2018
MASP.10806

347. *Untitled*, 1983
Polychromed wood
and iron billet
53 x 16 x 21 cm
Museu de Arte de
São Paulo Assis
Chateaubriand – MASP
Gift of Thais Darzé
and Paulo Darzé in
the context of the
Afro-Atlantic Histories
exhibition, 2018
MASP.10803

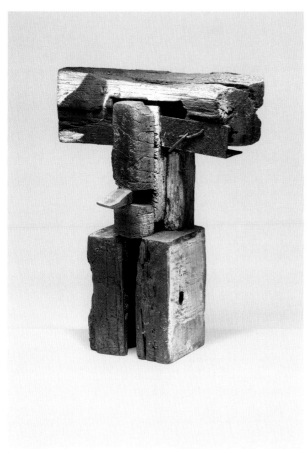

344

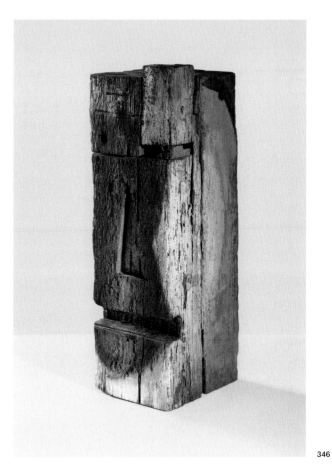

346

345

347

348

349

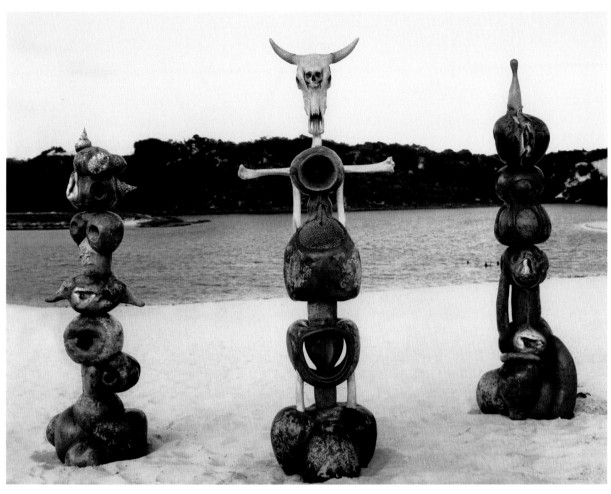

350

Chico
Tabibuia

Silva Jardim, Rio de
Janeiro 1936–2007
Casimiro de Abreu,
Rio de Janeiro

348. *Self-Fellatio*,
1980s
Wood
106 x 39 x 27 cm
Museu de Arte de
São Paulo Assis
Chateaubriand – MASP
Gift of Rafael Moraes
in the context of the
Afro-Atlantic Histories
exhibition, 2018
MASP.10807

Vicentina
Julião

b. Prados, Minas
Gerais, Brazil, 1955;
lives in Prados

349. *Heaven's Tree*,
undated
Wood, 195 x 50 x 5 cm
Collection of
Iwata-Moreira, Vitória
da Conquista, Bahia

Juarez
Paraíso

b. Rio de Contas,
Bahia, 1934; lives in
Salvador, Bahia

350. *Gourd and Bone
Totems*, 1980s
Gourd, shells,
polyester resin, and
fiberglass,
250 x 80 cm;
260 x 89 cm;
264 x 80 cm
Collection of the
artist, Salvador

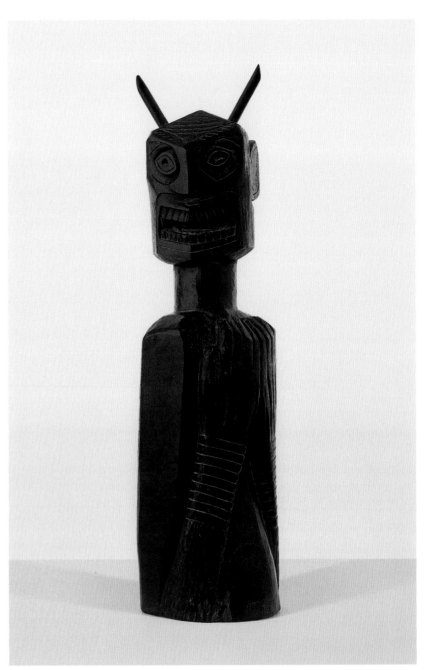

351

David
Miller Sr.

Jamaica 1872–1969
Kingston

351. *Obi*, ca. 1940
Wood,
63 x 15 x 15.5 cm
National Gallery of
Jamaica, Kingston

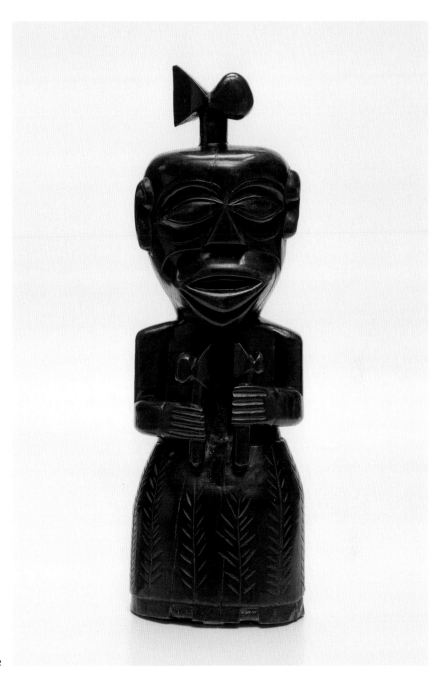

352

Agnaldo Manoel dos Santos

Ilha de Itaparica,
Bahia 1926–1962
Salvador, Bahia

352. *Shango*, undated
Wood, 65 x 24 x 17 cm
Collection of Orandi
Momesso, São Paulo

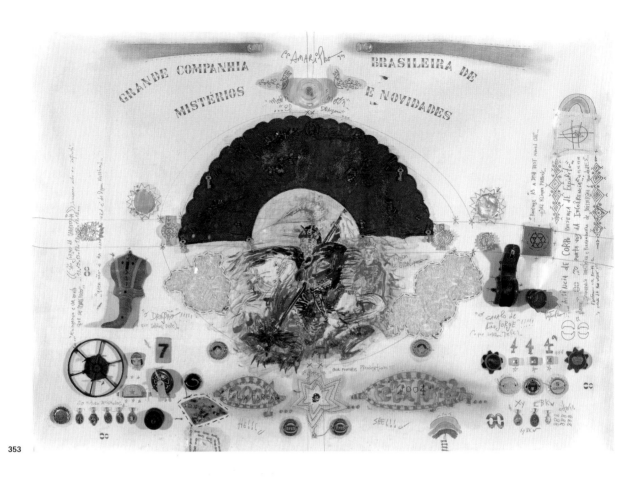

353

Félix Farfan

b. Brasiléia, Acre, Brazil, 1960; lives in Recife, Pernambuco, Brazil

353. *Amarrilho*, 1999
Mixed media,
70 x 100 cm
Galeria Estação,
São Paulo

Cyprien Tokoudagba

Abomey, Benin 1939–2012 Abomey

354. *Ayidohouedo, Rainbow God*,
undated
Acrylic on canvas,
138.5 x 115.5 x 4 cm

355. *Zodji*, undated
Acrylic on canvas,
116 x 68.5 x 3.5 cm

Associação Museu
Afro Brasil, São Paulo

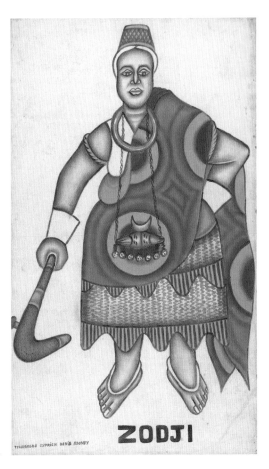

354

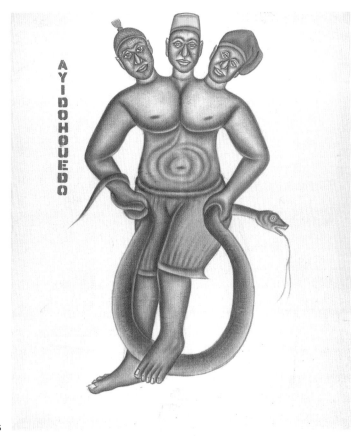

355

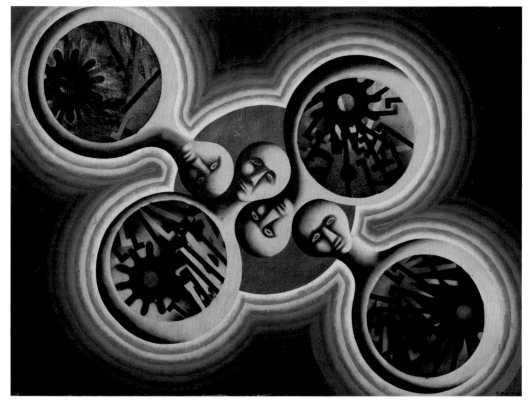

356

Edinízio
Ribeiro
Primo

Edsoleda
Santos

Babalu

Ibirataia, Bahia
1945–1976 Búzios,
Rio de Janeiro

356. *Gourds*, 1972
Oil on canvas,
67 x 92 cm
Collection of
Dermeval Rios,
Lençóis, Bahia

b. Salvador, Bahia,
1939; lives in Salvador

357. *Obaluaê*, 2014
Acrylic and watercolor
on paper,
59.5 x 35.5 cm
Collection of the
artist, Salvador

Salvador, Bahia
1945–2008 Salvador

358. *Untitled*, ca.
2005–6
Acrylic on canvas,
98 x 138 cm
Collection of
J. Cunha, Salvador

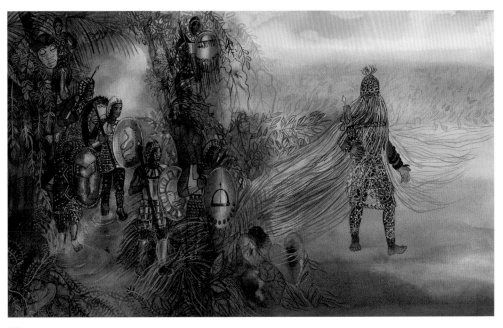

357

358

359

Sonia Gomes

b. Caetanópolis,
Minas Gerais, Brazil,
1948; lives in São
Paulo

359. **Memory**, 2004
Thread, knots, fabric,
lace, and varied
fragments,
140 x 270 cm
Galeria Mendes Wood
DM, São Paulo

Arthur Bispo do Rosário

Japaratuba, Sergipe,
Brazil 1909 or 1911–
1989 Rio de Janeiro

360. *I Need These
Words*, undated
Embroidered fabric,
120 x 189 x 3 cm
Museu Bispo
do Rosário Arte
Contemporânea,
Rio de Janeiro

360

363

361

Nadia Taquary

b. Salvador, Bahia, 1942; lives in Salvador

361. *Dinkas Collection, Dinka Obaluaê*, 2018
Russian glass beads, shells, gourd, and straw,
160 x 40 x 13 cm
Collection of Paulo Darzé Galeria, Salvador

Martinho Patrício

b. João Pessoa, Paraíba, Brazil, 1964; lives in João Pessoa

362. *Rosary*, 2003
Satin and satin ribbon, 100 x 45 cm
Courtesy of Galeria Superfície, São Paulo

362

Jaime
Fygura

b. Cruz das Almas,
Bahia, 1956; lives in
Salvador, Bahia

363. *Outfit*, 1980s
Poultry wire, rod,
leather, metal, and
boots,
180 x 100 x 50 cm
Paulo Darzé Galeria,
Salvador

363

364

J. Cunha

b. Salvador, Bahia, 1947; lives in Salvador

364. *Tridimensional Ceramic*, undated Pigments and terracotta, 60 x 45 x 45 cm Collection of the artist, Salvador

Ramiro Bernabó

b. Buenos Aires, 1947; lives in Salvador, Bahia

365. *Atabaque*, 2016 Carved wood, 76 x 80 cm Collection of the artist, Salvador

Dicinho

b. Jequié, Bahia, 1945; lives in Salvador, Bahia

366. *Baobab*, 2014 Cellulose pulp, plaster, metal, and pigments, 85 x 145 cm Museu de Arte Moderna da Bahia, Salvador

365

366

367

368

Jaime Lauriano

b. São Paulo, 1985; lives in São Paulo

367. *They presented an imminent threat to the public order*, 2015
Enamel paint on carved cedar wood, 30 x 80 x 4 cm
Collection of Cleusa Garfinkel, São Paulo

368. *Notes of Resistance*, 2015
Enamel paint on carved cedar wood, 30 x 80 x 2.5 cm
Collection of Regina Pinho de Almeida, São Paulo

João Cândido da Silva

b. Campo Belo, Minas
Gerais, Brazil, 1933;
lives in São Paulo

369. *Zumbi*, 1976
Wood, 97 x 48 x 34 cm
Collection of Paulo
Pedrini, São Paulo

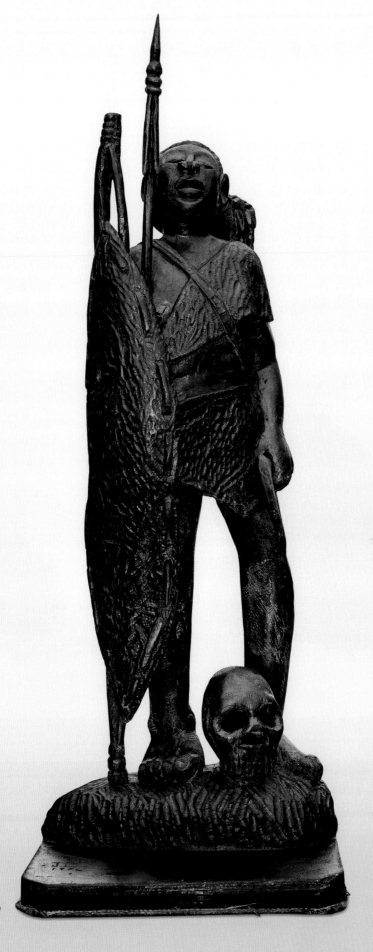

369

371

Pascale
Marthine
Tayou

Marepe

b. Yaoundé,
Cameroon, 1967; lives
in Ghent, Belgium

b. Santo Antônio de
Jesus, Bahia, 1970;
lives in Santo
Antônio de Jesus

370. **Bend Skin**, 2017
Video, bicycle,
cardboard, ribbon,
and paint,
220 x 400 x 235 cm
Courtesy of the artist
and Galeria A Gentil
Carioca, Rio de
Janeiro.

371. **Moving**, 2005
Wood, metal, rubber,
plastic screen, and
hinges,
210 x 360 x 140 cm
Instituto Inhotim,
Brumadinho, Minas
Gerais, Brazil

372

Bauer Sá

b. Salvador, Bahia,
1950; lives in Salvador

372. *White Shoe*,
undated
Photographic print,
60 x 40 cm
Alma Fine Art &
Galeria, Salvador,
Brazil

AFRO-
ATLANTIC

MODERNISMS

Afro-Atlantic Modernisms

This area gathers paintings from some of the leading names of Afro-Atlantic modernism and abstraction, in a chronological selection ranging from 1942 to 1975. There are several common threads among the ebbs and flows of the cultural exchange between Africa, the Americas, and Europe, many of them overlaid by the violence of colonialism. Two episodes stand out. The first involves the Benin Bronzes, more than a thousand sculptures and plaques that were looted by Britain in 1897 during a punitive expedition in which the African kingdom was demolished. The second involves Pablo Picasso, the Spaniard who was inspired by the shapes of the African masks he saw at the Palais du Trocadéro in Paris around 1906. The masks gave birth to his African period, an early case of cultural appropriation that generated one of the most celebrated paintings of European modernism, *Les Demoiselles d'Avignon* (1907). But while European modernists were plundering Africa's cultural idioms, often appropriating them in superficial or formal ways, African and Afro-descendant artists were cannibalizing the forms and vocabularies of European modernism, reprocessing and reinvigorating them through their own localized aesthetic expressions.

The history of Afro-Atlantic modernism begins with Aaron Douglas, a major figure of the Harlem Renaissance who synthesized elements of ancient Egyptian culture, geometricism, and Art Deco, as seen in the painting *Into Bondage* (1936; fig. 8), in Maps and Margins. Wifredo Lam is another seminal artist. Born in Cuba, Lam was a descendant of Spaniards and Africans, the grandson of a Santería priestess, and the son of a Chinese immigrant. He lived in Spain and France during the 1920s and 1930s, meeting Picasso, André Breton, and Aimé Césaire. Returning to Havana in 1941, Lam rediscovered his native country and Santería, an Afro-Cuban religion that originated in the Yoruba culture. From then on, he developed a

new visual language blending Cuban and African references with modernist forms. His most prolific period was in the 1940s. In a work from around 1942 (fig. 379), he depicted two figures with angular features outlined in black and faces reminiscent of African masks against a bluish gray background. The painter's relationship with African art was not solely formal, but aligned with his interest in Santería and Afro-Caribbean culture.

Many of the most important African artists of the 20th century are included here: Sudanese Ibrahim El-Salahi, Nigerian Uche Okeke, South African Ernest Mancoba, and Ethiopian Alexander "Skunder" Boghossian. Others appear elsewhere in this volume: South Africans Dumile Feni (fig. 238, Portraits) and Gerard Sekoto (figs. 113, 117, 226, Everyday Lives, Portraits), and Nigerians Ben Enwonwu and Uzo Egonu (figs. 228, 230, 248, Portraits). Several African artists during the 1960s—especially after Ethiopia, Sudan, and Nigeria won independence (1941, 1956, and 1960, respectively)—invented aesthetic vocabularies relevant to their respective countries, despite having studied in Europe (Lam and Mancoba in Paris, Boghossian and El-Salahi in London). It is worth noting that some artists from the Americas traveled to Africa, like John Biggers (figs. 107, 126, Everyday Lives, Portraits), Jacob Lawrence (figs. 125, 132, Everyday Lives), Mestre Didi (figs. 339-341, Routes and Trances), and Rubem Valentim (figs. 375, 378).

El-Salahi, an artist, writer, critic, and politician, references Arabic and African visual arts in his work: Islamic calligraphy, human and totemic figures, masks and lances, and decorative, architectural, and graphic elements, all in a palette of brown, ocher, and white evoking the arid landscape of his home country of Sudan. His figures are typically rendered in dark tones on a light background or vice versa (figs. 377, 380). At times, the configuration of dark and light tones creates a confusing optical effect such that it is often difficult to distinguish figure and ground.

Boghossian absorbed both Ethiopian culture and the Coptic art of Egypt, along with modernist influences via contact with the Négritude literary and artistic movement, which sought to reassert Black identity and culture, especially in France and its former colonies in Africa and the Caribbean. The elaborate and fantastical landscape of *The End of the Beginning* (1972–73; fig. 376) is dominated by abstract geometric compositions that allude to Axum and Lalibela, important urban centers in Ethiopian history. Loose brushstrokes at the top of the canvas represent the fire that allegedly razed both cities. Figurative elements carry metaphors. For example, the white bird at center resembles a phoenix rising from the ashes to survive the destruction. The winged figure in ritualistic garments at right helps explain the painting's title: the work seems to foreshadow the revolution that would topple Ethiopia's monarchy in 1974, one year after it was completed.

Mancoba escaped South Africa's racist regime by migrating to Paris in 1938. There, he met his future wife, Danish artist Sonja Ferlov, who joined him in the inaugural COBRA exhibition, al-

though Mancoba is frequently excluded from the group's official narrative. The work presented here (fig. 382) is typical of Mancoba's art, characterized by thick, colorful strokes over an ocher ground that create chromatic fields delimited by irregular borders. Recurring geometrical elements at the center suggest a human form, blending abstraction and figuration.

Okeke cofounded the now-famous Zaria Art Society, established in 1958 by students of the Nigerian College of Arts, Science and Technology, who resisted the British-imposed curriculum. The group evolved the concept of "natural synthesis," fusing themes from their native Igbo culture and modern European aesthetics. Okeke's *Ana Mmuo* (*Land of the Dead*) (1961; fig. 373) is one example of this cultural blending. Here, the warm palette of the abstract background supports black line drawings, almost figurative, that resemble masks worn by dancers during Igbo funeral rites, as indicated by the title.

In Brazil, the work of Bahia native Rubem Valentim eloquently illustrates the productive currents flowing to and from African, Brazilian, and European contexts. Valentim's approach was anthropophagic, combining Constructivism—a high point of European modernism—with references from the Afro-Brazilian religious universe. In *Composition 12* (1962; fig. 375), geometric shapes are symmetrically arranged above and below a semicircle that evokes a scale or balance. The central axis is an Eshu figure with its usual red and black colors and a hint of the phallus. The inner semicircle might represent an *alguidar*, the traditional clay

vase used in offerings to orishas. The red bands above and below symbolize the sky (òrun in Yoruba) and the earth (àiyè). The vertical lines to left and right contain upward-pointing arrows that indicate the rising of the offerer's wishes, and the central line channels the power of Eshu, the messenger deity who establishes communication between the earthly and divine realms, with blessings falling on earth.[1] More than just an abstract composition, the painting is a distillation of the complex Yoruba cosmogony.

Three monochromatic paintings—by Valentim, Antonio Bandeira, and Howardena Pindell—subvert one of the purest models of modernist painting. White monochromes conventionally denote simplicity, synthesis, economy, and the independence of language—an art liberated from figurative representation and references to everyday life. Typical of African modernisms, these sanitized creations betray their origins in the perspective of white European elites. Our trio of monochromes, however, are "contaminated" with narrative.

In Valentim's *Emblem* (1968; fig. 378), the pristine white surface is breached by a double-sided ax, an attribute of Shango, the orisha of justice, lightning, thunder, and fire. In Bandeira's *Black and White Vertical City* (1965; fig. 383), the flat white monochrome is stained with short, rapidly applied black lines over a thick mass of white paint. A key figure of Brazilian abstract art, Bandeira became well known for luminous paintings that vibrate with splashes and drops of intense color and black lines that create an organic and irregular grid in

contrast to the rigid grid of geometric abstraction fashionable in Brazil at the time. Despite working in an abstract idiom, Bandeira assigned his works concretely referential titles alluding to landscape and architecture. While this work at first appears to be abstract, it is actually marked by soft black lines composed at an accelerated and contrasting pace—a possible reference to the urban life referenced in the title.

Early in her career, African American artist Howardena Pindell challenged the critical prerogatives of Minimalism and Conceptualism with messy monochromes such as *Untitled* (1975; fig. 384). The unstretched canvas hangs directly on the wall, *sans* frame. The edges are uneven, indicating a certain disregard for the traditional rectangular format—in fact, a small piece has been cut from the lower left corner. As in many of her works from the 1970s, the surface looks white from afar, but closer examination reveals tiny colored paper circles, some on top of, some under the paint. Pindell's conviction that "using aggregates is African" opened a path to an abstract Black aesthetic and to asserting a raced, gendered identity through process.

Other Afro-Atlantic artists forged new directions in painting that were focused on formal investigations of abstraction, without wholly abandoning political engagement. African American artists Alma Thomas and Norman Lewis are two examples. Lewis has always been linked to Abstract Expressionism and was one of the few Black artists in the movement. His output is a peculiar fusion of formal experimentation typical of Abstract Expressionism and figuration linked to the everyday life of Black communities in the United States, as in *Untitled* (*Assassination of Malcolm X*) (1968; fig. 316, Resistances and Activisms). In an earlier *Untitled* (ca. 1958; fig. 381), washes of warm white in varying degrees of opacity on a taupe-colored linen canvas give the composition movement and depth. The swirls of "little people," as the artist called them, rendered in flecks of black, tan, and pinkish red, create the sense of a vast collective engaged in political, religious, or festive activity.

Born in the era of racial segregation in Columbus, Georgia, Alma Thomas worked as a teacher for almost forty years before retiring in 1960 and dedicating herself full-time to art. In 1972, she became the first African American woman to have a solo exhibition at the Whitney Museum of American Art in New York. Most of her work is abstract and depoliticized, although in the early 1960s she produced a few overtly political works such as *March on Washington* (1964; fig. 00, Resistances and Activisms). *Carnival of Autumn Leaves* (1973; fig. 374), exemplifies the formal experimentation of her last years, dedicated to the study of pattern found in nature. Vertical lines of rectangular red strokes—the leaves—nearly obliterate the background of blues, greens, and yellows, the remnants of which bring to mind embroidery on fabric. Lines of irregular red shapes resembling mosaic tesserae punctuate the rhythmic progression across the canvas. "Through color," Thomas explained in 1970, "I have sought to concentrate on beauty and happiness, rather than on man's inhumanity to man."

1. According to Marcelo Mendes Chaves (audio guide available at https://soundcloud.com/maspmuseu/sets/historias-afro-atlanticas).

373

Uche
Okeke

Anambra, Nigeria
1933–2016 Njikoka,
Nigeria

373. **Ana Mmuo** (**Land
of the Dead**), 1961
Oil on board,
91 x 122 cm
National Museum
of African Art,
Smithsonian
Institution,
Washington, D.C., Gift
of Joanne B. Eicher and
Cynthia, Carolyn Ngozi,
and Diana Eicher

Alma
Thomas

Columbus, Georgia
1891–1978
Washington, D.C.

374. **Carnival of
Autumn Leaves**, 1973
Acrylic on canvas,
127 x 127 cm
Collection of Halley
K. Harrisburg and
Michael Rosenfeld
Gallery, New York

374

375

376

Rubem Valentim

Salvador, Bahia
1922–1991 São Paulo

375. *Composition
12*, 1962
Oil on canvas,
100 x 70 cm
Museu de Arte de
São Paulo Assis
Chateaubriand–
MASP, Gift of
Ana Dale, Antonio
Almeida, and Carlos
Dale Junior, 2017,
MASP.06409

Alexander "Skunder" Boghossian

Addis Ababa 1937–
2003 Washington,
D.C.

376. *The End of the
Beginning*, 1972–73
Oil on canvas,
122 x 170 cm
National Museum
of African Art,
Smithsonian
Institution,
Washington, D.C.,
Museum Purchase

377

Ibrahim
El-Salahi

Rubem
Valentim

b. Omdurman, Sudan,
1930; lives in Oxford

Salvador, Bahia
1922–1991 São Paulo

377. *Untitled*, 1964
Oil on canvas,
32 x 62 cm
Collection of Gamal
Mohamed Ahmed,
London

378. *Emblem*, 1968
Oil on wood relief,
66 x 46 cm
Banco Itaú, São Paulo

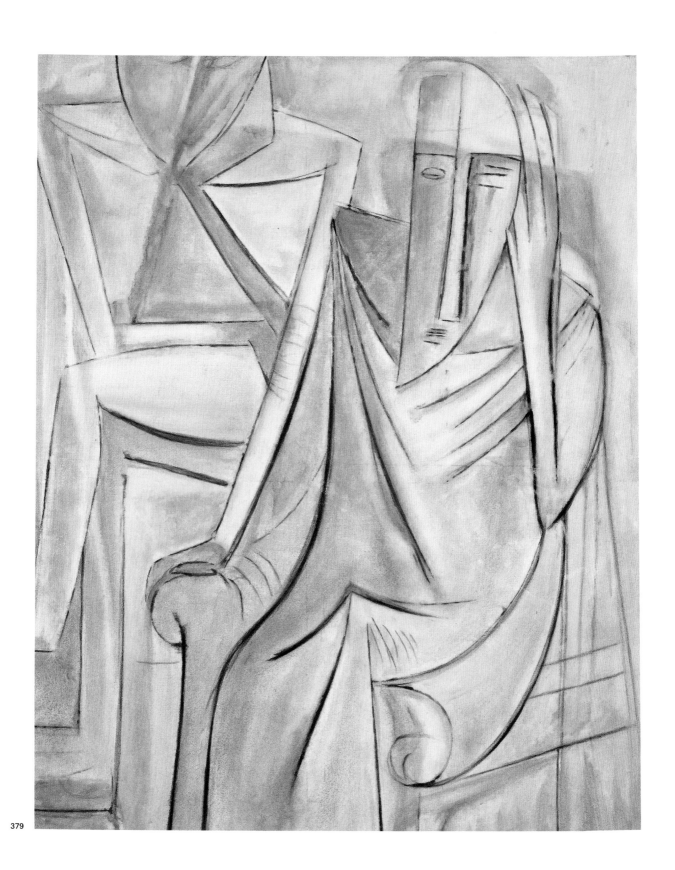

379

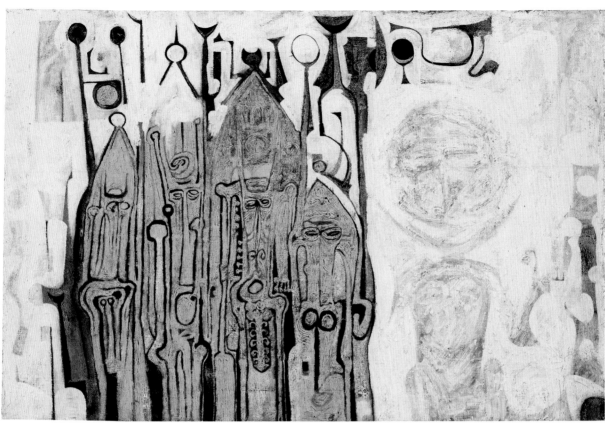

380

Wifredo
Lam

Sagua la Grande,
Cuba 1902–1982
Paris

379. *Untitled*, ca.
1942
Oil and charcoal
Collection of Luis
Paulo Montenegro,
Rio de Janeiro

Ibrahim
El-Salahi

b. Omdurman, Sudan,
1930; lives in Oxford

380. *They Always
Appear*, 1961
Oil on canvas,
61 x 92 cm
Collection of Toby and
Zoe Clarke, London

381

Norman
Lewis

Ernest
Mancoba

New York City 1909–
1979 New York City

Turffontein, South
Africa 1904–2002
Clamart, France

381. *Untitled*, ca.
1958
Oil on linen,
130 x 162 cm
Estate of the
artist and Michael
Rosenfeld Gallery,
New York

382. *Untitled*, 1958
Oil on canvas,
42 x 33 cm
Courtesy of Fundação
Sindika Dokolo,
Luanda, Angola

382

383

384

Antonio
Bandeira

Fortaleza, Brazil
1922–1967 Paris

383. **Black and White
Vertical City**, 1965
Oil on canvas,
162 x 97 cm
Collection Sattamini,
Rio de Janeiro

Howardena
Pindell

b. Philadelphia, 1943;
lives in New York City

384. **Untitled**, 1975
Mixed media on
canvas, 159 x 183 cm
Courtesy of the artist
and Garth Greenan
Gallery, New York

SELECTED BIBLIO-GRAPHY

Ades, Dawn, and Guy Brett. *Art in Latin America: The Modern Era, 1820–1980*. New Haven: Yale University Press, 1989.

Aguilar, Nelson, ed. *Mostra do redescobrimento: Arte afrobrasileira—Afro-Brazilian Art*. São Paulo: Associação Brasil 500 Anos Artes Visuais and Fundação Bienal de São Paulo, 2000.

Alberto, Paulina. *Terms of Inclusion: Black Intellectuals in Twentieth-Century Brazil*. Chapel Hill: University of North Carolina Press, 2011.

Alencastro, Luiz Felipe de. *O trato dos viventes: Formação do Brasil no Atlântico Sul*. São Paulo: Companhia das Letras, 2000.

Alhadeff, Albert. *Théodore Géricault: Painting Black Bodies, Confrontations and Contradictions*. New York: Routledge, 2020.

Alonso, Angela. *Flores, votos e balas*. São Paulo: Companhia das Letras, 2015.

Alpers, Edward A. "'Mozambiques' in Brazil: Another Dimension of the African Diaspora in the Atlantic World." In *Africa and the Americas: Interconnections during the Slave Trade*, ed. José C. Curto and Renée Soulodre-La France, 43–64. Trenton, N.J.: Africa World Press, 2005.

Alteveer, Ian. *Kerry James Marshall: Mastry*. New York: Skira Rizzoli, 2016.

Andrade, Oswald de. *João Miramar*. São Paulo: Companhia das Letras, 2016.

Andrews, George Reid. *Afro-Latin America, 1800–2000*. Oxford: Oxford University Press, 2004.

Antologia da fotografia africana e do Oceano Indico. Séculos XIX & XX. Paris: Éditions Revue Noire, 1998.

Apter, Andrew. *The Pan-African Nation: Oil and the Spectacle of Culture in Nigeria*. Chicago: University of Chicago Press, 2005.

Araujo, Ana Lucia. *Shadows of the Slave Past: Memory, Heritage, and Slavery*. New York: Routledge, 2014.

Araujo, Emanoel, ed. *O Haiti está vivo ainda lá: A arte das bandeiras, dos recortes e das garrafas consagradas ao Vodu*. São Paulo: Museu Afro Brasil, 2010.

———. *João e Arthur Timótheo da Costa: Dois irmãos pré-modernistas brasileiros*. São Paulo: Museu Afro Brasil, 2013.

———. *A mão Afro-brasileira*. São Paulo: Editora Tenenge, 1988.

———. *Para nunca esquecer: Negras memórias/memórias de negros*. Brasília: Ministério da Cultura, 2001.

A arte sob o olhar de Djanira: Coleção Museu Nacional de Belas Artes. Paraná: Museu Oscar Niemeyer, 2005.

Assis Filho, Waldir Simões de. *Cícero Dias: Uma vida pela pintura*. Curitiba: Simões de Assis Galeria de Arte, 2002.

Azevedo, Paulo Cesar de, and Mauricio Lissovsky, eds. *Escravos brasileiros do século XIX na fotografia de Christiano Jr*. São Paulo: Ex Libris, 1988.

Bagneris, Mia L. *Colouring the Caribbean: Race and the Art of Agostino Brunias*. Manchester: Manchester University Press, 2018.

Bamgboyé, Oladélé. *South Meets West*. Bern: Kunsthalle, 2000.

Bandeira, Julio, and Pedro Corrêa do Lago. *Debret e o Brasil: Obra completa*. Rio de Janeiro: Capivara, 2007.

Barson, Tanya, and Peter Gorschlüter. *Afro Modern: Journeys through the Black Atlantic*. London: Tate Publishing, 2010.

Bastide, Roger, and Florestan Fernandes. *Brancos e negros em São Paulo*. São Paulo: Editora Global, 2008.

Benny Andrews: There Must Be a Heaven. New York: Michael Rosenfeld Gallery, 2013.

Berlowicz, Barbara, et al., eds. *Albert Eckhout Returns to Brazil, 1644–2002*. Copenhagen: Nationalmuseet, 2002.

Berry, Ian, and Lauren Haynes. *Alma Thomas*. Munich: Prestel, 2016.

Bindman, David. *Ape to Apollo: Aesthetics and the Idea of Race in the 18th Century*. Ithaca, N.Y.: Cornell University Press, 2002.

Bindman, David, Henry Louis Gates, and Karen Dalton, eds. *The Image of the Black in Western Art*. 5 vols. Cambridge: Cambridge University Press, 2010–14.

Bondil, Nathalie, ed. *Cuba: Art and History from 1868 to Today*. Munich: Prestel, 2009.

Boxer, David. *Edna Manley, Sculptor*. Kingston: National Gallery of Jamaica, 1990.

Burke, Peter, and Maria Lúcia Garcia Pallares-Burke. *Repensando os trópicos*. São Paulo: Editora UNESP, 2009.

Campbell, Mary Schmidt. *Harlem Renaissance: Art of Black America*. New York: Abrams, 1994.

Candido, Mariana. *An African Slaving Port and the Atlantic World: Benguela and Its Hinterland*. New York: Cambridge University Press, 2013.

Capone, Stefania. *Searching for Africa in Brazil: Power and Tradition in Candomblé*. Durham, N.C.: Duke University Press, 2010.

Cardoso, Fernando Henrique. *Capitalismo e escravidão no Brasil meridional*. São Paulo: Civilização Brasileira, 2003.

Carneiro, Edison. *O Quilombo dos Palmares*. São Paulo: Martins Fontes, 2011.

Chalhoub, Sidney. *A força da escravidão: Ilegalidade e costume no Brasil oitocentista*. São Paulo: Companhia das Letras, 2012.

——. *Visões da liberdade*. São Paulo: Companhia de Bolso, 2011.

Chiarelli, Tadeu, ed. *Territórios: Artistas afrodescendentes no acervo da Pinacoteca*. São Paulo: Pinacoteca do Estado, 2015.

Clifford, James. *The Predicament of Culture*. Cambridge, Mass.: Harvard University Press, 1988.

——. *Returns*. Cambridge, Mass.: Harvard University Press, 2013.

——. *Routes*. Cambridge, Mass.: Harvard University Press, 1997.

Clifford, James, and George E. Marcus. *Writing Culture: The Poetics and Politics of Ethnography*. Berkeley: University of California Press, 1986.

Conrad, Robert E. *Tumbeiros: O tráfico de escravos para o Brasil*. São Paulo: Brasiliense, 1985.

——. *Os últimos anos da escravatura no Brasil*. São Paulo: Civilização Brasileira, 1975.

Cooper, Rosie, Sandeep Parmar, and Dominic Willsdon, eds. *The Two-Sided Lake: Scenarios, Storyboards and Sets from Liverpool Biennial 2016*. Liverpool: University of Liverpool Press, 2016.

Costa e Silva, Alberto. *A enxada e o lança*. Rio de Janeiro: Nova Fronteira, 2000.

——. *Imagens da África*. São Paulo: Penguin Books & Companhia das Letras, 2012.

——. *A Manilha e o Libambo: A África e a escravidão, de 1500 a 1700*. São Paulo: Nova Fronteira, 2011.

——. *Um rio chamado Atlântico: A África no Brasil e o Brasil na África*. Rio de Janeiro: Nova Fronteira, 2008.

Cravo, Christian, and Mario Cravo Neto. *Exu Iluminado*. Rio de Janeiro: Versal Editores, 2011.

Culllen, Deborah, and Elvis Fuentes, eds. *Caribbean: Art at the Crossroads of the World*. New Haven: Yale University Press, 2012.

Cunha, Manuela Carneira da. *Da senzala ao sobrado*. São Paulo: Nobel, 1985.

——. *Negros estrangeiros*. São Paulo: Companhia das Letras, 2012.

Davila, Jerry. *Diploma of Whiteness: Race and Social Policy in Brazil, 1917–1945*. Durham, N.C.: Duke University Press, 2003.

——. *Hotel Trópico: O Brasil e o Desafio da Descolonização Africana, 1950–1980*. São Paulo: Paz e Terra, 2011.

De Guzman, René, and Robin D. G. Kelley. *Hank Willis Thomas: Pitch*

Blackness. New York: Aperture, 2008

D'Horta, Vera. *Lasar Segall: Un expresionista brasileño*. Buenos Aires: MALBA, Fundación Eduardo F. Costantini, 2002.

Dias, Elaine. *Heitor dos Prazeres/Coleção Folha Grande Pintores Brasileiros*. São Paulo: Folha de São Paulo/Instituto Itaú Cultural, 2013.

Diener, Pablo, and Maria de Fátima Gomes Costa. *Rugendas e o Brasil*. Rio de Janeiro: Capivara, 2002.

Dixon, Kwame, and John Burdick, eds. *Comparative Perspectives on Afro-Latin America*. Gainesville: University Press of Florida, 2014.

Djanira. Rio de Janeiro: Museu Nacional de Belas Artes, 1976.

Douglas, Emory, Bobby Seale, and Sam Durant. *Black Panther: The Revolutionary Art of Emory Douglas*. New York: Rizzoli, 2007.

Du Bois, W. E. B. *The Souls of Black Folk*. New York: Penguin Books, 2021.

Dube, Prince Mbusi. *Dumile Feni Retrospective*. Johannesburg: Wits University Press, 2006.

Eltis, David, and David Richardson. *Atlas of the Transatlantic Slave Trade*. New Haven: Yale Univeristy Press, 2015.

Enwezor, Okwui. *Contemporary African Art Since 1980*. Bologna: Damiani Editore, 2009.

——. *Contemporary African Photography from the Walther Collection: Events of the Self: Portraiture and Social Identity*. Göttingen: Steidl, 2010.

——. *Postwar: Art between the Pacific and the Atlantic, 1945–1965*. Munich: Prestel, 2016.

Enwezor, Okwui, and Chinua Achebe, eds. *The Short Century*. Munich: Prestel, 2001.

Ermakoff, George. *O negro na fotografia brasileira do século XIX*. São Paulo: G. Ermakoff, 2007.

Fanon, Frantz. *The Wretched of the Earth*. New York: Grove Press, 2004.

Farkas, Solange. *Mostra Pan Africana de Arte Contemporânea*. São Paulo: Cultural Videobrasil, 2005.

Ferguson, Russell, et al., eds. *Out There: Marginalization and Contemporary Cultures*. New York: The New Museum of Contemporary Art, 1990.

Fernandes, Florestan. *O negro no mundo dos brancos*. São Paulo: Global, 2011.

Ferreira, Roquinaldo. *Cross-Cultural Exchange in the Atlantic World:*

Angola and Brazil during the Era of the Slave Trade. New York: Cambridge University Press, 2012.

Fine, Ruth, ed. *Procession: The Art of Norman Lewis*. Berkeley: University of California Press, 2015.

Florentino, Manolo, and José Roberto Goés. *A paz das senzalas*. Rio de Janeiro: UNESP, 2017.

Florentino, Manolo, and Cacilda Machado, eds. *Em costas negras: Uma história do tráfico de escravos entre a África e o Rio de Janeiro (séculos XVIII–XIX)*. São Paulo: Companhia das Letras, 1997.

——. *Ensaios sobre a escravidão (I)*. Belo Horizonte: Editora da UFMG, 2003.

Fonteles, Bené. *Rubem Valentim: Artista da luz*. São Paulo: Pinacoteca do Estado, 2001.

Franklin, John Hope, and Alfred A. Moss. *From Slavery to Freedom: A History of African Americans*. New York: Knopf, 2000.

Freitas, Décio. *Escravos e senhores de escravos*. Rio Grande do Sul: Mercado Aberto, 1983.

Freyre, Gilberto. *Casa grande e senzala*. São Paulo: Editora Global, 2006.

——. *O escravo nos anúncios de jornais brasileiros do século XIX*. São Paulo: Global Editora, 2012.

Fundação Biblioteca Nacional. São Paulo: Banco Safra, 2004.

Gaspar, David Barry, and Darlene Clark Hine. *More Than Chattel: Black Women and Slavery in the Americas*. Bloomington: Indiana University Press, 1996.

Gell, Alfred. *The Art of Anthropology*. Oxford: Berg, 1999.

Genovese, Eugene. *The Political Economy of Slavery*. New York: Vintage Books, 1967.

——. *Roll, Jordan, Roll: The World the Slaves Made*. New York: Pantheon, 1974.

Gilroy, Paul. *The Black Atlantic: Modernity and Double Consciousness*. London: Verso, 1996.

Ginzburg, Carlo. *The Enigma of Piero: Piero della Francesca, The Baptism, the Arezzo Cycle, the Flagellation*. London: Verso, 1985.

Godfrey, Mark, and Zoé Whitley. *Soul of a Nation: Art in the Age of Black Power*. London: Tate, 2017.

Gomes, Flávio dos Santos. *Experiências Atlânticas*. Passo Fundo: Editora Universitária, 2003.

——. *Histórias de quilombolas*. São Paulo: Companhia das Letras, 2006.

——. *Mocambos e quilombos: Uma história do campesinato negro no Brasil*. São Paulo: Companhia das Letras, 2017.

Gorender, Jacob. *O escravismo colonial*. São Paulo: Ática, 1978.

Goulart, Mauricio. *A escravidão africana no Brasil*. São Paulo: Alfa Omega, 2008.

Graham, Richard. *Escravidão, reforma e imperialismo*. São Paulo: Perspectiva, 1979.

Grinberg, Keila. "Processos criminais: A história nos porões dos arquivos judiciários." In *O historiador e suas fontes*, ed. Carla Pinsky and Tânia R. De Luca, 119–40. São Paulo: Contexto, 2009.

Guerreiro, Goli. *Terceira Diáspora*. São Paulo: Corrupio, 2010.

Gutman, Herbert. *The Black Family in Slavery and Freedom, 1750–1925*. New York: Vintage Books, 1977.

Ham, Gijs van der. *Tarnished Gold: Ghana and the Netherlands from 1593*. Amsterdam: Vantilt, 2016.

Hanchard, Michael. *Racial Politics in Contemporary Brazil*. Durham, N.C.: Duke University Press, 1999.

Harney, Elizabeth. *In Senghor's Shadow*. Durham, N.C.: Duke University Press, 2004.

Harrisburg, Halley K. *Embracing the Muse: Africa and African American Art*. New York: Michael Rosenfeld Gallery, 2004.

Hassan, Salah M. *Ibrahim El-Salahi: A Visionary Modernist*. Long Island City, N.Y.: Museum for African Art, 2012.

Hawthorne, Walter. *From Africa to Brazil: Culture, Identity, and an Atlantic Slave Trade, 1600–1830*. Cambridge: Cambridge University Press, 2010.

Herkenhoff, Paulo. *Arte brasileira na coleção Fadel: Da inquietação do moderno à autonomia da linguagem*. Rio de Janeiro: Andrea Jakobsson Estúdio, 2002.

Hills, Patricia. *Painting Harlem Modern: The Art of Jacob Lawrence*. Berkeley: University of California Press, 2009.

Horcasitas, Beatriz Urías. *Histórias secretas del racismo em México, 1920–1950*. Mexico City: Tiempo de Memória Tusquets Editores, 2007.

Hucke, Claudia. *Picturing the Postcolonial Nation: (Inter)Nationalism in the Art of Jamaica, 1962–1975*. Kingston: Ian Randle, 2013.

Ianni, Octavio. *As metamorfoses do escravo*. São Paulo: Difusão Europeia do Livro, 1962.

———. *Raças e classes sociais no Brasil*. São Paulo: Editora Brasiliense, 2004.

Izecksohn, Vitor. *Slavery and War in the Americas*. Charlottesville: University of Virginia Press, 2019.

Jopling, Carol F. *Art and Aesthetics in Primitive Societies*. New York: E. P. Dutton, 1971.

Karasch, Mary C. *Slave Life in Rio de Janeiro, 1808–1850*. Princeton: Princeton University Press, 2019.

Kasfir, Sidney Littlefield. *Contemporary African Art*. London: Thames & Hudson, 2000.

Klein, Herbert S. *African Slavery in Latin America and the Caribbean*. New York: Oxford University Press, 2007.

———. *The Atlantic Slave Trade*. Cambridge: Cambridge University Press, 1999.

Kouoh, Koyo. *We Face Forward: Art from West Africa Today*. Manchester: Cornerhouse Publications, 2012.

Koutsoukos, Sandra Sofia Machado. *Negros no estúdio do fotógrafo*. Campinas: Editora da Unicamp, 2010.

Krens, Thomas. *In-sight: African Photographers, 1940 to the Present*. New York: Guggenheim Museum, 1996.

Lago, Luiz Aranha Corrêa do. *Da escravidão ao trabalho livre: Brasil 1550–1900*. São Paulo: Companhia das Letras, 2014.

Lago, Pedro Corrêa do. *Brasiliana Itaú: Uma grande coleçao dedicada ao Brasil*. São Paulo: Capivara, 2009.

Lago, Pedro Corrêa do, and Bia Corrêa do Lago. *Frans Post, 1612–1680: Catalogue Raisonné*. Milan: 5 Continents, 2007.

Lambert, Catherine. *Seven Stories about Modern Art in Africa*. Paris: Flammarion, 1995.

Lara, Silvia Hunold, ed. *Campos da violência: Escravos e senhores na capitania do Rio de Janeiro, 1750–1808*. Rio de Janeiro: Paz e Terra, 1988.

———. *Ordenaèões Filipinas—Livro V*. São Paulo: Companhia das Letras, 1999.

Lazaro, Wilson. *Arthur Bispo do Rosário*. Rio de Janeiro: Réptil, 2012.

Leite, José Roberto Teixeira. *Pintores Negros do Oitocentos*. São Paulo: MWM Motores, 1988.

Lemke, Sieglinde. *Primitivist Modernism: Black Culture and the Origins of Transatlantic Modernism*. Oxford: Oxford University Press, 1998.

Libby, Douglass Cole, and Junia Ferreira Furtado, eds. *Trabalho livre, trabalho escravo: Brasil e Europa, séc. XVII e XIX*. São Paulo: Annablume, 2006.

Lima, Valéria. *Uma viagem com Debret*. Rio de Janeiro: Zahar, 2004.

Lindop, Barbara. *Sekoto: The Art of Gerard Sekoto*. London: Pavilion, 1995.

Lody, Raul. *O negro no museu brasileiro: Construindo identidades*. Rio de Janeiro: Bertrand Brasil, 2005.

Lovejoy, Paul E. *Transformations in Slavery*. Cambridge: Cambridge University Press, 2011.

Luna, Francisco Vidal, Iraci de Nero da Costa, and Herbert S. Klein. *Escravismo em São Paulo e Minas Gerais*. São Paulo: Edusp/Imprensa Oficial, 2009.

Machado, Maria Helena P. T. "Between Two Beneditos: Enslaved Wet-Nurses amid Slavery's Decline in Southeast Brazil." *Slavery & Abolition* 38, no. 2 (June 2017), 320–26.

———. *Crime e escravidão: Trabalho, luta e resistência nas lavouras paulistas, 1830–1888*. São Paulo: Brasiliense, 1988.

Mack, John. *Africa: Arts & Cultures*. Oxford: Oxford University Press, 2001.

Mamigonian, Beatriz G. *Africanos livres: A abolição do tráfico de escravos no Brasil*. São Paulo: Companhia das Letras, 2017.

Marquese, Rafael de Bivar. "Capitalismo, escravidão e a economia cafeeira do Brasil no longo século XIX." *Saeculum: Revista de História*, no. 29 (2013), 289–321.

Mattos, Hebe. *Das cores do silêncio: Os significados da liberdade no Sudeste escravista, Brasil século XIX*. Campinas: Editora da Unicamp, 2015.

———. *Escravidão e cidadania no Brasil monárquico*. Rio de Janeiro: Jorge Zahar, 2001.

Mattoso Kátia. *Ser escravo no Brasil*. São Paulo: Brasiliense, 1982.

Mbembe, Achille. *On the Postcolony*. Berkeley: University of California Press, 2001.

Meltzer, Milton. *Slavery: A World History*. New York: Da Capo, 1993.

Mesquita, Ivo, and Adriano Pedrosa. *F(r)icciones. Versiones del sur*. Madrid: Museo Nacional Centro de Arte Reina Sofía, 2000.

Mestre Didi—Mo Ki Gbogbo In—Eu saúdo a todos. São Paulo: Almeida a Dale Galeria de Arte, 2018.

Migliaccio, Luciano. *Arte brasiliana del XIX secolo*. Venice: Forum Edizioni. 2008.

Moraga, Cherrie, and Gloria Anzaldúa, eds. *This Bridge Called My Back: Writings by Radical Women of Color*. New York: Kitchen Table Press, 1983.

Morel, Marco. *A revolução do Haiti e o Brasil escravista: O que não deve ser dito*. São Paulo: Paco Editorial, 2017.

Mott, Luiz. "Uma escrava do Piauí escreve uma carta." *Mensário do Arquivo Nacional* 11, no. 5 (1980), 3–21.

Moura, Carlos Eugênio Marcondes de. *A Travessia da Calunga Grande*. São Paulo: EDUSP, 2001.

Moura, Clóvis. *Dicionário da Escravidão Negra no Brasil*. São Paulo: EDUSP, 2005.

Mudimbe, V. Y. *The Idea of Africa: African Systems of Thought*. Bloomington: Indiana University Press, 1994.

———. *The Invention of Africa: Gnosis, Philosophy, and the Order of Knowledge*. Bloomington: Indiana University Press, 1988.

Munanga, Kabengele. *Rediscutindo a mestiçagem no Brasil: Identidade nacional versus identidade negra*. São Paulo: Autêntica Editora, 1999.

Museu Afro Brasil. São Paulo: Banco Safra, 2010.

Museu de Arte Contemporânea da Universidade de São Paulo. São Paulo: Banco Safra, 1990.

Museu de Arte da Bahia. São Paulo: Banco Safra, 1997.

Museu de Arte Moderna da Bahia. São Paulo: Banco Safra, 2008.

Museu de Arte Sacra da Universidade Federal da Bahia. São Paulo: Banco Safra, 1987.

Museu do Estado de Pernambuco. São Paulo: Banco Safra, 2003.

Museu Histórico Nacional. São Paulo: Banco Safra, 1989.

Museu Imperial. São Paulo: Banco Safra, 1992.

Museu Lasar Segall. São Paulo: Banco Safra, 1991.

Museu Mariano Procópio. São Paulo: Banco Safra, 2006.

Museu Nacional de Belas Artes. São Paulo: Banco Safra, 1985.

O Museu Paulista da Universidade de São Paulo. São Paulo: Banco Safra, 1984.

Museus Castro Maya. São Paulo: Banco Safra, 1996.

Naro, Nancy Priscilla, ed. *Blacks, Coloureds and National Identity in Nineteenth-Century Latin America*. London: Institute of Latin American Studies, 2003.

———. *A Slave's Place, a Master's World*. London: Bloomsbury, 2018.

Naves, Rodrigo. *A forma difícil: Ensaios sobre arte brasileira*. São Paulo: Ática, 1996.

Needell, Jeffrey D. *The Party of Order*. Palo Alto, Calif.: Stanford University Press, 2006.

Nettleton, Anitra, Julia Charlton, and Fiona Rankin-Smith. *Engaging Modernities: Transformations of the Commonplace: Standard Bank Collection of African Art*. Johannesburg: University of Witwatersrand Art Galleries, 2003.

Njami, Simon. *Africa Remix: Contemporary Art of a Continent*. London: Hayward Gallery, 2005.

No subúrbio da modernidade: Di Cavalcanti 120 anos. São Paulo: Pinacoteca do Estado, 2017.

Nuttall, Sarah. *Beautiful/Ugly: African and Diaspora Aesthetics*. Durham, N.C.: Duke University Press, 2007.

Obrist, Hans Ulrich, and Asad Raza. *Mondialité: Or the Archipelagos of Édouard Glissant*. Paris: Skira, 2018.

Ogbechie, Sylvester Okwunodu. *Ben Enwonwu: The Making of an African Modernist*. Rochester, N.Y.: University of Rochester Press, 2008.

Oguibe, Olu, and Okwui Enwezor. *Reading the Contemporary: African Art from Theory to the Marketplace*. Cambridge, Mass.: MIT Press, 1999.

Okeke-Agulu, Chika. *Postcolonial Modernism: Art and Decolonization in Twentieth-Century Nigeria*. Durham, N.C.: Duke University Press, 2015.

Okpewho, Isidore, Carole Davies, and Ali A. Mazrui. *The African Diaspora: African Origins and New World Identities*. Bloomington: Indiana University Press, 2001.

Oliver, Roland. *The African Experience: From Olduvai Gorge to the 21st Century*. New York: Routledge, 2018.

Oliver, Roland, and J. D. Fage. *A Short History of Africa*. London: Penguin Books, 1988.

Paiva, Eduardo França. *Dar nome ao novo: Uma história lexical da Ibero-América entre os séculos XVI e XVIII (as dinâmicas de mestiçagens e o mundo do trabalho)*. Belo Horizonte: Autêntica, 2015.

Paiva, Eduardo França, and Carla Maria Junho Anastasia. *O trabalho*

mestiço: Maneiras de pensar e formas de viver, século XVI a XIX. São Paulo: Annablume, 2002.

Parés, Luis Nicolau. A formação do candomblé: História e ritual da nação jeje na Bahia. Campinas: Editora da Unicamp, 2006.

Peabody, Rebecca. Consuming Stories: Kara Walker and the Imagining of American Race. Berkeley: University of California Press, 2016.

Pedrosa, Adriano, and Fernando Oliva, eds. Maria Auxiliadora: Vida cotidiana, pintura e resistência/Daily Life, Painting and Resistence. São Paulo: Museu de Arte de São Paulo Assis Chateaubriand, 2018.

Pedrosa, Adriano, and Lilia M. Schwarcz, eds. Histórias mestiças. Rio de Janeiro: Instituto Tomie Ohtake, 2015.

Pinacoteca do Estado de São Paulo. São Paulo: Banco Safra, 1994.

Pinho, Patrícia de Santana. Mama Africa: Reinventing Blackness in Bahia. Durham, N.C.: Duke University Press, 2010.

Pinsky, Jaime. A escravidão no Brasil. São Paulo: Editora Contexto, 2000.

Piper, Adrian. Out of Order, Out of Sight, Volume 1: Selected Writings in Meta-Art, 1968–1992. Cambridge, Mass.: MIT Press, 1996.

Pivin, Jean. An Anthology of African art: The Twentieth Century. New York: D.A.P., 2002.

Powell, Richard J. Black Art: A Cultural History. London: Thames & Hudson, 2003.

Powell, Richard J., and Virginia M. Mecklenberg. African American Art: Harlem Renaissance, Civil Rights Era, and Beyond. New York. Skira Rizzoli, 2012.

Powell, Richard J., Jock Reynolds, and Kinasha Conwill. To Conserve a Legacy: American Art from Historically Black Colleges and Universities. Cambridge, Mass.: MIT Press, 1999.

Prandi, Reginaldo. Mitologia dos Orixás. São Paulo: Companhia das Letras, 2001.

Price, Sally. Primitive Art in Civilized Places. Chicago: University of Chicago Press, 1989.

Rediker, Marcus. O navio negreiro. São Paulo: Companhia das Letras, 2011.

Reis, João José. Rebelião escrava no Brasil: A história do Levante dos Malês em 1835. São Paulo: Companhia das Letras, 2003.

——. Tornar-se escravo no Brasil do século XIX. Cambridge: Cambridge University Press, 2017.

Reis, João José, and Flávio dos Santos Gomes. Liberdade por um fio. São Paulo: Companhia das Letras, 1996.

Reis, João José, Flávio dos Santos Gomes, and Marcus J. M. de Carvalho. O Alufá Rufino: Tráfico, escravidão e liberdade no Atlântico negro (c. 1822–c. 1853). São Paulo: Companhia das Letras, 2010.

Risério, Antônio. A utopia brasileira e os movimentos negros. São Paulo: Editora 34, 2007.

Rishel, Joseph J., and Suzanne L. Stratton, eds. The Arts in Latin America, 1492–1820. New Haven: Yale University Press, 2006.

Rodrigues, Jaime. De costa a costa: Escravos, marinheiros e intermediários do tráfico negreiro de Angola ao Rio de Janeiro, 1780–1860. São Paulo: Companhia das Letras, 2005.

——. O infame comércio: Propostas e experiências no final do tráfico de africanos para o Brasil (1800–1850). Campinas: Editora da Unicamp, 2000.

Rodrigues, Nina. Os Africanos no Brasil. São Paulo: Editora Madras, 2008.

Romo, Anadelia A. Brazil's Living Museum: Race, Reform, and Tradition in Bahia. Chapel Hill: University of North Carolina Press, 2010.

Rudisel, Christiane, and Bob Blaisdell, eds. Slave Narratives of the Underground Railroad. New York: Dover, 2014.

Rutherford, Jonathan, ed. Identity: Community, Culture, Difference. London: Lawrence & Wishart, 1990.

Salles, Ricardo. E o Vale era o escravo. Vassouras, século XIX: Senhores e escravos no coração do Império. Rio de Janeiro: Civilização Brasileira, 2008.

Sansone, Livio. Negritude sem etnicidade. Salvador: EdUFBA, 2003.

Sansone, Livio, Elisée Soumonni, and Boubacar Barry. Africa, Brazil and the Construction of Trans Atlantic Black Identities. Trenton, N.J.: Africa World Press, 2008.

Schwarcz, Lilia Moritz. O espetáculo das raças. São Paulo: Companhia das Letras, 1993.

——. "Lendo e agenciando imagens: O rei, a natureza e seus belos naturais." Revista Sociologia & Antropologia 4, no. 2 (2014), 391–431.

——. Lima Barreto: Triste visionário. São Paulo: Companhia das Letras, 2017.

——. Nem preto nem branco, muito pelo contrário: Cor e raça na sociabilidade brasileira. São Paulo: Companhia das Letras, 2012.

——. Registros escravos. São Paulo: Biblioteca Nacional, 2006.

——. O Sol do Brasil. São Paulo: Companhia das Letras, 2015.

Schwarcz, Lilia Moritz, and Flávio de Santos Gomes, eds. Dicionário da escravidão e liberdade. São Paulo: Companhia das Letras, 2018.

Schwartz, Stuart B. Slaves, Peasants, and Rebels: Reconsidering Brazilian Slavery. Urbana: University of Illinois Press, 1992.

——. Sugar Plantations in the Formation of Brazilian Society. Cambridge: Cambridge University Press, 2004.

Sims, Lowery Stokes. Common Wealth: Art by African Americans in the Museum of Fine Arts, Boston. Boston: Museum of Fine Arts Publications, 2015.

Skidmore, Thomas. Preto no Branco: Raça e nacionalidade no pensamento brasileiro. São Paulo: Companhia das Letras, 1989.

Slenes, Robert W. Na senzala, uma flor. São Paulo: Editora UNICAMP, 2011.

Soares, Carlos Eugênio Libano. A capoeira escrava. Campinas: Editora da Unicamp, 2001.

Souza, Marina de Mello e. Reis negros no Brasil escravista. Belo Horizonte: Editora UFMG, 2002.

Spring, Chris. Angaza Afrika: African Art Now. London: Laurence King, 2008.

Stam, Robert, and Ella Shohat. Race in Translation: Culture Wars around the Postcolonial Atlantic. New York: New York University Press, 2012.

Sullivan, Edward J., ed. Latin American Art in the Twentieth Century. London: Phaidon, 1996.

Thornton, John. Africa and Africans in the Making of the Atlantic World, 1400–1800. New York: Cambridge University Press, 1998.

Tinhorão, José Ramos. Os sons dos negros no Brasil. São Paulo: Editora 34, 2008.

Valladares, Clarival do Prado, ed. The Impact of African Culture on Brazil: Brazilian Exhibition/II FESTAC/Lagos—Nigeria. Brasília: Ministério das Relações Internacionais e Ministério da Educação e Cultura, 1977.

Vandenbroeck, Paul, and Catherine de Zegher. America, Bride of the Sun: 500 Years Latin America and the Low Countries. Ghent: Imschoot, 1992.

Verger, Pierre. Fluxo e refluxo: Do tráfico dos escravos entre o golfo de Benin e a Bahia de Todos os Santos, dos séculos XVII a XIX. São Paulo: Corrupio, 1987.

Vergne, Philippe, ed. Kara Walker: My Complement, My Enemy, My Oppressor, My Love. Minneapolis: Walker Art Center, 2007.

Viotti da Costa, Emília. A Abolição. São Paulo: Editora UNESP, 2010.

——. Da senzala à colônia. São Paulo: Editora UNESP, 2012.

Vogel, Susan. Africa Explores: Twentieth Century African Art. New York: Museum for African Art, 1991.

Wade, Peter. Race and Ethnicity in Latin America. London: Pluto Press, 2010.

Walker, Roslyn Adele. The Arts of Africa at the Dallas Museum of Art. New Haven: Yale University Press, 2009.

Walvin, James. Atlas of Slavery. London: Routledge, 2005.

Williams, Eric E. Capitalism & Slavery. New York: Russell & Russell, 1961.

Williamson, Sue. Resistance Art in South Africa. Lansdowne: Double Storey, 2010.

Willis, Deborah. Reflections in Black: A History of Black Photographes 1840 to the Present. New York: W. W. Norton, 2000.

Willis, Deborah, and Barbara Krauthamer. Envisioning Emancipation: Black Americans and the End of Slavery. Philadelphia: Temple University Press, 2012.

Wissenbach, Maria Cristina Cortez. Sonhos africanos, vivências ladinas: Escravos e forros em São Paulo (1850–1880). São Paulo: Hucitec, 1998.

Wood, Marcus. Black Milk: Imagining Slavery in the Visual Cultures of Brazil and America. Oxford: Oxford University Press, 2013.

——. Blind Memory: Visual Representations of Slavery in England and America. London: Routledge, 2000.

Compiled by Artur Santoro

PATRONS

Charitable Patrons
Amalia Spinardi and Roberto Thompson Motta
Ana Salomone
Carlos Jereissati
Geyze and Abilio Diniz
Maria Victoria and Eric Hime
Rose and Alfredo Setubal

Diamond Patrons
Cleusa Garfinkel
Nadia and Olavo Egydio Setubal Jr.
Tania and Antonio de Freitas Valle
Teresa Bracher

Gold Patrons
Camila and Walter Appel
Cleiton de Castro Marques
Frances Reynolds
Guilherme Affonso Ferreira
Henrique Meirelles
Israel Vainboim
Ivo Wohnrath
José de Menezes Berenguer Neto
José Orlando A. de Arrochela Lobo
Juliana and Francisco de Sá
Lais and Telmo Porto
Lilian Feuer Stuhlberger and Luis Stuhlberger
Luciana de Oliveira Hall and Ronaldo Cezar Coelho
Maria Claudia and Leo Krakowiak
Marina Diniz Junqueira and Fernando de Almeida Nobre Neto
Martha and André De Vivo
Mônica and Eduardo Vassimon
Mônica and Fábio Ulhôa Coelho
Paloma and Fersen Lambranho
Paulo Galvão Filho
Paulo Proushan
Regina Pinho de Almeida
Roberto Setubal
Silvia and Marcelo Barbará
Sonia and Hamilton Dias de Souza
Susana and Ricardo Steinbruch
Susie and Guido Padovano
Sylvia Pinho de Almeida
Tania Haddad Nobre and Alexandre Nobre
Titiza Nogueira and Renata Nogueira Beyruti
Vania and José Roberto Marinho
Vera Lucia dos Santos Diniz

Silver Patrons
Alessandra (*In memoriam*) and Rodrigo Bresser-Pereira
Ana Eliza and Paulo Setubal
Ana Karina Bortoni Dias e Marcos Fernandes Navarro
Ana Lucia and Sergio Comolatti
Ana Maria Igel and Mario Higino Leonel
Ana Paula Capricho de Azevedo Motta and Daniel Augusto Motta
Ana Paula Martinez and Daniel K. Goldberg
Andrea and José Olympio da Veiga Pereira
Beno Suchodolski
Carolina Aguiar and Luís Paulo Saade Montenegro
Carolina and Patrice Etlin
Cecília and Abram Szajman
Célia and Bernardo Parnes
Cristiana and Dan Ioschpe
Dulce and João Carlos Figueiredo Ferraz

Fabiana and Marcelo Marangon
Isa Teixeira Gontijo and Nicola Calicchio Neto
Janaina Dobbeck Fiorini and Reinaldo Carlos Fiorini
Julio Roberto Magnus Landmann
Ksenia and Marcos Amaro
Lavínia and Ricardo Setubal
Luiz Roberto Ortiz Nascimento
Marcelo Eduardo Martins
Marguerite and Jean Etlin
Maria Alice Setubal
Maria Eduarda and Ricardo Brito Pereira
Maria Luiza and Tito da Silva Neto
Marta Fadel
Miguel Setas
Paula Pires Paoliello de Medeiros and Marcelo Medeiros
Sandra and José Luiz Setúbal
Sonia and Luis Terepins
Sônia Regina Hess de Souza and João Miranda de Souza Júnior
Vera Negrão
Vicente Furletti Assis
Vivian Jessica Blair Bigoni and Marcio Verri Bigoni

Patrons
Alexandra Mollof
Alice and Bruno Baptistella
Angela and Ricard Akagawa
Antonia Bergamin and Mateus Ferreira
Antonio Almeida and Carlos Dale
Antonio Beltran Martinez
Augusto Livio Malzoni
Beatriz Yunes and Carmo Guarita
Berardino Antonio Fanganiello
Christina Bicalho and José Carlos Hauer Santos
Claudia and Paulo Petrarca
Daniela and Helio Seibel
Daniela Johannpeter
Danielle Silbergleid and Antônio Pitombo
Debora and Gustavo Doná Machado
Eduardo Saron
Eliane and Luiz Francisco Novelli Viana
Fernanda and Alberto Fernandes
Fernanda Feitosa and Heitor Martins
Flavia and Silvio Eid
Giorgio Nicoli
James Acacio Lisboa
Joan and Jackson Schneider
Liane and Roberto Bielawski
Luciana and Moacir Zilbovicius
Luciana Vale Borges and Alessandro Zema Silva
Luisa Strina
Márcia Fortes, Alessandra D'Aloia, and Alex Gabriel
Maria Angela and Roberto Klabin
Mariana Guarini Berenguer
Marina and Marcos Gouvêa
Marisa and Salo Seibel
Marjorie and Geraldo Carbone
Marta and Paulo Kuczynski
Max Perlingeiro
Nara Roesler
Neide Helena de Moraes
Neyde Ugolini de Moraes
Patricia and Fabio Parsequian
Paula Depieri
Paulo Donizete Martinez
Paulo Saad Jafet
Priscilla and Marcelo Parodi
Raquel and Marcio Kogan

Renata Bittencourt
Renata de Paula David
Renata Tubini
Ricardo Ohtake
Rita de Cássia and Carlos Eduardo Depieri
Sabina and Abrão Lowenthal
Sandra and William Ling
Sílvia Teixeira Penteado
Silvio Tini de Araújo
Sonia and Paulo de Barros Carvalho
Thaissa and Alexandre Bertoldi
Thalita Cefali Zaher
TVML Foundation
Vera Havir and Raul Corrêa da Silva
Vera Novis
Vilma Eid

YOUNG PATRONS

Young Silver Patrons
Ana Khouri
Eliza Correa de Almeida Nobre
Francisco Fernando Correa de Almeida Nobre
Marcela and Alfredo Nugent Setubal
Matheus Farah Leal

Young Patrons
Ana Varella and Daniel Pedrosa Sousa
Antonio Certain Toledo
Arthur Jafet
Beatriz Ferrer de Ulhôa Coelho
Camila Yunes and Conrado Mesquita
Carolina Freitas
Caroline Ficker
Dante Alberto Jemma Cobucci
Felipe Calil de Melo and Julia Suslick
Felipe Hegg
Fernanda Ingletto Vidigal
Gabriela Camargo
Gabriela and Lucas Giannella
Guilherme Simões de Assis
Gustavo de Barros Oliva
Gustavo Nóbrega
Gustavo Silveira Cunha
Heloisa and Amos Genish
Ivan Prado Marchetti
Ivo Kos
Jéssica Cinel
João José de Oliveira Araújo
João Zeferino Ferreira Velloso Filho
Juan Eyheremendy
Juliana and Leonardo Gonzalez
Lia and Ricardo Pedro Guazzelli Rosario
Lívia and Gustavo Harich
Lucas Marques Pessôa
Luiza and Marcelo Hallack
Marcelo Vicintin
Maria Flavia Candido Seabra
Maria Rita Drummond and Rodolfo Barreto
Mariah Rios Rovery José
Marina Sirotsky
Mateus Reppucci
Mila Junqueira and Adolpho Lemos da Costa
Mirella Havir Ramaccioti and Diego Puerta
Monize Neves and Ricardo Vasques
Paula and Bruno Rizzo Setubal
Paula Proushan

Rafael Bolelli Abreu
Rafael Moraes
Regina and Avelino Alves Palma
Renata Alice Lobo Lisboa
Rodrigo Hsu Ngai Leite
Sofia Derani
Thomas O. Lemouche and André D. Mathias
Vivian Cecco

Strategic Partners
Itaú
Vivo

Master Sponsors
Bradesco
B3
Citibank
Klabin
McKinsey & Company
Qualicorp
Renner
Unilever

Sponsors
Aché
AkzoNobel
Alupar
Alvarez e Marsal
American Express
Banco Votorantim
Biolab Farmacêutica
Bloomberg Philanthropies
Colégio Poliedro
Deloitte
EMS
Goldman Sachs
Goodyear
Grupo Ultra
Instituto Votorantim
Lefosse
Leroy Merlin
Livelo
Morgan Stanley
Nova Energia
Sotheby's
XP Private

Supporters
Banco Daycoval
Banco MUFG
British Academy
British Council
Comerc Energia
GreenYellow
JP Morgan
Mattos Filho
Racional
Tallento
Trench, Rossi e Watanabe

Friend Firms
Eastman
Elos
Grupo Oikos
Kaspersky
Mercedes Benz
Rodobens

Media Partners
Boxnet
Canal Arte1
Canal Curta!
Cult
Folha de S.Paulo
Harper's Bazaar
Intelly
Revista Piauí
Revista 451
Socialbakers

AFRO-ATLANTIC HISTORIES

Published in conjunction with the exhibition *Afro-Atlantic Histories*. This exhibition is co-organized by Museu de Arte de São Paulo Assis Chateaubriand and Museum of Fine Arts, Houston.

Exhibition Itinerary:
Museum of Fine Arts, Houston
October 2021–January 2022

National Gallery of Art, Washington, D.C.
April–July 2022

Los Angeles County Museum of Art
December 2022–April 2023

Dallas Museum of Art
October 2023–January 2024

Published in 2021 by DelMonico Books • D.A.P. and Museu de Arte de São Paulo Assis Chateaubriand

DelMonico Books
ARTBOOK | D.A.P
75 Broad Street Suite 630
New York, NY, 10004, United States
artbook.com
delmonicobooks.com

MASP
Museu de Arte de São Paulo Assis Chateaubriand
Avenida Paulista, 1578
São Paulo, SP, 01310-200, Brazil
masp.org.br

ISBN: 978-1-63681-002-7
Library of Congress Control Number: 2021943887

COVER
Dalton Paula, *Zeferina*, 2018 (fig. 195)

FRONT ENDPAPERS
Unidentified Artist, *Woman from Bahia*, ca. 1850 (fig. 205)
Toyin Ojih Odutola, *All These Garlands Prove Nothing X*, 2013 (fig. 245)

BACK ENDPAPERS
Osmond Watson, *Johnny Cool*, 1967 (fig. 227)
Frédéric Bazille, *Young Woman with Peonies*, 1870 (fig. 240)

BACK COVER
Ernest Crichlow, *Harriet Tubman*, 1953 (fig. 69)

FOLLOWING PAGE
Frente 3 de Fevereiro
385. *Where are the Blacks?*, 2005, Installed on the façade of the Museu de Arte de São Paulo Assis Chateaubriand in 2018
Museu de Arte e São Paulo Assis Chateaubriand, gift of the artists in the context of the *Afro Atlantic Histories* exhibition, 2018-2020, MASP R.03005

EDITORS
Adriano Pedrosa, Museu de Arte de São Paulo Assis Chateaubriand
Tomás Toledo, Museu de Arte de São Paulo Assis Chateaubriand

EDITORIAL CONSULTING
Karen Marta, Todd Bradway, Karen Marta Editorial Consulting

EDITORIAL ASSISTANT
Madeline Gilmore, Karen Marta Editorial Consulting

PROOFREADING
Anne Wu

PRODUCTION
Karen Farquhar, DelMonico Books
Todd Bradway, Karen Marta Editorial Consulting

IMAGE COORDINATION
Marcelina Guerrero, Museum of Fine Arts Houston
Amanda Negri, Museu de Arte de São Paulo Assis Chateaubriand

GRAPHIC DESIGN
Paula Tinoco, Roderico Souza, Carolina Aboarrage, Estúdio Campo, São Paulo

TRANSLATION
Adriana Francisco
Alessandra Ribeiro
Patrick Brock
Emma Young

FONTS
VTC Carrie; Freight Text Pro; Fakt

Printed and bound in China

MASP, a diverse, inclusive, and
plural museum, has the mission to
establish, in a critical and creative
way, dialogues between past and
present, cultures and territories,
through the visual arts. To this end,
it should enlarge, conserve, research,
and disseminate its collection,
while also promoting the encounter
between its various publics
and art through transformative
and welcoming experiences.

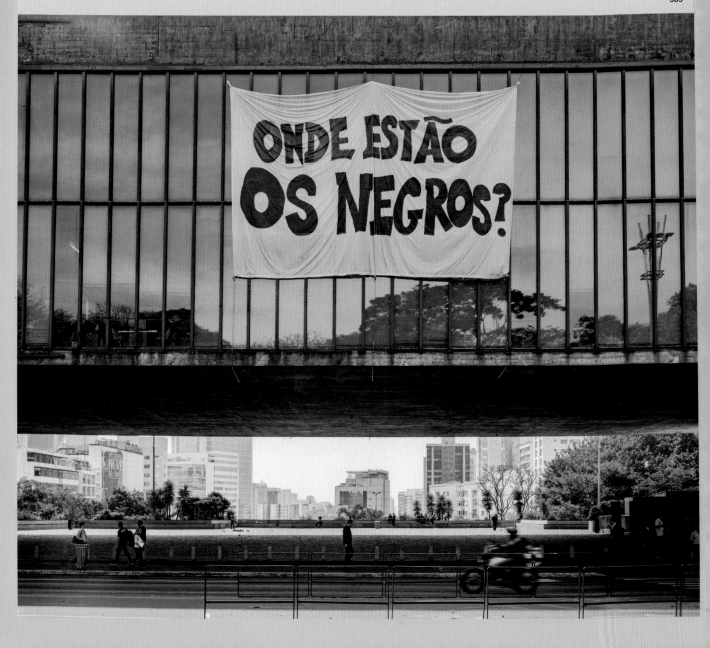